# SELL & RE-SELL
## YOUR PHOTOS

### HOW TO SELL YOUR PICTURES TO A WORLD OF MARKETS A MAILBOX AWAY

**FOURTH EDITION!** Includes information on how to use your computer and **the Internet** to sell your photos

## ROHN ENGH

D0166986

**WRITER'S DIGEST BOOKS**
CINCINNATI, OHIO

**Sell and Re-Sell Your Photos.** Copyright © 1997 by Rohn Engh. Printed and bound in the United States of America. All rights reserved. No part of this book may be reproduced in any form or by any electronic or mechanical means including information storage and retrieval systems without permission in writing from the publisher, except by a reviewer, who may quote brief passages in a review. Published by Writer's Digest Books, an imprint of F&W Publications, Inc., 1507 Dana Ave., Cincinnati, Ohio 45207. Fourth edition.

Other fine Writer's Digest Books are available from your local bookstore or direct from the publisher.

03   02   01   00   99      6   5   4   3   2

Library of Congress Cataloging in Publication Data

Engh, Rohn.
   Sell & re-sell your photos / by Rohn Engh.— 4th ed.
      p.      cm.
   Includes bibliographical references and index.
   ISBN 0-89879-774-8 (alk. paper)
   1. Photography—Marketing   2. Photography—Business methods.   3. Stock
photography.   I. Title.
TR690.E53   1997
770'.68'8—dc21                                                97-9074
                                                                CIP

Edited by Marc Jennings
Production edited by Jennifer Lepore
Cover designed by Stephanie Redman

*I'd like to dedicate this book to my parents, Mr. and Mrs. Lynn A. Engh ("Muzzie and Coolie"). My dad inspired me to believe that anything is possible if you "keep in a good frame of mind." My mother showed me how to enjoy my blessings twofold by sharing them with others.*

*. . . To my two boys, Danny and Jim (both are pictured in this book), for constantly reminding me that most problems can be solved if you meet them with childlike freshness and clarity of vision.*

*. . . And to my wife, Jeri, for the common sense, good humor and love that keep our family on a straight course.*

*I'd like to acknowledge Jeri's wonderful help on this book. Not only did she bring her professional writing expertise to the project, she is my severest critic and my best friend.*

*Sincere thanks also go to J. Dianne Brinson for her knowledgeable aid with the copyright section, to Bill Hopkins for his contributions to the computer/online chapter, to Lori Sampson and Crimson Star for their help on the World Wide Web section, to Julian Block for his expertise on the taxes section, and to Rick Smolan, Mitch Kezar, Galen Rowell and Lou Jacobs, Jr. for their encouragement and support in my publishing efforts.*

*There are many others whose influence or example through the years have helped make this book possible. The best way I can express my appreciation is to pass what I have learned on to you.*

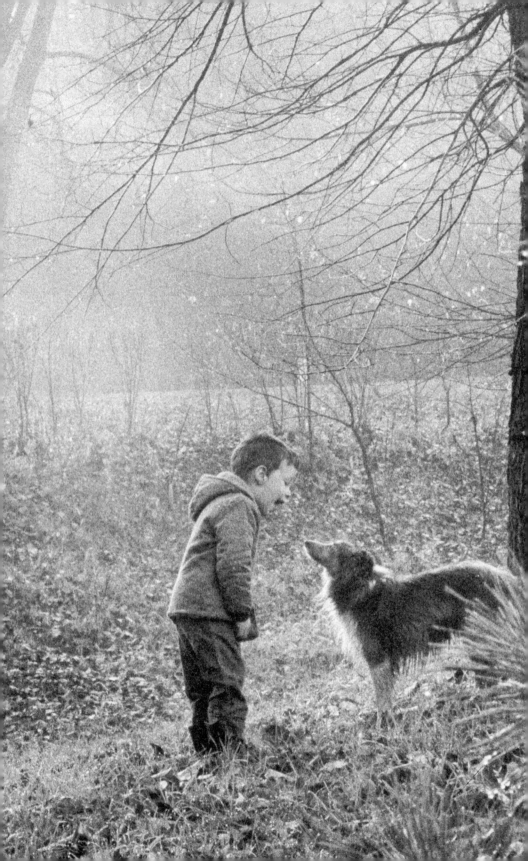

# Contents

Photocopying Your Photographs. The Central Art File. The PhotoDataBank. The Permanent-File System. The Pirates. The Legal Side.

Cross-Referencing System for Retrieving Your Pictures. Counting the Beans. Protecting Your Files. Everything Has Its Place.

## 14. Working Smart
Setting Goals. Getting Organized. Time Your Goals. Is It Easy? A Survival Secret. Think Small. You Manage the Business—Not the Other Way Around. A Self-Evaluation Guide. How to Measure Your Sales Strengths. Pictures Just Aren't Selling? A Potpourri of Additional Aids in Working Smart. Your Success Scorecard.

## 15. Rights and Regulations
Copyright Infringement. Group Registration. How to Contact the Copyright Office. Interpreting the Law. Be Wary of Dates. Laying Claim to Your Picture. Some Drawbacks of the Copyright Law. A Remedy. Q&A Forum on Copyright. Work for Hire. Electronic Rights—Be Careful. Which Usage Rights Do You Sell? Read the Fine Print. Forms to Protect Your Rights. Legal Help. Model Releases. Freedom of the Press. You Will Rarely Need a Model Release for Editorial Use. Model Releases—When Must You Get Them? Oral Releases. Can We Save Them Both? The Right of Privacy and Our First Amendment Rights. "Fruity" Question.

## 16. Your Stock-Photo Business: A Mini Tax Shelter
The Tax Return. Carrybacks. Your Stock-Photography Business Deductions.

## 17. Stock Photography in the Electronic Age
Which Computer to Buy? Cataloging and Retrieving Your Pictures. CD-ROMs. Establish Your Own CD-ROM Service. The Three F's: Phone, Fax and FedEx. Internet: The Electronic Post Office. Online Delivery. The Fax. Printers to the Rescue. Captions. Word Processing. Spreadsheets. Graphics. Picture Enhancement. Where to From Here? Interesting Reading.

## Appendix A: Third-Choice Markets
Paper Product Companies. Commercial Accounts. Other Third-Choice Markets.

## Appendix B: The New Way
Payment: Will It Be By Royalty? Should I Sign Up With a Digital Stock Disc Catalog? Should You Let a Client Use Your Photos on the Internet? Digital Imaging: Should I Do It Myself or Farm It Out? Where Do You Fit In?

## Appendix C: Photo-Related Discussion Groups on the Internet

## Bibliography

## Index

# Foreword

Back in 1981 when I wrote the first edition of this book, the idea of selling and re-selling your photos was new to most photographers. In contrast, today, "stock" has earned its place as an important division of photography.

At seminars and trade shows, I meet many photographers who introduce themselves to me and say *Sell & Re-Sell Your Photos* introduced them to stock photography.

Over the past fifteen years and several revised book editions, stock photography has evolved to *two* kinds: commercial stock and editorial stock.

There are many fine books published about commercial stock photography, and I've listed them in the bibliography. If the fast lane, somewhat frenetic, world of commercial stock photography is your goal, this book is not for you. But if you want to pursue the mellow pace of editorial stock photography and live where you want to live, be your own boss, take the kind of pictures you want to take (and not what others want you to take), work on your own schedule and take paid vacations—welcome to the expanding world of editorial stock photography.

In a nutshell:

*The commercial stock photographer* produces standard excellent stock pictures that are used widely in advertisements, commercials and promotional literature. Examples of these photos can be found in stock agency print catalogs and online photo galleries. Like popular TV commercials, they reflect current trends and enjoy high fees, but are vulnerable to going out of date quickly.

*The editorial stock photographer* produces content-specific stock pictures that are used in books, magazines and New (electronic) Media. These pictures usually evoke a mood rather than document a scene or situation. They depict human emotions and happenings that can be understood universally, worldwide. The pictures may be documentary, but are more often "made" by the photographer, allowing the viewer to read into the picture. Typical editorial stock photography can be found when you remove the advertising photos in a magazine. What's left are the editorial stock photos, or as I like to call them, "photo illustrations." They don't command the high prices of commercial stock photography, but they enjoy a long "shelf life," can be sold and resold over and over, and eventually become of historical significance. They can even be digitized and become an annuity for the photographer's heirs.

The field of commercial stock photography has become crowded with

stock photographers shooting and re-shooting the same commercial themes (ocean waves, clouds, covered bridges, waterfalls, healthy senior citizens riding bikes through the beautiful autumn color) and placing the images on CD-ROMs or Web photo galleries.

Many other photographers prefer to establish themselves instead as *editorial* stock photographers. They take the long view, seek out markets that are already waiting for their particular specializations, and settle in to long-term relationships with specific markets in their own segment of the vast Information Age we are experiencing.

This book teaches you how to specialize with success, in areas you enjoy, in the field of editorial photo illustration, in ways that will bring you both dollars and fulfillment in your pursuit of photography.

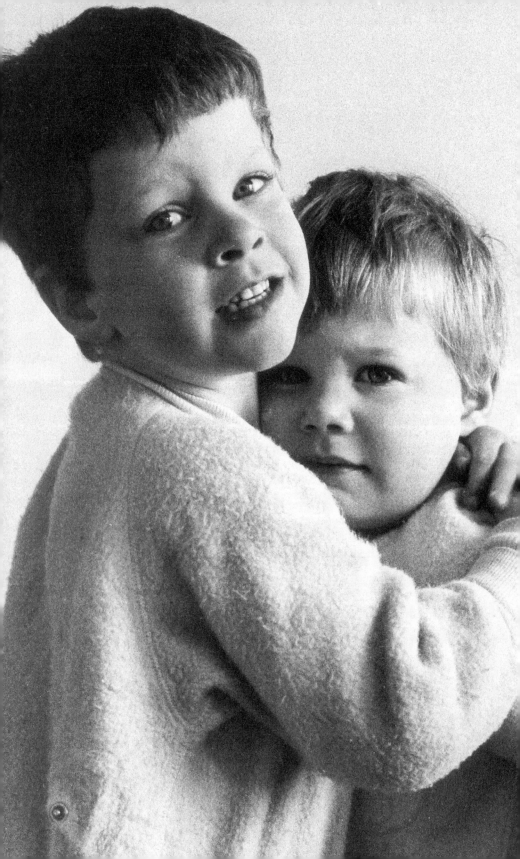

# Introduction

## Exciting Opportunities at Your Doorstep

Will a Rolls-Royce be sitting in your driveway if you follow the principles set forth in this book? Maybe not. But then again, maybe two of them will. Or maybe a moped will. In other words, you'll reach whatever goals you set for yourself. That's the exciting part about all this: Whatever your goals, *you* have complete control over whether they come to fruition. Success or failure in publishing your pictures is not determined by the wave of some mysterious wand out there in the marketplace. If you've got the know-how, *you* determine how far and how fast you go. This book will give you that know-how.

In more than thirty years of selling photographs, I've refined a marketing system that works for me today better than ever, and that works for scores of other stock photographers who have learned the system in my seminars and through my market newsletters. Hundreds of letters in my files attest to the efficacy of the system, testimony from photographers who are publishing pictures (and depositing checks) regularly.

The components of the system are simple—but the process isn't easy. It takes effort, energy, and perhaps some unlearning of initial misconceptions—but that's all that's required, and there are compensations:

**Live anywhere.** No need to live in the canyons of Manhattan or downtown Chicago to be close to the markets. They're as close as your mailbox or your computer. You can work entirely by mail, entirely at home, and still score in the wide world of markets open to you. Whether your headquarters is a high mountaintop cabin in Wyoming or a high-rise in Hartford, the markets will actually come to you through this system.

**Pick your hours.** You can arrange your own schedule and enjoy the flexibility of being independent. You can work at your stock photography full time or part time.

**Be your own boss.** Photobuyers don't care whether you're an amateur or a pro, a housewife or a parachutist. They're concerned about the quality of your picture and whether it meets their current needs.

**Take paid vacations.** You can pay for your trips through assignments you initiate or by judicious picture taking and picture placing, all described in my system. If you enjoy travel, you'll find your situation can become one of

having to pick and choose among all the trip opportunities open to you.

**Earn more money.** You will sell the same photo over and over again. You'll choose from hundreds of good-paying markets you never knew existed, and you'll enjoy working with them because they're in your interest areas.

**See your pictures in print.** You'll be seeing your photographs in national circulation, sharing insights and your views of life in all its beauty, humor, discord, poignancy, delight, tragedy and fascination. Sometimes your picture will make a tangible social contribution, sometimes it'll be business as usual. But it will all be deeply satisfying, with the gratification that comes from starting with a clear piece of film and creating something entirely your own.

## The System: Eight Elements

There are eight elements in my marketing system that I'll explore with you in detail in the course of this book:

1. I touched on this one above: You market your photos by **mail**, and in some cases, by computer. No need to pound the pavements with a portfolio.

2. You distinguish between *service* photography and *stock* photography (photo illustration). The service photographer markets his *services*—on schedules that meet the time requirements of ad agencies, businesses, wedding parties and portrait clients. The stock photographer takes and markets his *pictures*—on his own timetable, selling primarily to books, magazines and publishing companies of all kinds all over the country. My marketing system addresses the stock photographer.

3. You distinguish between *good* pictures and good *marketable* pictures. The former are the excellent scenics, wildflowers, sunsets, silhouettes of birds in flight, scenic shots of the lake and pet pictures. These are A-1 pictures, but in spite of the fact we see them everywhere in the market-place (on greeting cards, record covers, posters, travel brochures, magazine ads), they're terribly difficult (they can cost you money) to market yourself. I'll tell you why later in the book. You learn how to place these pictures in the right stock photo agencies, who *can* market them for you, for now-and-then supplementary income. For regular income you sell good *marketable* pictures: photo illustrations. You continue to take pictures in your interest areas, but you learn how to turn a picture into a highly marketable shot, for sale to book and magazine publishers.

4. You look like a **pro** with photo-identification methods, stationery, labels, packaging, cover and query letters, and your product.

5. You determine your **PMS/A**—your **personal photographic marketing strength/areas**—and specialize. Knowing how to do this will give you invaluable insight and irresistible momentum. To my knowledge, it is treated nowhere else in the photographic literature.

6. You focus on only a slice of the market pie. Not the whole pie. You specialize.

7. You determine *your* **Market List,** coordinated with your PMS/A. You

don't sell your pictures before you understand how to market them. Selling happens naturally, after you do your marketing homework. Once you develop a solid Market List, you cultivate the long-term "Net Worth" of each photo editor on your Market List.

8. You find the market **first**, then create for that market, not the reverse.

You may find this book quite different from what you initially expected. Many books on photography glamorize market possibilities for the serious amateur or new professional; I have tried to present an honest overview. I am a working editorial stock photographer, and also publish three photo-marketing newsletters; my business deals with dozens of photo editors daily. As changes in online publishing and digital photography occur, I'm among the first to know. It gives me solid feedback that separates the hype of the information highway from the realities.

My goal in this book is to give you the tools to be able to sell consistently to markets you enjoy working with.

The new markets you discover will surprise you with their photography budgets of $10,000, $30,000 and $70,000 a month (a month, not a year). "Are these markets in New York and L.A.?" you might ask. No. Times have changed. New York, Chicago and L.A. markets are still the top markets for service photographers, but publishing markets for the stock photographer abound all over the country.

This book will help you tap these markets, and you'll discover the real excitement, the genuine exhilaration, of the venturesome process of producing your pictures and sharing them through publication.

**Onward.** With today's dramatic increase in the use of photography, in the number of new markets and special-interest magazines, books, CD-ROMs, New Media and websites, the challenges and satisfactions have never been greater. You can be part of them.

The sky *is* the limit. Where you go with your photography is up to you.

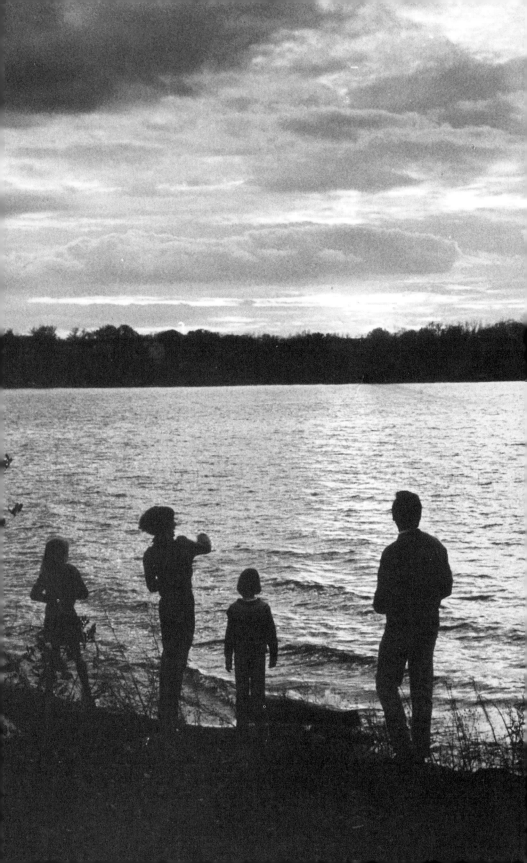

# The Wide World of Possibilities

## The Buyers Are Waiting

You've probably turned to a photograph in a book or magazine and said, "I can take a better picture than that." You are probably right . . . and not only from the point of view of quality or subject matter. Often a photo you see published in a magazine or book doesn't really belong there. When the deadline arrived, it was used by the photo editor because it was there, not because it was the perfect photograph.

Photobuyers would gladly use *your* photographs, if they knew you existed, and if you'd supply them with the pictures they *need*, when they need them. The buyers are literally waiting for you, and there are thousands of them. This book is going to show you how to locate the markets that are, at this moment, looking to buy pictures from someone like you, with your special know-how and your camera talent. This book is also going to show you a no-risk method for determining what photobuyers need, and how to avoid wasting shoe leather, postage and e-mail and website visits, plus markets that don't offer any future for your kind of photography. You'll earn the price of this book in one week through the postage or phone bills it will save you.

If you're a newcomer to the field of photo marketing, you'll be surprised to learn you can start at the top. I know many who have done so, and I did, myself. I sold my first picture to the *Saturday Evening Post*. Many of my pictures have sold to *People, Redbook, Parents, U.S. News & World Report, Reader's Digest* and others. But let me interrupt here to say I soon discovered that if I wanted to sell *consistently* to the top magazines, I would have to travel continually and make my headquarters in a population center a good deal larger than Osceola, Wisconsin. That was not in my master plan. I wanted to make a life for my family in the country, so I started researching the possibilities.

I found there were at least 10,000 picture markets out there (many more, today). I figured that if I subtracted the top-paying newsstand magazines, numbering about 100, that left 9,900 for me to explore, to find several

hundred with emphasis in subject areas that I liked to photograph. I learned that most of these markets were as close as my mailbox, and that many of them were actually eager for my photographs. Most important, I could sell to these markets on my own timetable and live wherever I wanted to.

## Trends in the Marketplace

Back in 1960 when I began marketing my pictures, there were very few persons with the title "photo editor." The art director or an editor at a publishing house doubled as the person who selected pictures, and the process was often hurried, at the last moment, whenever the book or magazine text was finalized. Pictures in those days frequently served simply to fill white space or to document a subject.

During recent decades, our society has become increasingly visually oriented, to the point of a veritable explosion in the use of visuals. People today are more prone to be viewers than readers. Reading material is more and more capsulized (witness the proliferation of condensed books and specialized newsletters; the success of *USA Today* and the influence it has had on the format of many other newspapers; and the shaping of many departments in magazines like *Time* and *Newsweek* into chunks of summarized information). People rely less on the printed word and more on pictorial images for entertainment and instruction. A Mr. Coffee appliance gives its instructions in pictures rather than text. Cash registers at some restaurants provide pictures for clerks rather than words. Textbooks have more pictures and larger type. Illustrated seminars, CD-ROMs and instructional CD and video presentations are the preferred tools for education throughout industry, and of course TV is conditioning all of us to visuals every day.

Words and printed messages aren't going out of style, but a look in any direction today shows us that photography is one of the most prominent means of interpreting and disseminating information.

If you've grown up in the TV era, the switch to increased picture use is probably not apparent to you. The publishing industry, however, is greatly aware of it. New positions have been created in publishing houses—photo editor, photo researcher, photo acquisition director—positions that never existed in the past. Revolutionary technology is developing to handle and reproduce pictures. Publishers produce millions of dollars worth of books, periodicals and audiovisual materials every year. The photographs used in these products often make the difference between a successful venture and a failure. An editor isn't kidding when he says, "I *need* your picture."

The breadth of the marketplace may come as a surprise. For example, some publishing houses spend as much as $10,000 to $80,000 a month on photography. Some of those thousands could regularly be yours, if you learn sound methods for marketing your pictures.

As I mentioned earlier, you can start at the top. It's not impossible. But making a full-time activity of selling to the top markets requires a specific

lifestyle and work style. You need to examine your total goal plan and make some major decisions before you launch out after the biggies. Only a handful break into that small group of top pros who enjoy regular assignments from the top markets. And most of those top pros pay their dues for years before they get to where their phone rings regularly.

Too often, the newcomer to any field believes the top is the only place it's at. The actor or the musician rushes to Hollywood to make it big. We all know how the story ends. Out of thousands, only a few are chosen. We also know they are *not* chosen on the basis of talent alone. Being at the right place at the right time is usually the key. The parallel holds true in photography. Good photographers are everywhere—just check the yellow pages. As with actors and musicians (or artists, dancers, writers), talent is only one of the prerequisites.

But if you are serious about your photography and are willing to look beyond the top, you'll discover a wide, wide world of possibilities out there for you. There are markets and markets—and yet more markets. You *will* get your pictures published, consistently, with excellent monetary return and with the inner satisfaction that comes from putting your pictures out where others can enjoy them. You can accomplish this if you apply the principles I outline in this book. Your pictures will be at the right place at the right time, and your name will be on the checks sent out regularly by the picture buyers you identify as *your* target markets.

## 20,000 Photographs a Day

As you read this, at least 20,000 photographs are being bought for publication in this country at fees of $25, $35, $50, $75 and $100 for black-and-white, and often twice as much for color. I'm not talking about ad agencies or general newsstand-circulation magazines. They're closed markets, already tied up by staff photographers or established pros.

I'm referring to the little-known wide-open markets that produce books, magazines, CD-ROMs, digital online sites and related printed products. Such publishing houses have proliferated all over the country in the last three decades. Opportunities for selling photographs to the expanding stock photo industry have never been greater. Some publishing companies are located in small towns, but that's no indicator of their photography budgets, which can range, I repeat, from $10,000 to $80,000 per *month*.

### A Wide-Open Door

These publishers are in constant need of photographs. Many publishing companies produce up to three dozen different magazines or periodicals, plus related publications such as bulletins, books, curriculum materials, CD-ROM materials, brochures, video series and reports. Staffs of the larger publishing houses have scores of projects in the fire at one time, all of them needing photographs. As soon as a company, large or small, completes a

publishing project or current issue, it is searching for photographs for the next project on the layout board.

Textbook publishers are in fierce competition with each other to nail down contracts with colleges and universities, technical institutes, school boards and educational associations to produce millions of dollars of photo-illustrated educational materials ranging from manuals to CD-ROMs.

Regional and special-interest magazines number in the thousands. While many general-interest magazines have been struggling or folding, regional and special-interest magazines (open markets for the stock photographer) have been on the rise, and new ones continue to appear on the publishing scene. With the enormous amount of information available in any field and on any subject in today's world, our culture has become one of specialization. Increasingly, magazines and books reflect this emphasis, focusing on self-education and specific areas of interest, whether business, the professions, recreation, entertainment or leisure. This translates into still more markets for the stock photographer.

Another major marketplace is the hundreds of denominational publishing houses that produce scores of magazines, books, periodicals, curriculum materials, posters, bulletins, video programs, CD-ROMs and interactive media. Some of these denominational companies employ twenty or more editors who are voraciously eager for photos for all their publishing projects. Very few of these are what you might think of as religious. Their photography budgets are high because their sales volume is high. Many have a photography budget of $25,000 per month.

As I mentioned earlier, there are nearly 10,000 markets open to the stock photographer today. (That's apart from the about 100 top magazines such as *National Geographic* and *Sports Illustrated*.) These are 10,000 open markets, accessible to both the part-timer and full-timer. Photobuyers in these markets are continually revising, updating and putting together new layouts, new issues, new editions, new publication projects, and updating their CD-ROMs and websites.

If you compare the per-picture rate paid by these markets against that paid by the 100 top magazines, or against what an advertising photographer receives for commercial use of his picture ($500 average), there's a big difference. But that's misleading. Unless you number yourself among the relative handful of well-known veteran service photographers who sell to the top magazines (many have staff photographers in any case), gunning for those markets is sweepstakes marketing—a sometime thing. The same goes for top commercial assignments. When you score, it's for a healthy dollar, but how frequently can you count on it? In addition, commercial accounts often require all rights, including electronic rights and even rights to technologies yet to be developed (they ask you to sign a "work-for-hire" agreement).

In contrast, as a stock photographer "renting" your photos for editorial use ("sold" on a "one-time use" basis), you can circulate hundreds of pic-

tures to publishing houses for consideration, each picture making from $25 to $200 at every sale. You don't have to worry about the beck-and-call mobility and time-deadline requirements of top magazine assignments, or the frazzle of commercial assignments under the dictates of the art director, and you can sell the same pictures over and over again.

You can do this from your own home, wherever you live. For the past twenty years I've operated successfully out of a one-hundred-acre farm in rural Wisconsin, and can attest that more and more photographers are doing the same thing from such diverse headquarters as a quiet side street in Kansas City, an A-frame in Boulder or an apartment in Santa Rosa.

When you master the photo-marketing system outlined in this book, you'll know how to select *your* markets from the vast numbers of possibilities and then tap them for consistent, dependable sales. If you're like most of us, you'll find that your range of markets includes some that are good starting points (easy to break into but pay modestly); some that are good showcases for you (prestigious publications in your special-interest area that may pay little but offer a good name to include in your list of credits, or good visibility to other photobuyers); many that will be regular customers for modest but steady return; and many that will be regular well-paying customers.

## Find the Market, Then Create

Many photographers who are successful today say their careers surged when they realized they were conducting the business side of their endeavors exactly backward. They had been creating first, then trying to find markets for the photos they produced. This system can work to a certain extent (and everyone gets lucky now and then), but it doesn't make for consistent, predictable sales. It's another form of sweepstakes marketing. The secret to guaranteed sales: *Find the market first.*

This isn't to say that you pick just any market and create for it. I mean search out markets that appeal to you as a person and a photographer— markets that use the kinds of photographs that you would like to take— markets you would love to deal with and create for. Markets that wild horses couldn't pull you away from.

Finding your corner of the marketplace (see chapter three) is going to be like prospecting. It's going to take some digging, but the nuggets you discover are going to be worth the effort.

# The "Theme" Markets

The primary markets for photo illustration are the publishing companies located in every corner of the country, and the magazines and books they produce. I've already touched on some major categories—educational,

regional, special interest and denominational. Now we'll take a look at each market in detail. Remember: Publishing houses specialize. If in your research you come across a magazine that's new to you in one of your fields of interest, you'll often discover that the magazine's publishing house produces several additional magazines, usually related and focusing on the same subject area, the same "theme." If your photo-marketing strengths include that theme, you've discovered one of *your* top markets.

## Prime Markets

1. Magazines
2. Books

## Secondary Markets

1. Digital media
2. Stock photo agencies
3. Decor photography outlets

## Third-Choice Markets

1. Paper product companies (calendars, greeting cards, posters, postcards, etc.)
2. Commercial accounts (ad agencies, PR firms, record companies, audiovisual houses, desktop publishers, Web designers, graphic design studios, etc.)
3. Newspapers, government agencies and art photography sales

You'll find a full discussion of third-choice and secondary markets later in this book, so I'll say just a word about them here.

The third-choice markets range in marketing potential from "possible" to "not possible" for the photo illustrator. In appendix A, I outline what to expect at these markets and what the requisites are for making sales in them.

The secondary markets—digital media, sales through stock photo agencies and channels for decor photography—are discussed in detail in chapter twelve. Stock agencies aren't markets in the usual sense; they're middlemen who can market your photo illustrations for you. Decor photography (sometimes called photo decor or wall decor) involves selling large photos (16″×20″ to wall size) that can be used as wall art in homes, businesses and public buildings.

Both the agency and decor areas offer sales opportunities to the photo illustrator and can be important to your operation, but just how important may be different from what you initially assume. Agency sales can be successful when you place the right categories of pictures in the right agencies (not

necessarily the most prestigious), and this takes some homework. Likewise, the decor route has its assets and its liabilities. Chapter twelve gives you the know-how to approach agencies and decor photography with a chance for elation rather than frustration.

Now to the prime markets for the stock photographer—magazines and books (see tables 1-1 and 1-2).

## Magazines

You can determine how large a photo budget a magazine has by asking yourself this question: "Whose dollars support the magazine?" If the magazine runs on advertising support, the photography budget is usually high. In the case of a trade or industry magazine, if a company underwrites it, the photography budget is usually also high. The photo budget is in the middle range if an organization or association supports the magazine or if subscriptions alone support it. Many magazines operate with a combination of advertising and subscription revenue, making for healthy photo budgets. Magazines with no advertising, subscription or industry/association support will have low photography budgets. In chapter three, I'll show you how to be selective in choosing your magazine markets.

Budget, of course, should not be the sole factor you use to determine what markets to work with. Often it's actually easier to sell ten pictures at $75 each to a medium-budget publication than one picture at $750 to one of the top-paying magazines. You can use the budget question to good advantage, though, to determine how healthy a magazine is and how stable a market it might be for you. Chapter eight will show you how to determine a market's photo budget and the prices you should ask for your photos.

## Books

Upwards of 50,000 books are published in this country in any given year. Books are produced by publishers who orchestrate the complete package: assigning manuscripts, editing, graphics, printing, promotion and distribution. When you deal with a book publisher, get the answers to these questions: "How well known is the publishing company?" "How long have they been in business?" "How wide is the market appeal of the book in question?" The photography budget is usually high if the book has a broad potential audience and the publishing company is well established. Fledgling book publishers, small presses and limited-audience publishers rarely pay high fees. Again, however, this is primarily to orient yourself—I am not suggesting your targets should be only the high-paying markets. Selling one hundred pictures at a bulk rate of $25 each to a small publisher or a CD-ROM producer makes good sense. In chapter three, I'll show you how to find your target book markets; chapters seven and eleven will tell you more about sales to book publishers.

# Magazine Markets

| Category | Description | How they use photographs | Examples |
|---|---|---|---|
| Special interest (avocation) | Focus on a specific subject area; aim at a specific target audience (e.g., travelers, skiers, runners, animal breeders, sailboaters, etc.) who are either activists or armchair enthusiasts. Sold at newsstands, by subscription or free. Advertising supported. Good markets when they match your PMS/A. Pay is excellent. | To illustrate articles, essays, poetry, how-to features, photo stories, covers, chapter heads. | *Organic Gardening* *Ski Canada Magazine* *Official Karate* *Hot Rod Magazine* *Photo Electronic Imaging* *Horse and Horseman* *Driver Magazine* *Popular Photography* *Writer's Digest* |
| Trade (vocation) | Address a specific professional audience, such as farmers, electricians, computer programmers, pilots, wholesalers. Not sold at newsstands. Advertising supported. If your PMS/A includes technical knowledge, this will be a rewarding market. Pay is excellent. | To illustrate technical articles, how-to features, covers, photo essays, industry news. | *Studio Photography* *The Ohio Farmer* *Western Flyer* *American Hunter* *Land* *National Utility Contractor* *Wired* |
| Business | Industry produced (internal and external) as a medium to reach both employees and the general public. Not sold at newsstands. Usually free. Editors expect a solid knowledge of their field of interest. Pay is excellent. | To illustrate articles, covers, photo essays, industry trends; to establish a mood. | *Career Woman* *Automotive News* *Entrepreneur* *Fortune* *Athletic* |
| Denominational | Scores of denominational publishing houses produce magazines, newspapers, bulletins and curriculum materials specific to different age groups, couples, families. Distributed by subscription or given away free to membership. Pay is medium to low, but volume purchasing is high. | To illustrate articles, essays, poetry, photo stories, news items, covers, chapter heads, video programs. | *Business* *Standard Publishing* *Back to the Bible* *Marriage Magazine* *Christian Home and School* |

*Table 1-1. Magazine markets.*

| Associations, organizations | Published for members of organizations and clubs. News and events, plus general-interest articles. Not sold at newsstands. By subscription. Supported sometimes by dues and by advertising. Audience is usually specialized. Pay is mediocre. | To illustrate articles, covers, news items, photo essays; to establish a mood. | *Kiwanis Magazine*<br>*National 4-H News*<br>*Scouting Magazine*<br>*The Rotarian*<br>*The National Legal Foundation* |
|---|---|---|---|
| Local | Audience is usually a local metropolitan area. Feature stories, articles and pictures of local interest. Advertising supported. Subscription, newsstand. Pay is low, but exposure is valuable. | To illustrate articles, covers, news items, photo stories; to establish a mood. | *Chicago*<br>*Michigan Living*<br>*Portland Life &*<br>    *Business Magazine*<br>*Los Angeles Magazine*<br>Sunday newspaper<br>    magazine sections<br>*Outdoor Oklahoma* |
| State and regional | Audience is statewide or encompasses several states. Feature stories, articles and pictures of regional interest. Sold at newsstands and by subscription. Pay is usually low, but volume makes up for it. | To illustrate articles, covers, news items, photo stories and essays; to establish a mood. | *New England Skier's Guide*<br>*South Carolina Magazine*<br>*Northwest Magazine*<br>*Arizona Highways*<br>*Sunset Magazines*<br>*Minneapolis–St. Paul* |
| News services | Timely features and news pictures produced by staff, stringers and freelancers. They can use pictures of your area. Pay is low. | To illustrate articles, news items, covers; to establish a mood. | Newsday Newspaper<br>The Sun/Globe<br>    Communications<br>L.A. Times Syndicate |
| General newsstand | General, national interest and large circulation. These magazines are supported by advertising and subscription, and appeal to a broad segment of the population (e.g., women, sports enthusiasts, etc.). These are third-choice markets for you because they assign most of their photo needs to staff photographers, well-known veteran stock photographers or stock-photo agencies. | | *Redbook*<br>*Good Housekeeping*<br>*Money*<br>*People*<br>*National Geographic*<br>*Sports Illustrated*<br>*Reader's Digest*<br>*Esquire*<br>*Cosmopolitan* |

*Table 1-1. (cont.)*

| Book Markets | | | | |
|---|---|---|---|---|
| Category | Description | How they use photographs | Examples | Rating in terms of numbers of photo illustrations purchased |
| Encyclopedias and dictionaries | Multivolume and single volume. Some contain a broad range of information; others cover specific topics such as medicine or woodworking. Foreign-language editions. Children's versions. | To illustrate articles, section heads, updates, revisions, supplements. | *Britannica* *World Book, Inc.* *Handyman's* *Van Nostrand's* *Scientific* *New World* *Dictionary* | C |
| Textbooks | Textbooks range from brief paperbacks to multivolume hardcover series. Used in schools, associations, churches, businesses. All subjects (e.g., biology, math, history, special ed.). Foreign-language editions. | To illustrate chapter heads, covers, technical articles, revisions, supplements; to establish mood. | Ginn Scott, Foresman Pearson Learning Houghton-Mifflin D.C. Heath | A |
| Church curriculum | Sunday school course books, Bible study materials, adult education, confirmation texts, family living and inspirational books. | To illustrate articles, chapter heads, updates, photo essays; to establish mood. | United Methodist Church The Liturgical Press Church of the Nazarene | B |
| Consumer trade | Sold in bookstores, in supermarkets, by mail order and through book clubs. Range from coffee-table books to best-sellers to vest-pocket references. General and specialized hardcover and paperback. Specialized subject areas range from photography to popular science to poetry. | To illustrate chapters, jackets, covers, chapter heads, section heads, how-to photo essays, updates. | Sierra Club Books *Fodor's Travel* *Guides* Bantam Books *The Family* *Handyman* *How to Travel* *Inexpensively* American Booksellers | D |

*Table 1-2. Book markets.*

## A Hedge Against a Downturn in the Economy

When there's a downturn in the economy, photobuyers turn to stock photography rather than hiring photographers to go on assignment. In the thirty years I've been in stock photography, a recession (there have been four of them, so far) has always boosted my sales. Once the recession is over, some of those photobuyers stay with me, having learned the economic advantages of buying stock from individual photographers. As Craig Aurness says in his *International Stock Photography Report*, Westlight, 2223 S. Carmelina Ave., Suite 1000, Los Angeles, CA 90064, "Stock is perceived as a recession-resistant industry, as downward trends force companies to look for alternatives to expensive assignment photography."

## Good Pictures—Wrong Buyers

The prime markets pay stock photographers millions of dollars a year to get the pictures they need. Sounds promising for the photographer, and it is, but wait—the key word is *need*. Whether you plan on grossing $50 or $50,000 in sales each year with your photography, don't ever forget that photobuyers purchase only pictures they *need,* not pictures they like. If you supply the *right* pictures to them, they'll buy. I've heard dozens of photographers over the years complain that their pictures weren't selling. When I examined their selling techniques, it was easy to see why: They were putting excellent photographs in front of the wrong buyers. A photobuyer may think your pictures are beautiful, but won't purchase them unless they fit the publication's specific needs. A photo editor is like any other consumer: If he needs it, he'll buy it. Chapters two and three will show you how to determine what the photobuyer's needs are and how to fill them.

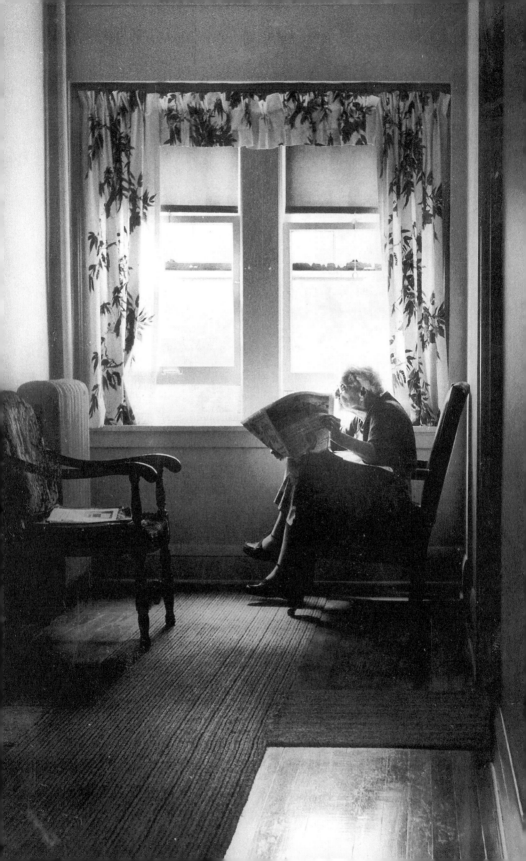

CHAPTER TWO

# What Pictures Sell and Re-Sell?

## The Difference Between a Good Picture and a Good Marketable Picture

What kind of picture can you be sure will sell for you—consistently? And what kind of picture will disappoint you—consistently?

You may be surprised at the answer to these two questions. The heart of the matter is that one type is a good picture, and the other is a good *marketable* picture. The surprise is that the good pictures seem like they ought to be marketable, because we see them everywhere, looking at us from billboards, magazine covers, brochures, advertisements and greeting cards. These good pictures are the lovely scenics, the beautiful flower close-ups, the sunsets and dramatic silhouettes—those excellent Kodak-ad shots and contest winners. These photos could also be called "standard excellent" pictures.

"But why do they consistently ring up *no sale* when I try to market them?" you ask. Because the ad agencies, graphic design studios and top magazines who use these standard excellent shots don't *need* them: 99 percent of the time their photobuyers have hundreds, indeed thousands, of these beauties at their fingertips—in inventory, at their favorite local stock photo agencies or available from the list of service photographers they've long worked with and know are reliable. Ninety-nine percent of the pictures you see published in major newsstand magazines or in calendars, brochures or posters are obtained from one of those two sources: stock photo agencies or top established pros.

The established pro usually has a better supply of standard excellent pictures than the average photographer or serious amateur, even though the latter may have been photographing for years. Pros have work schedules and assignments that afford them hundreds of opportunities to supplement their stock files. The pros can shoot more easily and less expensively because an assignment already has them in an out-of-the-way, timely or exotic location, and they can piggyback stock-file photos with their original assignment. Getting the same shots could cost you a great deal in travel and operations expense. And when buyers of these photos want a good picture, they

don't turn to a photographer with a limited—albeit excellent—stock file who's unknown to them and has a limited or no track record.

The best place for your standard excellent photos, then, is in a major stock agency. This, too, is a form of sweepstakes marketing. But chances are that, even amid the tough competition in the agencies or on a website, you'll realize a sale now and then as a nice tributary to the main river of your sales. The key phrase here is "now and then." It's not a case of putting your photos in an agency or in a Web gallery and sitting back to watch the checks roll in.

I realize there are a dozen books on the market that report that you can sell the standard excellent picture to buyers. There are also books that assert that you can write the blockbuster novel, write a top-forty hit song and make a hit record that sells a million copies. I don't doubt that the authors of these books have hit the jackpot themselves or know someone who has. But you open yourself up to two disadvantages when you attempt to appeal to the common denominator of the public's taste:

1. First of all, the romance and appeal of commercial stock photography soon fades after you've snapped an angle of the Washington Monument or a sunset in Monterey Bay for the twentieth time; likewise with a standard symbol of power (ocean waves), hope (sunlight streaming through rolling dark clouds) and so on.

The original exhilaration of stock photography diminishes when you realize you are following someone else's tracks; when you know others have the identical pictures in their files that you do. On the one hand, it can be money in the bank when you hike in to get the standard shot of the *Maroon Bells* in Colorado, but it's disheartening to discover tripod marks or chewing gum wrappers in a spot where you had thought you were experiencing a moment of discovery. Eventually, you come back to your starting point and say, "There must be more to stock photography than this."

If you were to continue to snap these exquisite clichés as your standard stock in trade, what would you have after two or three decades? Would a publisher aggressively seek you out to publish an anthology of your work? Not if your photos were cookie-cutter versions of standard subject matter, making you indistinguishable from hordes of other commercial stock photographers.

2. The second disadvantage is economic. The law of supply and demand indicates that it's dangerous to count on consistent sales to the markets who buy the standard "excellents." The market is so flooded with these pictures, in the form of commercial stock agency catalogs, CD-ROM "click art" and online digital portfolios, that the idea that your particular versions would hit every time or most of the time enters the realm of high optimism—admirable perhaps, but not too practical.

I like to call exquisite clichés *unbelievable.* Although elements of a marketable picture are there, they are missing one major element: believability.

## Enduring Images

Look at the two editorial pictures below (illustrations 2-1 and 2-2). Can you read into these pictures? Do they evoke a mood? When they were made in the thirties, few photobuyers considered them blockbusters. Instead, picture buyers at the time were probably purchasing the standard decorative pictures of the day. Today, the pictures below endure and are included in anthologies. Are you aiming your stock photography activities at pictures that will endure?

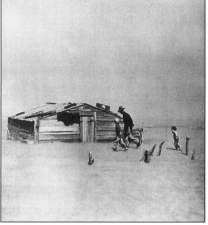

*Illustration 2-1.*

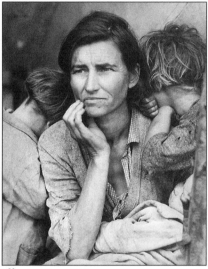

*Illustration 2-2.*

If you feel you've been spinning your wheels and getting frustrated in your photo-marketing efforts, this chapter is going to be worth the price of this book many times over, because it will blueprint for you the kinds of pictures you *can* start taking and *selling*—today.

## Good Marketable Pictures

What, then, are the good *marketable* pictures that will be the mainstay of your photo-marketing success and supplement your retirement income, as well as be an asset to pass onto your heirs? These pictures are the consistent marketing bets—the photos you can count on to be dependable sellers. These photos have buyers with ample purchasing budgets eager to purchase them, right away and over and over.

### No-Risk Marketing

These good *marketable* pictures are the ones photobuyers *need*. Let the pictures in the magazines and informational books in your local library be your guide. These editorial (nonadvertising or noncommercial) pictures show

> A s I begin my seminars:
>    When photographers have trouble selling their photos, nine times out of ten it's because . . .
>
>    1. They take excellent pictures, but they're trying to sell them to the *wrong* markets.
>    2. They take excellent pictures, but they don't know how to take *marketable pictures.*

ordinary people laughing, thinking, enjoying, crying, helping each other, working, building things or tearing them down, playing, sharing. The world moves on and on, and our books, magazines and online media are our chronicle. About 40,000 such photo illustrations are published every day. They are pictures of all the things people do at all ages and in all stations of life. These pictures are what editors need constantly. These are good *marketable* photo illustrations—the best-sellers. They may not sell for $750 apiece, but if you plan your marketing system wisely, you can easily sell ten for $75 each.

To clarify the difference in your chances of selling these good *marketable* pictures compared with standard excellent pictures, consider the Boston Marathon. Out of hundreds of dedicated runners, there's only one winner. The trophy goes to the top pro who practices day in and day out, who makes running a full-time occupation. Anyone can get lucky, so I can't deny that you might win the Boston Marathon—that is, you might score with one of your standard excellent pictures in a national magazine. But for someone just starting out, the odds weigh heavily against you.

The first step, then, toward consistent success in marketing your photographs is to get out of the marathon and start running your own race. The marathon is crowded with fine photographers, all of them shooting pictures that everyone else is shooting. Newcomers usually enter the photo-marketing marathon because of an erroneous concept of what photobuyers want (need), and thus an erroneous concept of what they, as stock photographers, should supply buyers with.

I once asked a photobuyer, "Why do newcomers always submit standard excellent pictures, instead of on-target, marketable pictures?" His answer: "I think the photography industry itself is partly at fault. Their multi-million-dollar instructional materials, their ads and their video programs are always aimed at how to take the 'good picture.' Photographers believe they have reached professional status if they can duplicate that kind of picture."

Well-meaning advice from commercial stock photographers themselves sometimes adds to this misconception. In their books, seminars or conversations, successful stock photographers sometimes tend to forget how many years of dues paying they went through before they could sell standard "ex-

cellents" consistently. Successful people in any field—medicine, theater, professional sports, photography—often hand out advice based on the opportunities open to them at their current status. They fail to put themselves in the shoes of a newcomer who has yet to establish a track record.

In running your own race, you'll be up against competition, too, but it's manageable competition. As you'll discover in chapter three, you'll target your pictures to specific markets and take pictures built around your particular mix of interests, access and expertise.

## The Rohn Engh Principle
## for Producing a Marketable Picture Every Time

The secret to producing good marketable stock photos can be discovered in the markets themselves—the books, magazines, periodicals, websites, CD-ROMs, brochures, ads and other materials that are produced by the publishing industry every day.

Use this test: Tear pages of photographs from magazines, periodicals, booklets, etc., and spread them out on your living room floor. Now place your own black-and-white or color prints[1] on the floor, or project your color slides. Do a self-critique. Do you see a disparity in content and appearance between the published photos and your own? If so, how could you improve your pictures? If your pictures blend in, matching the quality of the published photos, you'll be leaps ahead of the competition.

Next, give yourself a quick course in how to take marketable illustrations: Select any of the published photo illustrations, and then go out and take photographs as similar to them as you can set up, using a Polaroid or digital camera to give yourself fast, on-the-spot checks on how you can improve your picture quality.

Am I suggesting that you copy someone else's work? Yes. And if they will admit it, pros will tell you that's how they originally learned many of the nuances of good photography.

When you check the content and style of published photo illustrations, you'll find they consistently feature a reasonably close-up view and a bold design, much like the clean, graphic elements of a poster. Magazine covers are good examples of stock photography.

A stock photo is successful when the viewer can (1) read into it; (2) sense a mood. The viewer shouldn't have to work hard at studying the picture to perceive what it's trying to say, so a medium or close-up view works best. Bring the main subject or person in close. Most newcomers to stock photography improve their pictures 100 percent when they move toward their subject for a tighter composition.

---

[1]Transparencies (slides) are generally used for publication in books and magazines. However, more and more printing plants are beginning to accept color prints, thanks to new advances in scanning techniques and the merging of the film and digital industries.

Like the background, the composition of your pictures should be simple and uncluttered. Strive for a clean and poster-like design, a picture that conveys its reason for being at one glance.

Try not to think of yourself as a "photographer," but instead as a graphic designer who happens to use photography as her medium.

### The Principle

This four-step principle is guaranteed to produce marketable photo illustrations every time:

$$P = B + P + S + I$$

PICTURE equals BACKGROUND plus PERSON(S) plus SYMBOL plus INVOLVEMENT.

Most of the successful stock photos you come across in your research will contain these elements. There are always exceptions to the rule, and we'll go into some of those after we explore the formula in detail. And, of course, as we learned in esthetics, all works of art have both form and content. You are able to learn how to produce the *format* of a painting, poem or photograph. But producing the content, the *spirit*, is another matter. This talent is unique to you.

**Step 1: Background.** Choose it wisely. Too often a photographer doesn't fully notice the background until he sees his developed pictures. The background you choose can often make the difference between a sale and no sale. For example, if you are photographing a pilot, don't just snap a picture by a corner of a hangar that could be any building. Search the airport area for a background that says aviation. Similarly, an office shot could include a desk or computer to set the scene. Or a stock brokerage could show a wall screen with numbers in the background.

These background clues should be noticeable but not obtrusive, and the picture should not be cluttered with other objects. The background is crucial to how successfully your picture makes a single statement. Your illustration is more dramatic and more marketable if it expresses a single idea—and does it with economy. As you plan your stock photo, ask yourself, "What can I eliminate in this composition while still retaining my central theme?"

### Evoke a Mood

Your central theme doesn't always have to be describable in words; it can be a mood you wish to convey—a feeling that, if expressed with simplicity, actually lends itself to a variety of interpretations by different viewers. This is a marketing advantage to you, because if the picture lends itself to, say, ten different moods or interpretations, you've increased its marketability ten times.

By eliminating distractions, you guide the viewer to a strong response to

your photograph. A clean, simple background is usually available to you. Remember, you have 360 degrees to work with. Maneuver your camera position until the background is uncluttered.

Employ your knowledge of design, color and chiaroscuro (the play of darks against lights and vice versa). If the pilot is wearing a light uniform, shift your camera angle to include a dark mass behind him for contrast. If he is wearing a dark uniform, choose a light background. This technique will give your stock photos a three-dimensional quality.

Think "cover." Leave space near the top of your composition for a logo. Editors complain to us here at PhotoSource International that most pictures are submitted in a horizontal format. A vertical format lends itself best to book and magazine covers, and many page layouts as well.

**Step 2. Person(s).** Now that you have a suitable background, maneuver yourself or your models (in some cases, you'll have to do the maneuvering because the models won't or can't move for you) so that background and models are in the most effective juxtaposition. The models themselves must be interesting-looking and/or appealing. Choose them, when possible, with an eye to their photogenics.[2]

If your pictures will be used for commercial purposes, such as advertising, promotion or endorsement, you will want a model release (signed consent to be photographed) from your models. For pictures that will be used for editorial purposes, such as in textbooks, magazines, encyclopedias or newspapers, a model release is not necessary in most cases. (See chapters six and fifteen for more on models and model releases.)

Your photos are illustrations, not posed portraits, so the people in them must be engrossed in doing or observing something. We are all people watchers, and stock photos are always more interesting when the people in them are genuinely involved in some activity.

The rule: You are *making* a picture, not taking one. The only thing you should take is your time.

**Step 3. Symbol.** In stock photography, anything that brings a certain idea to mind is a symbol, sometimes referred to as an *icon*. Symbols are everywhere in our visually oriented world. They are used effectively as logos or trademarks in business, for example. In a stock photo, a symbol can be anything from a fishing pole to a tractor to a stethoscope. In the case of the pilot, his uniform, his cap, an airplane, a propeller and a wind sock are all symbols. Including an appropriate symbol will make your illustration more effective. Use your object symbols as you would a road sign—to tell your viewers where you are. However, be careful that your symbol is not so large or obvious that it overpowers the rest of your photo; symbols are most

[2]Model = any person in your picture. Neighbors, relatives, politicians, celebrities, schoolteachers, lifeguards, policewomen, groups of children at a playground, groups of adults at a town meeting—all are defined in our terms as models. I'm not talking about professional models, which are generally not used in editorial stock photography.

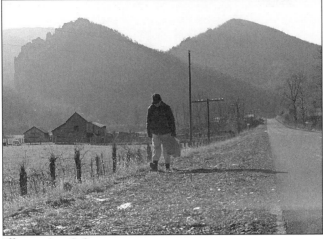

*Illustration 2-3.*

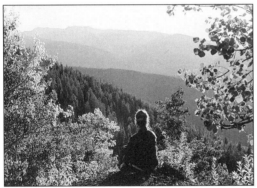

*Illustration 2-4.*

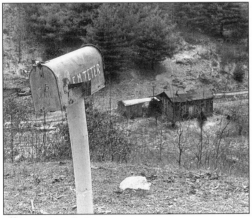

*Illustration 2-5.*

effective when they are used subtly. Avoid the temptation to use mundane symbols, such as a pitchfork for a farmer, a sombrero for a Mexican musician or a net for an Italian fisherman. The goal is to clue in your viewer to what is going on, but not knock him over the head with it. Let him experience some discovery as he looks at your picture. Next time you are perusing pictures in a magazine or book, watch for the "road signs" and note how, and how often, symbols are used in stock photos.

Step 4. Involvement. The people in your picture should be the subject of the picture (showing enjoyment, unhappiness, fear—some feeling); or they should be interacting, helping each other, working with something, playing with something, etc.; or they should be absorbed in watching or contemplating some object, scene or activity. Marketable photo illustrations have an involvement, a dynamism, about them that's distinct from the portrait or scenic quality of standard excellent pictures.

## Using the Principle

The principle gives you the necessary ingredients. As with all recipes, that's just a starter. There can be variations, and the final results are in the hands of the chef.

### Photos That You Can Read Into

Illustrations 2-3 through 2-9 show the formula at work. In the first picture (illustration 2-3), the principle is used to suggest a story. When I took this photograph, I was driving a back road in West Virginia. The dilapidated shed, the lighting on the Appalachian foothills, the shadows and the lonely road all seemed to suggest rural poverty. I asked my traveling companion to walk along the road and hang his head down. For the symbol I gave him a suitcase. It introduces an element of involvement and spurs the viewer to think that the man is leaving home or is returning. Either interpretation gives rise to feelings about the photograph and its subject, with resultant interest. This picture was taken in the 1960s and is no longer in my contemporary file. Yet I have sold it twice in the last year from my historical file.

The principle can still work even if some of the elements are missing. In the mountain scene (illustration 2-4), symbol and involvement, per se, are lacking. Yet the picture is still successful, because, in this case, the background doubles as the symbol. The background is a panorama the person is obviously involved with, enraptured by, as she sits quietly as part of the stillness of the scene. Without the person, the photo would have failed as a marketable picture. The photo moves from the standard excellent scenic category to the good marketable category because of the predominant position and emphasis (with backlighting) given to the person. The picture says involvement or contemplation, in contrast to pictures that say pretty scene and include a person placed in the photo as a minor element for orientation.

Again, here is a variation on the principle that nevertheless works as a

marketable stock photo. In this case, the person is missing (illustration 2-5). In most cases stock photos need people, but, as in this instance, not always. The symbol here is the mailbox; involvement is with the modest cabin in the background, achieved by the juxtaposition of the two. The picture gives the desired feeling of poverty and isolation, heightened by the arduous climb to the mailbox—the link to the rest of society. As long as a picture without people *implies* people, as this one does, you come out with a marketable stock photo.

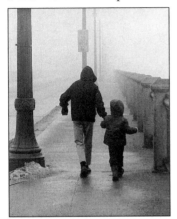

*Illustration 2-6.*

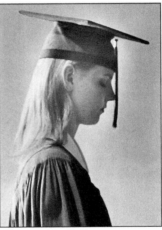

*Illustration 2-7.*

In illustration 2-6, I wanted to use light poles disappearing into the fog to create a mood,[3] and I knew my picture would be more salable if it had people in it. But people can detract from the feeling of a picture if they're just stuck in the composition. Having the older boy take the younger by the hand as they headed down their path along the lampposts added the right touch of naturalness and involvement. This picture has sold twenty-seven times so far.

Rather than overstate, let simplicity transmit the mood you wish to convey. In illustration 2-7, the contemplation of the soon-to-be graduate is captured in profile, almost cameo, against the smooth expanse of the wall in a school hallway. In this case, a clean background was chosen in order to focus attention on the symbol—the graduation cap and tassel. The person is involved with the symbol by its effect on her demeanor, causing her to be in deep reflection.

Symbols can underscore what your photograph is attempting to portray. On location where you are photographing, you will often find objects readily

[3]Very often, a single photo may express several moods, e.g., silence, quietude, peace, contemplation, wonder, bereavement, etc. The marketability of a photo is multiplied by the number of moods or emotions that can be read into it.

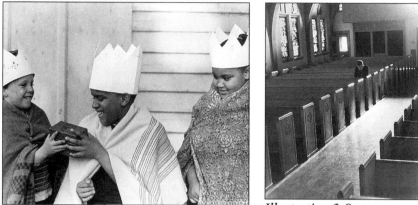

*Illustration 2-8.*

*Illustration 2-9.*

available to you. Once you position your model(s) for the best light, nondistracting background, etc., you can add dimension to your photograph by adding appropriate symbols. These children were practicing for their backyard theater (illustration 2-8). I found a $3'' \times 5''$ filing box and had the three Magi pass it among themselves.

Involvement in your photo illustrations sometimes means serenity for your models. Why is illustration 2-9 so successful?

B = Background is uncluttered and lends itself to story line.
P = Person is included in story line.
S = Symbol [church pews] highlights the mood of contemplation or prayer.
I = Involvement is real.

You can manufacture a mood by coming in the back door. While doing a story at a university, I was struck by the starkness of an examination room. The folding chairs, lined up in sterile rows, symbolized the loneliness and isolation that students can experience at a large university. I asked a young man who was accompanying me to sit in one of the chairs in the middle of my composition and to lean forward and look at his shoes. The picture (page 96) gets the idea across, and he was spared the self-consciousness or awkwardness of having to come up with a facial expression for the mood I wanted to portray.

### The Missing Link

Meaningful pictures happen when you take an active hand in your composition. A snowy birdhouse hanging from a frosty limb on a December morning is picturesque. But when you add a young mother and her little boy (the people), a new dimension evolves. For illustration 2-10, you may have supposed the photographer snapped a picture of a young mother and son who

happened upon a snow-covered birdhouse: The process was actually in reverse. I happened upon the birdhouse, and then sought out my models as an interesting contrast to the stark frozen beauty. Think of your photography in these terms—in reverse. Find your symbol or background first, and then the other elements: people, involvement and either background or symbol. The resulting photo illustrations will be more marketable.

Illustrations 2-11 through 2-14 show why, with the elements in slightly different alignment, or with one or another of the principal elements missing, illustration 2-10 wouldn't make it as a good marketable picture.

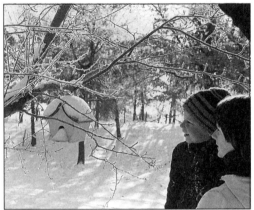

*Illustration 2-10.*

1. Background distracting or inappropriate (illustration 2-11).
2. People missing (illustration 2-12).
3. Symbol missing (illustration 2-13).
4. No involvement with symbol (illustration 2-14).

### Students: Close, But Not Quite Right

Illustrations 2-15 through 2-24 were taken by photography students. They are close to being good marketable pictures, and some are better than others, but they all need alterations to make the grade.

## You Are an Important Resource to Photobuyers

This, then, is what marketable editorial stock photography is all about. These are the kinds of good marketable pictures that allow you to run your own race.

To restate the problem with generic clichés: While you might hit a calendar or magazine cover with one of these now and then, to depend on this type of shot for consistent sales is a mistake. Every buyer has hundreds of this kind of shot in inventory. Or he gets buried in them if he puts out a

*Illustration 2-11.*

*Illustration 2-12.*

*Illustration 2-13.*

*Illustration 2-14.*

request for them. *National Geographic*, for example, will not let us run a listing in our *PhotoDaily* marketletter asking for photos of a bald eagle: They know they would be deluged with bald eagles. The editors know they could find a CD-ROM filled with eagles, or shout out the window and fifty photographers would respond with bald eagle photos. But you will find plenty of *National Geographic* listings for people interacting with the environment, or for wildlife from specific parts of the world.

For every one of those "good pictures" that finally hits, you'll sell hundreds of good marketable pictures. One sunset at the beach might finally sell to an ad agency for a nice $500, but you won't sell it again for three years—or five years. Meanwhile, one picture of a boy chasing a bubble will sell scores of times—and bring more return in the long run. The latter is a good marketable stock photo. And you'll have twenty, thirty, forty more of these, selling at the same pace, for every sunset in your supply.

Don't rely on wishful thinking. A few stock photographers do get lucky, but by and large, those who are on top, and who stay there, are those who have recognized the overwhelming odds in the marathon route and have switched over to what I call "Track B" in the next chapter. There's competition in that race, too, but it's manageable enough to keep you healthily striving for excellence. You may win a blue ribbon for one of your sunsets, but the real judge of marketable photography is the photobuyer who signs the check.

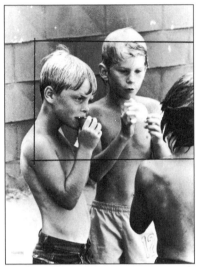

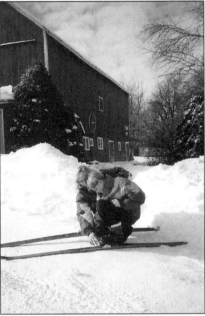

*Student Illustration 2-15. Move in close. Your audience needs to see what's going on. The photographer wasted half his frame in this case. This picture improves when we eliminate everything but the essentials.*

*Student Illustration 2-16. The background is clean and uncluttered; the involvement factor is high. Move in closer! We want to see more facial expression. A telephoto lens would have helped.*

Whether you sell and re-sell your pictures is not up to the photobuyers, but to you, the stock photographer. You control whether you sell or don't sell—by controlling the content of your pictures.

When you are out on your next photographing excursion, keep two guidelines in mind:

1. Shoot discriminately. Treat each piece of film you expose as a finished product that will one day be on a photobuyer's desk.

2. As you prepare to take a shot, ask yourself, "Is it marketable?" (One photographer I know taped this question to the back of her camera.) I am not suggesting that you get involved in areas of photography that don't appeal to you. As I explain in the next chapter, you have assets, photographically, that are individual to you. In the course of this book, I'll show you how to match your photographic interests with the needs of buyers who are on the lookout for the kind of pictures you can easily supply. For example, if you live in New Mexico, there's a lot of picture taking and selling to be done that a person in Michigan can't do. And your geographic location is only one advantage you have over other photographers. You may be into

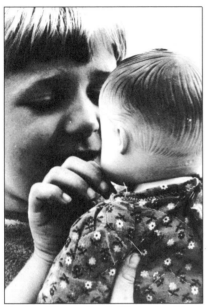

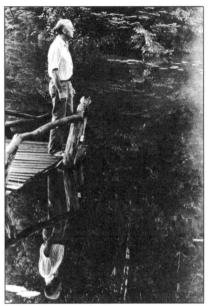

*Student Illustration 2-17. Again, this picture needs that "right" expression. The idea here is good—but the photographer lost a chance for a good marketable picture by not shooting enough film (shoot ten to one) to have a selection that includes the best expression from the best angle. The lighting on the little girl's face is not flattering, but remember, stock photography is not portraiture. Your primary aim is to capture expression and mood.*

*Student Illustration 2-18. This stock photo expresses a mood or an emotion. It has the potential to be highly marketable because it lends itself to the many themes treated in books and magazines. Expression and position of the model could be improved. The man's nervous hands are incongruous with his contemplative face. On these shots, you need to shoot ten or twelve to capture that "just-right" expression. Ask the model to continue to move slightly after each exposure. Then choose the right picture when you examine your contact sheet.*

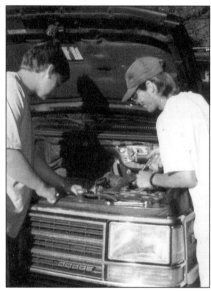

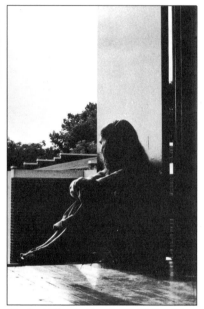

*Student Illustration 2-19.* Stock photos that are successful follow the P = B + P + S + I principle. By moving the hood up, the background is clean and simple. The men are involved with the tools (symbol). Avoid shooting in harsh sunlight. Objectionable shadows ruined the picture.

*Student Illustration 2-20.* Editorial stock photography can leave much to the imagination. This picture is successful because the person's face is not in full view. Thus, it is not a portrait; it conveys a mood. This picture could be used many ways: articles on loneliness, meditation, boy-girl relationships, education. You'll be surprised at the uses photobuyers find for your pictures. The background is relatively uncluttered and nondistracting, which helps to emphasize the center of interest. This photo gets eight points out of ten as a good marketable picture.

**Student Illustration 2-21.** *This is a typical amateur picture, "The Character Study." (We all have at least ten of these in our files.) This type of photograph is very difficult to market—there are millions of them available to photobuyers because everybody takes these pictures. It's a portrait with no involvement, no symbol, no dynamism and no action: Include any of these elements, and it becomes a marketable picture.*

**Student Illustration 2-22.** *A slice of life is what photobuyers like to see in your editorial stock photos. This could be a good nuts-and-bolts picture with marketing potential. But the photographer should move in closer to the girl and let us know her feelings. Is she tired? Proud? Enthusiastic? Would the photo have been more successful if the background was less distracting?*

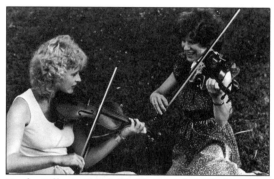

*Student Illustration 2-23. Use your knowledge of optics and composition to get the best stock photo out of every situation. Making a three-quarter view out of this one and using a telephoto lens would improve it 100 percent. You are not making a portrait of the two young women, so it is excusable to feature one face more than the other in your composition.*

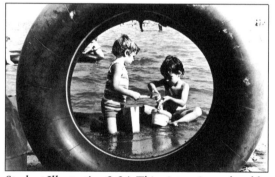

*Student Illustration 2-24. This picture is marketable, but it borders on being too clever, too cutesy. It's also old hat. Clichés are a fact of life in the stock-photo business—but handle them with care and use them sparingly. On the other hand, don't go to the other extreme and be obscure.*

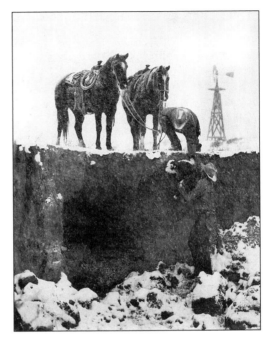

*This photo has four essential elements: meaningful background, people, symbol and involvement. Sometimes all four occur spontaneously; other times you have to plan them out. "Rescue from a Washout," by western photographer Bill Ellzey of Telluride, Colorado, illustrates the latter, or "pre-visualization," as he calls it. Ellzey found one of the few remaining wooden windmills in his region, set up a tripod and coached his cowboy cousins into lifting a calf from the draw. Nature cooperated with a sudden flurry of snow. So did the horses by responding to one cousin's whistle (as directed by Ellzey). It took twenty-two shots to get a just-right picture. Back at the ranch, Ellzey and his cousins thawed out (and the calf returned to its mother). The picture continues to be a hot seller.*

sailing or raising hunting dogs. You may be an armchair geologist. Your hobbies and interests, and your knowledge and your career field, are assets. So, I say to people new in the field of photo marketing, "You can position yourself where the competition is manageable." With your own PMS/A (personal photographic marketing strength/areas), which we'll learn to identify in the next chapter, you can be an important resource to buyers who are, right now, waiting for your pictures.

Your aim is to sell the greatest number of pictures with the least amount of lost motion (i.e., unsuccessful submissions). Why take risks? Photo marketing is a business. Now that you know the difference between a good picture and a good marketable picture, your sales will start to soar.

# A Gallery of Stock Photos

Stock photos and stock photographers come from all walks of life. Here is a selection of pictures that have had repeat sales, and a glimpse at the people who produced them.

I asked fellow stock photographers to send me samples of stock photos that produce continual revenue for them. All of these photographers zero in on their own PMS/A and supply their own corner of the market.

"I've never been a fisherman, but I can imagine that making a special photograph is like catching the 'big one' that always 'got away.' I have been a photographer for more than twenty-five years, yet the thrill of seeing and capturing photographs that, I hope, have a lasting value is as exciting as it was when I was a pup."

BRENT JONES, CHICAGO, IL

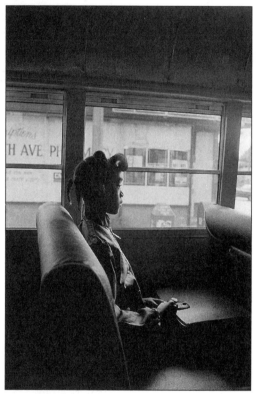

"As a photo team that produces more than 20,000 new color photos each year, we are two of the most prolific and widely published photographers in the United States. We have been selling our images directly to clients for over fifteen years, and are represented by a variety of national and international stock agencies. Our photo expeditions carry us into all aspects of American culture, where we photograph travel resorts, sports and recreation, disasters, soaring mountain peaks, thriving financial centers and just about everything else for our advertising, commercial and editorial clients. In an average year, we travel about 26,000 miles in our minivan as we crisscross the North American continent to expand and update our photo library, which consists of 130,000 images."

MARK & AUDREY GIBSON, MOUNT SHASTA, CA

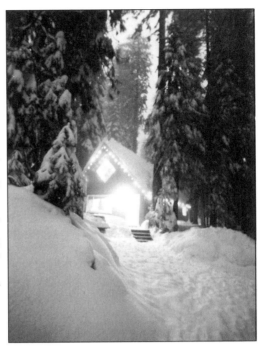

"I came to stock photography via the back door. I was a travel writer for eight years. I learned that pictures not only enhanced the impact of my articles, but also the sales. In the early stages of my career, I spent a lot of time contacting potential markets. Now I've discovered ways of getting them to contact me. I have built a solid market list. Periodically I send out 3,500 travel photo postcards to my list. I keep in touch. Invariably the mailing results in assignments and also sales of the picture featured on the postcard. The mailing always pays for itself. The added promotional value is priceless. This picture has been used as the entire backdrop for a $3' \times 5'$ poster and has accompanied several of my own and other people's articles about the Grand Canyon."

W. LYNN SELDON, JR.

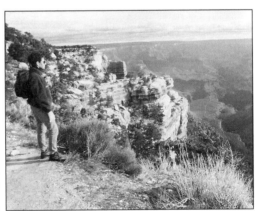

"I've looked through my older files for black-and-white stock, now that my color files have been edited and distributed. In the early years, magazine assignments yielded few reusable shots, but when I began taking pictures for my children's books and how-to photography books (I've written about twenty), I was encouraged to build a stock file that I add to frequently. I sell through four different agencies and avoid conflicting submissions. This London street has sold to various publications over several decades. As I travel, I try to envision possible markets for whatever I shoot."

LOU JACOBS, JR., CATHEDRAL CITY, CA

"Although my main income is derived from assignment photography, stock photography has always been a very important part of my total income. This 'Jumping Bass' shot is a good example of why. It's part of a series of six slightly different jumping bass shots, all done at the same time, which in the fifteen years since they were taken have been an honest 'annuity fund'—selling and re-selling. The 'Jumping Bass' series has produced more than $82,000 in use fees to date."

BURTON McNEELY, LAND O'LAKES, FL

"I have been doing stock photography since 1972, and over two hundred different publishers have used my work, mostly as illustrations in books and magazines. Besides marketing stock photography through my mini stock agency, I have written a stock photography management computer program for the Macintosh (MacStock Express), do custom programming, dabble in farming, etc. My photography covers the gamut of human-interest subjects. This photo, shot in Egypt, has sold thirty-eight times so far, illustrating Christmas, the Middle East, adventure, etc."

ROBERT MAUST, KEEZLETOWN, VA

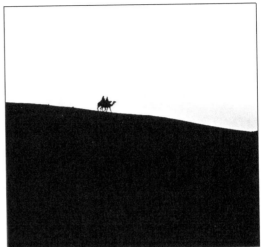

"Our specialty is travel photography, and we have flown over seven million miles and visited ninety-seven countries. Currently, our stock files contain over 670,000 images on a wide variety of subjects. We market these directly to advertising agencies, magazines, newspapers, textbooks, PR firms and picture agencies. We also market our pictures via electronic databases with America OnLine, Picture Network International and CORBIS Corporation."

CARL AND ANN PURCELL

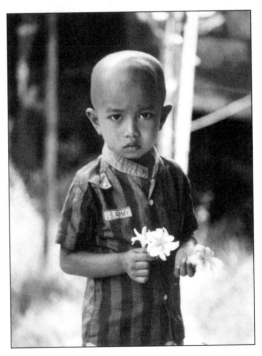

"I've been involved with photography for the past thirty years, mostly as a photojournalist working on assignment for national magazines. My strongest images are of people—a subject I never tire of. I find I'm able to sell and resell these photos to book publishers and magazines through my own mini stock-photo agency. This photo is especially popular, as it combines the beautiful facial expression of the little girl with a large open area for publishers to use for type."

RICK SMOLAN, SAUSALITO, CA

"I used to do mostly assignments, but now I do mostly stock. By keeping informed through watching television, studying images in magazines and reading (yes, *reading*), you can keep abreast of trends and create appropriate images. You can't look at other stock agencies' catalogs or go purely by publishing photos; if you do that, all you're doing is reacting and you're already too late. You've got to seek out and perceive universal themes. Rarely is there such a thing as a lucky shot. Good images are not only *of* something, they are *about* something as well. Above all, you've got to do the work you like. You must shoot for yourself, while keeping potential clients in mind as well. To be happy you must make the photos you'd make if nobody was paying you for it. After all, in stock photography, nobody *is* paying you for it until after the fact, sometimes *way* after the fact!"

DALE O'DELL, DEWEY, AZ

"Usually, you take the best pictures in your career of the things that you love. I've loved airplanes since I was a child. Now they're my photographic specialty. It's what I do for a living—photographing aviation-related subject matter for industry trade publications at home and abroad, building my stock file with every shot."

CHRIS SORENSEN, SHEBOYGAN, WI

"I sold my first stock photo in 1971. It was a picture of a bear to *Encyclopaedia Britannica*. I operate my stock-photography business out of my home. I'm a one-man band—I don't hire any help, I keep it simple and I've got my files of 45,000 photos down to a system that's easy to handle.

"I maintain two files, my 'star' file (where I log in my super-winners) and my regular file. I place my 'star' slides in 4″ × 5″ black mounts, seal them and store them in shoe boxes according to subject matter. I don't need a computer search program: I know where everything is. I use the CRADOC Captionwriter, the early version for the PC. It works great."

LARRY MULVEHILL, OCEANPORT, NJ

"I was working for the Aspen Ski Corporation back in 1975 when I discovered I could turn my photography hobby into a profitable business. When ski magazines started buying my photos (one put one on the cover), I knew I could compete with the pros. The magazine work led to assignments (one company sent me to Mt. Kilimanjaro). Eventually we migrated to the East coast, where my western style of ski shooting was in demand. It was a challenge, though—no spectacular mountains, crisp blue skies, mild, dry weather. My specialty is outdoor recreation in all seasons."

DAVID BROWNELL, ANDOVER, NH

"After many years in corporate America, I felt it was time to begin the greatest adventure of my life. I studied successful stock photographers, until I learned to combine my business experience with my love of photography. I built a stock portfolio of thousands of images of children experiencing the many faces of family life in America. Learning your craft is much more than knowing which lens, f-stop or film to use. It's also the nature and soul of light, the art of seeing . . . not just composition and color, but seeing the story, the life force and the way it touches us all. Then *treating* it like a 'business' five days a week—contacting photo editors and mailing images to prospective customers on your PMS/A list, keeping up with the industry, staying organized and disciplined. Nothing has been harder—or filled me with more joy."

KATHLEEN WILLIAMS, PORTLAND, OR

"I'm a stock photographer. I now shoot mostly on speculation. In a recent San Francisco workshop, I was asked to recount my activities during the preceding six months. The process of looking back was both pleasant and a bit surprising. I had worked in Thailand; in Oregon (a wild horse roundup); in the Grand Canyon (225 miles of white water); at Joshua Tree National Monument; in Indonesia (five weeks via motorcycle). I had photographed California Desert Bighorn and the Canadian Rockies, plus Vancouver, B.C. (pre Expo). Our family income is admittedly modest, but my wife and I think of ourselves as rich."

RON SANFORD, GRIDLEY, CA

"I've been taking pictures since I was a child. My specialty is family living with an emphasis on minorities and ethnic groups, with sales primarily to magazines and publishing companies. 'Grandpa and Grandson' won the *Parade Magazine* competition and has been used in over two hundred magazines, calendars and greeting cards all over the world. I am also a professional trumpet player who has worked with Cab Calloway, Ray Charles and Nina Simone, to name a few."

OSCAR WILLIAMS, KIRKLAND, WA

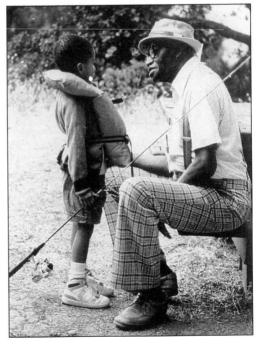

"I've always loved to travel and make photographs of the beautiful places and people along the way. Turning this love into a successful business has required taking care of business as though my photography were a product—not an art. It's one thing to make great photography; it's something else to sell it and administer those sales into profit. The simple formula for success is Quality Product, Business Sense and Ability, Strong Marketing and Sales, and the Right Attitude."

CLIFF HOLLENBECK, SEATTLE, WA

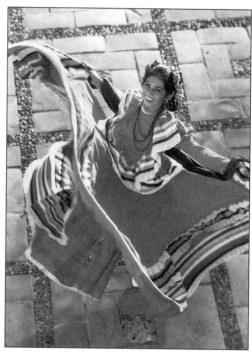

"When I first broke into stock photography, I photographed just about everything. Early on, I realized that I should pick out certain specialties and become proficient in them. My general specialty is travel photography, and I'm known in the industry for my extensive collection on China. I have visited there over twenty times."

DENNIS COX, CHINASTOCK LIBRARY, ANN ARBOR, MI

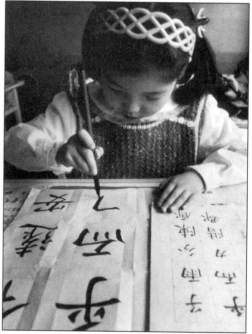

"Having been a professional photographer for twenty years, I strongly feel that the secret to selling and re-selling is to maintain a strong stock file and to be professional and dedicated in one's marketing. Follow up every lead, contact photobuyers, send out stock lists and be always alert to any possibility that opens up new avenues of potential income. While much of my photography is travel oriented, I also cover journalism, and in my New York studio specialize in theatrical portraiture for the performing arts. Many of my repeat sales in travel photography are, of course, in color."

LEE SNIDER/PHOTO IMAGES, NEW YORK, NY

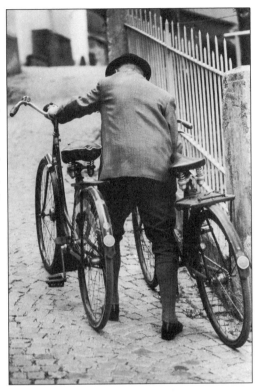

"I began my freelance career while I was still a newspaper photographer in Tampa. Now I'm freelancing full time and, along with my editorial work, have added advertising and corporate assignments. To make those kinds of photographs, it takes extensive preparation and tons of equipment. The results are well worth the effort, and with my assignment travel to the far corners of the world, I'm constantly building my stock collection and developing my extensive Market List."
(Note: See examples of Mitch Kezar's photography on pages 220-221.)

MITCH KEZAR, LONG LAKE, MN

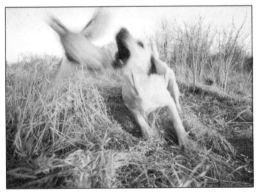

"After twenty years as a service photographer/reporter for a newspaper, I became a full-time freelance stock photographer twenty years ago. I enjoy the freedom from assignments. I offer thousands of good stock photos to magazine and book publishers; my specialty is the human-interest people picture, in basic contexts of home, school and church."

DAVID S. STRICKLER, NEWVILLE, PA

"I frequently work with freelance writers on picture stories. The material can often be rewritten and reslanted for extra mileage. I've been freelancing full time since 1973. I wear two hats. My work has ranged from portraiture and service photography to editorial, illustrative and decor photography. This picture is an example of decor photography. I have made a concerted effort to establish myself in this area. My archival black-and-white decor prints have been selling well lately."

BILL ELLZEY, TELLURIDE, CO

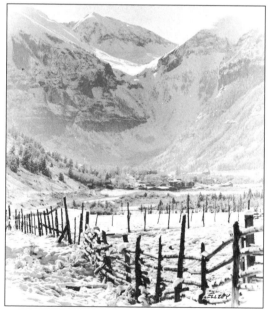

"More than thirty-five years ago, I left my job as a newspaper travel editor and struck out into the land of freelance stock photography and photojournalism, focusing primarily on nature subjects. Business management and developing marketing skills have been as important to my success as good pictures, and today I convey these principles in my 'Touch of Success' nature photography seminars. Along with marketing my stock photos, I've produced several books, including *The Island*, *American Rivers* and *How to Make $50,000 a Year as a Nature Photojournalist.*"

BILL THOMAS, GLENDALE, KY

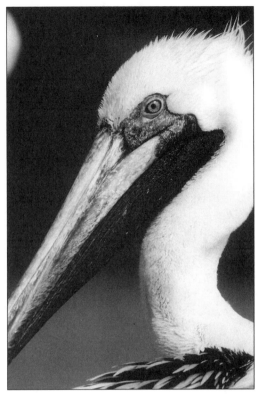

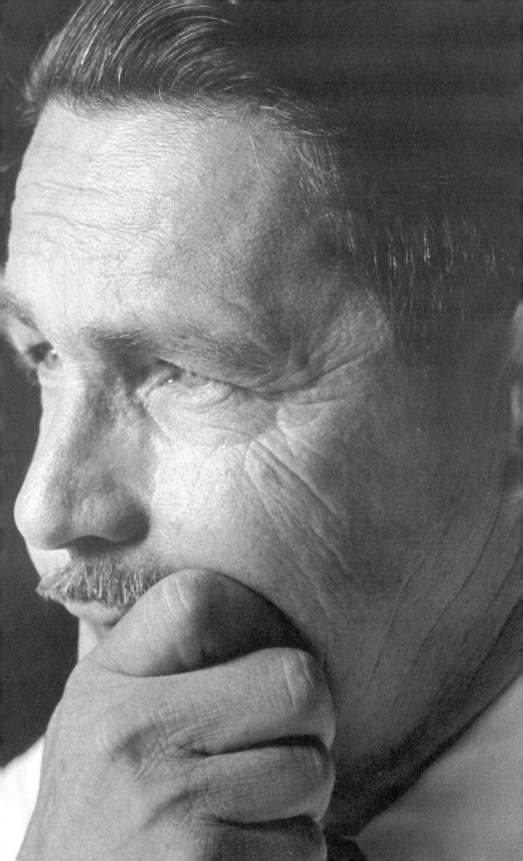

# Finding Your Corner of the Market

## First, Find Yourself

Who are you? Photographers who are successful in selling their pictures have learned this marketing secret: *Know thyself.* That is, know your photographic strengths and weaknesses before you begin marketing your pictures.

You want to find your corner of the market. But first, you must find out who *you* are, photographically. You can do that by completing the following simple exercise.

### Photographically . . . Who Am I?

Save a Sunday afternoon to fill out this section—it will be invaluable in terms of the wheel spinning you'll encounter if you jump into photo marketing without having the information in this chapter. If you are reading this book a second time because your stock-photography enterprise is sputtering and coughing and you're wondering what went wrong, read this chapter *carefully.* Many photographers fail to do so and then fail. As the saying goes, "When all else fails, read the directions."

Take a piece of paper and make two columns like the ones in figure 3-1. Head the column on the left *Track A,* the column on the right *Track B.* The columns can extend the length of the page or pages, if necessary.

Next, fill in the Track B column with one-line answers (in no special order) to these questions:

1. What is the general subject matter of each of the periodicals you subscribe to, or would like to subscribe to (or receive free)? (For example, if you subscribe to *Today's Pilot,* you would write *aviation.*) Write something down for each magazine. Do you welcome catalogs in the mail? What's the subject matter? Write it down.

2. What is your occupation? (If you've had several, list each one.) Also include careers you'd like to pursue, or are studying for or working toward.

3. When you are on a photo-taking excursion, what subjects (e.g., rustic buildings, football, celebrities, sunrises, roses, waterfalls, butterflies, fall foliage, children, puppies, Siamese cats, hawks, social statements, girls) do

| Track A | Track B |
|---|---|
| scenics | gardening |
| flowers | electronics |
| fountains | grocer |
| insects | teacher |
| sunsets | scenics |
| historic sites | flowers |
| | fountains |
| | insects |
| | sunsets |
| | historic sites |
| | antique automobiles |
| | snowmobiling |
| | old barns |
| | old movies |
| | Minneapolis |
| | Wisconsin |
| | Mississippi River |
| | St. Croix River |
| | Interstate Park |
| | TV cameraman |
| | dentist |

*Figure 3-1. John's track list.*

you enjoy taking the most? Use as many blanks as you wish. The order is unimportant.

4. List your hobbies and pastimes (other than photography).

5. If you were to examine all of your slides and contact sheets, would you find threads of continuity running through the images? (For example, you might discover that you often photograph horses, train stations, rock formations, physical fitness buffs, minority groups.)

6. What are your favorite armchair interests? (For example, if a passing interest is solar energy, astronomy or ancient warfare, write it down.)

7. What is the nearest city of more than 500,000 population?

8. What state do you live in?

9. List any nearby (within a half-day's drive) geographical features (ocean, mountains, rivers) and human-made interests (iron or coal mine, hot-air-balloon factory, dog-training school).

10. What specialized subject areas do you have ready access to? (For example, if your neighbor is a bridge builder or a ballerina, or a relative is a sky diver, or your friend is an oil-rig worker, list them.)

If the list in Track B includes any of the following, *draw a line through them:* landscapes, birds, scenics, insects, plants, wildflowers, major pro sports, silhouettes, experimental photography, artistic subjects (such as the "art" photography in photography magazines), abstracts (such as those seen in photo-art magazines and salons), popular travel spots, monuments, landmarks, historic sites, cute animal pictures. Transfer all of the subjects that you just drew a line through over to Track A.

You'll find your best picture *sales* possibilities in Track B. Track A is a high-risk marketing area for you. Most photographers have spent a great deal of their time photographing in the Track A area. Because it is such a popular area, photobuyers can find these pictures easily in stock agencies, on CD-ROMs and online.

When you get off Track A and onto Track B, you'll stop wasting time, film, postage and materials. You'll get published, receive recognition for your specialization in photography and deposit checks. Let's examine the Track B and Track A of one hypothetical photographer, John, whose interests are listed in figure 3-1.

1. John subscribes to magazines dealing with gardening, electronics and antique automobiles. Not only do these reflect John's interests, but the combined total for photographs purchased for magazines and books in these three areas can exceed $150,000 per month. Yet most of John's picture-taking energy and dollars have been put into Track A pictures, which have limited marketing potential because of the law of supply and demand.

2. John's occupation is grocery store manager. The trade magazines in this area spend about $20,000 each per month for photography. John could easily cover expenses to the national conventions each year, plus add an

extra vacation week at the convention site, with income generated by his camera.

John is a former teacher, and retains his interest in education. His experience gives him the insight and know-how to capture natural photographs of classroom situations. Such photos are big sellers to the education field, denominational press and textbook industry. Let's make a conservative industry estimate of the dollars expended each month for education-oriented pictures: $800,000.

3. In his picture-taking excursions, John usually concentrates on scenics, flowers, fountains, insects, sunsets and historic sites. These all have limited marketability for the independent freelancer without a track record with the big agencies and top magazines. However, John could place some of these Track A pictures in stock agencies for periodic supplementary sales. A stock agency that specializes in insects, for example, will be interested in seeing the quality of John's pictures. Some of John's other Track A pictures belong in different stock agencies. (Chapter twelve tells how to research which agencies are right for which pictures on your Track A list.)

4. John's favorite hobby is antique cars. He can easily pay for trips to meetings and conventions through judicious study of the market needs for photography involving antique cars.

John also lists snowmobiling as a hobby. More than $80,000 a month is expended on photography in publications dealing with winter fun in season.

5. John finds that he photographs picturesque old barns every chance he gets. The market is limited (Track A). One day he may produce a book or exhibit of barn pictures, but it will be a labor of love.

6. His armchair interest is old movies. No marketing potential unless placed in a specialized photo agency.

7, 8. Nearest city: Minneapolis. (Chapter eleven will explain how to capitalize on your travel pictures.)

9. The Mississippi and St. Croix rivers are nearby, plus a state park (see chapter eleven).

10. John's neighbor is a TV cameraman. He could get specialized access to television operations and be an important source to photobuyers who need location pictures dealing with the TV industry. John's brother is a dentist, so he has access to the field of dentistry. Publications in each of these areas easily spend a combined $20,000 per month for pictures.

## Your PMS/A (Personal Photographic Marketing Strength/Areas)

Let's take a closer look at Tracks A and B:

### Track A: The Prognosis Is Guarded

These are the areas of formidable competition. Track A pictures are used in the marketplace all right, but it's a closed market. Photobuyers have tons of

these photographs in inventory, or they locate them easily from their favorite top pros, or they click one from a clip art disk or an online service, or they contact a stock agency that has thousands upon thousands to select from. If you want to concentrate your efforts in the Track A area of photography, I suggest you stop reading right here, because you'll need to put every minute of your time into making a go of it. Only a handful of freelancers in this country—most of them full-time pros—are successful at making regular sales of Track A photographs, and the majority must still supplement their incomes with writing, consulting, speaking or teaching.

If you're not planning to concentrate on Track A pictures, but you still want to take them, one solution is to put your Track A shots into a stock-photo agency and then not worry about how often they sell for you. Every once in a while, you may get a nice surprise check. (Chapter twelve shows you how to determine which agencies are for you.) A second solution is to turn to producing decor photography (again, see chapter twelve). Keep in mind, though, that you can't expect either of these solutions to result in *regular* sales for you. Decor photography is a labor of love; the big money-maker at a stock agency is the director. Practically speaking, your forte and solid opportunity for immediate and consistent sales—in other words, your strong marketability areas—remain on Track B.

### Track B: The Outlook Is Bright

Take time to do a complete job of filling out Track B, and you'll find that you've sketched a picture of who you are photographically. This list is your PMS/A, your personal photographic marketing strength/areas. You have vital advantages in these areas. You offer a valuable resource to photobuyers in these specialized subjects. You have access and an informed approach to pictures in these areas that many photographers do not have. Your competition in marketing Track B pictures is manageable. Throughout this book, I'll constantly refer to your PMS/A, your Track B list. You are already something of an expert in many of these Track B areas, and the subject matter appeals to you. Not all of your interests, of course, lend themselves 100 percent to photography. But you will be surprised how many do. For example, *chess* has spawned few periodicals that require pictures. But pictures of people playing chess have varied applications: *concentration, thinking, competition*—good illustration possibilities for textbooks or for educational, sociological or human-interest magazines.

Photobuyers for the Track B markets will encourage you to submit pictures by purchasing more and more of your photo illustrations. Gradually you'll receive higher fees—and eventually assignments. Pretty soon, you'll consider graduating to higher paying markets in your specialization area(s). Your efforts and sales in the nuts-and-bolts areas of Track B may one day even justify the time you still may wish to give to Track A photos, which actually *cost* you money to try to market.

Throughout this book, when I refer to *you*, the photographer, I mean for you to adapt what I'm saying to *your* particular photographic strengths and approaches. Refer again to the photographic picture of yourself you've outlined on Track B. When I say *you*, I won't mean *me*, or any other reader of this book. Another photographer would fill out this chart differently. He would also be an important resource to an editor or editors, but rarely would the two of you be in competition for the attention of the same photobuyers. Your task will be to find your own mix of markets, based on the areas you like and know best, and then hit those markets with pictures they *need*.

This approach eliminates the drudgery associated with the admonition we often read in books and hear at lectures: "Study the markets!"

When I first began marketing my photographs, I also heard "Study the markets!" I've always associated the word *study* with tedium. I found it unnecessary to study the markets. The only studying I needed was to study *myself*—and then develop my personal photographic marketing strengths. If I listed the market in my PMS/A, I was already a mini-expert on the subject. If it wasn't in my PMS/A, I had no business either studying it or photographing it.

## The Majors and the Minors

Do you know any successful photographers? *Success* eludes concrete definition. We all know that it is irrelevant to judge people's success by their net worth, where they live or the fame they have attained. When I refer to *success* in this book, interpret it not in terms of some stereotyped level of achievement, but in terms of the goals that are meaningful to *you*.

The major markets for your photo illustrations may not necessarily be

### MAKE A NAME IN YOUR AREA OF SPECIALIZATION

Would you go into a supermarket and ask for plain ol' soap? That's what shoppers did a couple generations ago. Today, there are vast numbers of highly specialized soaps available to consumers. In like manner, the upcoming digital age will make it possible for photobuyers to sort out and identify photo illustrators according to their specializations.

If you continue to build your photo file all across the board, focusing on *no* specific subject area(s), you'll find that your potential clients aren't interested in sorting through thousands of unspecific pictures, no matter how excellent they are. They'd just as soon let a service bureau (the stock agency of the future) do the searching for them. However, if you start building specialization areas now, eventually you'll have a vertical base inventory of photos that will appeal to your targeted customers when they come knocking at your cyberspace door, seeking pictures in your photo strength areas. You will be establishing a recognized identity for yourself.

the major markets for the stock photographer next door. Your neighbor's major markets may be your minor markets.

Will you have to change your lifestyle or your photography to apply the marketing principles in this book? Not at all. And breaking in won't put a dent in your pocketbook. Your major markets need not be in New York: They might be in your backyard.

The length of your Track B list will give you a good idea of the breadth of the market potential for your photography. Some stock photographers thrive in a very limited marketplace. Others find it necessary, because of the nature of their photographic interests, to seek out many markets. In my own case, I have six file drawers filled with correspondence with 980 publishing houses or photo-buying contacts developed over thirty years. The files, like the personnel in the publishing world, stay in a state of flux. New photo editors come and go, but the theme of the publishing house remains the same. As long as your collection of photos matches that theme, you have a lifelong market contact with that publishing house.

## How to Use the Reference Guides and Directories

Once you know your photographic strengths, you'll find your corner of the market more easily. Several excellent market guides exist that will point you in the right direction. Keep in mind that, because of publishing lead time, directories, even telephone directories, are up to one year older than the date on the cover. Use your directories to give you a general idea of potential markets for your photographic strengths. For specific names, titles, updated addresses and phone numbers, keep your directories current yourself by making personnel changes whenever you learn of them through your correspondence, phone calls or newsletters.

Treat your directories like tools, not fragile glassware. Keep them handy, scribble in them, paste in them, add pages or tear pages out. Your directories are a critical resource for moving forward in your photo marketing. If you are computerized, begin to maintain a photobuyer file. (See chapter seventeen for ideas on how a computer can help you organize your Market List.)

Table 3-1 tells you the names and addresses of published directories. Most of these you'll find at any large metropolitan library, and many of them are stocked by your local community or branch library.

Which directories are best for you? You'll find out by matching the subject categories in your Track B list with the market categories covered by the different directories. The most popular directory among newcomers to stock

---

You can find outdated directories at the "Spring Book Sale" held by your local library. Usually the cost of a directory is fifty cents to a dollar. A company that sells outdated directories (remainders): North American Directory Exchange.

photography is *Photographer's Market*, an annual directory that lists 2,500 up-to-date markets. This directory not only tracks down personnel changes in the industry, but also lists the fees photobuyers are willing to pay for stock photos.

## Using Your Local Interlibrary Loan Service

Some directories may be too expensive for you. They may also be too expensive for your community or branch library. Ask the librarian to borrow such a directory through the interlibrary loan service (or its equivalent in your area). If the book is not available at a regional library, the service will locate it at the state level. It generally takes two weeks to locate a book. Since the books you order will be reference manuals, your library will probably ask that you use them in the library. However, you can photocopy the pages you'll need, thanks to the *fair use* doctrine of the U.S. Copyright Act.

## Chart Your Course . . . Build a Personalized Market List

Now that you've defined your photographic strengths and focused in on accessible subject areas, you're ready to chart your market course.

Successful businesspeople in any endeavor aim to reduce the possibility of failure by reducing or eliminating no-sale situations. Why attempt to sell your pictures to a market where the no-sale risk is high? By using the procedure that follows, you will build a *no-risk* Market List and begin to see your photo credit line in national circulation.

Consult all of the directories available to you, and build a list of potential markets for *your* material by combing through the categories that match your photographic strengths. This might take several evenings of effort, but the investment of time is worth it.

Here at PhotoSource International, we provide a computerized printout of names and addresses of contact persons or photobuyers in every imaginable area. Your homework will result in several similar lists (the number of lists depends on the length of your Track B column).

### Setting Up Your List

Type the address of each market on a separate 3″ × 5″ file card, expandable personal directory or computerized database. On your lists you will want to include information about the photobuyers you deal with at each market—title, nickname, former position or title, plus a note or two about their photo-buying procedures, fee range, preferences, dislikes and assignment possibilities. Leave room for code designations of your promotional mailings to them (see chapter ten) and, of course, space for changes of address, title or personnel.

This system will allow you flexibility to delete, repair (e.g., make changes of address or spelling corrections) or add names easily.

You can start your personal Market List from the directories, but you can

**Art Network**
P.O. Box 1268
Penn Valley, CA 95946

**Advertising Photographers of America Directory**
27 W. Twentieth, Room 601
New York, NY 10010
Or: 7201 Melrose Ave.
Los Angeles, CA 90046

**Advertising Red Book**
West Telemarketing Corp.
9910 Maple St.
Omaha, NE 68134

**American Book Trade Directory**
121 Chanlon Rd.
New Providence, NJ 07974

**American Hospital Association Directory**
840 N. Lake Shore Dr.
Chicago, IL 60611

**American Society of Journalists and Authors Directory**
1501 Broadway, Suite 302
New York, NY 10036

**American Society of Picture Professionals Directory**
2025 Pennsylvania Ave. NW, Suite 226
Washington, DC 20006

**ArtNetwork Yellow Pages**
18757 Wildflower Dr.
Penn Valley, CA 95946

**ASMP Stock Photo Handbook**
ASMP–National
14 Washington Square, Suite 503
Princeton Junction, NJ 08550-1033

**Association for Education & Communications**
1025 Vermont Ave. NW, Suite 820
Washington, DC 20005

**Audio Visual Market Place**
R.R. Bowker Co.
121 Chanlon Rd.
New Providence, NJ 07974

**Bacon's Publicity Checker**
Bacon's Publishing Company
332 S. Michigan Ave.
Chicago, IL 60604

**The Bowker Annual of Library and Book Trade/Information**
121 Chanlon Rd.
New Providence, NJ 07974

**Broadcast Interview Source**
2233 Wisconsin Ave. NW
Washington, DC 20007

**California Media**
P.O. Box 1197
New Milford, CT 06776

**Canadian Almanac**
200 Hadlaide St. W., 3rd Flr.
Toronto, Ontario MH5 IW7
CANADA

**Cassell's Directory of Publishing**
Villiers House 41/47
Strand, London WC2N 5JE
ENGLAND

**Contact Book for the Entertainment Industry**
Celebrity Service International
1780 Broadway, Suite 300
New York, NY 10019

**Decor Services Annual**
Commerce Publishing Co.
330 N. Fourth St.
St. Louis, MO 63102

**Design Firm Directory**
Wefler & Associates, Inc.
P.O. Box 1167
Evanston, IL 60204

**Directory of Free Stock Photography**
InfoSource Publications
10 E. Thirty-ninth, 6th Flr.
New York, NY 10016

**Directory of Post Secondary Institutions, 1990**
Superintendent of Documents
U.S. Government Printing Office
Washington, DC 20402

**Editor & Publisher International Yearbook**
11 W. Nineteenth St.
New York, NY 10011-4234

**Educational Marketer Yellow Pages**
Knowledge Industry Pub.
701 Westchester Ave.
White Plains, NY 10604

**Encyclopedia of Associations**
Gale Research Inc.
835 Penobscot Building
645 Griswold St.
Detroit, MI 48226

**Gebbie Press All-In-One Directory**
P.O. Box 1000
New Paltz, NY 12561

**Gift and Decorative Accessory Buyer's Directory**
Geyer McAllister Publications
51 Madison Ave.
New York, NY 10010

**Guide to American Directories**
B. Klein Publications
P.O. Box 8503
Coral Springs, FL 33065

**Horse Industry Directory**
American Horse Council
1700 K St. NW, Suite 300
Washington, DC 20006

**IMS Directory of Publications**
Gale Research Inc.
835 Penobscot Building
Detroit, MI 48226

**Information USA Directory**
Viking Penguin Books
375 Hudson St.
New York, NY 10014

**Interior Design Buyer's Guide**
Interior Design Publications
475 Park Ave. S.
New York, NY 10016

**Internal Publications Directory**
Reed Elsevier Publishing
P.O. Box 31
New Providence, NJ 07974

*Table 3-1. Directories.*

The International Buyer's
Guide of the Music-Tape
Industry
Billboard Publications
1515 Broadway
New York, NY 10036

The Journal of the Society for
Photographic Education
Directory Exposure Magazine
% University of Colorado
Campus Box 318
Boulder, CO 80309

Literary Market Place
R.R. Bowker Co.
121 Chanlon Rd.
New Providence, NJ 07974

Madison Avenue Handbook
The Image Makers Source
Peter Glenn Publications, Ltd.
42 W. Thirty-eighth St.,
Suite 802
New York, NY 10018

The Mail-Order Business
Directory
Catalog Division
B. Klein Publications
P.O. Box 8503
Coral Springs, FL 33065

Manufacturers Directories
1633 Central St.
Evanston, IL 60201-1569

National Directory of
Magazines
Oxbridge Communications,
Inc.
150 Fifth Ave.
New York, NY 10011

Newsletter National Directory
Gale Research Inc.
835 Penobscot Building
Detroit, MI 48226

New York Publicity Outlets
Public Relations Plus, Inc.
P.O. Drawer 1197
New Milford, CT 06776

O'Dwyer's Directory of
Corporate Communications
J.R. O'Dwyer Co.
271 Madison Ave.
New York, NY 10016

O'Dwyer's Directory of
Relations Firms
J.R. O'Dwyer Co.
271 Madison Ave.
New York, NY 10016

Online Business Information
Sources
Cuadra Associates
655 Avenue of the Americas
New York, NY 10010

Patterson's American
Education
Educational Directories Inc.
P.O. Box 199
Mount Prospect, IL 60056-
0199

Photographer's Market
Writer's Digest Books
1507 Dana Ave.
Cincinnati, OH 45207

Reader's Digest Almanac and
Yearbook
Pleasantville, NY 10570

Register of the Public
Relations Society of America
33 Irving Place
New York, NY 10003

Society of American Travel
Writers Directory
4101 Lake Boone Trail,
Suite 201
Raleigh, NC 27607

Standard Periodical Directory
Oxbridge Communications
150 Fifth Ave., Suite 301
New York, NY 10011

Stock Photo Deskbook
The Photographic Arts Center
163 Amsterdam Ave.,
Suite 201
New York, NY 10023

Talk Show Guest Directory
Broadcast Interview Source
2233 Wisconsin Ave. N., #540
Washington, DC 20007

Traveler's Guide to Info
U.S. Dept. of Commerce
U.S. Travel Service
Visitor Services Div.
Washington, DC 20230

Travel Writer's Markets
Directory
Winterbourne Press
7301 Burnet Rd., #102-279
Austin, TX 78757

Ulrich's International
Periodicals Directory
R.R. Bowker Co.
121 Chanlon Rd.
New Providence, NJ 07974

Working Press of The Nation
Reed Elsevier Publishing
P.O. Box 31
New Providence, NJ 07974

The World Almanac
United Media
200 Madison Ave., 4th Flr.
New York, NY 10016-3903

World Aviation Directory
News American Publishing
Inc.
210 South St.
New York, NY 10002

World Travel Directory
Ziff-Davis Publishing Co.
1 Park Ave., Room 1011
New York, NY 10016

Writer's Guide to San
Francisco/Bay Area
Publishers & Editors
Zikawuna Books
P.O. Box 703
Palo Alto, CA 94302

Writer's Market
Writer's Digest Books
1507 Dana Ave.
Cincinnati, OH 45207

The Yearbook of American
and Canadian Churches
475 Riverside Dr., Room 866
New York, NY 10115

*Table 3-1. (cont.)*

discover additional markets for your pictures at newsstands, doctors' offices, business counters and reception rooms.

Your list is now tailored to your exact areas of interest. If you have several areas of interest, should you make several lists? My advice would be to keep one master list. Color-code the categories, or type them on different-color file cards. Then, when you repair or replace a listing, you need do it only once. (For more on recordkeeping, see chapter thirteen.)

## The Specialization Strategy

Now that you have charted your course to sail straight for your corner of the market, you are bypassing the hordes of photographers on Track A to move along Track B, where the competition is manageable.

As you work with this system, you will discover that you can define your target markets even more specifically and improve the marketability of your pictures 1,000 percent through a strategy used by all photographers who are successful at marketing their pictures—the strategy of *specialization*.

We live in an age of specialization. Once we leave school, whether it be high school or medical school, we are destined to become a specialist in something. In today's world, with the immense breadth of knowledge, technology and diversification, it's impossible for one person to be expert even in all aspects of a single chosen field. And in our culture, buyers of a person's services prefer dealing with someone who knows a lot about a specific area, rather than with someone who spreads himself too thin.

The same holds true for photobuyers. They know the discerning readers of their specialty magazines expect pictures that reflect a solid knowledge of the subject areas. Understandably, then, buyers seek out photographers who not only take excellent pictures, but who also exhibit familiarity with and understanding of the subject matter of their publications.

Technical knowledge alone is not sufficient to operate successfully in today's highly specialized milieu. Marketing has evolved beyond the "I buy a product because I like the product" stage. Marketing people have found that consumers often buy an image rather than a product. Their success at image-creating to sell cars, cigarettes and beer attests to the power of images to move the buying public. Since most magazines (and, to a lesser extent, books) are extensions of the advertisers or supporting organizations, photo editors, directed by the publisher's editorial board, are constantly seeking out photographs and photographers who can capture the publication's image in pictures. The image projected in a yachting magazine will be subtly different than that of a tennis magazine. The image projected by a magazine called *Organic Fruit Growing* will be radically different from that of one called *Chemical Fertilizers Today*.

These nuances are important for you to be aware of. (In chapter nine, I'll discuss these nuances further and show you an effective query letter for reaching editors.) Go over the list of markets you've compiled for yourself.

You need to familiarize yourself with the publications (write for copies or find them at the library) to educate yourself on their individual themes. Often, the book or magazine publisher will supply you with photo guidelines. If you can't get a handle on the image of some of the markets, put them at the bottom of your list. Keep the areas you're more sure of at the top. You have now fine-tuned your list; you can be more selective in your choices. The top of your list has your target markets, the ones that best reflect who *you* are *photographically,* the ones that fall within your personal photo-marketing strengths. Editors have specific photo needs, and the sooner you match *your* subjects and interest areas with buyers who *need* them, the sooner you'll receive checks.

You'll also be building a reputation among the photobuyers who need your specialized photography. Photobuyers pass the word.

### Keeping on Top With Newsletters

Another way to discover additional markets for your list, or to keep abreast of current market trends, is to read the newsletters in the field. You can usually find these in the library, or you can send for sample copies (include $1 and an SASE), to gauge whether your particular photographic approach would be served by subscribing. For names and addresses of the best in the field, see the bibliography.

## The Total Net Worth of a Customer

The effort it takes to locate your markets results in far more than a limited series of sales. You are in effect locating sources of long-term annuities. When you use the marketing methods outlined in this book, you're developing a potential long-term relationship with a proportion of your markets or customers, whether they are corporations, public relations firms or publishing houses. Publishing houses particularly lend themselves to a long-term affiliation because of the stability of their focus and emphasis. In my experience and in surveys of other photo illustrators, ten years is a reasonable average length of time you can expect to stay with a publishing house. Sometimes it's much longer.

This idea of the long-term value to you of a customer can be stated as the *Total Net Worth* of that customer to your business. To determine a customer's Total Net Worth to your specific operation, average your total sales—also factoring in those markets you contact that you *don't* achieve sales with. For example, using a *worst* case scenario: Taking only low-budget customers and figuring extremely conservatively that a customer may last only one year, you find you could spend up to $100 to acquire that one customer and still break even. (You'd break even because $100 is the net profit you could reasonably expect from one customer for one year at the low-budget level.) Since your promotional package to prospective photobuyers would cost about one dollar (an industry average), you could afford

to contact 100 potential customers $(100 \times \$1 = \$100)$. If out of those 100 you contact you land two, three or five steady customers, you're in the black. With experience gained through analyzing your data, you'll learn how many contacts you need to make, on the average, to land one consistent customer. Then you'll know the least amount you can afford to spend at the low-budget level to acquire a new customer.

Naturally, several contingencies are involved. For example: Does your prospect mailing list match your PMS/A? Is your promotional package professional looking? (Consult your mailing package checklist on pages 176-177 in chapter nine.)

If you acquire just one consistent customer (just 1 percent) in your promotional campaign to 100 prospects, you will break even. If you acquire ten (10 percent), you can make a potential (conservative) net profit of $1,000 for the year, and ultimately $10,000, based on the total net worth of each customer over a ten-year span.

Analyze your own market list. How many markets have bought from you once, twice, five times, twenty times in one year? What is the average for one year? How many years have they stayed with you? What average net profit do you get from each sale? If you are just starting out, keep track of this information to refine your educated guesses until you gradually accumulate your averages.

## Long-Term Value

I have presented this system conservatively. Actually, if you are aggressive and confident of the quality of your work and targeted value of your mailing list, you could lose money on your promotional campaigns and *still* come out ahead. The long-term income from your acquired customers would eventually eliminate the loss you initially experienced in acquiring them.

The Total Net Worth principle presents you with a model of your business, a mathematical relationship as to how your business works and what works. And it provides you with a warning signal before you make a bad decision. Once you have done the tedious initial work of tracking and analyzing your customers, further analysis is easy and simple. A computer will help and most database programs can be designed to process this information. This Total Net Worth principle will help you guide your business ship with far more precision.

There's a Target Market for every photographer. Take the time to fill out the lists on the next few pages. They are designed to fine-tune your photo marketing. What follows is a tested timesaving system for finding an exclusive Market List tailored to *your* personal photographic marketing strengths/areas.

1. Using the columns below, break down your photo-marketing potential into two areas—Track A and Track B, according to the instructions on pages 49-54.

|           TRACK A           |           TRACK B           |
| (Weak Marketing Potential)  | (Strong Marketing Potential) |
| --------------------------- | --------------------------- |
| _____ | _____ |
| _____ | _____ |
| _____ | _____ |
| _____ | _____ |
| _____ | _____ |
| _____ | _____ |
| _____ | _____ |
| _____ | _____ |
| _____ | _____ |
| _____ | _____ |
| _____ | _____ |

Before turning the page, draw a big
"X" over your Track A list.

*Figure 3-2. How to find your PMS/A.*

2. Which entries on your Track B list don't appeal to you photographically? In other words, you wouldn't enjoy photographing in this area.

Eliminate that list from your PMS/A. Write in your *new* PMS/A here:

List here:

_____        _____

_____        _____

_____        _____

_____        _____

_____        _____

_____        _____

_____        _____

_____        _____

_____        _____

_____        _____

_____        _____

_____        _____

_____        _____

*Figure 3-2. (cont.)*

3. Be realistic. Which areas on your PMS/A list would it be impractical for you to photograph? For example, if you listed as an *access* a relative in Alaska who is a shrimp fisherman, it might be difficult to photograph this area (unless you are reading this in Alaska).

Other considerations: Would any of the markets listed require a heavy investment in new photographic equipment? Does the magazine require model releases? Is it an uncopyrighted publication? Is it a low or no-pay publication?

List here:

_____

_____

_____

_____

_____

_____

_____

_____

_____

Eliminate the preceding list from your PMS/A. Write in your new PMS/A here:

_____

_____

_____

_____

_____

_____

_____

_____

_____

_____

_____

*Figure 3-2. (cont.)*

4. Which areas of your PMS/A don't lend themselves widely to publishing? Few areas don't, but one or two of them might be on your list.

For example, there may be a very limited audience for pictures of antique clock repair. Or there may be too few picture possibilities for an armchair interest in unidentified flying objects.

List here:

_____

_____

_____

_____

_____

_____

_____

_____

_____

_____

_____

Rewrite your list below, leaving out the subjects that are unlikely to apply widely to publishing. You have now further refined your PMS/A.

_____

_____

_____

_____

_____

_____

_____

_____

_____

_____

*Figure 3-2. (cont.)*

5. Decision! It's time to narrow down your PMS/A to *four* major areas. If you aim your marketing strategy at a minimum of four strength areas, you'll be able to develop them to their fullest potential.

   Here are seven factors that will aid you in your decision. (Make an educated guess on some of them, since you probably don't have access to current circulation and payment figures in all of these fields.)

High   Medium   Low

☐   ☐   ☐   Your knowledge or expertise in this field.

☐   ☐   ☐   Your personal interest in this field.

☐   ☐   ☐   Your existing supply of pictures.

☐   ☐   ☐   The payment range for pictures in this field.

☐   ☐   ☐   The competition factor—is it high, medium or low?

☐   ☐   ☐   Your access to the field or information about it.

☐   ☐   ☐   The audience (number of readers).

Using any other criteria you can think of, narrow down your PMS/A to four. Then decide which one of the four offers the best marketing potential for *you*. Then list the second best, and so on. Note your four strongest areas below.

### My PMS/A

No. 1: _____

No. 2: _____

No. 3: _____

No. 4: _____

*Figure 3-2. (cont.)*

1. Now that you have found your top personal photographic marketing strength/areas (PMS/A), you are ready to find the *markets* that are looking for pictures in your PMS/A. Your library, depending on its size, can provide you with many of the directories and reference guides listed in table 3-1. Your Market List is your gold mine; you will want to refine it in the same manner as your PMS/A. In the two columns below, list magazines, publishing houses and electronic markets that are potential markets for your PMS/A No. 1. Do your research thoroughly.

My initial Market List for PMS/A No. 1:

| | |
|---|---|
| _____ | _____ |
| _____ | _____ |
| _____ | _____ |
| _____ | _____ |
| _____ | _____ |
| _____ | _____ |
| _____ | _____ |
| _____ | _____ |
| _____ | _____ |
| _____ | _____ |

2. To tailor your list, ask these questions of each potential market on your list (you're going to do some shuffling):

A. **What is the supply/demand factor?** (Remember that *supply* in this case means the photobuyer's supply, not your supply.)

*Figure 3-3. Narrowing down your market list.*

High supply, no demand = move to lower third of list.

High supply, high demand = move to upper half of list.

No supply, high demand = move to top of list.

No supply, no demand = move to lower third of list.

**B. What is the competition factor?**

No competition = move to top of list.

Moderate competition = move to upper half of list.

Fierce competition = move to lower third of list.

**C. Miscellaneous considerations.**

The magazine or house demands model releases = move to lower half of list.

The magazine or house has no track record (has been in business less than three years) = move to lower half of list.

Foreign market = move to lower half of list.

Slow or no payment reported = move to lower half or remove entirely.

Poor reliability factor reported (e.g., photobuyers reported as uncooperative, disrespectful, poor administrators or inefficient in handling photographers' pictures) = move to lower half or remove entirely.

**D. What is the publisher's purchasing power?**

Rather than trying to determine a single magazine's circulation, research the entire publishing house's purchasing power. Most publishers concentrate on a specialized subject or theme. Often, if your pictures don't score with one editor, they are circulated among other editors within the house. (Some publishing houses have as many as twenty to thirty editors.) The best way to determine the buying power of a publishing house is to tally the number of periodicals and/or books published annually. If that figure is not available, you can get an idea of the house's purchasing power by looking at their circulation figures, number of pictures purchased per year or number of editors employed. Use table 3-2 to rate and list your markets in order of purchasing priority.

(Note: In this chart, *publishing house* means book *or* magazine publisher.)

*Figure 3-3. (cont.)*

3. What is the probability factor?

In the final analysis, you will determine your probability of scoring with a given magazine. Pictures in magazines can be broken down into two categories: advertising and editorial. As a stock photographer, your main concern is the *editorial market.*

These pictures are supplied by staff photographers, assignment freelancers, service photographers, stock-photo agencies and stock photographers such as yourself on the magazine's available-photographers list.

Using the magazines on your Market List, analyze their use of both advertising and editorial photographs. The amount of advertising in the magazine will give an indication of the magazine's picture budget. While you're at it, analyze the use of Track A pictures: This should convince you of the futility of trying to market Track A pictures yourself. (See chapter twelve for methods to sell these.)

Rate the magazines: 30 to 150 editorial pictures—place on top of list; 10 to 29 editorial pictures—place on top half of list; 1 to 9 editorial pictures—place on bottom half of list.

*Figure 3-3. (cont.)*

4. You have shuffled and refined your Market List for PMS/A No. 1, and your strongest markets have come out on top. Go through the same process for your PMS/A.

Transfer your four Market Lists to $3'' \times 5''$ file cards, a computer file or a three-ring (expanding file) notebook (see chapter thirteen). Make additions, deletions and address changes to your Market List as soon as they occur.

Some Market Lists are long because of the general nature of the subject. Others are short. Work closely with the top half of your list. But, because publishers' budgets change, continue to keep in contact with the lower half of your list as well. If in the future you acquire new knowledge or interest in another field, consider replacing one of your lists with a list for this new field.

*Figure 3-3. (cont.)*

| Guide to Publisher's Buying Power | | | |
| --- | --- | --- | --- |
| Place in list: | Top | Upper half | Lower half |
| Number of editors at publishing house. | 20 to 50 | 6 to 19 | 1 to 5 |
| Number of periodicals at publishing house. | 15 to 35 | 4 to 14 | 1 to 3 |
| Number of books or magazines published per year by this publisher. | 50 to 100 | 11 to 49 | 1 to 10 |
| Number of photos purchased annually by publishing house. | 400 to 3,000 | 51 to 399 | 1 to 50 |
| The circulation figure (for single-magazine publishers).* | 250,000 to 500,000 | 75,001 to 250,000 | 20,000 to 75,000 |

*Note: Magazines above 500,000 circulation are a closed market to most part-time stock photographers. Large-circulation magazines acquire their photos from (1) their staff, (2) stock-photo agencies, or (3) long-time established local (or sometimes national) service photographers. Once your stock-photo file grows to 20,000 and more salable images, you'll be eligible to deal regularly with top newsstand magazines.

Table 3-2. Publisher's buying power guide.

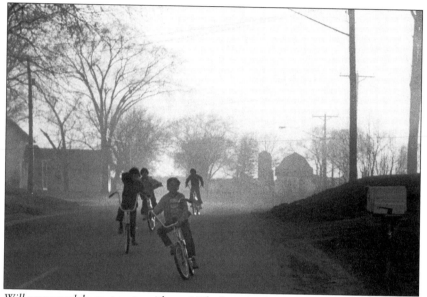

*Will your models cooperate with you? The boys in the picture above were happy to drive their bikes in a figure eight between two telephone poles I designated.*

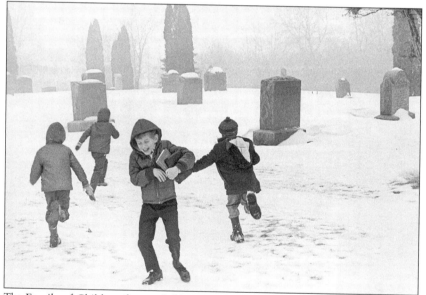

The Family of Children *featured this picture. I started with two scenes: children playing a game and a cemetery in winter. Put the two together and you have a new picture.*

*Photo illustrations are successful when they capture a mood that lends itself to magazine-article or book themes and topics. This picture has served many books and articles.*

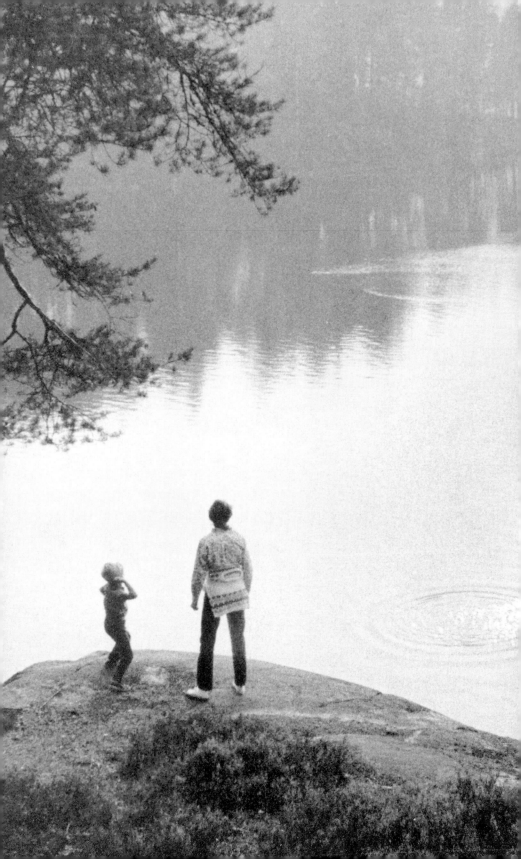

CHAPTER FOUR

# Getting Started

## Seize the Day

*"Many will come, but few are chosen." Will you be one of the chosen? Since 1981, when I published the first edition of this book, many photographers have benefited by it and write to tell me they are now well established in the editorial stock-photography field. What's their secret? Why have they been chosen?*

Throughout this book, I emphasize the importance of analyzing your personal photographic marketing strength/areas and then determining which markets need your kind of pictures. These invaluable assessments alone are an insurance policy against failure when you get started in your photo-marketing operation. Taking the time to pinpoint your PMS/A and research a sound Market List is fundamental to the success of your operation. If you skip this process or give it only short shrift, your photo-marketing prospects will be shaky.

Should you start today? My answer is yes, if you start by mapping out your PMS/A and Market List—then set aside four weekends to physically set up your operation.

That's right—in just four weekends, you can put yourself in business. We'll explore how to move step-by-step through those weekends in what we call the "Four-Weekend Action Plan."

## The Four-Weekend Action Plan

Most people have an aversion to starting things. Did you ever *not* start preparing a recipe because you weren't sure you had all the ingredients? Did you ever *not* start work on a project because you weren't sure you would be able to find one of the necessary tools when you were halfway through it? Or you weren't sure what you'd need? Most of us procrastinate.

Well, you're lucky. You don't have to wait any longer to fire up your photo-marketing enterprise. Why not? Because the Four-Weekend Action Plan contains all the ingredients, all the tools and all the know-how you need to propel yourself into the field of photo marketing.

Your resolve will require some understanding on the part of your family and friends. Announce to your family that you are going to take the next four weekends to establish yourself in the business of marketing your photographs.

Now here's a paradox: As soon as you make your announcement, your loved ones will find every imaginable reason to distract you for the next four weekends. ("Johnny has a choir concert." "We're scheduled to play cards with the Howards." "Mary has a Little League tournament.") After all, they like you so much, they don't want to see you invest yourself in something that they believe might not work out, and secondly, they don't want to see you engrossed in something they are not part of. At this point, you are most vulnerable to being talked out of your Four-Weekend Action Plan. Visualize your goals and hold firm. If you can, turn your loved ones' reservations into an advantage by recruiting their help in some of the routine tasks needed to set up your office and recordkeeping systems. Remember, though, that you are running the show.

Your blueprint is in table 4-1.

Don't fall into the trap of overpreparing: "One for the money, two for the show, three to get ready, four to get ready, five to get ready, etc." You are about to begin a long and adventurous journey. You must begin by taking that first step.

The photo-marketing enterprise you are about to embark on is going to take endurance. You are going to experience setbacks. You will no doubt encounter some trying times of reassessment. If your desire is strong, none of this will faze you. Welcome to a magnificent obsession with this profession!

# WEEKEND ONE: Set Up Shop.

Take action. Announce your plan to family, relatives, colleagues and friends. Enlist their help, but fly solo if they attempt to dissuade you from your plan.

Clear out a room, or partition off part of one, and set up a desk, chair, lamp, word processor or computer, filing cabinet and fax when possible. (Consult the yellow pages for used-furniture bargains.)
Tack a sign above your desk, "_____ Photo Illustrations."

Order your supplies:
>       Magnifying glass (loupe)
>       Personalized stationery
>       Mailing envelopes
>       Plastic sleeves
>       Labels
>       Slide view files
>       Rubber stamps
>       Business checks
>       Simplified bookkeeping system
>       Recordkeeping system
>       Subscriptions to business periodicals

# WEEKEND TWO: Zero In on Your PMS/A.

Determine your areas of strong marketing potential and the areas of poor marketing potential. Photo marketing is a *business*. Success comes when you eliminate the barriers and pitfalls that prevent you from succeeding (failure avoidance). Discover your personal photo-marketing strengths (who you are photographically).

Whether you have 500 or 5,000:
>       Catalog your slides (transparencies).
>       Catalog your prints (black and white and color).
>       Organize your computer disks.

Reread "First, Find Yourself" at the beginning of chapter three. Fine-tune your PMS/A (figure 3-2).

Reread chapter two, "What Pictures Sell and Re-Sell?"

*Table 4-1. The Four-Weekend Action Plan to help launch your photo-marketing enterprise.*

# WEEKEND THREE: Capture Your Corner of the Market.

Why compete with an army of photographers in the commercial stock-photography area when you can possess channels of knowledge and access to select areas that specific photobuyers are already looking for? Spend the weekend in your local library and compile your own Market List, a list of markets tailored to *your* photographic strengths. Take along the directories list in chapter three. Request photo guidelines from each of your markets.

Reread all of chapter three, "Finding Your Corner of the Market." Fine-tune your Market List (figure 3-3).

# WEEKEND FOUR: Roll the Presses!

All of your supplies are in. Set up a simple recordkeeping system (nothing elaborate) to note what you send out and to whom, and what sells. Validate your Market List. Confirm spellings. Make address corrections. Verify current contacts' names. Mail out your first submissions of photos.

Read chapter fourteen, "Working Smart."

Read chapter sixteen, "Your Stock-Photo Business: A Mini Tax Shelter."

From here on out, make it a habit to work in your new home office on a routine basis, for one hour or ten hours, whatever fits your work style, lifestyle and income projections.

Read your business and marketing periodicals, and expand your knowledge a little each day. Learn what others are doing; attend specialized workshops and seminars. Listen to business and marketing cassette tapes in your downtime (driving to and from work, in the darkroom, etc.). Incorporate elements of such information as they apply to you.

You are now on your way. Depending on the size of your stock file, you'll have many published pictures (and deposited checks) to your credit by the time you're ready to celebrate your first anniversary.

*Table 4-1. (cont.)*

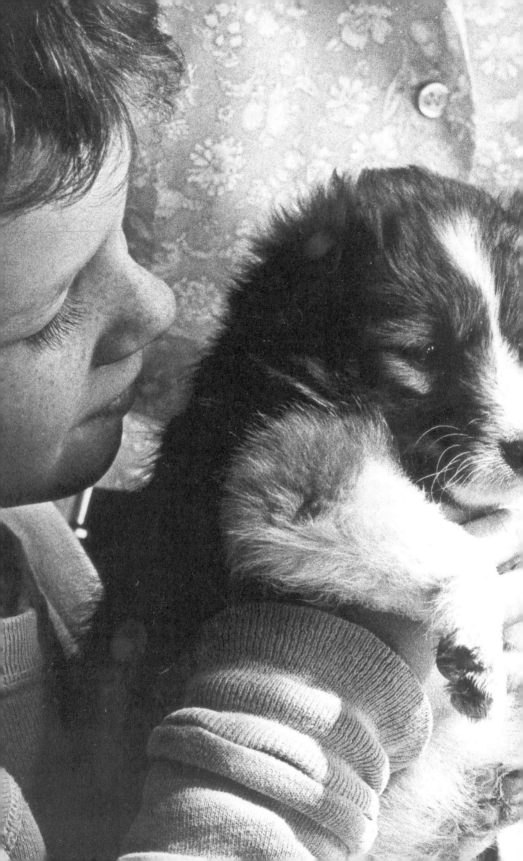

# Producing a Marketable Product

## Some Basic Questions Answered

Color or black and white: Which should I shoot? Your decision will be determined by your PMS/A (personal photographic marketing strength/areas) and your Market List. Use this test: Select a magazine from your Market List. What percentage of the editorial pictures are black and white? Color? Checking each of your markets or prospective markets in this manner will give you a realistic appraisal of whether you should be shooting black and white or color.

Many photographers prefer to shoot exclusively in color. Service photography market areas—ad agencies, graphic design studios, corporations, commercial assignments and stock-photo agencies—often require a heavy concentration on color. Right now, trends in the magazine and book industry also indicate an aggressive move toward more color. A good example is textbooks, which show a marked increase in the use of color over black and white in the last two decades.

Is it cheaper to shoot in black-and-white or color transparencies? At first glance, black and white would appear to be less expensive. But if you take into consideration your developing/printing time and costs, plus the cost of maintaining a black-and-white darkroom, color is actually less expensive.

Again, remember: Photo editors buy pictures because they *need* them, not because they *like* them. If you enjoy shooting color, shoot color; but if your markets require black and white, shoot black and white, too.

### What Film Should I Use?

"Film or digital?" is the question most asked by people just starting out in stock photography. Digital imagery has had a big impact on the world of photography. But digital has great limitations when it comes to the publishing world. Your photo editors (most of them) are going to prefer a film-based picture over a digital image. Why? Basically because of cost, speed and quality. Despite the hype about digital imagery, it does not presently meet the requirements of the publishing industry.

**Storage.** Once you have your picture, how do you store it? You can store film just about anywhere. For a digital picture, compression is the answer, but beyond 5:1, you lose quality. So at 5:1, you can't go past 0.0000001 cents per bit in price to match silver halides. Technological improvements might get the price up to 0.0001 cents per bit. That's still a thousand times more expensive than film storage. Depending on when you're reading this chapter, technology may still not have solved this problem of storage.

**Quality.** A frame of 24×26mm negative film costs about ten cents. It represents 20 million pixels. The same digital unit (picture) represents about 60 MB.

**Light sensitivity.** As a light-sensitive receiver, at 20 million pixels (100 ISO), silver halides is unbeatable. As a picture recorder, digital looks slow and cumbersome when you think about it.

**Speed.** With the current digital cameras, the frame advance is slow (approximately one exposure every three seconds). There are faster digital cameras, but the reproduction quality your photo editor will require is not there.

Digital photography has its place, of course. But this book is about editorial stock photography, and except for the Web or CD-ROMs, you'll find most of your activity with film, not digital photography.

## Color

The publishing industry is historically set up to accept transparencies, not color prints. However, desktop publishing, the Web, scanners and newspapers are putting a dent in this tradition, opening the door for a gradual shift to prints. For the time being, though, continue to plan on marketing color transparencies, not prints.

Both fast and slow color film will be valuable to you. For outdoor work, I use Kodachrome 25 film (daylight) ISO 25 and Kodak Lumiere Ektachrome 100P film (daylight) ISO 100.

Photographer James Innes likes Kodak's E100SW. "I'm impressed with its skin tones and ability to be pushed." He often increases it to 200 ISO, and reports the colors are saturated and the grain is very sharp. Other photographers agree. Eastman Kodak Ektachrome 100S ("Elite II") has a "cleaner yellow and white, and a brighter green."

Other equivalents are Fujichrome 100 (ASA 100) and the popular Kodachrome 200 film. The lower the ASA (or ISO), the better the photo editors like the results; the lower ISO speeds produce a tighter grained picture, which means the photo editor can blow it up larger and still get good definition. (Frequently, a photo buyer will use only a portion of a picture and enlarge it for the layout.) Kodachrome 25 film, for example, is reported to have a resolution of 200 lines per millimeter, and Kodachrome 64 a resolution of 100 lines per millimeter. The Fuji films, by the way, have earned a solid position among assignment and stock photographers. However, in some situations, such as tropical or horticultural scenes, the greens in Fuji film

are not as true as Kodak greens. Photo editors generally prefer Ektachrome and Fujichrome over Kodachrome—but check with your buyers. They are the real judges.

Color films for indoor use include Kodachrome 40 film 5070 (Type A) and Ektachrome 160T film (tungsten). These films are appropriate to use when you're inside under artificial light. If you're inside but able to shoot with available light from windows and doors, outdoor color film such as Ektachrome 200 and 400 (daylight) work just as well as indoor film. Other color films you might want to look into are Agfacolor's ULTRA 50 Pro and PRO Color Slide Film RSX 50, or Konica's Impressa Professional Color Print Film. Again, when you can manage it, it's handy to be able to use just one film for both outside and inside.

The preferred size for black-and-white prints is 8″ × 10″—for color, it's not so cut and dried. Both 35mm and 2¼ are welcomed by photo editors. For volume sales, such as inside editorial use, you'll find 35mm to be a consistent seller. In some cases, especially if you are a commercial stock photographer, 4″ × 5″ and even 8″ × 10″ will be useful, and sometimes required. For covers, chapter heads and commercial stock photos, your best bet is the larger format, mainly because when editors confront two transparencies of equally fine caliber, one a 35mm and the other a larger size, they usually choose the latter. One secret is to make 70mm reproduction-quality dupes of those slides you feel are eligible for covers, billboards, etc. Big is beautiful to the art director, and also to the business manager, who is often called in on decisions about big expenses. If a photobuyer is going to spend $750 for the use of a color transparency, plus the prepress costs, it seems logical to get the most for their money. Later we'll discuss the marketing advantages of duplicating and enlarging your best 35mm pictures to the larger 70mm and 4″ × 5″ format.

### Black and White

For black-and-white indoor shots, the faster films are best, of course. Ilford HP-5t, Fuji's NEOPAN 400 and 1600, and T-MAX 400 have proved popular with many photographers. For low-light situations, the films of choice are Fuji 1600 and Kodak's T-MAX P3200. The latter needs special processing. Fuji 1600 needs no special processing and is finer grained, but is one step slower. Most beginners using high-speed films tend to "overexpose" low-light situations. To remedy this, try exposing for the face of the person(s) you're photographing, rather than for the general area.

If you're shooting black and white outdoors, you'll want to investigate a slower film like Kodak's T-MAX 100, or its equivalent in other brands, such as the Ilford FP4 (125 ASA). Generally speaking, no outdoor situation is too difficult for the Kodak T-MAX film.

Unless you enjoy and can afford working with several cameras, it's handy to explore the versatility of a single film. It's convenient to work with one

film—no problems arise when you need to dash from inside a schoolroom to an outside playground in midroll, for example. You can develop a fine-tuned familiarity with the qualities of "your" film and what you can produce with it. With the advent of APS (Advance Photo System) films, the problems of changing lighting or subject matter are reduced. You need to change canisters only when you change venue.

## Black and White: What Makes a Marketable Print?

We are gazing at a black-and-white photograph at a salon. Texture and detail in the shadows come through superbly. The dark areas are black and rich; highlights sparkle with crisp whites. Between these poles flows a broad range of values that gives the print an almost three-dimensional quality. We are looking at the classic good print.

In photo illustration, not every print needs to have this full range of tonal gradation in order to be marketable. Your pictures have to be technically good to sell, but they don't have to be technically perfect. Buyers of photo illustrations are primarily concerned with content for communication. A photo illustration taken in the fog, for instance, can have no highlights, yet still be effective. Or a picture of students in animated discussion around a seminar table, which exhibits only middle tones, will nevertheless make a successful photo illustration.

To add to the mix, the same print can be treated in different ways in the darkroom and the results can achieve equal success as photo illustrations. I once showed three variations of one print to a group of seven photo editors. One version was contrasty, one dark and moody, one a classic good print. The editors couldn't agree which was the "best" print. The "rightness" of each printing approach depended on how the print would be used. Print quality is relative. David Vestal, photographer, lecturer and critic, says:

> Most good prints are craftsmanlike. They tend to give maximum information and show all the tones that the photographer chooses to show, clearly, richly and in an appropriate degree of contrast (dictated by feeling).
>
> Most good enlargements are in focus all over the paper, and are visually balanced, without unwanted inconsistencies. In poor prints, some areas usually "stick out" inappropriately or fail to be clear, or both, usually because the photographer has not paid enough attention to his picture or hasn't done the necessary work.
>
> In any mode, a good print is one where the photographer has seen accurately what the picture needs and has successfully used his craft to provide it. The technique can be simple, as with Edward Weston, or complicated, as with Jerry Uelsmann or Gene Smith. Either way, a good print normally reflects thorough craftsmanship, from shooting through fixing and washing.

## How Extensive Should Tonal Gradation Be?

No experts will commit themselves to a firm definition of a good print. But even considering the leeway involved, good prints do consistently exhibit the photographer's concern for tonal gradation. You will create a good print if you are able to extract the appropriate range of gradation values inherent in your negative, and select and match these with the mood and atmosphere you wish to convey in your photo illustration. In order to consciously eliminate some tones from a print to create the desired feeling in your picture, you must be aware of the range of gradation available to you in that print.

To say some prints come off well with portions of their full gradation missing does not invite you to settle for substandard or hurried printing results. Photo editors will recognize poor quality immediately. Only by taking time to see the precise potential offered in the tonal range of any particular print is it possible to develop creative control over tonal results. Educate yourself on different degrees of tonal completeness for technical excellence, yet remember that in photo illustration you can depart from textbook definitions of good print quality if the content of the picture says what you want it to say.

## Black and White: What Size Should I Print and What Paper Should I Use?

The standard black-and-white print size in the publishing industry is 8″ × 10″. This size fits conventional file drawers and is easy to handle. Here are some paper pointers, whether you do your own printing or farm it out and want to know what instructions to give the lab: Photo editors nowadays rarely ask for glossy prints, primarily because semigloss gives them a better idea of how the photograph will look when reproduced in their publication. In the old days, editors asked for prints with high shine ("Gimme a glossy!") because in the old days printers required a glossy surface for best reproduction. This is not the case today.

Semigloss paper is a good choice because it has a solid, professional look, and it takes spotting easily. You can also get a semigloss finish by using glossy paper and air-drying the prints in blotters rather than ferrotype-drying them. Because of their convenient air-drying feature, resin-coated (RC) papers are especially suitable for the editorial stock photographer who has neither the space nor the time for mass-producing pictures. Kodak offers a free fax-back help line for information on films, papers and chemicals, (800) 242-2424, Ext. 33, Choice 3.

## Should I Rely on Color-to-Black-and-White Conversion?

Some of your markets will require black-and-white prints. If you're strictly a color photographer, you'll find that, despite the profusion of color used

in the publishing industry, black and white is still used from 20 to 30 percent of the time.

"How about conversion?" you may ask. Many photo editors refuse to incur the cost of converting color to black and white (usually about $10 to $15 a picture). "If we do decide to convert to black and white," says one photobuyer, "we'll charge off the costs to the photographer." Other photo editors don't like to convert because it isn't reliable. "You never know what you're going to get. Black-and-white conversions are usually lacking in technical quality." The time factor is also important. Editors, working against a deadline, don't like to be at the mercy of a lab. The editor will choose the next-best picture, already in black and white.

One answer is to shoot both color and black and white on the scene, with two cameras. Another is to use Eastman 5247 color negative film, a negative 35mm movie-camera film from which both slides and black-and-white prints can be made; however, it has limitations, which I'll discuss later. Another answer is to convert color to black and white yourself. The results aren't guaranteed, but if your original picture exhibits reasonable definition, the results are often acceptable. Here are the three processes:

1. Make an 8″ × 10″ negative (black and white) of your slide, and then make 8″ × 10″ (black and white) contact prints.

2. Make a large-format internegative, then enlarge it to come up with the final print. This process can be markedly speeded up by the use of Polaroid positive/negative film. The Polaroid film holder (Model 405 or 545I) is placed on the enlarger baseboard, and the slide is projected directly onto the film. Exposure tests, of course, are necessary. The 405 holder uses type 665 pack film and gives a 3¼″ × 4¼″ negative; the 545I holder uses type 55 film and gives a 4″ × 5″ negative.

3. A third, even easier method, is to expose the slide in an enlarger like regular printing paper. Special processing produces a positive image in just one step—that is, no internegative. Print quality depends on both the quality of your original color transparency and your processing talents.

## Do It Yourself?

Now that we're in the Digital Era, some photobuyers will request scanned images from you. Depending on your PMS/A, you may want to invest some time in learning about scanning your images (digitizing them into pixels that can be manipulated, sharpened, color corrected and stored).

Many other photobuyers will say to you, "Just send me the picture; we'll scan them here." What they are saying is that, because there are so many levels of proficiency and so much variety in equipment when it comes down to transferring your film to pixels, they've found it effective to work with their own service bureau when it comes to scanning.

Of course, if you are a *commercial* stock photographer, you're more in a position to consider investing in a scanner such as Nikon's CoolScan and

doing the work yourself. This area is much like working in a darkroom. Some photographers don't want to trust their finished product to someone else. In the long run, if you are just starting out in *editorial* stock photography, farming your scanning out to a competent service bureau to do PhotoCD, PictureCD and other scanning is probably your best bet.

## How Do I Make Sure My Color Will Sell?

More than black and white, color requires extra technology, equipment and know-how to produce the right marketable picture. Three-fourths of all technical questions I receive as director of PhotoSource International pertain to color and how to avoid excessive expense in producing and marketing color photography. One of the first ways you can save is to ask yourself before every shot on your next photographic outing: "Is this marketable?" With each frame you expose, ask yourself, "Will this one be on a photobuyer's desk next week for consideration, and will it have a good chance because I've researched my photo editors and their specific needs?" If you find yourself shoulder to shoulder with dozens of other photographers on the bridge at Ellis Island, waiting for the right light on the Statue of Liberty at sundown, you can be reasonably sure you will get an excellent picture. You can also be reasonably sure the marketing potential of it will be zero. A dozen photographers waited on that bridge yesterday, and a dozen more will be there tomorrow.

Get in the habit of asking yourself, "Is it *marketable?*"

## The Most Commonly Asked Questions About Color

To figure your color marketing strategy, answer the following questions:

**What color film is most popular among photo editors?** When talking about film, technical quality looms as a more important consideration with color than with black and white. Photo editors draw up their technical requirements for color on the basis of recommendations set by their printers; printers are at the mercy of their particular printing equipment. If the equipment is sophisticated, they can sometimes excuse minor imperfections in a picture. If the equipment is mediocre, printers (and thus photo editors) depend heavily on a technically fine picture from you.

Basically, an outdoor picture should be taken on a low-ISO-rated film such as Fujichrome Velvia (professional) 50 or 100, or Kodachrome 25 or 64[1] film. An indoor shot is acceptable when shot on the higher rated ISO films such as Fujichrome Provia 100 and 400, Ektachrome 200 (daylight), Ektachrome 400 (daylight) and Ektachrome 160 (tungsten) film.

Since marketable editorial stock photography usually includes people, it's

---

[1]Some photo editors now favor Ektachrome and Fujichrome, which have more vibrant color than Kodachrome. Ask your photo editors which they and their printing services prefer. Skin tones in Velvia film will appear much redder than normal.

important to select a color film that works well for portraits. Many editorial stock photographers report that Provia (Fuji) works well. As with Kodak's E100SW, skin tones come out well.

There are exceptions to all rules, of course. Having said that, I'll say that photobuyers seem to prefer K-25 (Kodachrome) and Fujichrome Provia and Velvia for outdoor color, and Ektachrome 100 film for indoor shots. These three films are very reliable and predictable.

And why the low-ISO Fuji and Kodachrome films? As I mentioned earlier, an editor may wish to use only a part of your picture, or use all of it for a cover or a poster, and that would require magnification. If a higher ISO film is used, grain clumping might preclude using the picture. To get around the grain-clumping problem, a 5″×7″ internegative could be made, but often photo editors don't want to go through the extra time and expense. Another solution is to scan your picture (see chapter seventeen) and rearrange the pixels. Enhancing and manipulating pixels, however, is tantamount to retouching, which can be both time-consuming and expensive.

**Should I indicate which film I used?** Some editorial stock photographers indicate on their slide mounts the film and film speed that were used. This might be helpful in your learning process, but could be detrimental to sales if, for example, your color work is in the higher ASAs. Erase the information, or place your name and address label over it if it's in ink.

**Should I shoot vertical or horizontal format?** Photo editors continually lament that they do not have enough vertical shots to augment their layouts. "Printed matter is usually a vertical format," one editor told me. "Yet photographers persist in sending me horizontal pictures. I could use many more verticals than I get."

One photographer friend told me that when she was starting out she pasted a label on her camera that read, "Is it a vertical?"

**Do photo editors accept color prints?** At this printing of my book, very few photo editors, possibly 20 percent or less, accept color prints. When they do, they expect a quality 8″×10″ rather than the smaller "drugstore" prints. Do not send your color negatives. Keep them home, safe and on file. The industry as a whole would certainly fare better if color prints, rather than color transparencies, could be accepted across the board. However, the industry (except for major newspapers and some major printing houses) has invested millions in color-positive (transparency) processing and printing machinery, and they are not ready to make the transition yet. Little by little, what with new scanning processes, printing plants are beginning to convert to digital processes that will accept color prints.

But for now, although color negatives are more logical and convenient, and have a greater exposure latitude than transparencies, you're stuck with shooting transparencies. You must put up with the hazards of constant handling of your originals (your slides) by yourself and by photo editors.

**How can I get around the color print barrier?** If you have a lifelong history

of working only with color negatives, however, and are not willing to work with transparencies, read on. Some stock photographers have attempted to circumvent the color negative-vs.-transparency situation via these five methods:

1. Make your shots in color negative and enlarge to $8'' \times 10''$ color prints. Send the prints, or color photocopies of the prints, to several potential buyers on your Market List. Put a label or rubber stamp on the back explaining that a color transparency is available on request. If a photobuyer does request the transparency, send a rush order to your custom processing lab and have the lab either digitize the image or make a 70mm reproduction-quality transparency that you—or the lab, depending on the deadline—can forward to the photobuyer.

Incidentally, this type of duplicate (dupe) can be an *improved* version of your original. The 70mm transparency will prove to be of great advantage to you. The large 70mm size is impressive and sells more readily than the smaller 120 or 35mm. Even if your picture doesn't make the photobuyer's final cut, your 70mm transparency has especially good potential for scoring with other photo editors. And you know it's a marketable picture because one photobuyer has already considered using it.

Make full use of this marketing maxim: If one photobuyer wants a picture, other photo editors will want it too. Have duplicate or triplicate copies of your transparency made while it's at the lab. In multiples, the single cost is much less. Aggressively market your copies.

2. Make your photographs in color negative, select the most marketable and steamroll ahead with having reproduction-quality transparencies made from the selected negs. This approach could be costly unless you are confident in your ability to choose marketable pictures.

Kodacolor VR 200, Fujicolor Super G Plus 200 and Kodak VR film provide high resolution and fine grain. Also, Fujicolor Super G 400 and 800 and Kodacolor Vericolor III Professional 400 film provide excellent-quality images for indoor situations. For mixed-lighting situations, Fujicolor offers Reala, an ISO 100 color print film. Eastman Kodak will convert negs into display transparencies for about a dollar each, but the reproduction quality cannot be recommended in most cases. A custom lab will charge between $10 and $25 per transparency for better quality.

3. Eastman 5247 film is designed for use in the movie industry. It is a negative film that lends itself to 35mm camera use. Some photo illustrators may find it their film of choice. (See pages 93-94 for more details on it.)

4. Some photo editors on your Market List accept digital formats on disk, CD-ROM or online. Check you local yellow pages for a service bureau that will digitize your pictures for you. Formats include PhotoCD and Picture CD. Select your service bureau carefully. Like any photo lab, there are great variations in the quality of the finished product, depending upon the source. Some photo retail stores provide a kiosk for do-it-yourself digitizing. As with any

outsourcing, there's good quality and mediocre quality. Ask around your photography community for the optimum in digital services.

5. One other means: Kodak provides two printing processes for making transparency enlargements from color negatives. They're called Vericolor print film for enlargements and Vericolor slide film. Some editorial stock photographers use this method to make dupes of their images to leave on file with their favorite photo editors. Although the dupes are not of reproduction quality they are "good enuf" to show the impact of the available picture.

I don't want the above five suggestions to give you the impression that the color-neg system is the answer. In most cases it is not, for this reason: Photo editors want a picture now. Any extra steps, such as waiting for a service bureau to digitize your photo or for a transparency to be made, will often make the difference between a sale and no sale.

For the technically oriented photographer, here are two desktop references: *Techniques of Natural Light Photography* by Jim Zuckerman and *Permanence and Care of Color Photographs* by Henry Wilhelm and Carol Brower. (See bibliography.)

**Should I make duplicates of my slides?** Newcomers to the field of photo marketing have a well-founded hesitation about sending their original transparencies to some unknown entity. A seemingly popular answer is to make duplicates (dupes) of your originals. Before I launch into the pros and cons, here is the most convenient way to make dupes: Make them in-camera during the original shooting of your subject matter.

Since you know what pictures will sell to your Market List, you aren't gambling away film dollars by making several extra exposures of an especially marketable scene or situation.

Of course, depending on the scene or situation, your "originals" won't be exactly the same. Some you may want to discard. Those that remain will share equally strong marketing potential. With several "originals," you won't worry about losing, misplacing or damaging the original.

But what if you have only one original? I wish that I could say an inexpensive, quick and high-quality method of duplication is available to you. There is none—not for reproduction purposes.

Let me explain: The photobuyer is midway between you and the printer (the pressman, platemaker, etcher, etc.), who demands the best-quality image in order to satisfy the publishers', advertisers' and subscribers' tastes, not to mention his own. The printer has a bag of tricks that can perform some limited miracles, but, in the end, there is no substitute for a good original image.

This then rules out everything you've heard about making your own dupes or having them made professionally by a duping company at a dollar apiece. These products are duplicates, yes, but usually not dupes a quality printer can accept for reproduction.

But all is not lost. Reproduction dupes can be made, and the cost is usually

comparable to a lunch at a fast-food restaurant, five to seven dollars.

Here's how the pros make their dupes. Select an original that has the potential for wide sales. Contact a reputable color lab and have your original made into a 70mm transparency. In many cases, your original can actually be improved by adjusting the color balance in the dupe. Slides that are too dark, but with adequate shadow and highlight detail, may be lightened, either for a more pleasing effect or to bring their density into line with other slides in your presentation.

Overexposed slides may be darkened. Composition can be corrected or emphasis can be given to just a portion of the slide by cropping and copying a certain area. Color rendition can be changed by means of filters, for either correction or creative deviation from the normal.

The price quoted above is for a reproduction-quality dupe. At about half this fee, you can get a lesser quality, display-grade dupe.

Incidentally, many stock-photo agencies (see chapter twelve) will make 4″ × 5″ reproduction-quality dupes of your 35mms. The reason? The improvement in color balance, plus the added size, improves sales. These agencies often have sales reps here and abroad who carry these dupes with them in their display cases. They sell the dupes directly from the case as originals, which they now are.

To learn more about dupes, check out the free (three-page) report entitled "Increasing Stock Photo Sales With Duplicate Transparencies" on Royce Bair's website, http://www.xmission.com/~tssphoto/dupes.html. Incidentally, to find us, PhotoSource International, on the Web, just type in our name at any search engine, or type in "Rohn Engh."

One quality color lab is Creative Color, 4911 W. Grace Street, Tampa, FL 33607, (813) 289-4385, owned by Burton McNeely. In addition to producing reproduction-quality 4″ × 5″ transparencies from your 120 or 35mm originals, his firm also offers a full-time digital lab service.

Another lab that has often been recommended to our subscribers by photographer/writer Carl Purcell is Repro-Images, owned by Jeff Whatley, 243 Church St. NW, Suite 110B, Vienna, VA 22180, (703) 938-2604. Another lab, located on the West Coast and highly recommended by photographer Chuck O'Rourke, is The Darkroom, owned by Dave Gilpin, 9227 Reseda Blvd., Northridge, CA 91324, (818) 885-1153. Another that comes highly recommended is A&I Color (ZZYZX Corp.), 949 N. Highland Ave., Los Angeles, CA 90038, (800) 995-1025. Others are as follows:

**Baboo Color Labs**, 37 W. Twentieth St., New York, NY 10011
**K & K Color Lab**, 8302 SE Thirteenth Ave., Portland, OR 97202
**Photocraft**, 3550 Arapahoe Ave., Boulder, CO 80303
**Pro Color, Film Division**, 909 Hennepin Ave. S., Minneapolis, MN 55403
**Prolab**, 10325 Jefferson Blvd., Culver City, CA 90232
**REPLICHROME**, 89 Fifth Ave., #903, New York, NY 10003

A few stock-photo agencies and a few publishers will invite you to send 35mm display, or "file," dupes to be held on file as display. When the agency requires the original, they contact you for it. Display (file) dupes are inexpensive, usually under a dollar. The following processing companies produce quality display dupes:

**Atkinson/Stedco,** 7610 Melrose Ave., Los Angeles, CA 90046

**Color Film Corporation of America,** East Coast Lab, 777 Washington Blvd., Stamford, CT 06901

**World in Color,** P.O. Box 392, 39 Caledonia Ave., Scottsville, NY 14546-0170

A final option, of course, is to make dupes on your own—not only duplicates, but restorations of existing slides, color changes, sandwiches and experimental pictures. Type 5071 or Type K/8071 Ektachrome slide-duplicating film are the usual choices, along with a duplicator such as the Bowens Illumitran Model 3-C, which includes a special contrast control unit.

Unusual duplication techniques will come and go, but the duplication technique of choice will probably remain: The making of on-the-spot duplicates by shooting extra pictures as backups.

**Can I submit display prints of my transparencies?** Yes. If you are computerized, you can import recent photos into your cover letter to a buyer. Or you can download samples of your photos into a "sell sheet" and run them off on your color printer.

A second method, mentioned earlier, is to make color photocopies of your slides. Twenty 35mm or twelve 120-size can fit on a standard $8\frac{1}{2}'' \times 11''$ sheet. The image quality is passable. Instant-print shops, banks and libraries often feature this service. Consult the yellow pages for Canon Laser Copier or Xerox Centers in your area.

A final method is to make copies of your slides using the Vivitar Slide Printer ($99–$175, depending on where you buy it) in $3\frac{1}{4}'' \times 4\frac{1}{4}''$ format and fax them to your photobuyer. The Vivitar printer is distributed by Polaroid, (800) 225-1618.

The advantages of submitting color display prints or dupes of your slides to a photobuyer are as follows:

1. You can circulate more copies of your slide to more photo editors simultaneously.
2. Your originals remain safe in your file until a photobuyer orders.
3. You can try new markets without fear of losing valuable originals.
4. You save extra postal costs of shipping original transparencies.
5. You can, in effect, establish a catalog of your pictures with certain buyers on your Market List.

6. Your reliability factor (see chapter seven) goes up a few notches because you look more professional.

Of course, all these fine advantages go flying out the window when the photobuyer says, "I can't hold up production. I thought we had the *original* here. We'll have to use this other picture instead, because we have it right here."

## Is 5247 Film Useful for the Editorial Stock Photographer?

Eastman's 5247 is Kodak's standard movie film. It's an improved version of the earlier 5254 film, which didn't have the fine grain or wider latitude of the new film. Photographers have discovered that the 5247 film (it's a negative rather than a positive) can offer slides, color prints and black-and-white prints—all from the same negatives.

Here are some advantages for the stock photographer:

1. The film is available at 200 or 400 ASA. It can be shot indoors or outdoors at ASA 100: The corrections are made in the processing lab.

2. The film can be pushed to ASA 400 easily.

3. The color quality is comparable to Ektachrome. (As a movie film, it must be projected to movie-screen size.)

4. Several "originals" of each picture can be made and circulated simultaneously to photo editors. The photo editor never loses an original slide, unless the original negative is damaged.

5. You can use it to shoot black-and-white and color in the same shooting situation with only one camera. (No need to convert a color shot to black and white.) This film could prove to be very useful to the editorial stock photographer who shoots mostly indoors and where a 100 to 400 ASA range is practical.

6. You can make color contact prints of your available slides for the photobuyer's file.

7. Processing labs for this film are plentiful, and the processing system is safe, since it's basically designed to service the 35mm film industry, which can't afford processing mishaps in valuable film sequences.

8. It's cheap. If you shoot regular color print film and do not cut the strip, the processor can print the entire roll to slide for about six dollars.

9. If you supply photos to the newspaper or online industries that accept color prints, you'll find 5247 film an advantage.

10. Digital pictures are available through Seattle FilmWorks (listed on next page), (800) 445-3348.

The disadvantages of 5247 film are few, but major:

1. Because it does not have the tightness of grain of the lower rated ASA films such as K-25, photo editors will not accept its use in situations where K-25 could have been employed.

2. It is not standard. Photo editors tend to be suspicious of any films that are not standard. So do photographers.

3. Look to the future. If you expand your photo-marketing business, you may wish your images were shot on a more standard film when photo editors come around.

4. A final critique from a darkroom pro, Bob Meier, of Photo Marketing Labs: "The 5247 film for book or magazine reproduction? It gives, at best, mediocre black and whites and awful slides."

Following are labs that can process Eastman 5247 film:

Dale Laboratories, 2960 Simms St., P.O. Box 900, Hollywood, FL 33020, (954) 925-0103

Red Tag Photo, 1006 Wilshire Blvd., Santa Monica, CA 90401, (310) 260-9824

RGB Color Lab, 816 N. Highland Ave., Dept. 18, P.O. Box 38903, Hollywood, CA 90038, (213) 469-1959

Seattle FilmWorks, P.O. Box 34056, Seattle, WA 98124-9771, (800) 445-3348

Recommended black-and-white printing labs for stock photography are:

The Darkroom, Attn: Dave Gilpin, 9227 Reseda Blvd., Northridge, CA 91324, (818) 885-1153

Robert DeVaul Photography, RR 5, Box 1116, Suite 12, Forest, VA 24551, (804) 385-4530

GMR Custom Photographic Lab, 700 Cass, #106E, Monterey, CA 93940, (408) 373-8021

Various online forums sponsored by the film manufacturers listed in this chapter can be found on the Internet and their websites. At a search engine on the Web, type in the company name and select the product you'd like to know more about. Also, Kodak provides the "Kodak Viewfinder Forum" for serious amateurs interested in learning more about photography. To receive information and a sample newsletter, call (800) 395-7016 or (800) 242-2424. Finally, check out our website by typing "PhotoSource International" at any search engine such as AltaVista or Lycos.

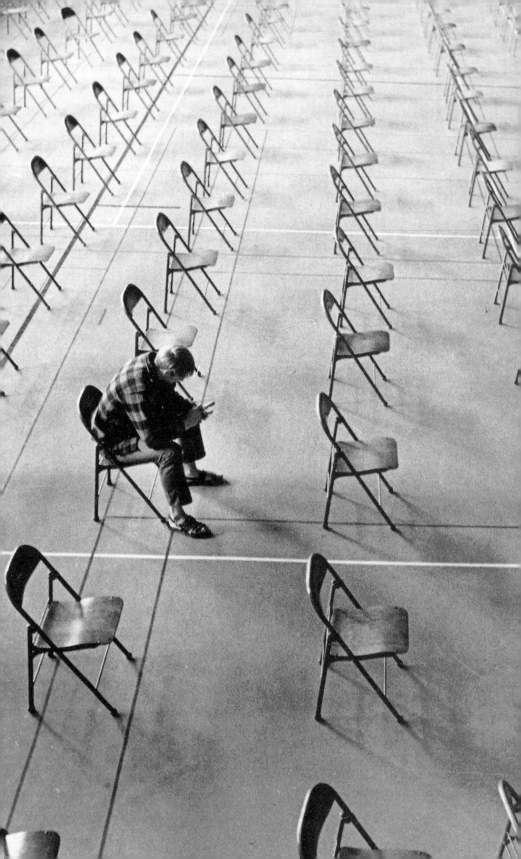

# Taking and Making Photo Illustrations

## Do You Take or Make Them?

Throughout this book, when I refer to photo illustrations, I am referring to the Track B stock photo—the marketable picture.

For almost a century, a history of the photo illustration has been recorded in magazines and books, yet no marketing book has been writen on the subject of Track B stock-photo illustrations. The photo illustration as we know it today has evolved from a documentary snapshot to a subtle and sophisticated art form. This evolution can be traced in magazines that have existed for one hundred years, such as *National Geographic*. Following the progression in bound *Geographic* volumes at the library can be entertaining as well as informative.

As we learn in zoology class, ontogeny recapitulates phylogeny (the stages in the development of the individual mirror those of the species). A photographer entering the field undergoes the same sort of progression. He begins by taking simplistic photographs, similar to the early photo illustrations, gradually incorporates new ideas and technical knowledge that enable him to produce better and more interesting pictures until, if he endures, he eventually turns out fine photo illustrations. This evolution is a valuable learning experience for the photographer, but it can be accelerated. Here's how.

Many photographers are conditioned to take photographs that reflect the world, somewhat as a mirror does. A documentary photographer *takes* a picture: He simply records things the way they were at that moment.

But to limit photography to mirrorlike documentation is to circumscribe knowledge and understanding.

Photo illustration, on the other hand, opens up a vast new field of interpretive endeavor. The fact that photo illustrations are in large measure workaday pictures doesn't preclude innovative and creative treatment of them. Photo illustration allows a photographer to *make* photographs. The photo illustrator creates a situation as it could be, or as it should be, or distills the essence of a scene or event. As we all know, painters rarely paint their landscapes true to nature. To limit their illustrations to exact duplications

of nature would be to confine their creativity and their viewers' enjoyment. They rearrange the elements in their paintings to achieve a composition of wholeness and meaning that did not exist earlier, just as jazz musicians improvise on the melody and rhythm of a familiar tune not because they wish to seem clever or self-consciously different, but because they wish to discover, for themselves and their listeners, new meaning in the music. Photographs, like other expressive media, can offer fresh insights and deeper understanding. A photograph can become a telescope/microscope for the viewer to see into and beyond what is being photographed.

All of this, of course, does not apply to photojournalism or documentary photography. It would be dishonest to alter or shape a news photograph to misrepresent a scene or subject.

The line between photo illustration and photojournalism, however, can sometimes be thin. W. Eugene Smith, one of the all-time greats, was once criticized for moving the bed away from the wall for better camera angle in some of his photographs of a midwife for a *Life* magazine story.

Photo illustrators often confront ethical questions when it comes to such improvisation. For example, if you photograph a teenager whose blemishes are here today but gone tomorrow, do you leave them in the picture or retouch them out? Which is the truer interpretation? Are the blemishes inappropriate if you are illustrating the winners in a student government activity or a science fair? Should they remain if you are illustrating nutritional deficiencies or youth gangs? Or should the blemishes remain no matter what the context?

The answers are ultimately left to you, the photo illustrator. It might appear to photography purists that allowing free rein to interpretive photography could lead to a lack of respect for the truth. However, before the arrival of the photograph and the photographer, pictorial illustrations came in the form of etchings, cartoons, drawings and paintings. We accepted the artists' interpretations and managed to survive.

In photo-illustration work, then, you are frequently and legitimately making a picture, not taking it. For example, you see something happen, you feel it was significant and you would like to photograph it. You have two alternatives:

1. You can hope it happens again in your lifetime, or
2. While you are still on the scene, you can attempt to re-create it, "improving" on it (stripping it of distracting elements) as you do your P = B + P + S + I principle.

In photo illustration, you can also create scenes that never happened, but could happen. On an assignment to photograph a child's visit to a toy factory, for example, I realized my little model wasn't at all intrigued by the assembly-line production. The bits and pieces didn't look like toys yet; the

pounding and banging of the machinery was hurting his ears; the paint smell was disagreeable. Yet I needed to illustrate a small boy's excitement at seeing toys being manufactured. In desperation, I wadded a piece of bubble gum (when working with kids, always have a supply of goodies handy) and stuck it on one of the panels of a toy truck as it moved toward the next assembly stage. I stood on a ladder above the moving belt and asked my model to point out the bubble gum as it came into view. He did so with enthusiasm, and I snapped a picture of a delighted youngster pointing at a toy truck on an assembly line. In illustrations, it is true, you may bring elements together that never happened. You are, in effect, contriving. But you can keep your illustrations authentic by selecting situations that could happen, and then reenacting them in a way that appears unposed.

## Danger Ahead: Trite Pictures

There's a trap waiting for the photographer who is new to photo illustration. Although I continually remind you in this book that workaday pictures are the most marketable, that kind of subject matter can fall into the trite category—if you let it. Corny pictures are easy to produce. Beware of the temptation to take pictures that are trite, old hat, cute or clichéd.

"There's nothing new!" you're probably saying.

Stop. Think about the pictures in your portfolio, print notebook or recent slide show. If you were to eliminate (1) dramatic silhouettes, (2) sunset scenes, (3) postcard scenes of mountains and clouds, (4) portraits of old men, (5) the father lovingly holding his daughter, and (6) experimental abstract shots, how many pictures would you have left?

I don't want to imply that the above subjects are always trite. We have all seen these subjects treated with compassion, depth and a sense of beauty. Many of them can qualify as standard excellent pictures. However, the more photographs we see of these familiar subjects, the less charity we have available for them in our appreciation bank.

The tendency to take trite pictures is almost a disease among photographers—even veterans. Because we see trite pictures every day in local, regional and national publications, we become conditioned to the status quo. Photographers find an easy way to take a school portrait or a commercial or architectural shot, or a standard stock photograph, and gradually lock themselves into an effortless routine that stifles creativity.

Photography, especially photo illustration, has become a vibrant communication vehicle in our daily lives. The public expects not only to be entertained, but also to be informed by photos; it doesn't take well to stock photographs that, like old news or old jokes, are mere repeats. People want new insights and angles, and thought-provoking interpretations of everyday subjects.

## An Example

Let's say a publisher has assigned you to produce a photo essay on "The Circus." Take a scratch pad and jot down ten picture situations that come to mind. Don't read further until you've jotted down at least ten. . . .

That was easy, wasn't it?

Well, if it was, I'll bet you've listed ten trite picture ideas. Producing untrite pictures takes a lot of thought.

Before you rush out and snap away five rolls of 35mm film on a subject that every man, woman and child is familiar with, take at least a half hour to sketch out some picture possibilities. This brief exercise will save you hours of location and darkroom time spent on pictures that would probably be rejected by a publisher. It will also eliminate those blinders we often inadvertently wear when we arrive at a picture-taking locale and become immersed in the scope and immediacy of the situation. Objectivity is easier to retain if you have a preplanned sketch of what you want to photograph before you get there. By the same token, don't go overboard and lock yourself into a plan that has no room for spontaneity and innovation sparked by on-the-scene elements. Always be ready to discover and adjust to new picture possibilities.

Let's take our circus example. These shots are not new to us: the clown in his dressing room; the elephant's trunk appearing through the window of the circus moving van; the tightrope walker silhouetted by spotlight against the tent's ceiling; the roustabouts taking a well-earned coffee break; the trainer at work with his chimpanzees; the cleanup crew the day after. We've all seen these pictures over and over again. Maybe the documentary photographer can be satisfied with such pictures, but not the photo illustrator or the photobuyer who strives to provide fresh insights, even on such familiar subjects as the circus.

What do we want to see in your essay on the circus? The answer will take thought, timing and preparation on your part. Imagination, luck and persistence will be important, too. You've got to zig when other photographers are zagging. You've got to anticipate. But most important, you've got to show us the circus as we never imagined it could be. (Caution: Please don't interpret this as license to go out and shoot obscure, experimental, weird-angle pictures in an effort to be different. That would be equally trite.)

What nontrite pictures, then, will you shoot at the circus? For starters, let's see an extreme close-up of one of the acrobats straining at push-ups, showing the effort and dedication it takes behind the scenes to produce a quality performance come showtime. How about a mother with toddler in arms happily holding a cotton candy cone up to a clown? Or an overweight father lifting his three-year-old up to touch the bar of the trapeze? How about a backstage shot of a roustabout pumping air into the tire of the goofy mobile while the chimpanzee driver waits nearby? As a photo illustrator,

you must remember that readers of publications are people, and that people love to watch and learn about other people. You will record how spectators at the circus relate to the performers (with admiration?); to the animals (with amazement, fear or pity?); to the atmosphere generated by the circus (with awe?); to each other (with friendship?). You will include symbols of the circus in your pictures—a trapeze, a cage, a tent—but you'll keep these low-key, to serve only as incidental elements to establish the circus atmosphere.

In most cases, you will want to apply the principle of making a picture rather than taking one. You can reenact or improve picture possibilities by asking the cooperation of spectators or performers. To a clown: "Would you mind taking a bite of that cotton candy again?" To a teenager: "Could I ask you to do that again—over here by the zebras?"

To see a refreshing photographic insight into the circus, look up the January 1986 issue of *American Photographer* at your library, and turn to the feature by Susan Felter on pages 58–65.

Photography is visual, and you can escape the plague of triteness by constantly visualizing picture-taking possibilities. Most successful photographers use this secret, so why not try it out yourself? In free moments, even days before you actually perform your assignment (circus, annual report, political convention, etc.), visualize the hundreds of picture-taking possibilities that will probably come up. Eliminate the trite, the corny and the too cute. Concentrate on innovative possibilities that are practical and realistic. (This process will save you on-the-scene time, too.) If you visualize, you'll arrive at your assignment well prepared. Most important, you will have worked all of the tempting trite pictures out of your system, and you'll be able to concentrate on a fresh approach to your subject matter.

Are trite pictures salable? Like trite paintings, songs and handicrafts, they are. There are also directories and catalogs devoted to displaying trite stock photos, and books devoted to making trite photographs. But not this one. If, after reading this admonition against trite pictures, you find some culprits in your stock-photo file, send them off to a stock-photo agency (see chapter twelve). Veteran photographers are familiar with stock agencies' need to provide standard trites to their (mostly commercial) clientele. One photographer friend says, "I market my best pictures myself, and I dump my clichés on my agency, which can use all I can send." While agency cliché sales do come in, for any one photographer the checks are "every now and then." You don't want to depend on them to pay the rent.

## How Do I Manage the Models?

Marketable photo illustrations are very often pictures of people doing things. How well the people in your picture perform can determine the success of your illustrations. The commercial service photographer usually has the convenience of working with professional models. In contrast, in photo illustration most of your models will be regular folks rather than

professionals, and it's up to you to make sure they feel comfortable and cooperative.

You will encounter many of your models spontaneously in the course of your routine shooting. For the most part, children, teenagers and adults will willingly cooperate with you for the fun or novelty of being photographed or being involved in the action. People are often intrigued that their picture might be published.

Before you begin photographing your on-the-spot models, let them know who you are and why you want to photograph them. And take the time to make them feel at ease.

Often their first question will be, "What's this photograph going to be used for?" Give your models a direct answer: "For a book. If this photo is selected for publication, you'll appear in a school textbook." Or "For a magazine [name]." Or "For my photograph files. I'm a stock photographer and have a library of pictures that I sell to magazines and books." Give some examples of where the picture might be used.

## Control the Conversation

If it seems appropriate, explain the mood you are trying to capture in your pictures. Control the conversation throughout the whole picture-taking session to trigger naturally the kind of expressions you're aiming for. Don't let the conversation slip into a subject that is contrary to the mood you are trying to create. For example, if your picture calls for a happy, gay mood, steer the conversation away from war, taxes, the storm or fire that took so many lives last week or the twenty-car pileup on the freeway this morning. However, if your picture calls for somberness, guide the conversation to something difficult or puzzling (not necessarily sad—serious expressions can be interpreted as sad).

## Relax Your Models

Sometimes, to elicit the right kind of expressions from a nonprofessional model, you'll need to go a few steps further and become an actor—occasionally to the point of giving an award-winning performance as a clown, demagogue or saint.

After a while, you'll find that, in working with people for your pictures, you've developed a technique of gentle persuasion. You become adept at moving the conversation along the lines you want it to go.

Be as selective as the situation allows in your choice of models. Don't choose the model because she is a neighbor, relative or friend. You'll make your task easier if you choose a model whose natural style or demeanor comes close to the expression you're aiming for—a serious thinker for sadness or weary expressions, a clear-eyed, upbeat individual for happy shots and so on.

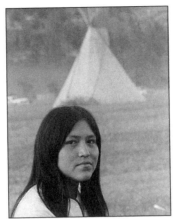

*Illustration 6-1.*

Here are some tips on how this works in practice:

**Happiness.** Don't ask for a smile. Instead, maneuver the conversation to some magic questions that always get smiles:

SENIORS: "Do you have any grandchildren?"

ADULTS: "How's your golf [bowling, tennis] game?" Or "Been on a vacation lately?"

TEENAGERS: Teenagers won't usually allow themselves to be categorized. I've found it best to learn the teenager's interests first (sports, music, movies, etc.), and then ask questions in those areas. Don't attempt to speak in their vernacular. They'll only become more suspicious of you.

PRETEENS: "Who's your boy- [or girl-] friend?"

SMALL CHILDREN: "What's your dog's [cat's, horse's] name?"

BABIES: If you make strange noises, you'll usually be rewarded with a smile (from everyone!).

**Sorrow.** Some people (Abraham Lincoln, for example) look sad naturally. You can induce a sad-looking expression by asking a model to look tired. Another method is to catch him "between expressions," which can appear pensive and sad looking.

**Intimacy.** Shoot from a three-quarter view with a long lens. This will bring two people closer. Ask your models to look at each other's eyebrows. Unless they are pros, models who do not know each other will feel self-conscious, and your resulting pictures will look stilted. For your intimate pictures, choose models who know each other.

**Overcoming shyness.** Use a long lens when your model is shy about being photographed. Teenagers are often self-conscious when asked to be

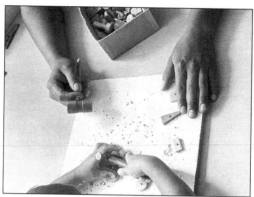

*Illustration 6-2.*

photographed. If you need a single shot, ask the shy teen to be photographed with a friend. Then use a telephoto lens to capture a single portrait of the person. In illustration 6-1, the long lens also brought the teepee (symbol— see chapter two) closer. "Don't take my picture!" shy people will often say. To accomplish your mission, try taking a picture of what they are doing, as in illustration 6-2.

Children are good models and can be diverted in ways that will enhance picture content. They tend to participate more fully than teenagers or adults. A good technique is to get your kid models involved in guessing games with you (the type of games we offer our children on long, boring car rides). Kids become animated when they like what they are doing.

Pictures of people sell. Photo editors know that we're human; that nothing touches us more than a picture of someone feeling something we identify with—be it anger, humor, pensiveness, bewilderment or delight. Thus, when you aim your camera at your models with photo illustration in mind, you've got to adjust your thinking from the cosmetic approach usually employed when taking pictures of people. Your customer is not the portrait client or the bride or Aunt Harriet, but a photobuyer. Photo editors are not interested in how pretty or handsome you have made your subject appear, but in what emotion, what spontaneity, what insight into the human condition you have captured.

## Should You Pay Your Models?

If you are shooting on speculation for inventory for your stock-photo file, many of your on-the-spot models will be satisfied with a copy of the published picture (tearsheet) if and when it is published. Other nonprofessional models are willing to cooperate just for fun or for the experience, especially if you are a beginner yourself. Still others are happy to have copies of the photographs. Give them your card, and have them write to you for the

pictures. If you do promise photographs, and they contact you for them, follow through. You'll find, though, that the majority of people don't get around to writing for the pictures.

Monetary payment is in order for nonprofessional models when you're shooting a commercial assignment as a service photographer. A good rule of thumb is to budget a minimum of 5 percent and a maximum of 10 percent of the fee you are receiving for the picture to pay your model(s). Seal the transaction with a signed model release.

## Other Model Sources

A good source of models is your local community theater. Amateur actors always need portraits for their portfolios. You can trade them some portrait shots for their posing (in natural settings, of course) for your people-picture needs (e.g., people talking, engaged in some activity, expressing fear, sadness, loneliness, joy, etc.).

Check also with local families and neighbors in need of family portraits. I will often sketch out photo-illustration ideas (using my principle $P = B + P + S + I$—see chapter two) and have the members of the family act out the photo-illustration situations. In return for their modeling services (about an hour's work), I supply them with a family portrait.

## What About Model Releases?

Are model releases required for the pictures you take, whether as a service photographer or as a photo illustrator? This question has several answers, depending on the situation.

If you anticipate that certain pictures might be used for commercial purposes (advertisement, endorsement), build a model release file. Print up a $3'' \times 5''$ model release pad, then file the releases alphabetically in a file-card box. The model release form (shown in figure 15-2) can be reduced easily to $3'' \times 5''$ size. Make one pad for adults and one pad for minors.

Generally speaking, photos used for book and magazine illustration or in newspapers, as opposed to advertising, endorsement or similar commercial purposes, do not need a model release. However, if the situation permits, obtain the release. Then if an opportunity arises later on for the photos to be used for a commercial purpose, you will have the release available and not miss a sale.

If you don't want the intrusion or the administration of releases for each photo, a general rule many stock photographers (and some service photographers) follow is to use photogenic neighbors, friends and relatives as models. Then if a model release is needed for a particular photo later on, they know where to find their models to obtain it.

Occasionally I get a model release request for a picture I took a decade ago. I consult my model file-card box and usually find that I received a blanket model release for an entire family when I originally took the picture.

To obtain a blanket release, I had both parents fill out and sign the release and asked them to list their (minor) children.

And what if I don't have a release? Because the model was usually a neighbor, friend or relative, I can often track him down for the release.

In the early stages of my stock-photography career, I obtained model releases on every occasion. I have since turned this completely around and now almost never get one. Experience has shown me that this administrative disruption of the mood or atmosphere of my picture-taking session isn't necessary. Model releases are not required when a picture is used for educational or informational purposes. Since my personal Market List consists of magazine and book publishers, I rarely get a release request from an editor. However, since your PMS/A and Market List are different from mine, you will know how extensive you'll want your model release system to be. (See chapter fifteen for a full discussion of using model releases.)

## Dealing With Officials

The scene: An important high school football game, and you've arrived to get pictures of the kickoff for an assignment and for your stock file. You'll leave as soon as you get the kickoff pictures, so you see no reason to pay admission. You enter by a side gate and are met by an attendant with an officious "Where do you think you're going?" expression.

You're not going to let this fellow steal your precious minutes, so you try to ignore him. You walk right past him. "Wait a minute!" he says, insulted that you have not recognized his importance. He has the right to detain you, and he does—long enough for you to miss the kickoff shots.

Sound familiar? It will, unless you keep in mind this photo illustrator's motto: "Officials: Handle With Care."

As stock photographers, we frequently can't get our pictures without first having to get permission from someone. Security is getting tighter in many sectors, and it's understandable because past abuses—or the sheer numbers of people—have made it necessary to screen who takes pictures of what. You'll encounter officials in many forms: gatekeepers, receptionists, police, bureaucrats, teachers, secretaries and security guards. You'll even encounter unofficial officials: janitors, ticket takers and relatives of officials. But no matter who presents himself as an official barrier to your picture taking, handle the person with care, allowing for the amount of time you sense will satisfy his need to detain you. For example, a gatekeeper with sparse traffic might have the luxury of detaining you longer than one who is dealing with hordes.

One of the easiest official-eliminators is the "I need your help" routine. In the case of the football gate attendant, you say, "I need your help. I'd like to get a dramatic picture of the kickoff [look at your watch]—could you tell me the quickest way to the fifty-yard line?"

If an official wants to know something about you—why you're here, what

the pictures will be used for—here's the answer: "I represent the John Doe Stock Photo Agency, and I'm John Doe. These pictures go into my files of over five thousand stock photos. They're used in magazines, textbooks, calendars, anything that would be in the public interest—you name it! [Smile.]"

Try to cultivate officials who could have access to information relevant to your assignment: Ask questions such as "When will he be back?", "How many players are on this team?" and "What time does the gate close?"

When you encounter an official who isn't cooperative, try offering a copy of the picture you're going to take. But don't take his name on a piece of paper; such papers either get lost or add to your office work. Instead, offer him your card and say, "Here's my address. Write me in about two weeks. The picture will be processed by then." (Experience predicts you have a one-in-a-thousand chance of hearing from him.)

Should you carry a press card? For large, important events, written permission from headquarters is your best introduction to on-site officials (headquarters usually issues its own press cards, stickers and/or passes). But for the 999 other events you'll attend, officials don't ask for a press card. If you're carrying two or more cameras around your neck (even if they're borrowed from a friend), that's official enough for them.

If you've found officials to be a constant thorn in your side, try the handle-with-care approach. However, there's an exception: If you stand to lose too much time by acquiescing to an official's demands ("Wait over there"; "Fill out this form"; "Stand in line"; "I'll put you on hold"; "I have to check with my boss first"), then take a different tack: Try a different official. In the case of the football gate attendant, if he is uncooperative, walk away and find another gate. In the case of an uncooperative receptionist, wait until she goes on a coffee break or to lunch. The replacement might be more agreeable (or you might think of a better approach).

In cases in which no officials appear, don't go out of your way to find someone to ask permission from. That someone may have no authority (a waiter in a restaurant, an attendant at a conference); he'll only pass the buck, detain you and cause delays. Rather than take no pictures (because you didn't have permission), jump in and start clicking. An official will usually come forward. Before he gives you his routine, give him your "I need your help" routine.

Officials can delay or even prevent you from getting your picture. When all else fails, remember this: "It's sometimes easier to apologize for jumping in and getting the photos than to get permission."

However, you owe it to yourself and the rest of us in the field to carry out your projects in a professional way and in a manner that will earn the respect of the public, keeping courtesy a priority.

## Special Effects

Some photo illustrations can be converted into new illustrations through the use of digital manipulation, posterization, special effects and line conversion with your film-based pictures. Of course, if you're working with digital pictures, software such as Adobe Photoshop or Adobe Illustrator is popular.

Photo editors use special-effect photography if it follows basic photo-illustration criteria and conforms to the needs of the book or magazine.

I got my special-effects aids from Edmund Scientific Co., 101 E. Gloucester Pike, Barrington, NJ 08007. You can find ads for special-effects aids in most photography and computer magazines, plus descriptions of techniques to employ to get various effects.

The following magazines and books, devoted to the film and digital darkroom, often include articles on special effects:

*ADOBE Magazine.* Adobe Systems, 411 First Ave. S., Seattle, WA 98104-2871.

*The Basic Darkroom Book: A Complete Guide to Processing and Printing Color and Black-and-White Photographs,* by Michelle and Tom Grimm. New American Library, 1633 Broadway, New York, NY 10019.

*Creating Special Effects.* Amphoto Books, 1515 Broadway, New York, NY 10036, (212) 536-5124. Guides the amateur through darkroom special effects. Also includes an advanced section on computer manipulation.

*Darkroom Dynamics,* by Jim Stone. Photo District News Books, 1515 Broadway, 11th Floor, New York, NY 10036. Practical guide shows techniques and processes to achieve more creative images.

*Darkroom Techniques.* Preston Publications, 6600 W. Touhy Ave., Niles, IL 60714.

*INTERNET WORLD.* 20 Ketchum St., Westport, CT 06880.

*Painting the Day Away.* Desktop Publishers Journal, 462 Boston St., Topsfield, MA 01983-1232.

*PC Graphics & Video.* 201 E. Sandpointe Ave., Suite 600, Santa Ana, CA 92707.

*Photo Electronic Imaging.* 57 Forsyth St. NW, Suite 1600, Atlanta, GA 30303.

*The Photographer's Digital Studio,* by Joe Farace. Peachpit Press, 2414 Sixth St., Berkeley, CA 94710.

*PUBLISH* (Product Watch). 501 Second St., San Francisco, CA 94107.

*WEBMASTER.* 492 Old Connecticut Path, Framingham, MA 01701-9208.

*WINDOWS Magazine.* 600 Community Dr., Manhasset, NY 11030.

## The Dramatic-Lighting Formula

As a photo illustrator gearing your pictures to the good marketable shots we've been describing, you may from time to time wish to treat a subject

*Illustration 6-3.* A portrait can be converted to line art by using a special-effects screen.

*Illustration 6-4.* For special effects, the highlights were dropped out and the dark grays became solid black to create a high-contrast print.

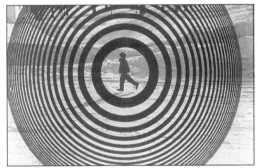

*Illustration 6-5.* A photo-copy machine can often produce interesting effects.

*Illustration 6-6.* For this result, I placed an 8″ × 10″ special-effect "bull's-eye" negative and glass over the print paper. The same effect can be accomplished using software such as Adobe Photoshop.

with unusual emphasis. The following formula comes in handy when you want to employ dramatic lighting with a subject, and it will enable you to produce top professional results every time. I call it the Dramatic-Lighting Formula. To check out the formula yourself, take a spot meter to illustrations 6-7, 6-8 and 6-9. Measure these three areas in each one:

1. The main light falling on the face (M)
2. The shadow side of the face (S)
3. The background (B)

You achieve the most dramatic effect when the shadow side of the face is 2¾ stops lower than the lighted side of the face, and the background is ¾ of a stop lower than the lighted side of the face. You see that in the actual photographs these gradations of light show marked contrast. On the scene, however, at the time you take the picture, there is not a corresponding marked contrast visible to the naked eye. What appears to the eye as very slight gradations of contrast will be definite contrasts in your print. With the aid of a spot meter, you can train yourself to perceive real-life light differences that are very subtle but that produce high-contrast results in your photographs. To achieve gradations in the face of your subject, use more or less fill light. To get the proper background ratio, move your background closer or farther away from your subject, or use a darker or lighter background area.

Here, then, is the formula:

$$P = M + S + B$$
when $S = M - 2¾$   and   $B = M - ¾$

P  = Portrait                 S  = Shadow side of face
M = Main light area of face   B  = Background

Measure the light ratios in portraits you've taken in which you were aiming for a highly dramatic effect. Chances are you'll find that the light ratio of M to B and S is much higher than in the above formula, resulting in an overdose of contrast, a loss of detail and an actual weakening of dramatic effect. Once again, you don't need to create lighting that gives high-contrast effects to the naked eye in order to get the kind of dramatic lighting you see in the illustrations. Quite subtle light gradations will give you dramatic contrast on your print, without losing the detail that gives life and breath to your picture.

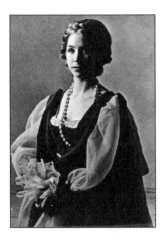

*Illustration 6-7. The formula is most effective when you position your model so that the eye in the shadow side will pick up a glimmer of light. If it does, the light falling on the high areas on the shadow side, such as the cheek, will give your photograph a dramatic dimension.*

*Illustration 6-8. The dramatic-lighting formula can be used easily in a "window-light" situation. In this case, a window blind behind my model served as a plain background.*

*Illustration 6-9. The dramatic-lighting formula is effective for portraits. The lighting may not always be flattering to your model, though it will be impressive to photobuyers, who are always interested in stock photography that catches readers' attention.*

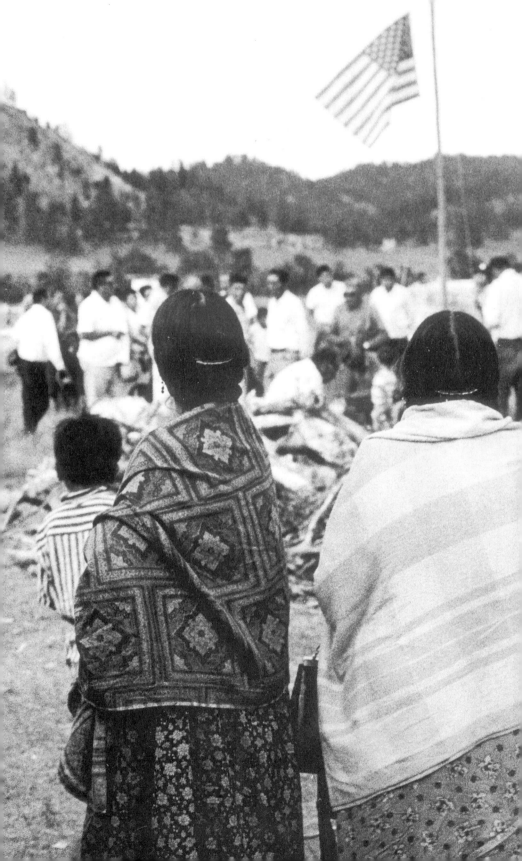

# The Fine Art of Dealing With Photobuyers

## Getting to Know Them

Thousands of photobuyers exist in market areas ranging from the commercial (advertising, public relations firms, corporations, etc.) to the editorial (books, magazines and publishing houses). In this book, when I refer to *photobuyers*, I will be referring almost exclusively to those (mainly editorial) photobuyers who deal with the stock photographer and not those (mainly commercial) photobuyers who deal with the service photographer.

Art director, picture editor, designer, photo acquisition director and photo editor are just a few of the titles bestowed on photobuyers at publishing houses and magazines. In this book, I refer most often to *photo editors*. They usually work out of an office, are between twenty-five and forty-five years old, and approve between $1,000 and $10,000 a month in photo purchases; probably half are female, and all are busy people.

You'll find that photobuyers are interested in photographs, not photography. You'll find, too, that setting up business with a photo editor is quite easy. Just a handshake—in a letter, over the phone or in person. No contracts or lengthy legal documents that you might encounter in commercial stock photography.

Photo editors tend to mellow with age. Younger editors, new to the job, sometimes exercise their newfound decision-making power by exhibiting impatience or intolerance. Handle them with care.

Veteran photo editors have usually survived the rigors of the publishing world with enough aplomb to be able to take the time to admire a photograph now and then. They've also honed their viewing skills to the point where they can speedily select the picture they need out of a large pile, as if by magic. Which brings to mind: Always send a picture buyer more pictures than you believe to be adequate, provided the pictures are appropriate. You'll often be surprised at the pictures the editor chooses. Don't edit your selection (except to delete off-target pictures): Let the editor do the editing.

---

**THE CUSTOMER IS ALWAYS RIGHT**

Would you buy an umbrella from a street vendor on a dry day in Houston? Or a Popsicle from a salesperson in Alaska in February?

Know your customers' needs. The best way: Let your customer educate *you*. Your clients are barometers and will let you know what they need, if you let them. Examine their periodicals, and occasionally survey your clients by phone. Request their *photo guidelines*.

If you find you are creating first and then trying to find a market for your stock photography, that's a recipe for disaster.

Reverse this process. Find markets who use photos in areas that are in your strong interest focus. Take photos with those markets in mind. Your photos will match their needs, and you'll establish lifelong clients who will keep coming back to you.

---

A visit to an editor's office will bring home to you my adage about picture editors buying pictures they need, not pictures they like. The walls of an editor's office are plastered with lovely Track A pictures: prints clipped from calendars or signed originals from friends. Track B pictures, the kind the editor authorizes a check to you for, are rarely on the wall. What editors need and what they like are different. Marketing is understanding that difference.

Your pictures may have won contests or received awards, but the real judge of a marketable picture is the photobuyer who signs the checks.

## The Reliability Factor

One paradox in the story of creativity in the commercial world is that those who succeed are not necessarily the most talented. In all creative fields—theater, music, art, dance—talented people abound. But the world of commerce is a machine, and a machine operates well only if all parts are moving smoothly together.

The people who sign the checks will readily admit that talent does not head the list when it comes to selecting a new person for a part, an assignment or a position. History has taught them that "the show must go on," that *reliable* people make commercial productions a reality. Someone with passable talent who is dependable may be selected before the genius.

Thus, an unwritten law in the world of commercial creativity is the reliability factor. How well would you stack up if a photobuyer were to ask, "Are you available when I want to contact you? Are you honest? Prompt? Fair? Dependable? Neat? Accurate? Courteous? Experienced? Sharp? Savory? Articulate? Talented?"

I placed talented at the bottom of the list because that's where most photobuyers will place it. They assume you are talented. Their basic question is "Can you deliver the goods when I need them?"

Because you are talented in photography, you purchased this book. You

know your work can easily compete with the pictures you've seen published. But talent will not be your key to success in marketing pictures. You will succeed in direct proportion to the attention you pay to developing and strengthening your reliability factor.

There are exceptions to everything, of course. Even with a low reliability factor, some creative people succeed. (Witness the temperamental screen idol or the eccentric painter.) But usually they are coasting on previously established fame, or they exhibit a unique ability. As a newcomer to the field of photo marketing, your greatest asset will be your ability to establish a solid reliability factor with the markets (photo editors) you begin to deal with.

## The Photobuyer Connection

You will connect with photobuyers in person, by phone, by fax, by e-mail and in writing, relying primarily on the latter. As an editorial stock photographer who conducts business via the mailbox, it's important to express yourself well in your communications with photobuyers.

From the vantage point of my ongoing overview of photographer/photobuyer relations at PhotoSource International, I have noted that if a breakdown occurs, it's usually because the photographer didn't express himself clearly, whether in writing, in person or by phone.

Many photobuyers reached their picture-editor post after serving as text editors—and many continue to do both. They're often journalism or English majors initially attracted to editing and writing because of their communication skills.

In your dealings with photobuyers, if you experience a misunderstanding or mix-up in regard to purchase, payment, assignment or whatever, here's how to handle it:

1. Give the photobuyer the benefit of the doubt. Despite the harangues we hear from some of our fellow photographers, rarely will you encounter an intentional hustle on the part of a photobuyer. If you are in a dispute with a photobuyer and you are positive the fault is his, rest assured it was probably an honest mistake. We're all allowed some of those.

2. Be firm, but not offensive. Consider the buyer's self-esteem, too.

3. If you are emotionally upset over a transaction between yourself and a photobuyer, wait a day (twenty-four hours) before you react.

4. Photobuyers are continually up against deadlines and will be short with you. Some will offer you a fuse to ignite: Don't be tempted. For a one-page report, write to me for "How to Turn a Recalcitrant Photobuyer Into a Kitten." Send an SASE.

Remember this: The photobuyer is probably dealing with you because he considers your work valuable, even essential. Don't let a harsh word or irresponsible statement slip out and get in the way of future opportunities to publish your work (and cash checks).

The newcomer to the field of photo marketing is often amazed, and sometimes insulted, by the casual approach many photobuyers take in their handling of photographers and the photographers' work. To a photographer, a photograph can be like a child, an extension of the soul, a piece of poetry or music. Photobuyers don't have the same reverence for your work that you do; they can't. You may consider your photograph a work of art; to them it's another piece of work to process. This is not to say they don't admire talent or good photography. They do—most of them. But to survive in their field, they have to learn to separate their emotional appreciation from their career demands.

If you take the same approach with your stock photography—that is, separate and compartmentalize your photography into marketable pictures that will feed your family, and not-so-marketable pictures that feed your soul—you will be able to suffer the jolts and inconveniences of photobuyers without feeling they are callous or insensitive. They usually aren't. They're just doing a job, and usually doing it well.

## Should You Visit a Photobuyer?

If you tailor your marketing plan correctly, your specialized markets will be scattered throughout the nation, even the world. Unlike the service photographer who can work effectively with commercial accounts within the confines of a single city, the editorial stock photographer deals with far-flung buyers—mostly through the mail (see chapter nine).

I myself have dealt with some photobuyers for a decade and have never met them. My reliability factor continues to score high with them. A personal visit would serve only to satisfy our mutual curiosity.

Yet while personal visits are not always necessary, they can be a real plus. Personal visits, if conducted smoothly, always help seal a relationship. If my itinerary and schedule permit, I drop in on photo editors when I can to say a personal hello. People do respond more actively to a face than to a letterhead. If you are trying to develop a new market, a personal visit to a key buyer could be your turning point. Or a personal visit might help solidify your relationship with an editor you've already been dealing with successfully. But you will not necessarily find photobuyers eager to set up an appointment with you, especially if they don't know you. Talent is plentiful. Besides, they have deadlines coming up tomorrow. If they need photographers, they'll consult their photographer files. They know that personal visits take time and aren't often immediately fruitful. Their needs are too specific for a general introductory visit to solve.

Don't make an appointment unless (1) you have sold a picture to the photobuyer in the past or (2) you have something of value to give the editor, such as information or photos targeted to what you have learned is a current need for him. Photobuyers are understaffed and underpaid. They'll have little reason to welcome an "I'm me and I have photos" visit from you. You'll

end up creating a reaction opposite to what you're after and get put on that buyer's blacklist. If you can make your visit worthwhile to the photobuyer, however, you'll be greeted warmly and your time will be well spent.

Realistically, a visit to a photobuyer can be extremely costly for you. In effect you are making a sales call, and in the corporate world, a salesman's call costs just about the price of the suit he is wearing. As of this writing, the average cost of a sales visit is $357. If you live close to some markets, those visits need not cost that much. But for your far-flung markets, the cost could be much more.

By working smart, you can cut such costs by diverting funds that would be spent for personal visits toward contacting buyers by mail instead. Since photobuyers buy pictures not because they like them but because they need them, your tailored selection of twenty-five to a hundred prints mailed to a buyer will serve the same purpose as a personal visit with your portfolio. Also, your selection will receive more attention from the photobuyer. Remember that, as an editorial stock photographer, your separate photobuyers will not require you to be versatile; therefore, a portfolio that demonstrates your wide range of photographic abilities will not be necessary.

## Should You Write?

"By mail" is by far the most effective way to contact and deal with photo editors. Chapter nine shows you how to write the standard cover letter (figure 9-1) and how to graduate to the "magic" query letter (figure 9-2) that captures a buyer's interest every time. You'll also learn that looking like a

---

### KEEP YOUR NAME ALIVE

Marketing wisdom says that it costs five times as much to pull in a new customer as it does to keep a current customer. Build your client base slowly and cost-effectively. Target your promotional efforts only to those photobuyers whose picture needs match your PMS/A (photo marketing strength/areas).

Once you have added new clients to your base of buyers, treat them like the treasure that they are. Many of these buyers (or the publishing houses they represent) can be lifelong sources of revenue for you.

Along with the usual courtesies of remembering them with a note during the holiday season, send them periodic news items, such as reprints of your work currently appearing in the national press. This assures them that they are working with a supplier other photobuyers value, and they'll want to stay on the bandwagon. Promotional material featuring your latest work, whether a postcard mailing or a twenty-four-page color catalog, seems to always pay for itself.

A good rule to remember: You are past history once you have published with a photobuyer. He needs to be continually reminded you are still alive.

pro is a key to the success of any correspondence you have with a photo editor.

Letter writing is probably the least expensive method of contacting photo editors. Nevertheless, the corporate world tells us that letter writing is not cheap: Each business letter costs about the price of breakfast at a restaurant. As of this writing, the cost is $8.75. The stock photographer's letter can be much less expensive, as I'll show in chapter nine. Because you have narrowed your list to a select group of markets, you'll find you'll need only about a dozen basic letters.

By using the mail to contact photobuyers, you'll have the opportunity to include self-promotional literature ("sell sheets") that will serve as an effective reminder to your clients that you exist and that you can produce what the photo editor needs.

How about e-mail? Maybe in the next generation e-mail will fulfill its promise. From this generation of photo editors, you can expect sparse e-mail correspondence. Why? Although e-mail works fine for interoffice or long-distance corporate communication, photo editors find themselves outside the loop when it comes to electronic talk. Their expertise is more visually oriented. You can expect to find a photo editor surfing the World Wide Web to research a photographic subject, but rarely just to chat. In fact, if you broadcast e-mail (or fax) messages indiscriminately to your Market List, your messages begin to be perceived as "junk mail." Put your dollar into traditional promotional techniques for effectiveness.

Your letter, with its unique self-promotion piece, photo example or two and cordial hello, can provide a pleasant interlude for the photo editor, with a succinctness that a personal visit cannot match. A few such letters over the period of a year will create and sustain a good working rapport between you and the photo editor.

Is dealing through the mail effective? Take a look at Sears, L.L. Bean and thousands of other mail-order houses. Granted, we call 90 percent of the solicitations that arrive in the mail *junk* mail. But the other 10 percent—a sale on Fuji film at a camera supply house, a free software offer or an antique camera catalog—hits our interest areas, captures our attention and makes us want to buy.

Editorial photobuyers purchase nearly 100 percent of their pictures through the mail. They expect mailed solicitations. Part of your mail-marketing operation will be to establish a regular, daily letter-writing routine. Depending on the size of your Market List, you will want to write one or more buyers on your list each day. Your letters should remind them of your continuing knowledge and interest (expertise!) in their readership area; update them on your trip plans or assignments pertinent to their subject needs; and include a photocopy of a recently published picture of yours. If your Market List is lengthy, a few months will pass before you come around again full circle to the first name on it. When you do, redesign your letter and

your enclosures, and begin again. This might seem like an endless routine to you, like the continual repainting of the Brooklyn Bridge, but this system will reward you over and over. If you have built an effective Market List, your mail program will be effective.

Should you send postcards? Sure! There's nothing to open. And a recent example of your work reminds the photobuyer of your expertise. Layne Kennedy of Minneapolis sends a postcard every quarter. The reverse side features one of his (brilliant) photo illustrations. He says, "The mailing always pays for itself." Postcard companies that are used to dealing with stock photographers are MWM Dexter and Mitchell Graphics.

## Should You Telephone?

The telephone has evolved from a luxury to an important marketing tool—a tool that must be used skillfully to be effective. The key to successful phoning is understanding the principle of give-and-take. Most photographers, when they call, make the mistake of expecting only to take. They take advantage of the photobuyer's courtesy by asking endless questions that could be answered through basic library research. (See the reference and directory list in table 3-1 and the bibliography.) They also take the photobuyer's valuable time. They come away with answers to their own questions, and leave the photobuyer with nothing.

Multiply such a call by ten times a day, five days a week, and you'll understand why a photobuyer is not interested in talking to photographers. Persistence is a virtue, but it has a reverse effect for stock photographers who persist in phoning editors indiscriminately.

*Here's the secret:* Before you make your call, study the buyer's needs backward and forward, then make up a *give* list. Decide what you will give the photobuyer.

How do his needs match your PMS/A, your personal photographic marketing strength/areas? You won't be wasting his time when you can say

I'm a bass fisherman, and I have some excellent pictures of Florida, which I understand you'll be covering in your magazine next August. (Newsletters in the field, such as *Travelwriter Marketletter* and *PartyLine* [see the directories], will carry this kind of advance information.)

I regularly vacation in Maine, and I'd be available for assignment when you need to update your files of New England pictures.

I notice you have continuing need for classroom pictures. My neighbor is a teacher. With a few guidelines from you, I could get the kind of pictures you want.

Once you establish rapport with photobuyers by showing that you can offer them something, they won't mind giving you the information you'd like. They'll also welcome your calls in the future, because they know your calls will save them time. Because you have narrowed your photographic interests to your Track B strong areas, you can approach any of the photobuyers on your list with confidence.

Telephoning can be inexpensive when you prepare by doing your marketing homework to zero in on the editor's needs. Often you can limit your conversation to five minutes. The editor will appreciate this; so will your bank balance.

Because you will be dealing with photobuyers who are in time zones different from your own, phone them before 8:00 A.M. or after 5:00 P.M. your time, when possible, for savings.

Not every photographer has mastered the art of telephoning. Some are afflicted with *phonephobia*. Practice your telephone techniques with a friend or a tape recorder. Professional telephone-marketing people tell us to write out our proposed message (script it), and then refine it with rehearsals. Make your first call to a photobuyer for whom you have a strong give list. The conversation will go easily if you are doing all the giving.

As you become more adept at telephoning, contact more photo editors on your list. Your give list might not be equally strong for each buyer, but as long as you figure out something to offer, what you pick up in your conversation might lead to picture ideas or subject matter that you can turn into a strong "give" the next time you call that same buyer. As you progress in your telephone-marketing program, make a record of your calls on your computer database, $3'' \times 5''$ file cards, a Rolodex or in a notebook, and measure their efficacy. It may take as many as five or six calls before you score. Eliminate from your telephone list those photobuyers who aren't productive for you. As you become more experienced in telephoning, you'll learn how to pick up leads in your conversations that will direct you to future picture-selling opportunities. You'll find it easier and easier to give to your photobuyers as you become more and more familiar with their exact needs.

If you are a making a trip abroad to areas that you know interest a certain selection of photo editors on your database, fax a form letter out to them. They may not go so far as to offer you an assignment, but they might file the information in their database for when they have need for pictures in that particular geographic area in the future.

And as usual, ask the photobuyer to disseminate your fax or package to others in the office who might find your itinerary of interest.

## Get on the Available-Photographers List

Your Track B list probably features several strong areas of special interest, ranging from gardening to sailing. You have contacted a number of potential photobuyers in each of these areas, all of whom would like to know more

# YOUR LETTERHEAD

Dear Photo Editor:

Kindly include my name and my work on your photographers list. I have checked off several areas below that I have strong coverage in and where I could be of photographic service to you.

**FORMAT AVAILABLE:**
☐ 8 × 10 black and white
☐ 35mm color
☐ 2¼ color
☐ 4 × 5 color
☐ Other _____

Reproduction fee for one-time inside-editorial North American print rights. Other rights (e.g., electronic rights) are available upon request.
B&W _____
Color _____

Holding fee past 2 weeks:
☐ I charge none
☐ My fee is: Color _____
                         B&W _____

**SOCIAL**
☐ Health
☐ Welfare
☐ Drug abuse
☐ Alcoholism
☐ Violence
☐ Sex education
☐ Rights movements
☐ Emergency
☐ Role reversals
☐ Juvenile delinquency
☐ Other _____

**PEOPLE**
☐ Preschool
☐ Elementary
☐ Junior high
☐ Senior high
☐ College
☐ Adult
☐ Families
☐ Senior citizens
☐ Multiracial groups
☐ Blacks
☐ Native Americans
☐ Chicanos
☐ Orientals
☐ Middle Easterners
☐ European-American
☐ Other ethnic groups ____
_____

☐ Customs
☐ Holidays _____
☐ _____
**SPORTS**
☐ Basketball
☐ Football
☐ Baseball
☐ Track
☐ Other _____
_____
_____
_____
**NATURE**
☐ Animals
☐ Scenic
☐ Seasons
☐ _____
_____
_____
**RELIGIOUS**
☐ Congregational worship
☐ Communion, Baptism, Bar
    Mitzvah
☐ Adult education
☐ Missionaries
☐ Church school,
    age levels _____
☐ Family worship
☐ Religious holidays
☐ _____

**INDUSTRIAL/TECHNICAL**
☐ Food
☐ Agriculture
☐ Industry
☐ Government
☐ Labor
☐ Manufacturing
☐ Mining
☐ Transportation
☐ Communications
☐ Fisheries
☐ Tourism
☐ Entertainment
☐ Medical
☐ _____

**EDUCATION**
☐ Adult education
☐ Primary
☐ Elementary
☐ High school
☐ College
☐ Vocational
☐ Other _____
_____

**OTHER**
☐ City life
☐ Rural life
☐ Environment/ecology
☐ Occupations
☐ _____

**TRAVEL**
I have current pictures (within the last three years) of the following COUNTRIES:
I have current pictures (within the last three years) of the following STATES:
[Your Name]

*Figure 7-1. A sample marketing categories form letter. Tailor this form to the photo editor you are contacting. If you are a "specialist," you'll find the photo buyer will take an interest in you. "Generalists" who have not mastered at least one of the categories above are of little interest to the buyer. Don't be tempted to check off dozens of categories.*

about you because your photographic interests match their needs. They each maintain an available-photographers list in the office. If your reliability factor looks high, you could be on several dozen photobuyers' lists. Here's how you get on a list.

Make a *categories* form letter similar to the one in figure 7-1, and send it off to photobuyers in your target market areas. Don't give in to the tendency to print up only the few categories that match your Track B chart. List them all, but check off only the ones that apply to your PMS/A and the editor's needs. This may be only five or six check marks. Photo editors will gravitate to their own immediate spheres of interest, and when they find those specific areas checked off, they'll take notice of you. Since you checked few other areas, they'll know you aren't dissipating your photographic talents over territory that is of little concern to them, and concomitantly that you must have a lot of material in the areas you concentrate on, e.g., what they specialize in. This is one of the reasons I suggest you curb your picture taking in Track A areas and accelerate your Track B areas (chapter three). This form letter is another way of saying to photobuyers, "I'm the person for the job." The photobuyer will respond, "This photographer speaks my language."

The categories letter is appealing to photobuyers because it doesn't call for any action on their part. They can just file it for future needs. And it is concise and to the point.

Photobuyers will do one of four things when they receive your letter:

1. Throw it away.
2. File it to have on hand for reference.
3. Phone you because of an immediate need.
4. Put you on their available-photographers list.

*Note:* To repeat, resist the urge to appear versatile by checking off several categories. Photobuyers prefer dealing with specialists in their areas. If you do check off plenty of squares, they'll say, "No one is *that* good!" and choose the photographers who appear to have large stock files in their areas of interest instead.

The available-photographers list in the photo editor's office can take many forms—3" × 5" file cards, a three-ring notebook, separate files or a computerized database. Photo editors will add notes to your file, such as what they perceive to be your strong areas within their categories of interest. They may also add notes concerning conversations with you, assignments, a running list of your pictures they have used to date or pictures they have chosen to include in their central art file for possible future use.

Once you are on the buyer's available-photographers list, you will periodically be sent a needs sheet, which delineates the current photo needs of that publishing house or magazine. Send your pictures in for consideration

## MOTIVATION TO CHANGE

Motivation to change is the bottom line when it comes to convincing photobuyers they should change to digital technology. Although compact discs are clearly a powerful and logical tool that schools can utilize to teach more effectively (interaction of text, visuals and sound), school districts and educational publishers are lagging behind in the hardware to accept optical discs (CDs, DVDs, etc.).

"The problem isn't only that many school districts are still operating with Apple IIe's, but many discs are inoperable with some CD-ROM drives," says Townsend Dickinson of MacMillan/McGraw-Hill (NY). "We will make the changeover to digital when we are motivated to. Right now, it's just a special situation when we produce a digital product."

How does this translate for stock photographers who supply the textbook industry? Suggestion: Continue to invest in film-based equipment. Although there is much hype about CD-ROM in schools, major publishers nationwide continue to produce print materials 95 percent of the time. If a digital product comes up, most often the publisher will still ask for transparency submissions, and then digitize those photos that make the cut.

whenever you receive a needs sheet. Since the sheet describes the exact photos needed, you'll find yourself saving postage and making points by not sending inappropriate pictures for consideration. The photobuyer will welcome your pictures because they are tailored to the publication's needs.

Since the publishing industry is forever in a state of change, mail your categories form letter to each entry on your Market List once a year. Why? Because some things might change: (1) your priorities, (2) the photobuyer's priorities, (3) your address, (4) your stationery, (5) the photo editor's address, (6) the photo editor.

Whether or not any changes have occurred, this letter is a good reminder to the photo editor. New competition appears on the scene every day. Your letter will keep you and your work in the front of the photo editor's mind.

## Selling the Same Picture Over and Over Again

"Multiple submission" is the phrase often used when photographers submit the same photographs to different publishers at the same time. Unethical? Not at all. The reason? Your Track B pictures will be submitted to specialized markets targeted to different segments of the reading (viewing) public. There is no cross-readership conflict, especially if your markets are regional or local. In other words, the readers of magazine X never read magazine Y or Z. Feed those statistics into the ten thousand photo-buying markets that exist, and you can see why an editor is not too concerned if your photo has already appeared, or will appear, in magazine X.

### Sell and Re-Sell Your Photos

What's the appeal of multiple submissions to photobuyers? Savings. Most editors don't have the budget to demand more than one-time rights. They know they can get a picture much cheaper if they rent (lease) the picture from a photographer on a one-time basis.

And the multiple-sales system is healthy for you, the stock photographer. It will encourage you to research more picture-taking possibilities, as well as to produce more photographs.

Multiple submission, of course, does not always apply to major national publications, such as *People* or *Ladies' Home Journal,* who would prefer that you sell them *first rights* to your picture. Nor does it apply to commercial stock-photographer accounts where you have signed a work-for-hire agreement in which you transfer all your picture rights to your client. (This is a procedure I do not recommend to the editorial stock photographer—more about this subject in chapter fifteen.)

But you'll find you can use the multiple-submission system with 95 percent of the photo editors you deal with. The exceptions will be, as mentioned, large-circulation newsstand magazines, most calendar and greeting card companies, ad agencies, PR agencies (service photographer areas) and other commercial firms that require, because of their nature, an exclusive right to, or sometimes ownership of, your photograph. (Unless a photobuyer offers you a fee you can't refuse, don't sell anything but one-time rights.) The picture on the cover of this book and on page 146 has earned me nearly $5,500. If I had sold all rights originally for $500, I would be out nearly $5,000! But I didn't, and the cash register keeps ringing. I'll also be able to pass the rights to the photo on to my heirs.

## Photocopying Your Photographs

A great boon to stock photographers has been the practice, on the part of photobuyers, of photocopying certain pictures (black and white or transparencies) when you send them in for consideration. The advantages:

1. Although photobuyers may not be able to immediately use a picture you have submitted, they might anticipate its future use. A photocopy in their central art file will serve as your calling card. When the need arises for your picture, the photobuyer contacts you for the original.

2. Some buyers might hold copies of twenty to thirty of your photos in their central art libraries (see next section). Often as many as ten to forty other photo editors at the publishing house can have the opportunity to view the pictures.

3. Since your original is returned to you, it can be sent elsewhere. Conceivably, photocopies of the same picture can be working for you in a couple dozen central art libraries at the same time.

4. You incur no costs.

## SHOULD I LET THEM SCAN MY IMAGES?

A photobuyer calls, "We like the photos you sent us and have scanned two dozen of them into our database."

"You what?" is your response.

The photobuyer responds, "You have a lot of pictures that we feel we could use in the future. We're building an in-house reference file. Any problems with that?"

Consider it a compliment. Scanning of photos by a photobuyer needn't be a threatening experience. Twenty years ago, when only large corporations had photocopy machines, copying a photo for their files initially seemed like copyright infringement to stock photographers. Gradually we saw we were getting sales from the photocopy reference photos on file with photobuyers.

The same is happening with scanning. The photobuyer scans photos to obtain low-resolution "thumbnail" images to put into their reference "view-only" database. A software program cross-references them.

In the future, scanning your selections will be commonplace. No need to fear thievery any more than you do at present. And, particularly if you are working within the confines of a photo-buying community where you know your buyers and they know you, it would be odd to hear of larceny.

Scanning comes in all forms, and most scanned thumbnails are useless for anything more than a reference print, "comps" or a postage-stamp-size image. To scan to produce a full-blown high-resolution "reproducible" image takes too much disk space. Most photobuyers are going to be confined to disk space that gives them room for just a few high-resolution photos at a time.

A graver problem regarding digital images is that it's possible to easily pass them on to others (swapping). If a photobuyer goes out of business or photobuyers begin trading images, yours, or parts of yours, could be involved in the action.

Again, however, if you are working as a specialist and deal with repeat buyers, you will know your buyers and they will know you. Encourage potential repeat buyers to scan your photos.

And the disadvantages? Unauthorized use of your photocopies for rough layouts might occur. Copyright infringement? There isn't any. The photobuyers are using your picture for the purpose of research [Sections 113(c) and 107 of the Copyright Act]. They are required neither to ask your permission nor to compensate you for its temporary use. But that's a small price to pay (and it happens only rarely) for the marketing potential your pictures enjoy while on file.

Digitizing of black-and-white and color photos is now refined to the point where it is difficult to tell the difference between your original picture and the resulting copy. Is this a disadvantage? Such technological advancement

---

**REQUEST A CREDIT LINE**

You'll receive additional sales when a photobuyer spots one of your published photos. They'll phone the publisher and ask for your name and address. If you don't include your identification (name, address, phone, fax and/or online address) on each of your images, you will miss sales and assignment opportunities. Carry this identification over to your stationery, labels, checks and other transmittal forms.

---

just might turn out to be a plus for the editorial stock photographer, much as the development of the recording industry made residual sales a boon to songwriters and musicians.

Color copiers now exist (at libraries, banks and instant-print shops) that will make reasonable color copies of your slides and prints. These, or digitized copies, serve as excellent samples to leave on file with photobuyers. (For information on file prints, see chapter five.) To increase sales, whenever you contact photobuyers—by letter, phone, e-mail or in person—encourage them to photocopy your pictures.

## The Central Art File

Publishing houses usually start from a modest venture, and then expand, sometimes over several generations. The main theme of the publisher usually remains the same. For example, automotive publishers expand with things automotive, and so on.

Large houses have large photography budgets—$40,000 to $50,000 per month is not uncommon for a large publishing house. If you have done your research well, part of that budget can be yours, because you can supply pictures that fill their needs.

As you research market possibilities geared to your photographic strength areas (PMS/A), you'll plug into some large publishing houses with twenty to thirty or more editors for as many periodicals and/or book specialties within the same firm. In marketing your pictures to such houses, you can save yourself time and expense if you send only one shipment of one set of prints or slides, rather than thirty sets to thirty separate photobuyers.

In most magazine or book publishing houses, you'll find a central art library (sometimes called the *photo library* or the *photo file*). Depending on the structure of the library, it will accept photos in various forms: originals, dupes, photocopies and digital. Incoming pictures are logged by a librarian and then distributed to the appropriate photo editors (or art editors or designers) for viewing. If your picture(s) is selected, the art librarian puts a purchase order into motion and, within a month, you receive a check.

Original color transparencies are returned to you, but once your black-and-white or color print is used, it is tagged and placed in the central library's filing system, usually by subject, age bracket or activity. Some libraries will

digitize them or make photocopies and cross-reference them in other related files for possible future use.

"But isn't a used picture less salable?" you might ask. On the contrary. The fact that your picture sold once puts a stamp of approval on it. The next photobuyer who comes along and sees your picture in the file and notes its previous use will be more likely to want to use it since it has received prior approval from a colleague.

You'll receive, generally, 75 percent of your original fee when your picture is used again. If the repeat sale is for other than inside-editorial use, you should receive a higher fee (see tables 8-2 and 8-3).

About once a year, the art librarian will conduct a spring cleaning of the central art file and return outdated photos to photographers.

## The PhotoDataBank

Nothing is more important to photo editors than to have the pictures they need in hand, in front of them and ready to go.

As the demand for photography in publishing grows, the need outraces the supply, and immediate access becomes increasingly difficult for photo editors.

Editors with highly specialized needs cannot always find their pictures readily, since stock-photo agencies hold in inventory only pictures with the potential to sell over and over. Where does a photobuyer go for that picture of Albuquerque after a winter snowfall taken within the last two years? Or a picture of a carbonized piece of grain? Or a scene of the plains in Iowa as the Mormons might have seen them in their trek across the country in 1847?

Here at PhotoSource International, we offer a free stock-photo service to our subscribers and buyers, the PhotoDataBank. Our *PhotoDaily* and *PHOTOLETTER* subscribers send us lists of highly specific subject areas they have in their files (e.g., snails, windmills, Memphis, etc.). When a photobuyer wants to locate pictures of Shetland sheepdogs, for example, we make a computer printout of all the photographers who designate Shetland sheepdogs, and send it to the buyer so he can contact the photographers directly. Another route: If you are an Internet user, check out the photography groups that include websites for photographers. Some of them will list your specialty categories at no charge.

## The Permanent-File System

Large publishing houses, especially the denominational houses that employ thirty or more editors, are always in need of up-to-date photographs that reflect the society we live in. Their need is so great (they produce several dozen periodicals and as many book titles each year) that editors keep a permanent file of transparencies and black-and-white and color photographs in their art libraries. Some publishers maintain a digital collection. These photographs are chosen because of their broad appeal to the particular

readership reached by that publishing house. The editors welcome additions to this file to keep on hand for immediate use when needed.

Photobuyers are fond of saying, "Send me pictures that I can always find a place for in my layouts." Of course, it would take a mind reader to score every time, but if you have been successful in selling to a certain market several times, in all probability you have a keen understanding of the photographic needs of that publishing house. Ask all your photo editors if they have a permanent file: If they do, submit your pictures for consideration. Your photos can be included in the file, and each time a picture is used, you will receive a check. Most photo editors prefer original slides, and you may not wish to place your originals with a central art librarian. However, the system works well for black and whites, color prints and digital files. Some textbook publishers will accept display dupes as file copies.

Can you depend on publishing houses to be financially conscientious in their dealings in this kind of arrangement? In my experience over three decades, yes. The risk factor of a mix-up in use and payments is low to nonexistent. And when you balance an honest mistake every now and then against all those checks you would not have received if you had never placed your pictures with the permanent file, your choice becomes obvious. Your greatest risk actually will be investing in multiple color and black-and-white prints and then relying on your judgment as to which publishing houses would be likely to use them most frequently.

As publishing houses become more sophisticated in developing digital files, the problem of sending original prints and slides to photo editors will diminish. However, you will find most editorial publishers are more interested in having a print or slide readily available, rather than the computerized version. Is this laziness? In some cases, yes. In reality, though, given the human tendency to resist change, most editorial photobuyers will defend the present way they are conducting business. As the new breed of photo editors comes on the scene, you can expect a shift to more use of digital files and research on the World Wide Web.

From time to time, you'll want to update your supply of work on file by sending in a fresh batch of photos. From time to time, too, the art librarian will return pictures to you to make room for more recent submissions.

## The Pirates

Some newcomers to photo marketing bring with them misconceptions about the ethics of photo editors. From my conversations and correspondence with beginners, I'm always amazed at how many have visions of picture-buyer pirates lurking in their office coves, ready to seize some unsuspecting photographer's pictures and sell them on the black market.

Such infringers might exist in the field of commercial stock photography, where stakes for a single picture are known to reach impressive heights (such cases are reported in trade journals such as *Photo District News*), but in

thirty years I have never run across a deliberate case of piracy in the editorial field. An occasional inexperienced photo editor may make an error of omission or commission. Photographers have been known to do likewise. The lesson here is to be cautious when working with new publications that don't have a substantial track record, or publishing houses that have a history of hiring greenhorns. I suggest that you deal with publishers who have been in business a minimum of three years.

## The Legal Side

If you're just starting out or starting over, don't be tempted to include the highly legalized transfer documents that are sometimes recommended by the American Society of Media Photographers (ASMP). These can be a definite turnoff to your would-be photo editor. In the early stages, expect to work on a handshake basis. Later, when you are on a first-name basis with photobuyers, or they have invited you to call them collect, you can introduce ASMP-type forms with all their legalese and fine print.

All in all, you'll find photobuyers of stock photography reliable and interested in you as a person and as a photographer. If you operate with the same attributes, you'll find dealing with photobuyers an easy task.

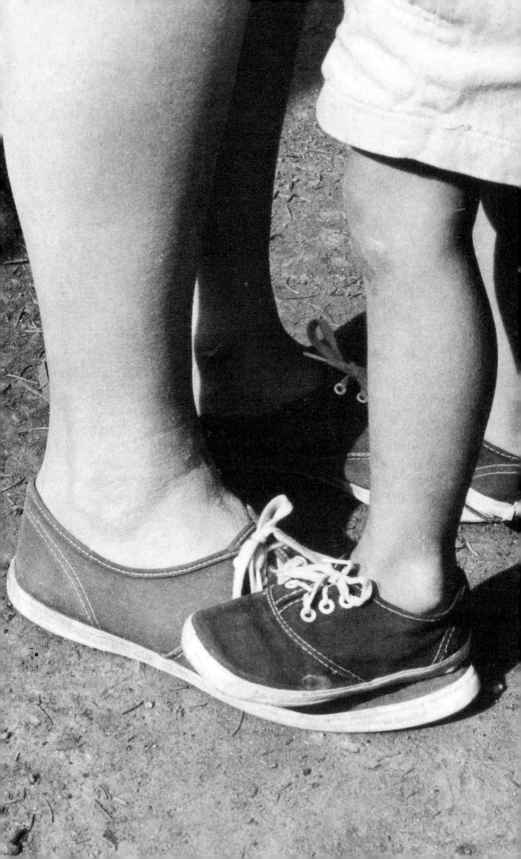

# Pricing Your Pictures

## Master Your Marketing System First

As I cautioned earlier, it is foolhardy to jump right into trying to sell your photo illustrations before you understand how to market them. Selling is what happens naturally after you do your marketing homework. In chapter two, I explained the difference between a good picture and a good marketable picture, and why (unless you break into that small elite of top professionals) it is almost impossible to sell with regularity to the big-money markets.

Rather than rely on luck (i.e., selling your pictures in scattershot fashion), use the system in chapter three to tap dozens of markets that will consistently rent your pictures from you on a one-time use basis. Some of these smaller or midrange markets have monthly photography budgets of $10,000 to $30,000. Yet they are markets that the pros rarely have the time to discover or research.

Chapters two and three show you how to set yourself apart from the hordes of stock photographers trying to sell the standard excellent picture (Track A) to photo editors who already have hundreds or even thousands of such pictures in inventory or on tap. Chapter three explains how to analyze your personal photographic marketing strength/areas (PMS/A) and, in so doing, immediately become a valuable resource to specific photo editors.

Be sure, then, to get chapters two and three under your belt before moving to this chapter on pricing. In other words, set up your marketing strategy first—before you attempt to sell. It will save you time and money spent on postage and packaging that bring only "nice work, but . . ." letters from photo editors, if they respond at all.

Trusting you've done your marketing homework, then, on to pricing your pictures.

Figuring prices need not be a mystery. The system I outline will aid you in keeping your prices professional and acceptable to photo editors.

It's important to remember that you will be dealing with photo editors as a photo illustrator (stock photographer), not as a service (assignment) photographer. Therefore, you can enter this field in high gear, provided your pictures are good and your reliability factor is high (i.e., you present yourself and your pictures professionally and on time).

## Sell and Re-Sell

There is a myth I will ask you to unlearn at this point: *"Selling a picture means selling it once—you can't sell it again."*

This myth is perpetuated because it can be true in the field of service photography: It doesn't apply to photo illustration (stock photography).

You can sell your pictures over and over again, because in selling a photo illustration, a stock photograph, you are selling one-time use of the picture, not the picture itself. Naturally, you must exercise common good judgment, and not simultaneously submit a picture to three sailing magazines that could have cross-readership. But you can submit the same picture simultaneously to three diverse markets: a sailing magazine, an elementary school textbook publisher and a denominational publishing house. Photo editors rent a photo for one-time use, whether for cover or inside-editorial use, to obtain quality pictures at fees lower than they would have to pay to purchase the picture outright. They do not attempt to exercise any control over where else you might market the same picture—it is understood that you observe the ethics of the business in not sending the same pictures at the same time to competing publications.

Photo editors recognize that the risk of the same picture appearing simultaneously in another publication is minimal. It rarely happens. In the nearly three decades I have been submitting pictures on a multiple basis, only one photo editor has been hesitant, and that was back in 1973 when the field was young and editors weren't always familiar with the benefits of renting pictures.

## The Price Range

Should you set a fee for your pictures and stick with it? If you are a service photographer, perhaps, yes. But if you are selling stock photographs, you'll learn that the different photo editors on your Market List have different budgets. You generally go by the pay range of each different market. If you have three hundred potential markets on your list, you are going to find a wide range of fees paid for your photos.

A low-circulation magazine will not have the budget of one with a high circulation. A high-circulation publication sponsored by a nonprofit organization might not have the budget of a low-circulation magazine sponsored by an oil company. Another consideration is advertising. Some trade magazines are heavily supported by advertising; other magazines with the same circulation figures have little or no advertising and are supported by subscriptions. You'll find the latter category on the lower end of the payment range. You, of course, have the option to choose what markets and what price ranges you want to deal with.

| \multicolumn{3}{c}{To apply to publishers and publishing companies for one-time inside-editorial use.} | | |
| --- | --- | --- |
| Range No. | Black and White | Color |
| 1 | $100 to $250 | $300 to $500 |
| 2 | $ 50 to $100 | $150 to $300 |
| 3 | $ 35 to $ 50 | $125 to $150 |
| 4 | $ 25 to $ 35 | $100 to $125 |
| 5 | $ 20 to $ 25 | $ 75 to $100 |
| 6 | $ 15 to $ 20 | $ 50 to $ 75 |

*Table 8-1. Pricing Guide One. Note: A photobuyer will fall into one of these sectors depending on budget, circulation, uniqueness and other factors.*

## Base Camp: Inside-Editorial Use

As a newcomer to the stock-photography field, you deal basically with photo editors, designers and art buyers at publishing houses. Your pictures are usually bought (rented) to illustrate the editorial content of periodicals or books. You'll find that 90 percent of your pictures go to inside-editorial use in magazines, periodicals, websites, encyclopedias, textbooks and trade books. Payment for this type of use spreads across the six basic fee ranges shown in table 8-1.

The textbook market deserves special mention here. In general, you don't have many options when quoting prices to textbook publishers. Their budgets are set, and usually are low when put against the world of commercial stock photography. Most textbook photo editors buy in volume, and expect to pay lower fees per photo as a result. For example, they'll purchase ten or fifteen photos at a time and pay $50 or $75 for each, when the photos ordinarily would sell singly for $100 or $125. Payment ranges from $50 to between $150 and $250 for a quarter-page. Fees depend on many factors: whether the picture is to be used for a chapter head or cover, size of print run, later electronic use, number of languages the book is to be printed in, etc.

In all fairness to textbook publishers, they often need hundreds of photos for illustration in a single book. If "reasonable" market prices were insisted on for each picture, some textbooks would never be printed.

Textbook publishers are also known to hang onto your pictures for months (up to six months is not uncommon). Yet despite all this, they're an excellent market for both the entry-level photographer and the seasoned

pro. The publishers pay on time, they're dependable, they have a voracious need for photos and, if you establish a working relationship with them, they'll come to you again and again. (See chapter three: "The Total Net Worth of a Customer.")

The six price categories in table 8-1 reflect the circulations and budgets of the existing market areas, from local newspapers to major magazines, book publishers and website markets. If a picture is to be used for a purpose other than inside editorials (for example, as a cover, chapter head or informational brochure), you should charge a higher fee, and you can use the above standards to figure what that higher fee should be. (We'll cover how to do this shortly, under the heading "Using the Pricing System: What to Charge.")

## Which Range for You?

The lower range fees on the chart represent those you will receive from, say, your local newspaper, a nonprofit organization or a small church magazine. The higher range looks more enticing. I would like to comment on both. I mentioned earlier that you can start your photo marketing in high gear—at the top, so to speak. However, if you are a newcomer to the field of photo marketing, you will find the lower paying markets a good testing ground. The smaller markets are more likely to tolerate errors as you refine your professionalism. And they offer other pluses: Many of these lower paying markets are based on special-interest themes that might reflect your own views. Their editors often have small budgets but big hearts. They are willing to give helpful advice and to provide you with copies of your published photographs for your files.

Depending on your Track B list and your Market List, you'll probably be dealing primarily with photo editors in fee ranges 2 to 5.

And why won't you deal with range 1? Although I've covered this question in chapter three, it bears repeating. Range 1 is a closed market. Photo editors who can pay $100 to $250 (and more) for a black-and-white photograph, or $300 to $500 for color, also enjoy the convenience of having close, regular contact with a number of top-flight stock photographers, as well as access to the major stock-photo agencies. Getting excellent pictures is no problem for them. Neither is the question of cost. For example, most of the photographers who subscribe to our *PhotoDaily* fax service deal in this area. The photo editors they are in contact with allow them to call collect. The modus operandi of range 1 photobuyers is to deal with pros they've bought from before and who have established a track record with them. You don't necessarily have to live within the shadow of the World Trade Towers to be included in the stable of photographers of a photobuyer who pays in range 1, but you do have to have high visibility and a known reliability factor. If you are listed in *Literary Market Place, The Creative Black Book, The ASMP Directory* or *Stock Photo Deskbook* (see the bibliography) as a photogra-

pher, or if you subscribe to *Photobulletin* or *PHOTOLETTER* (see the bibliography), you no doubt already have high visibility. This chapter may not apply to you.

If this sounds like a chicken-or-egg situation, it is. It takes an immense investment of time and concentration on the single-minded goal of breaking into range 1 to create a chance for yourself in this closed market. It can be done, but as I've mentioned before, it requires a freewheeling lifestyle, frenetic work habits and a willingness to always be on call. Some thrive on it. If your inclinations aren't in this direction, the struggle to break into range 1 will deprive you of valuable progress you could be making in establishing your own gold mine of markets in the 2-to-5 ranges.

## Using the Pricing System: What to Charge

As I indicated earlier, the fee for a particular stock photograph will vary according to who is using it. This presents the problem, "How do I determine which range to charge a particular market?"

There are three standard answers: (1) guess, (2) ask, (3) research it. All three are viable alternatives.

*Guessing*—educated guessing, that is—will become an important tool for you as you progress. You'll be able to judge a magazine by its cover (and its advertising and circulation). Once you know what comparable periodicals and books are paying, you'll find it easier to be on target with your pricing. Figure on using guessing later in the game, after you've racked up some experience.

*Asking* would be easy if the information were readily given by buyers, but photo editors are sometimes hesitant to reveal such information to unknowns. Most photo editors, however, provide photographer's guidelines. Write to each photobuyer on your Market List, using professional-looking stationery, and request a photo guideline sheet. (Be sure to include an SASE.) The guidelines of their picture needs often include price information. If you approach a photobuyer by phone or in person, phrase your question this way: "What is your payment range for black and white and for color?" Since photo editors always work within a given range, you are saying two things to photobuyers: (1) You know something about pricing if you ask for a *range* rather than a set fee and (2) you allow editors to save face and not have to commit themselves (which means you won't be coming back later with, "But you said such and such . . ."). Photo editors will usually cooperate when your question is worded in this manner. However, before you embark on your quest for price-range information, review chapter seven, on dealing with photo editors by phone, by mail and in person.

*Researching* your answer might be easiest for you. Turn first to the marketing directories and reference guides listed in chapter three. Remember that fees quoted in a national directory are probably going to be

conservative; that is, they will be the lower figure (the minimum) on the pricing guide in table 8-1.

As an example, let's say in your research you find that the published fee for a black-and-white print for *Golf Today* magazine is $35. You can assume that this magazine will pay in Range 3 ($35 to $50 for a black and white, $125 to $150 for a color transparency, inside one-time use).

Many market directories will also give circulation figures, which are invaluable in determining the price ranges of publications that are similar. For example, if *Golf Today* pays in range 3 and its circulation is 800,000, we can assume that another magazine, *Teen Golf Digest*, with a circulation of 400,000 and with similar advertising accounts, might pay in range 4. If *National Golf Review* has a circulation of 1,000,000 and stronger advertising support than *Golf Today*, we can figure that they probably pay in range 2 ($50 to $100 per black and white, or $150 to $300 per color, inside, one-time editorial use). These examples can give you a base from which to start.

## Payment for Other Uses

Again, the fee ranges in table 8-1 apply to inside-editorial use. As I mentioned, if your photograph is used by the publisher for a different purpose, such as a website, you should receive a higher fee.

Publications, of course, will be local, regional or national in scope. You should be compensated accordingly. National use carries the most generous compensation, but keep in mind that sometimes a national magazine will be limited to a highly specialized audience and thus yield a lower pay rate. For example, a skydiving magazine would be limited in its impact, even though it might have national circulation. So would a national magazine directed to nurses or model railroad enthusiasts.

Table 8-2 provides a system for arriving at a fair price to charge for other-than-inside use of your photos, no matter what level publishing market you're dealing with. Take the price you normally receive for one picture from that market and multiply it by the factor that represents the purpose for which the photo will be used.

For example, if a photo editor in range 3 (see table 8-1), who normally pays $50 for a black and white (inside-editorial use), would like to use one of your photographs for local public-relations use, multiply $50 by the factor 1.429 to come up with a round figure of $75 ($71.450). To figure the fee for the same black-and-white photograph to the same market for use in a national advertisement, multiply $50 by the factor 7.144 and you get $350 ($357.200). By the same token, if you are working with range 1 buyers and the one-time-use fee is $450, national advertisement use would be $2,850.

For the sake of completeness, table 8-2 includes uses such as advertising, calendars, record covers, postcards and CD-ROMs; these are all commercial areas that publishers sometimes delve into. (Table 8-2 applies to projects by publishers or publishing companies, not to commercial uses by ad agencies,

To get at a "ballpark" fee for use of your picture for other than inside-editorial use, multiply these factors times the figures in table 8-1.

** Advertising

| | |
|---|---|
| ***National | 7.144 |
| Regional | 3.155 |
| Limited | 2.867 |
| Local | 1.621 |

Annual Reports

| | |
|---|---|
| Local | 1.429 |
| Regional | 2.867 |
| National | 3.155 |
| Cover | 7.144 |

Audiovisual Packages

| | |
|---|---|
| ***National | 1.621 |
| Limited | 1.429 |
| Cover | 5.859 |
| Advertising | 3.155 |

Brochures

| | |
|---|---|
| Inside | |
| Limited | 1.429 |
| ***National | 4.867 |
| Cover | |
| Limited | 3.621 |
| National | 6.859 |

Calendar

| | |
|---|---|
| Exclusive (limited three-year rights) | 2.143 |
| One time | 1.429 |
| World Rights | 50% additional |
| Advertising | 3.155 |

CD-ROM (New Media)

| | |
|---|---|
| Limited | 1.429 |
| ***National | 1.621 |
| Cover | 5.859 |

(Note: Some CD-ROM companies may ask you to take part of the risk by receiving royalties only.)

Coffee-Table Books (see table 8-1)

| | |
|---|---|
| Chapter head | 1.621 |
| Cover | 2.859 |
| Advertising | 3.155 |

Contests (Payment based on contest rules. Allow only limited rights to your winning entry, never all rights.)

** Curriculum

| | |
|---|---|
| Inside | **(see table 8-1) |
| Chapter head | 1.429 |
| Cover | 1.621 |
| Advertising | 2.143 |
| Montage | Negotiable |

Decor Photography

| | |
|---|---|
| Sold by an agency Framed prints | (Find out what royalties the competition is paying.) |
| Limited editions | Negotiate |
| Sold by yourself Framed prints | (Sell to a distributor in volume at one-third his retail fee.) |
| Limited editions | Negotiate, but expect a wide range depending on client, use and your "name." |

| | |
|---|---|
| ** Electronic | (see Intranet; Web) |

** Encyclopedias

| | |
|---|---|
| Inside | ***(see table 8-1) |
| Chapter head | 1.621 |
| Cover | 2.143 |
| Advertising | 3.155 |

| | |
|---|---|
| Gift Wrap | 2.859 |

*Table 8-2. Pricing Guide Two.*

### Greeting Cards

| | |
|---|---|
| Exclusive (limited three-year rights) | 2.143 |
| One time | 1.429 |
| World Rights | 50% additional |
| Advertising | 3.155 |

### **Hardcover Books (see also Paperback, Coffee-Table Books, Textbooks, Encyclopedias)

| | |
|---|---|
| Inside | (see table 8-1) |
| Jacket or cover | |
| Limited | 2.621 |
| National | 3.859 |
| Chapter head | 1.429 |
| World Rights | 50% additional |
| Advertising | 3.155 |

### **House Magazines

| | |
|---|---|
| Cover | |
| Limited | 2.429 |
| National | 3.143 |

### **Intranet (Electronic House Magazines)

| | |
|---|---|
| Limited | 2.429 |
| National | 3.143 |
| Cover (entry point) | 3.555 |
| Banner or design element | 4.100 |

### *Magazines

| | |
|---|---|
| Cover | |
| Limited | 3.429 |
| Regional | 5.621 |
| ***National | 7.716 |

### Motion Pictures

| | |
|---|---|
| Nonprofit | 1.255 |
| Experimental | 1.429 |
| Test | 1.621 |
| Limited | 1.429 |
| Regional | 1.621 |
| ***National | 2.143 |
| Promotion | 5.621 |

### *Newspapers, News Services

| | |
|---|---|
| Cover | |
| Limited | 1.429 |
| Regional | 1.621 |
| National | 2.143 |

Spectacular exceptions (disasters, etc.): Consult your directories (or the library) to determine competing national news agencies or periodicals and then put the picture up for bids on a limited-rights basis. An agent might be your best bet.

### *Nonprofit Organizations

| | |
|---|---|
| Regional | 1.429 |
| ***National | 2.143 |
| Poster | 3.155 |

### On-Demand Printing

Short-run print runs will usually be local or regional. Fees can range from 30% to 50% lower than a standard brochure run.

### Paperback Books—Editorial (see also Hardcover Books)

| | |
|---|---|
| Cover | |
| ***National | 2.859 |
| Limited | 1.621 |
| World Rights | 50% additional |

### Place Mats

| | |
|---|---|
| Exclusive (limited three-year rights) | 2.143 |
| One time | 1.429 |
| World Rights | 50% additional |
| Advertising | 3.155 |

### Playing Cards

| | |
|---|---|
| Exclusive (limited three-year rights) | 2.143 |
| One time | 1.439 |
| World Rights | 50% additional |
| Advertising | 3.155 |

### Postcards

| | |
|---|---|
| Exclusive (limited three-year rights) | 2.143 |
| One time (national) | 1.621 |
| One time (regional) | 1.429 |
| One time (local) | 1.077 |
| Advertising | 2.188 |
| World Rights | 50% additional |

*Table 8-2. (cont.)*

Posters

| | |
|---|---|
| Exclusive (limited three-year rights) | 2.143 |
| One time | 1.429 |
| World Rights | 50% additional |
| Advertising | 3.155 |

Product Packages

| | |
|---|---|
| Regional | 1.621 |
| ***National | 5.716 |

Public Relations

| | |
|---|---|
| Limited | 1.429 |
| Local | 1.429 |
| Regional | 1.621 |
| ***National | 3.155 |

Puzzles

| | |
|---|---|
| Exclusive (limited three-year rights) | 2.143 |
| One time | 1.429 |
| World Rights | 50% additional |
| Advertising | 3.155 |

Record Covers

| | |
|---|---|
| Limited | 1.621 |
| ***National | |
| Front | 3.143 |
| Back | 2.521 |
| Wraparound | 5.211 |
| Advertising | 6.155 |
| Promotion | 5.429 |

*Television

| | |
|---|---|
| Editorial | |
| Local | 1.429 |
| Regional | 2.859 |
| ***National | 3.155 |
| Advertising | |
| Local | 3.155 |
| Regional | 5.333 |
| ***National | 7.144 |

(Note: Expect to negotiate with major advertisers.)

*Textbooks (see also Hardcover Books)

| | |
|---|---|
| ***Inside | (see table 8-1) |
| Chapter head | 1.429 |
| Cover | 2.143 |
| Advertising | 3.155 |

*Trade Publications

| | |
|---|---|
| Cover | |
| Limited | 1.129 |
| Regional | 3.621 |
| ***National | 5.155 |

Video

| | |
|---|---|
| Commercial | |
| Nonprofit | 1.621 |
| Limited | 2.444 |
| ***National | 6.152 |
| ***Optical disk | |
| Educational | 1.429 |
| Industry | 3.621 |
| Advertising | 5.155 |
| Cover | 5.859 |

*Websites

No price standards have been established for websites. Use table 8-1 as your guide, and see Intranet in this table. The most commonly accepted approach to pricing for websites is to use standard print fees as your guide. Some companies may ask you to take part of the risk by asking you to receive royalties only, based on the number of "hits." In any case, arrange to renegotiate with the Web or Internet owner every six months.

*For inside-editorial use, see table 8-1.
**Note: A general rule for photographs used in a publisher's advertising campaign: Charge 50% of the space rate the publisher is paying. Space rates are available by phoning the newspaper, magazine, etc. For websites, use table 8-1 as your guide.
***These fees are based on domestic rates. For World Rights, charge 25% more for one language, 50% for two; negotiate thereafter.

*Table 8-2. (cont.)*

calendar companies and the like.) Most often, however, you will use table 8-2 to figure fees for book or magazine covers, catalog promotions of a periodical or book, chapter heads, informational brochures and similar editorially connected uses.

Pricing your photographs for covers or other special uses is easy if you follow the pricing guidelines in table 8-2. The key is to determine the photobuyer's *basic budget range*. Once you have that, all other prices will fall into line when you use this factor system. Considerations such as inflation or a drop or raise in the photobuyer's fee structure will not be a problem. The factors still work, based on the buyer's basic fee paid for inside-editorial use.

One final word regarding the use of table 8-2: When you take the appropriate factor, whether you multiply it by the lower or higher figure of a fee range or pick a figure in the middle depends solely on your own experience and/or judgment with regard to that particular market or photobuyer. If your reliability factor has been high with the client and you're confident of the quality of your pictures, aggressively market them. Aim for the *highest* fee practical (check out "Negotiating Your Fee" in chapter eleven) that still keeps the door open for future assignments from the same people.

In the end, the buck stops with you. You will have to be the final judge in setting the price. As you gain experience, you will come to know each magazine or publishing house; you will know their photo editors and the temper and tone of your relationships with them. All of these factors will help you to fine-tune your pricing.

## Within the Price Range, Should You Charge the High End or the Low End?

There's an adage in the business world, "You can always come down in your fee, but you can't go up." For the service photographer, this is usually true. As a stock photographer, it will also be true when you seek assignments: You will want to negotiate for the highest fee.

As a newcomer to the field of stock photography, however, initially you will want to charge the lower figure of the price range. Why? Because you are an unknown to the photobuyer. He has little to gain if you charge the maximum fee within the range. He already has a roster of high-priced but familiar photographers with a known reliability factor who would require less time to deal with. But if your pictures are on target and your fee is at the lower end of the range, he can justify the time taken out from his busy day to instruct you in the submission procedures, holding requirements, payment policies, etc., unique to his publishing house. Once you have made two or three sales to the photobuyer, test the waters by raising your fee on your next statement. Since you already know the photobuyer's price range, you know you won't exceed his maximum.

Think in terms of long-range goals. You have done your marketing homework. You know that your PMS/A is matched with your personalized Market

List. By progressing patiently up the pay-range scale, you'll gain experience and eventually become a top-notch contributor to each of the outlets on your Market List. Most successful pros in any field will tell you this is the way it's done. After all, actors start at the community theater level; baseball players start in the minor leagues.

## Unique Pictures—What Are They?

As antique dealers and baseball card traders know, the word "unique" has to do with the buyer, not the seller. If you price your pictures based on your own assessment of what's unique and what's not, you might be off target. Like art, uniqueness is in the eye of the beholder.

With the arrival of CD-ROM "click art," exquisite clichés began to lose their appeal to photo editors. It'll be a rare occasion when one of your Track A pictures is considered unique. As the saying goes, they're "a dime a dozen."

In order to make their own publications unique, many photo editors will shy away from using clip art and seek out unique pictures. Translated into real terms, that means buyers will look for highly specialized pictures that match their editorial needs. A generic picture won't do. If your specialization (PMS/A) matches the photo editor's theme or special interest, your pictures are unique to that photobuyer.

## Second Use of Your Pictures

As an editorial stock photographer, you price your pictures on a one-time-use basis. In effect, you are renting your pictures to the photobuyer. What happens if the photobuyer wants to rent your picture a second time? Should he use it free, at a discount or at the same fee? Many publishing houses have set policies on photo reuse. But you can set policies also. For a starting point, you can use the guide in table 8-3.

Here is an exception to these reuse guidelines: If a publishing house has retained your picture in its central art library and reuses it in a new format,

|  | Percent of original fee |
|---|---|
| For use in same format as original use (e.g., in a revision, new printing) | 75% |
| For use in an anthology | 75% |
| For use in a new format (a new or different project) | 100% |
| For use as a cover, in advertising, public relations, filmstrip, etc. | See table 8-2 |

*Table 8-3. Pricing guide for photo reuse.*

you should expect 75% and not 100%. The 25% in such a case is understood as a privilege fee for holding your pictures in the library; it goes toward the library's operating costs and services.

The fees discussed in this chapter are for domestic use of your picture. You may have the occasion to sell World Rights to your photo. A generally accepted fee structure is to charge 25% per language. For two languages, charge 50% additional; for three or more languages, negotiate. If the photo editor asks, "What would you charge for World Rights in all languages?" a generally accepted answer is 200%.

## State Your Fee

Always state your fee when you submit pictures to a photobuyer (assuming you've done your homework and can quote a fee you know is within the photobuyer's range). This practice will increase your chances for sales. Why? Photo editors tell me that one of the main deterrents to purchasing a picture from a submission is that the photographer failed to state a fee in the cover letter.

When I first began submitting photographs, I fell into the hesitancy trap. I hesitated to put down a fee. I believed that the photobuyer would want my picture so much that he would phone me, write and ask for the fee or, better still, tell me what he would pay.

It didn't work out that way. Yes, the photobuyer wanted my picture. But he would have to go through the busywork of getting in touch with me (and what if I were out of town), perhaps negotiate with me and endure time-consuming back-and-forth communication with someone he wasn't even familiar with. And he had a deadline to meet. So to avoid those problems, he would use a second-best picture that was available and had a price on it. (Have you ever wondered why some pictures that are not as good as yours are published? This is one reason.)

The fee you are charging is the most important element in your cover letter (except for spelling the photobuyer's name correctly). If you can't come up with a price you know is within the buyer's range, make an educated guess based on your research. Even a guess too high or too low can result in a sale that you might not have made if you had not quoted a fee at all. When all else fails, use a rubber stamp that says "for publication at your usual rates." By telling you this, however, I hope I haven't given you license not to do your homework.

## Pricing the Service Photo

Although this book is written for the stock photographer, from time to time every stock photographer finds himself involved in a service-photography assignment. Briefly, here are some tips for gauging a fair price for your now-and-then stints as a service photographer.

Six excellent guides exist for the person who sells photography in the

following assignment areas: advertising illustration; architectural; general commercial (studio and/or location); photojournalism, photo reporting; public relations; and publicity.

These are the price guides:

*ASMP—Professional Business Practices in Photography*, 14 Washington Square, #502, Princeton Junction, NJ 08550-1033

*ASMP Stock Photography Handbook (ASMP National)* (same address as above)

*FotoQuote*, Cradoc Bagshaw, 1574 Gulf Rd., #1552, Point Roberts, WA 98281

*Gold Book of Photography Prices*, by Thomas I. Perrett, Photography Research Institute, Carson Endowment, 21237 S. Moneta Ave., Carson, CA 90745

*Negotiating Stock Photo Prices*, 110 E. Frederick Ave., Suite A-3, Rockville, MD 20850

*Pricing Guidelines*, Graphic Artists Guild, 90 John St., #403, New York, NY 10038-3202. (212) 463-7730

*ASMP—Professional Business Practices in Photography* is a compilation of rate surveys made among the highest-paid photographers in the country. If some of the markets on your Market List are over a quarter-million in circulation, this book could be worth the investment (around $25). The ASMP is an organization of more than three thousand media photographers. (I was a member in the 1960s, but dropped my membership when I changed my focus from service photography to editorial photo illustration.)

Service photography, because of the complexities and the high fees often involved, requires extra attention to precision when you negotiate a picture sale or an assignment. The ASMP book will inform you about book-publishing contracts, settlement of disputes, trade definitions, photographer-agency relationships, copyright, commercial stock-photo sales, online sales and insurance. It also contains forms (which you can adapt to your own needs) for assignment confirmations, delivery memos and model releases. Remember, though, that the mission of the ASMP book is to guide the photographer who operates in a city of at least one million population, or who deals with publications of 250,000 circulation or higher. If you employ the ASMP guidelines or forms outside of those parameters, you and your clients might find the experience less than satisfactory. Keep in mind that it is the photobuyer who approves the assignment, initials the proposal or forwards a statement for reimbursement.

So use the ASMP book wisely. It was conceived and produced for top pros in the big leagues of Madison Avenue and parts west. A book is always the extended shadow of its author; in this case, the book was written by a

committee. Unless you have lucked into a top-paying, range 1 assignment, modify the ASMP guidelines accordingly. (Incidentally, the ASMP underscores that fees mentioned in the guide are only guidelines by stating in their introduction, "ASMP does not set rates.")

The ASMP is a group of hardworking photographers who devote their energy and time to setting and maintaining high standards for the industry. As a group, they are in a position to exert pressure for the betterment of working policies for service photographers. If you lean toward service photography and would like more information about the ASMP, write to them at 14 Washington Square, Suite 502, Princeton Junction, NJ 08550-1033.

As a service photographer, you probably know that a Hilton Hotel room or a Hertz rental car costs about 25 percent less in smaller cities. The same reduced rates hold for photography assignments and stock sales in smaller cities. The *Gold Book of Photography Prices* has been produced by Thomas Perrett since 1972. Although the *Gold Book* is more costly than the ASMP book, it may be of greater value to you if you are a service photographer working with accounts in smaller cities.

The *Gold Book* is actually a three-ring notebook, and it's revised every month to reflect inflation and changes in the industry. Because the book was originally compiled from questionnaires sent to photographers throughout the country (as was the *ASMP—Stock Photography Handbook*), you can be reasonably sure that the suggested prices for architectural, public relations, fashion and advertising photography are realistic. The *Gold Book* can save you research time as well as dollars by telling you what photographers across the nation actually receive for their service photography.

*Negotiating Stock Photo Prices* is an excellent guide for the experienced commercial stock photographer. Although the suggested fees are not in the entry-level range where you might realistically enter the market (the range is number 1), this guide by photographer Jim Pickerell shows you the opportunities that are available to you if you choose to enter the field of commercial stock photography.

FotoQuote (if you have a computer) is another way to determine fees for just about any kind of stock-photography usage—editorial, advertising, record covers, television, CD-ROM, Web pages or online. The program takes costs into consideration. When you input various information elements concerning the sale of the photo, it adjusts all factors and comes up with a suggested fee for you. There's even a special "coaching" section that suggests negotiating tactics for commercial stock photography.

If you don't wish to invest in any of these pricing guides, you can determine the going rate in your area by a somewhat roundabout route. It's sometimes difficult to get the information from other photographers or the photo editors themselves. (Unlike photo illustrators, who work in their own market and subject areas, and therefore don't compete with other photographers for the same dollar, service photographers very often compete with each

other for specific assignments and are not eager to give information to new-comers.) Do ask other photographers and photo editors, but do it long-distance—go to a large library and get hold of the yellow pages of several cities around the country that are of comparable size to your own. Pick out several photographers and photo editors and phone them (before 8:00 A.M. and after 5:00 P.M. your time, when possible, to take advantage of lower rates) to find out what they consider fair fees. Be sure to establish early in the conversation that you are calling long-distance. The time and money spent in such research will save you hundreds of dollars in either under-pricing or accounts lost (assignments missed) because of overpricing.

## Royalty Payments: Will They Work?

As we move into the age of digital imagery, it seems sensible for the industry to adopt a royalty system similar to that used by the music and television industries. It would work like this: A CD-ROM company, website or book publisher advances you a nominal amount for the use of your picture, plus a royalty tied to the number of units sold or some other factor. If the project is successful, you benefit. If it isn't, you are stuck with a low payment for your image.

Royalty payments are not a popular subject with photo editors: Most feel the accounting problems would be a nightmare. However, as computers and software become more sophisticated, royalty payments might prove to be to everyone's benefit.

## The Lowest Fee Possible: Nothing

I can't close this chapter without a word about zero-price marketing.

Some publishing houses have no budget for photography. They have budgets for carpenters, secretaries, printers and the IRS, but they don't budget for you, the stock photographer.

If you discover some of these nonpaying markets on your Market List, chalk it up to the research and refinement inherent in hammering out a strong Market List, and delete these markets or let them sink to the bottom.

You may wish to let one or two no-pay markets stay in at the bottom because you feel they'll serve as a showcase for your photography. As a newcomer, you want to build your published-pictures file as quickly as possible. Your credit line next to your pictures will establish your credibility and lead to other sales. Aside from the free-advertising benefit you reap from such publications, you can request copies (tearsheets) of your published picture(s) as payment. The usual method is to request three copies after publication. If you're interested in several dozen copies, contact the photobuyer a month before publication and ask the publishing house to give you or sell you overrun pages. (They'll let the press run a little longer for your order, generally for a dime a page.) Request a number of these copies, and use them as stuffers in your mailings to other prospective photobuyers (see chapter

*Joy! to the reader, and also to the photographer—me! Because this picture taught me how to market my pictures. It was taken more than thirty years ago, sold right away and has been selling over and over again ever since. Sales from this one picture have paid for all of my camera and darkroom equipment. Photobuyers use it for articles on children's games, summer recreation, health, playtime activities, camping—not to mention articles in textbooks on happiness, sorrow, depression and exuberance. To date, it has earned more than $5,450. The cash register keeps ringing.*

ten). There's also a chance that some no-pay markets may be ground-floor businesses with promise—i.e., markets that eventually will grow to healthy budgets for photography, and that will remember and appreciate you when they do, if you keep reminding them of your existence. (It's always up to you to keep the communications alive.)

Once you have attained whatever benefits you sought in allowing your pictures to be published free, begin working up toward the top of your Market List, where pricing is healthy and lucrative.

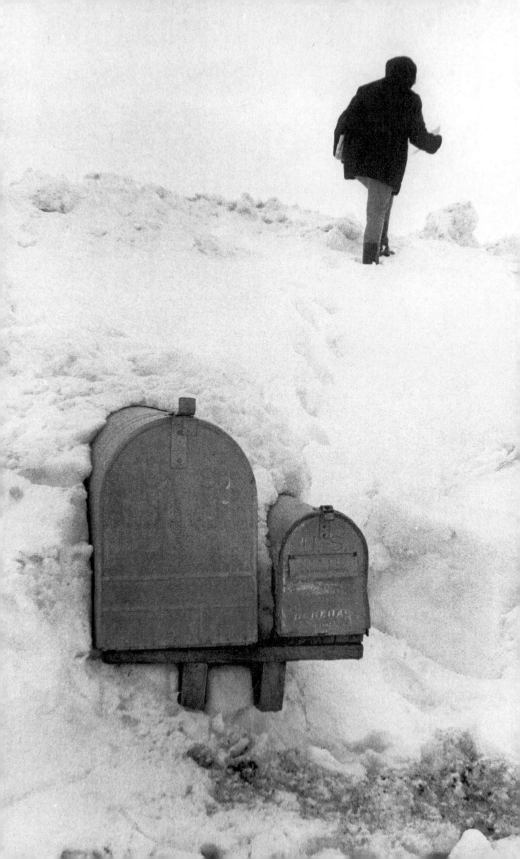

# Managing Your Mail-Marketing Operation

## How Do I Get My Pictures From Here to There?

The ad in the photography magazine shows a distraught lady at the airline terminal being informed by an attendant that she has missed her plane. "Don't Let This Disaster Happen to You!" reads the caption. The full-page ad for a software company goes on to imply that if you don't keep up with digital technology (by buying their product), you will be left hopelessly behind.

Do you sometimes get a nightmare vision of your competition flying light-years ahead of you, enjoying high-powered electronic sales and delivery advantages with the photobuyers out there in cyberspace?

"Hey, I don't have the expertise or the budget to keep up the pace in the digital world. How can I compete?" you say.

While it's true that fax, e-mail and Internet connections are opening up new worlds of instant-speak, what channel of communication do photobuyers *really* prefer?

The Good News: Here at PhotoSource International we are in touch with hundreds of editorial photobuyers every week. Over ten thousand are in our database. The great majority of these buyers prefer the U.S. Mail, not only for delivery of photos, but also for sales intros, promotion and routine communication.

### Delivery: As Close As Your Mailbox

Communication by computer enjoys big-time media attention, but the reality is that standard U.S. Mail continues to be decidedly the communication method preferred by editorial photobuyers. Before you shut down your computer, however, check out chapter seventeen. You are going to find that the Internet offers an important and growing sales and delivery method that may one day rival the U.S. Mail, and you can start getting your feet wet with it right now.

Back in 1981, I wrote in my newsletter, *PHOTOLETTER*, that within a decade, digital delivery of photo illustrations would be the norm. I was wrong. Even commerical stock photographers are not convinced that digital photos will replace film-based photography. Digital (online) delivery of images is a long way off. However, delivery of *information* about your photos is here today, in the form of a website. If you specialize and inform Web users of your specialty, they can take a look at your specialized portfolio. A phone call or e-mail will get the sales process moving from there. Again, for more on this, see chapter seventeen.

In this chapter, however, we'll address the communication method that 90 percent of your buyers in the editorial field prefer.

## Our Postal Service— A Bargain for the Photo Illustrator

As a stock photographer, you can market your pictures almost entirely by mail. Photobuyers like working this way. It saves them time and it's efficient. For you, marketing by mail is less expensive than costly personal visits. The risk? Minimal. Here at PhotoSource International, I've been engaged in a long campaign to debunk the myth of photos missing in the mail.

We've all heard horror stories about the U.S. Postal Service, but I've found the vast majority of those "lost picture" stories to be untrue. For example, at my seminars I ask people to describe their experiences with photographs *lost* in the mail. When the facts are laid out, I've yet to discover one case that could be documented. Not that it isn't easy to have a photograph damaged or lost in the mail. Simply ship it out in a flimsy envelope and don't identify it as yours: The odds are you'll never see the picture again.

When photos fail to arrive at their destination or fail to return home, it most frequently is the photographer's fault: Typical reasons are incorrect address, incorrect editor, no editor, no ZIP code, no return address, no identification on prints or slides or poor packaging. We sometimes get a call from a photobuyer who asks, "Can you locate the address of Harrison Jones for us? We want to send him a check, but all we have is a slide with his name on it. No address. No phone."

Stock-photo agencies and film processors must know something about the U.S. Mail. They have shipped pictures across the nation and the globe for years. Magazines use the postal service successfully, as do Light Impressions, Spiegel and Calumet.

If there is a risk, it is in *not* sending your pictures through the mail. Pictures gathering dust in your files are hazardous to your financial health.

## Preparing Your Stock Photos for Market

The first impression a photobuyer has of you comes from the way you package and present your material. Photobuyers assume that the care you've

given to your packaging reflects the care you take in your picture taking and your attentiveness to their needs. They believe they are paying you top dollar for your product. They expect you to deliver a top product. If you want *first-class treatment* from a photobuyer, give *her* first-class treatment.

### Sending Transparencies

To best protect your transparencies, send them in vinyl sleeves. Use slides mounted in plastic or cardboard, or else unmounted. For mounted slides, use the popular vinyl pages that have twelve 2¼-inch or twenty 35mm-size pockets on one page. For unmounted transparencies, the vinyl pages are also useful. Four 4″ × 5″, two 5″ × 7″ or one 8″ × 10″ can fit in one page. If you have only a few transparencies to submit, cut the page in half or quarters. Send your selection in a smaller envelope. Single acetate sleeves are another option for protecting transparencies. They're available at photo-supply houses. In the past, there has been some concern as to whether the polyvinyl-chloride (PVC) in vinyl sleeves can damage a slide. Use this rule: Ship your slides in thick vinyl (or nonvinyl) sleeves, but store your slides in archival plastic pages. A thin plastic page should not be used to ship your slides because the slides fall out too easily.

When you submit transparencies, you might wish to keep not only a numerical record of your submission, but a visual record as well. Here are two ways: (1) Make a color photocopy (at a library, Xerox Center, bank, Kinko's or print shop) or (2) make a 35mm (black-and-white or color) shot of your slides on your light box. Keep the results on file until your slides are returned.

How can you caption unmounted transparencies? Fit your information on an adhesive label and place this at the bottom of the protective sleeve or vinyl page pocket where it won't cover the image.

Inexpensive protective vinyl (or similar plastic) transparency-holder pages are available from the following sources:

**Bardes "Clearlast,"** 5245 W. Clinton Ave., Milwaukee, WI 53223

**Elden Enterprises,** Mount Division, P.O. Box 3201, Charleston, WV 25332

**Kleer Vu Plastics,** P.O. Box 449, Station 5, Brownsville, TN 38012

**Light Impressions,** 439 Monroe Ave., P.O. Box 940A, Loop Station, Rochester, NY 14603

**NEBS,** 49 Vose Farm Rd., Peterborough, NH 03458

**PHOTAK,** 180 Main St., Bldg. 5, Menash, WI 54952-3174, (800) 723-9876

**PHOTOFILE,** 466 Centura Ave., Suite 31B, Northfield, IL 60093, (800) 356-2755

**PHOTOPHILE,** P.O. Box 1368, Chicago, IL 60613, (800) 543-5236

**20th Century Plastics,** P.O. Box 2367, Los Angeles, CA 92622-2367

**Unicolor Photo Systems,** 7200 W. Huron River Dr., Dexter, MI 48130

These companies also produce single-slide vinyl protectors. Insert the protected slide in the pocket. When a buyer extracts it from the full-page sheet, you'll be doubly protected.

### Sending Black and Whites

If your black-and-white prints are dog-eared or in need of trimming and spotting, they may miss the final cut. Often excellent pictures never reach final layout boards because they make such a poor first impression. As the saying goes, "You never get a second chance at a first impression." Your stock photos make the rounds of many buyers, so check your prints regularly to trim any edge splits or dog-ears. Before submitting black-and-white 8″ × 10″s, retouch any flecks.

Use plastic sleeves to protect your black and whites. These sleeves present a fresh, professional and cared-for appearance, and they hold your prints in a convenient bundle for the editor. They come in 8½″ × 11″ (or larger) size and are available from the plastic distribution houses listed in the yellow pages of metropolitan phone books. One sleeve can hold up to fifteen single-weight or ten double-weight black-and-white prints. Two companies that sell .003 mil sleeves: Hiswick Trading, Inc., 31 Union Ave., Sudbury, MA 01776; Sunland Mfg., 6800 Shingle Creek Pkwy., Station 12, Minneapolis, MN 55430, (612) 560-7711.

### Print Multiple Copies

Successful stock photographers develop a solid Market List and then supply on-target pictures to photobuyers on that list. To save darkroom time, print several copies of each black and white at one session, and distribute them simultaneously to appropriate buyers on your list or keep them on hand as backups in your files. Use a similar technique for color by shooting several originals of your subject when on the scene (see "Color," chapter five).

Should you send contact sheets as part of your mail-marketing system? Only rarely will a buyer want to see contact sheets. If you were on assignment, for example, it's conceivable the editor would want to see other selection possibilities. He would ask you to pre-edit them, and you would circle with a grease pencil alternative shots. Otherwise, don't display your less-than-perfect pictures by sending contact sheets.

Should you send negatives? If an editor wants your negs, it's probably to make better prints than those you have submitted. Rather than run the risk of damage to your negatives, volunteer to reprint the pictures or to have a custom lab print them. Avoid sending negatives to photobuyers.

### Sending Color Prints and Disks

Color prints are gaining acceptance in the stock-photo industry. But until the technology in the printing industry changes, most photobuyers are stuck

with accepting only transparencies (slides). If your buyer *will* accept color prints, use the same techniques mentioned above for black and whites.

The same holds true for digital disks: You'll find few buyers ready to accept your disk. In most cases, they will request that you send your original print or transparency, and then they will either digitize it in-house or have it digitized by a local service bureau.

### Identify Your Prints and Transparencies

Identify each of your black-and-white prints with a rubber stamp on the back that includes the copyright notice and your name, address and telephone number. (If you handwrite the information, print neatly and lightly so the impression doesn't come through.) Also include your picture identification number (see chapter thirteen).

RC papers do not take standard rubber-stamp ink. Circumvent this problem by first placing a blank label on the back of your print, and then rubber-stamping the label. Or use spirit-base ink and pen the identification information by hand. The ink has a tendency to dry up, but keeping it in a resealable plastic bag solves this. An excellent source for rubber stamps and inks is Jackson Marking Products Company, Brownsville Road, Mt. Vernon, IL 62864, (800) 851-4945. Their fast-dry stamp pad is called the Mark II.

Do not include a date code in your identification system. Photobuyers will recognize the date, and your picture will be dated before its time. If slides have a date printed on the side, cover it with a label imprinted with your identification details. If for some reason you need a date, put it in Roman numerals or use an alphabetical code—for example, A = 1, B = 2, C = 3, etc. The fifth month would be E, and the year 1999 would be II (E/II).

### Captions

Because your pictures will be used as illustrations, not as documentation or news pictures, captions will seldom be necessary. Besides, in most cases the editor is looking for a picture to fit a theme or use he has in mind; he may already have written the caption.

Captions are sometimes necessary for travel pictures, wildlife, horticulture, and related themes or picture sequences. When you need to include captions, type them all on one page, and key them by number to each photograph or slide. Keep a photocopy for yourself. As a general rule, make your captions brief; include who, what, where, when and why. The editor will tailor the information to the publication's style.

Before packing up your photographs to send off to a prospective buyer, give them this checklist test:

☐ **Selection**—Do your photographs fall within the specialized interest area of the photobuyer?

☐ **Style**—Do your photographs follow the illustrative style the buyer is partial to?

☐ **Quantity**—Are you sending enough? Generally, you should submit a minimum of two dozen, a maximum of one hundred. There are exceptions to this, such as the single, truly spectacular shot that you might rush to an editor because of its timeliness or for another reason.

☐ **Quality**—Can your photographs compete in aesthetic and technical quality with stock photos the buyer has previously used?

☐ **Appearance**—Are your prints and transparencies neat and professionally presented?

If your photos don't conform to the suggestions I've given, then hold off submitting. Eagerness is a virtue, but as in any contest, you must match it with preparedness.

## Packaging: The Key to Looking Like a Pro

Once you have your photos prepared, present them in a professional package. One editor told me that she receives about ten pounds of mail every morning. She separates it into two piles: one that she will tackle immediately, and a second that she will look at if and when time permits. I asked her how she determined which pile things belonged in, and she answered, "By the way they're packaged."

Your package will be competing with all those other pounds of freelance material when it arrives. The secret to marketing your pictures is to match your PMS/A with the correct Market List. But if the editor never sees your pictures because of faulty packaging, they won't get their chance.

Use a packaging system that is trim and sturdy and that stands out. I recommend large white mailers made of stiff cardboard. They give an excellent appearance and have a slotted end flap that makes them easy and fast to open and close. Buyers can use the same mailer to return unused photographs. (Since you can't be sure the buyer will automatically reuse your envelope [or *mailing carton* as it's called in the industry], have a rubber stamp or label made that reads: "Open Carefully for Reuse" or "Mailer Reusable" and put it on the flap of the envelope.) The mailers can be recycled several times, since they are made of heavy material and hold up well. Place your new address label over the existing label, and white self-apply labels (available at stationery stores and through computer sales catalogs) over previous stamps and markings. Three distributors of white cardboard mailers:

Calumet Carton, 16920 State St., South Holland, IL 60473

Mailers, 40650 Forest View Rd., Zion, IL 60099, (800) 872-6670

PACK A LOPE, International Envelope Company, Number 11 Crozerville Rd., Box 2156A, Dept. 52, Aston, PA 19014

This type of mailer also saves you from having to pack your photographs between two pieces of cardboard, wrap rubber bands around same and then stuff the result into a manila envelope. You can understand why, when editors have to unwrap this type of submission twenty times a day, they welcome a submission in a cardboard envelope, where pictures tucked in a plastic sleeve slide in and out easily. Manila envelopes also have the disadvantage that postal workers tend to identify the manila color as third class. Also, photobuyers might think of your photos as third class, and worse, you may think they are. Go first class, and mail in a *white* envelope. It will help your package receive the tender care it deserves, both coming and going.

As long as we're considering the book-by-its-cover judgment, invest in some personalized, self-apply address labels. Your reliability factor will gain points if your logo on the labels is distinctive. Also use this opportunity to display your "unique slogan." Have return labels printed with your name and address, which you'll include on the inside of your package with an SASE for the editor.

### How to Send Your Submissions

Assuming you use the U.S. Postal Service, you will find that priority mail treats your packages with respect and moves them quickly to their destinations for the least cost. Priority mail is placed in the first-class bin.

Courier systems such as FedEx and UPS are popular with stock photographers, especially if you are dealing with a buyer new to your Market List. The advantage of couriers is that they hand deliver (usually) directly to the photobuyer and have her sign for the package.

You might want to consider insuring your U.S. Mail package. (The best bargain is the $1 to $50 coverage for seventy-five cents. Postal insurance rates change, so give your local post office a call for current rates.) Keep in mind that in the event of damage or loss, the U.S. Postal Service considers your pictures worth only the cost of replacement film. Your main reasons for getting insurance will be the extra care it guarantees your package and the receipt the delivery person collects from the recipient. The post office will have documentation that your package arrived if you need to trace it. (For less than a dollar more, you can also have a return receipt sent directly to you.) This document can come in handy if the photobuyer ever says, "I didn't receive your shipment."

---

**TRACK SALES FOR SUCCESS**

If you don't know where you are going, how are you going to get there?" is the adage we hear often. Numbers let you know where you are and where you've been. They can also predict how soon you will be there, and which buyers are producing the most sales and the greatest revenue. Tracking results of your photo sales is made easier and less boring these days with accounting, spreadsheet and photo-tracking software.

---

Shipping your photos by registered mail is good insurance, too, of course, but expensive. The lower cost of sending material via priority mail for regular shipments usually outweighs the speed advantages of registered mail or Express Mail. I'm aware that many photography books recommend sending your shipment via registered mail. I'm also aware that the authors of those books are not engaged in stock photography as their principal source of income. Registered mail is expensive.

Insuring or registering your photos for $15 or $1,500 will not ensure that you will receive that amount if they are lost or damaged. Only if you have receipts showing how much you have been paid for your pictures previously will you have a case. Otherwise you'll receive only the replacement cost—about fifty cents for each slide or print. The best insurance is prevention. Use the packaging techniques I've described here and you will have little or no grief.

If you are just starting out in stock photography, include return postage in your package. Most buyers not only expect it, they demand it. Some refuse to send photographs back if return postage is not included. Purchase a small postal scale at a stationery store, and you can easily figure your postage costs at home.

There are three acceptable ways to include return postage (SASE), described as follows:[1]

1. If you use a manila-envelope packaging system, affix the stamps to a manila envelope with your return address, fold and include in your package.

2. Place loose stamps for the amount of the return postage in a small (transparent) coin envelope, available at hobby stores. Tape (don't staple) this envelope to your cover letter. This method has the advantage that often the photobuyer will return the stamps to you unused. You can interpret this as a sign that the photobuyer is encouraging you to submit your pictures again in the future.

3. Write a check on your business checking account for the amount of return postage. Make it out to the publishing house, agency, etc. Your reliability factor will zoom upward and, nine times out of ten, you'll receive the

---

[1]Readers outside the U.S.: Contact your local Postal Service, purchase International Reply Coupons and include them as equivalent return postage.

check back, uncashed. Besides, the bookkeeping department at the photo-buyer's probably has no accounting system for such checks. Another advantage: Say by rare chance the client happens to lose or damage a print and reports to you they have no record of receiving the pictures; if they cashed the check, you would have proof that they received your submission.

## Writing the Cover Letter

Always include a cover letter in your package. But remember that photobuyers are faced with the task of sifting through hundreds of photo submissions weekly. They don't appreciate lengthy letters that ask questions or detail f-stops, shutter speeds or other superfluous technicalities. Such data is valid for salon photography or the art photo magazines, but not in stock photography.

If you do feel compelled to ask a specific question (and sometimes it's necessary), write your question out on a separate sheet of paper and enclose an SASE for easy reply.

The shorter your cover letter, the better. Your personal history as a photographer, or where and when you captured the enclosed scenes, is of little interest to the photobuyer. All you really need in the cover letter is confirmation of the number of photos enclosed, your fee and the rights you are selling. Let your pictures speak for themselves.

Your cover letter should be addressed to a specific person, whose name you'll find by consulting your Market List or by calling the reception desk of the publishing firm or agency. A typical cover letter might read like the one in figure 9-1.

This cover letter may not win any literary awards, but it's the kind photobuyers welcome. It tells them everything they want to know about your submission.

Photobuyers like to deal with photographers with a high reliability factor—photographers who can supply them with a steady stream of quality pictures in the photobuyers' specialized interest areas. They don't want to

---

**THE SOHOA: HELP FOR THE AT-HOME WORKER**

The Small Office/Home Office Association (SOHOA) is an organization for small-business owners who want to stay up to speed with new business and technological developments. Membership at this writing is $49. They are hooked up with over 2,000 service centers that offer discounts to members. They are also in alliance with *Home Office Computing Magazine* and *Small Business Computing Magazine*. They offer the guide "Working at Home: Everything You Need to Know About Living and Working Under the Same Roof," by Paul and Sarah Edwards, who are pioneers in the area of "Electronic Cottages." [Contact SOHOA at 1765 Business Center Dr., Suite 100, Reston, VA 22090, Toll Free: (888) 764-6211.]

go through the time-consuming process of developing a working relationship with photographers who can supply only a picture or two every now and then. The right cover letter will signal to the photobuyer that you are not a once-in-a-while supplier.

### First-Class Stationery

To make a professional impression, have your cover letter typeset. If this isn't practical, use a word processor to type it, and then have the letter printed at one of the fast-print services on 24- or 28-pound business stationery. Include your letterhead and logo for a first-class appearance. Leave the five blanks in your letter to fill in by hand for each submission (see figure 9-1).

The strategy here is that photobuyers will not be offended by receiving a form letter, but rather will welcome it as the sign of a knowledgeable, working stock photographer. The message the letter telegraphs is that someone who's gone to the expense of a printed form letter on quality stationery has more than a few photographs to market. If the pictures you submit are on target and you include an easy-to-read, concise cover letter, you are on your way to establishing yourself as an important resource for the photobuyer.

If you have learned of a specific need a photobuyer has (through a mailed photographer's memo, announcement in a photo magazine or listing in a market service such as *PHOTOLETTER*, *PhotoDaily* or *VSN/Photonet*), what kind of letter should you send? Again, your letter should be brief. Include many of the details listed in figure 9-1. However, also include the number or chapter of the book, brochure or article for which the photos have been requested. Photobuyers often work on a dozen projects at a time. Knowing which project your pictures are targeted for helps!

Use a form letter if I've convinced you; otherwise, send a neatly word-processed letter.

## Deadlines: A Necessary Evil

Because photography is only one cog in the diverse wheel of a publishing project, photos are necessarily regarded by layout people, production managers, printers and promotion managers not as individual aesthetic works, but as elements of production value within the whole scope of the publishing venture. Book and magazine editors often have a tendency to treat photography as something that should support the text rather than the other way around. Hence, they load photo editors with impossible deadlines. If your photographs are due on such and such a date, the photo editor is not kidding. Being on time can earn you valuable points with a photobuyer.

Develop the winning habit of meeting deadlines in advance. It will increase both your reliability factor and the number of checks you deposit each month.

---

## YOUR LETTERHEAD

[Date]

Dear _____:

Enclosed please find [number] [slides, 8″ × 10″ b&w prints] for your consideration. They are available at $ _____ (color) and $ _____ (b&w)[2], for one-time publishing rights, inside-editorial use. Additional rights are available. Please include credit line and copyright notice as indicated.

You are welcome to scan or photocopy the enclosed picture(s) for your files for future reference. My name and address, as well as a print number, are included on each picture.

I'd appreciate it if you would bring the enclosed pictures to the attention of others at [publishing house or company office] who may be interested in reviewing them.

You are welcome to hold this selection for two weeks (no holding fee). I have enclosed postage for their return.

Thank you for your attention.

Sincerely,

[Your name]

---

*Figure 9-1. Sample cover letter to send with submissions to photobuyers.*

[2]It's essential that you state a fee (see tables 8-1 and 8-2).

---

**JOINT VENTURES**

Other businesses can help you, and you can help them. It's called a joint venture. For example, a local seed company publishes an annual catalog. You work up a joint venture with them. You reduce your fee because they arrange for the models and the filming locations. You get to include all photos in your file to sell as stock or to send to your agency. The company also guarantees a credit line for you on the front and back cover of their catalog.

There are many ways to joint venture with other companies whose audience, clients or mission is the same as yours. Both of you can benefit.

---

## Unsolicited Submissions

The word on the street is that photobuyers look upon unsolicited submissions with disdain. This is partly true. If you were an editor of an aviation magazine and I sent you, unsolicited, a couple dozen of my best-quality horse pictures, you'd be righteously perturbed. However, if I sent a group of pictures, unsolicited, that were tailored to your needs, and showed a knowledge of aviation plus some talent with the camera, you'd be delighted, especially if I sent you an SASE for those you couldn't use.

"Most freelancers send me views of birds against the sun or close-ups of flowers, and maybe a kid with a model sailboat. Don't they even look at our magazine?" an editor of a sailing magazine asked me.

You can understand why some editors have a tendency to lump freelancers and unsolicited pictures into the category of undesirable.

If you've done the proper marketing research, photobuyers will welcome your unsolicited submission. On the other hand, if you haven't figured out the thrusts of the magazines or the needs of the publishing houses, don't waste your time or postage and earn their ire by submitting random photos to them. You won't last long as a stock photographer, no matter how good your pictures are. Ask yourself before you send off a shipment: "Am I risking a *no-sale* on this one?" Choose a market whose needs you've pinpointed— one that you're sure of scoring with.

## The Magic Query Letter

If you have advanced to a stage in your photo-marketing operation in which you are prepared to contact multiple markets on your list, here is an introductory-query-letter system that will prove helpful. This system is designed to hit the right buyer with the right photograph every time.

When postage was a dime (pre-1975) and photo paper was a quarter (pre-1970), photographers used a shotgun method of contacting prospective markets. That is, they sent samples of their photographs almost indiscriminately to any photobuyer on any mailing list. Today's economics encourage,

instead, the rifle method of reaching buyers; that is, narrowing down your prospective photobuyer list to a select Market List.

When you are ready to select targets for your query letter, concentrate on the fields of your particular interest, for example, education, medicine, sailing, gardening, botany, automotive or camping. Within your personal interest fields, you'll find specialized magazines, specialized publishing houses, specialized readers and specialized advertisers.

The age of the general-audience magazine disappeared with the weekly *Life, Look* and *Saturday Evening Post*. Their place was filled by the special-interest magazines, which contain subject matter ranging from hang gliding to geoscience to executive health. The diversification continues. Gardeners have their interests featured in magazines covering houseplants, ornamentals, backyard farming, organic gardening, flowers, etc. Boat enthusiasts all have their own special magazines ranging from sailboats to submarines. Horse lovers have their own private reading: magazines on the Arabian, the quarter horse and so on. Why venture into fields that have little or no interest to you when you are already a mini-expert in at least a half-dozen fields that could provide you with more than enough markets to choose from?

The key to the magic-query method is an initial query letter to each prospective editor. What you say in this letter will move the editor to invite you to submit your photographs.

The query letter, to be effective, must be brief and simple—yet spur the editor to reply immediately and request your submissions for consideration. Here's how to plan your letter, individualized to each market.

You must immediately hit the buyer where his heart is: In your first sentence you must include a magic phrase that will grab his attention and rivet him to your letter.

It will take some research on your part, but once you've worked out that magic phrase, not only will your letter be read, it will also be hearkened to and acted on. The query letter in figure 9-2 provides a useful model for you to follow.

The majority of publications today are designed for specialized audiences. Imagine the structure of a special-interest magazine as a pyramid. At the base of the pyramid are the thousands of readers and viewers who are fans of this special area of interest. Next up on the pyramid are the people with an economic interest in this specialized area: the advertisers. Farther up are the creative and production people who put the magazine together—the writers, designers, layout artists, printers, photographers, etc. At the top of the pyramid is the publishing management. The pinnacle of our pyramid contains the concept, the idea or theme upon which the magazine is based.

Now, here's the key to that magic phrase. Outside appearances would have you believe that the essence of, say, a magazine called *Super Model Railroading* would be model railroads. It is not.

You're only one-eighth right. (And this is where most suppliers—writers,

---

# YOUR LETTERHEAD

[Date]

Dear _____:

I am a stock photographer who specializes in[3] _____

_____ [Note: It's on these lines that you enter

_____ your magic phrase or sentence.] _____

_____     _____

May I be of assistance to you? I'd like to send you a selection of my

photographs for your consideration. They are available at $ [4] for one-

time rights, inside-editorial use.

I have enclosed an SASE for your convenience. I look forward to work-

ing with you.

Thank you for your attention.

Yours sincerely,

[Your name]

---

**Figure 9-2.** *The magic query letter.*

[3]Or you could say, "I am a photographer who has a file of pictures that . . ."
[4]Insert your fee (see chapter eight).

graphic designers and photographers—lose the trail when they initially contact a prospective editor.) Here's the essence of *Super Model Railroading*: to allow adults the license to buy and play with expensive toys.

In the first sentence of your query letter to the editor of this magazine, you would use a magic phrase like "I specialize in photographs of people enjoying their hobbies."

Let's look at another example. A magazine called *Today's Professional RN* appears to have professional nursing as its theme. Yes, that's the magazine's stated theme. But what is its unstated theme—the subject that touches the heart of its readers, and therefore the publication's management? The essence of *Today's Professional RN*: to remind nurses that they deserve the respect and esteem accorded to other community health-care professionals such as physicians, psychologists and dentists.

In the first sentence of your query letter, you would use a magic phrase like "I specialize in health-care photography, and have in my stock file a large selection of pictures showing nurses playing a key role in our health-care system." The editors of specialized magazines are always looking out for their readers, advertisers and bosses. If the first sentence in your query letter indicates you can help in that mission, the editor will say to himself, "Now here's a person who speaks my language!"

Your job as a query-letter writer becomes one of separating illusion from reality in the publishing world. As you can see, it will take some study on your part. But the study becomes pleasurable if you direct your research to magazines you already enjoy reading. Make a game of distinguishing between a magazine's stated theme and its real theme. You'll be surprised how easily you learn this technique, especially for the magazines on your Market List.

And what is the reaction of an editor who receives a query letter that shows no preparation on the part of the photographer? He feels insulted: He runs a tight ship. He has deadlines. He trashes the letter. He's not about to show any consideration to a photographer who has not shown him the courtesy of studying his magazine.

But if you've done your job in your first sentence, and your first paragraph shows you are interested in both the magazine *and* the photo editor, you will have his attention. He will be alerted to your inventory of pictures, but beyond that, a couple more ideas will be occurring to him:

1. If you are an informed photographer (in his field), you are a miniexpert and therefore a valuable resource to him, and you could be available for assignments.

2. Although you've said you have certain photographs that you believe to be adaptable to his needs, you might have many more photographs that are adaptable to his needs. For example, perhaps his publishing firm is starting up a sister publication and is on the lookout for additional pictures in an allied area of interest.

The second paragraph of your query letter should confirm the attitude expressed in your first paragraph, namely, that you are aware of his photo needs.

And how do you become aware of those needs? By studying the magazines you find in libraries, dentists' offices, friends' homes and business reception rooms. Photo-marketing directories, such as *Photographer's Market* and those listed in table 3-1, describe thousands of magazines and list them by special-interest areas.

Before you send your query letter to an editor, request his photographer's guidelines. Most magazines provide a sheet of helpful hints to photographers, and if you contact the photobuyer on deluxe, professional stationery, complete with your logo, he'll send a sample issue of their publication as well.

You are now ready to write the magic query letter. Figure 9-2 is a sample of how your query letter should sound.

You'll notice in the magic query letter that there is an abundance of *I*s. This may seem contrary to your writing style (or training), but those *I*s are there for a purpose: To give the editor the impression that this new recruit is dynamic, aggressive and self-centered. (Note: Welcome to the world of business! If being dynamic, aggressive and self-centered turns you off, you've got to reexamine and adjust your thinking. Timidity, modesty and humility are nice attributes, but not if you want the world to see your pictures.)

In this letter, there is a good balance with the word *you*. (Most schools of persuasive writing teach that *you* is the most beautiful word in the language.) Your job as a letter writer is not really to inform an editor, but to move him to action, to make him want to see and buy your pictures. The magic query letter will put you leaps ahead of your competition, because editors will act.

## Should You Deal With Foreign Markets?

Once you are settled in to dealing with domestic markets for your stock photography, you might want to investigate the hundreds of foreign markets, some of which might be target markets for you. The easiest way to break in is to work with an established foreign stock-photo house.

*Where to Sell Your Photographs in Canada*, by Melanie E. Rockett [PPP Ltd., 1128 Quebec St., Unit 304, Vancouver, BC V6A 4E1, Canada, (604) 899-9403.], shows American and Canadian photographers where the markets are. A helpful magazine article is "Marketing Overseas," by Sharon Cohen (*Studio Photography*, July 1990). For a directory of foreign markets, ask at your library for *Ulrich's International Periodicals Directory* (Reed References).

## Which Are the Heavy Purchasing Months?

Recently I sent out a questionnaire to one hundred photobuyers, asking them which months of the year are their busiest in terms of picture buying. Table 9-1 indicates that the thirty-five photobuyers who responded share one of two prime purchasing periods: midwinter and midsummer. My more than two decades of experience as a stock photographer marketing by mail confirms that these are heavy purchasing periods for a good proportion of the publishing industry.

Why midsummer and midwinter? At first glance, one might suspect editorial reasons: In midsummer, photo editors are buying for holiday-oriented projects; in midwinter, they are buying for the beginning of the next school year.

But editorial considerations don't appear to be the case. My guesstimate would be budgetary reasons. Publishers are working on either a fiscal (July 31) or a calendar (December 31) year, which means cash flow is down in July or December and up again in August or January.

How does this information help you as a stock photographer? Morale-wise, it might help you to know why those checks aren't coming in during the months of July and December. It can also help you to market more accurately. Your marketing strategy calls for periodic mailings of photo illustrations for consideration. Note in table 9-1 that you can increase your chances of scoring if you aim at the midwinter and midsummer months.

But before you decide that you have photo marketing down to a formula, don't forget that table 9-1 represents a sampling of only thirty-five publishing houses. Also, some of the photobuyers, such as Rodale Press and *Highlights for Children*, reported that "All months are equally busy." And what about the peak in the graph in May and the dip in June? I have no concrete explanation, except that editors have been known to clear their

| JAN | FEB | MAR | APR | MAY | JUN | JUL | AUG | SEP | OCT | NOV | DEC |

*Table 9-1. Seasonal trends in photobuying in the book publishing industry.*

desks before departing for summer vacation! The last couple of weeks in December are especially dead in the publishing industry.

If your Market List leans toward textbooks, you'll want to consider this: Many textbook companies work with two different printing dates during any given year—June, for the regular September delivery date on textbooks, and December (usually the month of kickoff sales meetings), when all new special books and textbooks are presented to the sales staff for the coming year's sales efforts. You can figure that picture selections for books and textbooks are made anywhere from two to four months before the printing date. This average, of course, is relative and subject to variations (both yours and the photobuyer's), so be sure to consider table 9-1 only as an indication of what happens much of the time in much of the market—to be balanced against your own PMS/A, your Market List, your experience and your schedule.

If nothing else, table 9-1 might help to explain that slow payments or slow sales do not necessarily reflect a stock photographer's ability to photograph or a photobuyer's ability to pay. To everything there is a season.

Don't forget: When preparing seasonal pictures, check with your individual markets as to their lead time (usually about six months). In other words, be prepared to send springtime pictures in September. Photobuyers usually work that far in advance.

## How Long Do Photobuyers Hold Your Pictures?

"The photobuyer is holding my pictures an unreasonably long time, don't you think?" a photographer recently asked me. He had sent his pictures six weeks previously.

"Not so," I said. "Especially if the photobuyer makes a purchase."

The buyer subsequently bought the pictures in question. Everyone was happy.

How long should a photobuyer hold your pictures? Two weeks to two months is a safe answer. Magazine editors, for example, will hold your pictures about two weeks, sometimes four. However, if you've requested in your cover letter that the editor circulate your submission to others at the publishing house who might be interested in reviewing them, and the publishing house is a large one, you may not see your pictures again for six weeks (up to six months for a textbook publisher).

If you've directed your pictures to a book or textbook publisher, they could remain at the house for as long as eight weeks, since book production schedules often require more complex dovetailing and coordinating than magazine schedules. Ad agencies and PR firms are less likely to hold your picture for an unreasonable length of time. The reason? They are usually working on a tight deadline. Their decision must be quick.

You will not notice how "unreasonably" long photobuyers are holding your pictures if you make several duplicates of your black and whites and

offer them to your Market List simultaneously. If you have made reproduction dupes of your transparencies, offer them simultaneously to several non-competing markets.

Here are a few variables that can result in photobuyers holding your pictures for a while:

1. The deadline for the project (textbook, brochure, article) has been extended, giving the buyer more time to make a decision on your pictures.
2. The buyer likes your pictures and has set your package aside for further consideration.
3. The buyer likes your picture but wants to do a little more shopping, in case he can find something even more on target.
4. The photobuyer has forwarded your pictures to the author (of the textbook, book, etc.) for consideration. The author is holding up the decision.
5. The buyer's priorities have changed and your picture is now in the number 2 (or number 6) priority stack.
6. The photobuyer is a downright sloppy housekeeper and your pictures won't surface until spring housecleaning time. (Fortunately, there are very few photobuyers in this category.)

If a photobuyer keeps your pictures longer than four weeks (and you are certain the selection date has passed), drop him a courteous note. You can expect a form-letter reply letting you know of the disposition of your pictures. Textbook editors hold pictures longer, as mentioned earlier. Usually, if a picture lingers at a textbook publisher's, you'll be notified within three months that it is being held for final consideration.

Most editors (textbook editors included), however, when looking over photography (especially general submissions), attempt to review pictures the very same day they arrive, and if none of the pictures is to be considered for publication, the editor will have them shipped back the following day. This makes good sense both for insurance purposes and for office organization. If one or more of your pictures is being considered for publication, the photo editor might hold your complete package until a decision is made.

Again, the best solution to the "unreasonable" length of time a photobuyer may hold your pictures is to make several duplicates. Get many, many black-and-white prints and transparencies out working for you, and you'll be so preoccupied with sending them out and reaping the rewards that you won't have time to track down tardy photobuyers.

What insurance coverage does a publishing house have that, in case of fire or similar calamity, would cover your pictures being held? In some cases, your slides and black-and-white prints would be considered "valuable documents" and be replaced accordingly. Generally speaking, publishing houses

have a blanket insurance policy on your photographs. This blanket policy also includes their office equipment, light fixtures and other tools of the trade.

Nevertheless, publishing houses do not like to keep your pictures any longer than they have to, because as long as your pictures are in their possession, they are responsible. Between your place and theirs, the U.S. Postal Service or UPS has that responsibility—if you happen to insure your package. (Note: UPS, FedEx and other carriers will insure all your packages, free, to a maximum of $100, but will reimburse for loss only to the amount of replacement. You can declare a higher value and pay a higher fee. But, again, unless you can prove the value of the prints, transparencies or disks, you'll receive only the minimum fee unless you take it to court, which can often cost you more than you receive in compensation.)

### Using Postcards to Relieve the Agony

If not knowing the disposition of your photos is frustrating to you, take a tip from stock photographers who include a return postcard with their submissions. The stamped card is addressed to the photographer and says in effect that the photo shipment was received by so-and-so on such and such date.

Another effective contact with a photobuyer would be a memo, on your letterhead, with the message shown in figure 9-3. The accompanying postcard reads as shown in figure 9-4.

### A Holding Fee—Should You Charge One?

As mentioned before, some editors must of necessity hold your pictures for several months. This in effect takes your picture out of circulation. If it's a timely picture, such as a photograph of performers who will be in town in two weeks or a photograph taken at the fair that ends this week, you could lose sales on it. By the time it's returned to you, it could be outdated and have lost its effectiveness. To compensate for this potential loss, the holding fee was born. (Happily, most of your photo illustrations are universal and timeless if you've applied the marketable-picture principles of this book.) Some photographers have been known to charge a holding fee for pictures held beyond two weeks. The holding fee ranges anywhere from $1 to $5 per week for black and whites to $5 to $10 per week for color.

To make a potentially lengthy discussion short: Don't charge a holding fee unless you are a service photographer dependent on quick turnover of your images, or you are an established stock photographer working exclusively with price range 1 (see table 8-1).

As a newcomer to the field, you'll find, of course, exceptions to my dictum. And you'll have to be the judge when the situation arises. Generally speaking, editors will frown on an unreasonable holding fee and on you, especially if you are a first-time contributor to their firms.

TO:

FROM:

PROJECT:

On _____

I sent _____ [transparencies] [prints] to

your office for consideration. Kindly let me know their disposition on the

enclosed return-reply postcard.

Thank you for your interest in my work.

                                    Yours sincerely,

                                    [Your name]

*Figure 9-3. Memo to inquire about pictures being held too long.*

We have received your [transparencies] [prints].

☐ Your pictures were returned to you on _____ .

☐ We are still holding your pictures for final selection. You should hear
   from us by _____ .

☐ _____ of your pictures have been selected. You will receive payment
   on _____ .

☐ Enclosed are _____ of your pictures. We are still holding _____
   pictures for final consideration.

Remarks:

_____

Name                            Title

_____

Firm

*Figure 9-4. Postcard form for editor's reply about late pictures.*

As I mentioned, here's the secret to overcoming the possibility of losing sales on your timely pictures: Make duplicates, and have several of them out working for you simultaneously. (For information on quality color reproduction duplicates, see chapter five.)

## Sales Tax—Do I Need to Charge It?

Not every state charges sales tax, but if you live in a state that does, contact your state Department of Internal Revenue for details. If you make a sale within your state, you need to charge sales tax. If the sale is to an address outside your state, no sales tax is required. Generally speaking, most stock photographers deal long-distance and sell outside their own state. Since you are "re-selling" a product (photographic paper or transparencies), you are probably eligible to receive a Seller's Permit, which exempts you from having to pay sales tax when you buy supplies such as paper and film.

In California, the question of "one-time" use of photographs came up, and the State Board of Equalization addressed it with this ruling: "Photographers who license their photographs for publication should be aware that merely because the photographer owns the rights to the photographs and retains the negatives does not mean that a sale has not taken place. The transfer of possession and use of a photograph for a consideration (license fee) is a sale and is subject to state sales tax. There is only one exemption to the above, which is for newspaper use—but not for magazines or any other commercial use—even if for 'one-time use only.' "

You'll need to check what your state's policy is. Generally speaking, most states do not require you to collect sales tax.

## When Can You Expect Payment?

Most photobuyers on your Market List will pay on acceptance rather than on publication. If they don't, drop them to the bottom of your Market List. After all, your PMS/A matches only certain markets, but you bring to those markets an exclusive know-how that other photographers do not possess. You are an important resource to editors. Be proud of your talents. If some editors don't reward you with payment on acceptance, replace them.

Photobuyers usually send a check to you within two to four weeks after they've made their decision to purchase. However, each publishing house works differently: Some pay more quickly, others take longer in their purchase-order and bookkeeping procedures. However, if a publishing house has a $30,000-a-month photo budget—not a high figure in the photo-buying world—and is slow in paying, I'm sure you won't be too irate if the several checks a month addressed to you customarily arrive a little late. Many publishing houses across the nation have $30,000-a-month photo budgets or close to it, and they're seeking your pictures right now. If one publishing house is late with its payment, spend your energy sending the

others more pictures rather than composing letters of complaint. (If you've built your Market List correctly, you'll find few deadbeats in it.)

## How Safe Are Your Pictures in the Hands of a Photobuyer?

Contrary to popular opinion, photobuyers do not have machines that split and crack 8″×10″s, scratch and crinkle transparencies and sprinkle coffee over both. Your submission will receive professional handling if you are careful to submit only to professionals. If you aren't sure whether a publishing company is new to the field, check a previous edition of *Photographer's Market* or similar directory. If the house was listed three years ago, that's a factor in its favor.

Here at PhotoSource International, I receive occasional complaints from photographers about a photo editor's handling of their pictures. Invariably, mishandling of pictures can be traced to employees of a company new to the publishing business. It's rare that a publishing house with a good track record will mishandle your submissions. The reliability factor works both ways: Buyers expect you to be dependable, and you should be able to expect the same from them. If you find that a publishing house projects a low reliability factor, avoid it.

Don't spend sleepless nights fretting about your pictures. Instead, imagine your stock-photography operation as a long tube. You put a submission in one end, and keep putting submissions in, moving down the tube. Instead of waiting by the mailbox, put in more time in the darkroom or snap more slides for your stock-photo file. Keep the submissions moving down the tube. One day you'll hear a sound at the other end—the check arriving!

### Lost, Stolen or Strayed?

In order to be useful, stock photos have to be published rather than hoarded. A stolen photo that's subsequently published increases the thief's chances of being discovered. You'll rarely hear of a stock photo stolen by an established publishing house. However, online delivery of stock photos, plus improvements in scanning techniques, makes it easy for the online desktop publisher to "borrow" images. As the Internet matures, new encryption methods and enforcement of copyright will meet this challenge.

Will your photos get "lost"? As I mentioned earlier, when a picture is lost, whether en route or at a photobuyer's office, the record reveals that it is most often the fault of the photographer.

Here are some common reasons:

1. No identification on the pictures, or identification that is blurred or unclear.
2. Return mailing information missing, incomplete or unclear.
3. Erroneous address on the shipment to begin with.
4. Failure to include return postage (SASE) when appropriate.

I have talked with many photobuyers who say they have packets of photographs and many single photographs gathering dust in their offices because the photographers did not include an address on the pictures. Once pictures become separated from the original envelope, the buyer has no way of knowing where to return them. Many orphan photographs hang temporarily on photo editors' walls—they're that good!

I myself have lost one shipment in over twenty-five years of photo illustration. I should say temporarily lost, because after five years, the editor's replacement discovered my ten photographs in the back of a filing cabinet. My mistake: Sending a shipment to a novice editor.

Loss of your black and whites or transparencies is best avoided through prevention: Don't send pictures to photobuyers or publishing houses that have no track record. Prevention is cheap. And it's a good habit to get into in photo marketing.

## Your Recourse for Lost Pictures

This is not to say that an honest error can't be committed by a photobuyer. Let's say that some of your pictures are lost and the photobuyer appears to be at fault. Your best policy is good old-fashioned courtesy. Otherwise, a good working relationship between you and the photobuyer can break down, sometimes irreparably. Don't be quick to point an accusing finger, and perhaps lose a promising client. Consider the following:

1. Have you double-checked to see if the person you originally sent your pictures to is the same person you are dealing with now?
2. Have you waited ample time (four weeks for a magazine, eight weeks for a book publisher) before becoming concerned?
3. Have you asked if your pictures are being considered for the final cut?
4. Have you checked with the postal authorities on initial delivery?

If you definitely establish that your pictures arrived and are now lost, three options are open to you, depending on who lost your pictures, the photobuyer or you.

When I speak of lost pictures, I am referring now to one or more transparencies, or a group of prints. Photobuyers generally do not expect to engage in negotiations over a single print that they know can be reprinted at much less than the cumulative exchanges of correspondence over it between photographer and photobuyer. If a single print disappears, my suggestion is to accept the loss and tally it in the to-be-expected-downtime column.

Transparencies are another story. A transparency is an original. Photobuyers are prepared to talk seriously about even a single transparency—if it has been established that they did receive the picture. One excellent way (mentioned earlier) to keep tabs on delivery of your shipments is to invest

in a return receipt. The post office will provide you with documentation that someone signed for the package.

Another protection is a liability stipulation, which you include in your shipment, to the effect that if the buyer loses or otherwise damages your transparency, his company is liable to you for $1,500.

Does this latter course seem excessive? Many photobuyers think so, and you get on their blacklist if you try it. There's an old story about Joe Montana demanding a special jersey number, a special footlocker and white football shoes. The coach just laughed at him. Joe was thirteen at the time. Even Ernest Hemingway had to settle for less than optimum contract agreements in the early stages of his career. So did Van Cliburn, Tom Cruise and Barbra Streisand.

When you're an unseasoned freelancer, you "takes what you gits." Initially, exposure and credit lines are your prime rewards. Only when you have proved to an art director or photobuyer that you can deliver the goods, and that she needs you, can you call the shots. Until you've proved yourself valuable to a photobuyer or publishing house, you're not in a position to talk liability stipulations.

In this age of malpractice suits, some publishers have become gun-shy because a small but significant number of photographers have aimed at ensnaring companies by pressing suit for loss of transparencies (rarely are prints involved). Consequently, publishers shy away from dealing with new and untried stock photographers, or they take precautionary measures with them such as having the photographer sign a waiver that in effect releases the publishing house from any and all liability.

That's why it's important to discern who's doing the talking when you hear old pros advise that "you ought to require photobuyers to sign liability agreements." When the pro advises you to get a liability release from the publisher, he just might be using one of the tricks of the trade (any trade) to eliminate competition. He knows that photobuyers will steer clear of you if you summarily present them with a liability requirement. Or it might be an ego trip for the pro to suggest that you get the release. Only the known and the best can make demands, as Joe Montana eventually learned.

The commercial stock photographer and the editorial stock photographer may have different attitudes toward this liability problem. As an editorial stock photographer, your interest in photography as an expressive medium differs a lot from that of the commercial stock photographer who concentrates on photography as a graphic element in advertising, fashion or public relations. The commercial stock photographers' rights to sell their services and to protect their business with holding fees, liability terms and conditions and so on should be honored. But their business is not editorial stock, and their markets are not magazine and book publishers, when it comes to dealing with photo illustrations. Yes, of course, if you're dealing with a buyer in range 1 (see table 8-1), you'll probably arrive at some mutually reasonable

LIABILITY: Submitting any film, print, slide or negative to this firm for processing, printing or other handling constitutes an AGREEMENT by you that any damage or loss by our company or subsidiary, even though by our negligence or other fault, will only entitle you to replacement with a like amount of unexposed film and processing. Except for such replacement, the acceptance by us of the film, print, slide or negative is without other warranty or liability.

Customer's film is developed by _____ _____ without warranty or liability of any kind, except to furnish the customer with replacement film at least equivalent in number of exposures to negatives lost or damaged in processing.

NOTE: Responsibility for damage or loss is limited to cost of film before exposure.

*Figure 9-5. Liability notices.*

liability agreement before too long. If you deal with buyers in range 6, the subject may never come up.

## How Much Compensation Should You Expect?

The compensation you should expect from a photobuyer for a lost picture is dependent on several factors: (1) the value of the picture to you and to the photobuyer, (2) the anticipated life of the picture itself, and (3) which price range (1 to 6) the photobuyer is in. I have talked with photographers who have received compensation ranging from $100 to $1,500 for an original transparency. A good rule of thumb is to charge three times the fee you were originally asking. If the lost transparency is a dupe, only the cost of replacement would be in order. One final consideration: There's some politics involved here. Each photobuyer can be a continuing source of income for you. How you handle these negotiations will influence how much of that income continues to come your way.

If you are still not convinced that a liberal policy toward a photobuyer's liability is sound, consider this: Two other entities also handle your transparencies: the film processor and the delivery service (U.S. Postal Service, UPS, FedEx). None of these organizations will accept liability for your transparencies (or prints) beyond the actual cost of replacement film and paper, unless gross negligence can be proven. You've seen this in small print, but as a reminder, see figure 9-5. (These notices are all from reputable film-processing companies.)

The U.S. Postal Service, UPS and FedEx will not award you more than the *replacement cost* of the film or prints. If you've insured your package for the intrinsic value of your pictures, in the event of damage or loss, the carriers will want to see a receipt establishing that value. If you don't have one, they will pay you only what it would cost you to print the pictures again or have duplicates made. The insurance would not cover sending you back to France to retake the pictures.

If you were a commercial stock photographer and the loss was substantial, and gross negligence by the courier was involved, you might want to consider taking the courier to court.

Such harsh terms should encourage you to prevent the loss of your film or pictures by packaging them well.

If you have arrived at a point in your own stock-photo career where you'd like to test the reaction of your photobuyers to a Terms and Conditions Agreement form, write to the American Society of Media Photographers (ASMP), 14 Washington Square, Suite 502, Princeton Junction, NJ 08550-1033, (609) 799-8300, for a current copy of *Business Practices in Photography* ($29.50). It includes the following sample forms (which you can photocopy or modify): Assignment Invoice, Stock Photo Submission Sheet, Stock Pictures Invoice, Model Release and Terms of Submission and Leasing (which lists the compensation for damage or loss of a transparency at $1,500). You'll also find similar forms in a book on commercial stock photography by Michal Heron entitled *How to Shoot Stock Photos That Sell* (see the bibliography). Write to me here at PhotoSource International for a free copy of a "transmittal form" we provide our subscribers (please send an SASE). If you'd like to know more about ensuring your rights when a transparency or shipment of black and whites is lost or damaged, here are five references:

*Guide to Photographer's Copyright*, Ellen Kozak, P.O. Box 380, Milwaukee, WI 53201

*Guide to Travel Writing & Photography*, Ann and Carl Purcell, Writer's Digest Books, 1507 Dana Ave., Cincinnati, OH 45207

*The Photographer's Business and Legal Handbook*, Leonard Duboff, Images Media Inc., 89 Fifth Ave., #903, New York, NY 10003-3020, (800) 367-4854

*Photography: What's the Law?*, Robert Cavallo and Stuart Kahan, Crown Publishers, Inc., 201 E. Fiftieth St., New York, NY 10022

*Stock Photography Handbook*, Michal Heron, editor; Richard Weisgrau, editorial director; ASMP, 14 Washington Square, Suite 502, Princeton Junction, NJ 08550-1033

Remember, the key to successful marketing of your pictures lies in effective communication with the people who approve payment for your pictures—the photobuyers. Your photos may have won ribbons in photo contests, but the real judge of a marketable picture is the photobuyer.

# A Twenty-Five-Point Checklist to Success

Sending out a submission to a photobuyer? Run your package through this quality control:

## Packaging

1.  ☐ Clean, white, durable outside envelope.
    ☐ Correct amount of postage.
2.  ☐ Professional-looking label with your return address and logo printed on it.
    ☐ Address that is legible and correct.
3.  ☐ SASE enclosed.
4.  ☐ Photos that are all identified: picture number, plus your name and address.
5.  ☐ Copyright notice.
6.  ☐ No date on your slides or 8″×10″s (unless you use a code).
7.  ☐ Captions when appropriate.
8.  ☐ Transparencies in thick vinyl pages.
9.  ☐ Cover letter (printed form letter) that is brief and on clean, deluxe stationery.

## Cohesiveness

10. ☐ Solicited submission: Pictures are on target as per request of photobuyer.
11. ☐ Unsolicited submission: Pictures follow style and subject of photobuyer's publication. They fit the buyer's graphic and photographic needs.
12. ☐ Pictures are consistent in style.
13. ☐ Pictures are consistent in quality.

## Quality

### Color

14. ☐ Color balance is appropriate for subject and is suitable for reproduction.
15. ☐ Chromes are used for outdoor 35mm.
16. ☐ Dupes are reproduction quality (with proper filtering) or else identified as display dupes.
17. ☐ Each slide has been checked with a magnifying glass or a loupe for sharpness. No fuzzy shots!

### Digital

18. ☐ Resolution matches the photobuyer's needs.

**Black and White**

19.  ☐  Good gradation: stark whites; deep, rich blacks; appropriate gradations of grays.
20.  ☐  Spotted.
21.  ☐  Trimmed: Edges are crisp and straight; no tears or dog-ears.

**Both Color and Black and White**

22.  ☐  In focus, sharp, good resolution (no camera shake).
23.  ☐  Current (not outdated).
24.  ☐  Appropriate emphasis and natural (unposed) scenes.
25.  ☐  P = B + P + S + I. Pictures evoke a mood.

*Can your subjects look straight at the camera without diminishing the effectiveness of your photo illustration? Yes—but not always.*

# If You Don't Sell Yourself, Who Will?

## Promoting Your Photography: How to Blow Your Own Horn

The greatest hurdle in the area of self-promotion, it seems, is not *how* to advertise oneself (many clever and creative methods are open to you), but the reticence most of us have when it comes to self-advertising. We're uncomfortable talking about ourselves in glowing terms, afraid of seeming pushy or immodest.

Many a talent has gone undiscovered because he failed to act on this salient reality: If we're going to be discovered, it's our job to orchestrate it. The number of talented photographers in this country alone must run in the hundreds of thousands. Picture the Bronx telephone directory, and then imagine that all those names are modest, talented photographers, and your name is among them. It would seem preposterous to think that the world of its own accord is going to come along and pick you out from all those other fine talents, wouldn't it? Sometimes it's actually immodest to be modest.

Society has ingrained in us the idea that unless we exhibit an acceptable degree of self-effacement, we won't be thought well of ("He's so conceited!" "She's stuck on herself!" "What an ego!").

But the viewing public deserves to see and enjoy your pictures. You deserve to have your talent rewarded with what allows us to survive in today's world: money. You must overcome the conditioning our culture lays on us and accept the fact that if your stock photographs are going to be seen and enjoyed, you are going to have to blow your own horn.

With good judgment, you can accomplish this and come off looking not like an overbearing egomaniac, but like a talented businessperson who knows how to keep her product in the marketplace.

### Talent Can Take You Just So Far

Here are four tips that should help you maintain your resolve to promote yourself—and to keep on promoting:

1. Many stock photographers, once they have achieved a name in their local area, lull themselves into supposing that the *world* is aware of their work. Not so. Think big. Don't just toot that horn, *blow* it.

2. If you want your photo illustrations to continue selling, you have to continue selling yourself. Horn blowing is an ongoing task. Don't be satisfied that photobuyers, or potential clients, are going to remember you next week because of your success with them last week or last month. Today's successes will become history tomorrow.

3. Once you begin to promote yourself, you will be pleasantly surprised to find that the people you thought would be highly critical of your promotional efforts will actually be the first to compliment you.

4. Because part of your motivation as a photographer is to share your insights and your vision of the world with others, you will find that the rewards of promoting yourself (and therefore your stock photography) will far outweigh the personal discomfort you sometimes feel when writing and distributing press releases about yourself, or when enclosing tearsheets of your triumphs in business correspondence. Without such promotion, you leave yourself at the mercy of chance. Sure, a few photographers are going to make it by sheer luck alone. Someone always wins the lottery or the $200,000 jackpot at Atlantic City. But the majority of photographers who become successful have managed it by means of effective self-promotion.

## Look Like a Pro Even If You Don't Feel Like One Yet

This applies to everything from your stationery to your flyers. The adage in this business is: *Appearance communicates quality of performance.*

Your new contacts in the photo-marketing field, since they rarely meet you in person at first, will rely heavily on the appearance you project via your communication materials. Your photography speaks for itself. Your promotional material speaks for you. It tells photobuyers how serious you are about your work—whether you're a good bet to be producing the same fine photography next month, or next year, at an address they can reach you at (your *reliability factor*). Photobuyers assume that your performance and dependability will match the quality of your presentation.

As publisher of *PhotoDaily*, I have the opportunity to see numerous creative methods of self-promotion. I've included some examples in the following sections. They will give you an idea of the possibilities open to you: producing brochures of photo samplings, making catalogs, enhancing your stationery with examples of your work and designing a distinctive logo. Limitations on space preclude my showing many more fine examples.

## Your Personal Trademark

Your photography itself becomes your trademark once you get established. But before you reach that point, a trademark may very well be an important

element contributing to your success. A distinctive logo or design can help your correspondence to start looking familiar to buyers—and your name to start being remembered.

When you design your symbol, or logo, be aware of a common error: the temptation to use the obvious—a camera, a tripod or a piece of 35mm film. You may, of course, want to choose from things photographic, but try for a combination or adaptation that's all your own. Make it simple and easy to remember. Recruit that graphics student, or that friend who's good at designing, drawing or critiquing your work, to help in the decision, based on the pointers mentioned above. Flip through the yellow pages or a business directory to see how others have tackled the question of logo. Don't be too cute in your design—the novelty will soon wear off, or even be offensive to clients. Don't be obscure, either. I consider the design of a stock photographer's stationery so important that I prepared a small kit for our newsletter subscribers that aids them in selecting a letterhead and logo for their stationery. To obtain a kit, send $2.50 to cover cost, postage and handling to me at PhotoSource International, Pine Lake Farm, Osceola, WI 54020. Mark your request "Stationery Kit."

If your photographs are highly specialized in one area, be specific with your trademark. If you are a nature photographer, you can choose a design that reflects your work—a silhouette of a fern or a close-up of a toad. Children's photographer? Choose a classic shot of yours that lends itself to a simplified sketch or drawing. As your photo-marketing enterprise grows, you'll be building equity in, and getting exposure and mileage from, your trademark. Decide your specialty early and produce a trademark that will cause editors to say, "Aha—he's a transportation photographer" or "She's a tennis photographer." However, don't worry if you don't have a strong specialty yet. You can work gradually toward becoming strong in one or two defined areas on your personal photographic marketing strength/areas (PMS/A) list, and then alter your trademark from a more general design to one tied into your specialty.

Your personal trademark doesn't necessarily have to include a design (logo) or photograph. It can consist of the name you give to your stock-photo business, with or without an identifying design. The name can be your own name or a product of your imagination. Choosing your trademark is like naming a child: The result is here to stay, so do it carefully.

It's not necessary to formally register your trademark (three hundred dollars, at this writing), but if you wish to explore the process to ensure that no one will copy your design, you can write Trademarks, Superintendent of Documents, U.S. Government Printing Office, Washington, DC 20402, and enclose one dollar (price subject to increase). You can also register your *mark of trade* with your state officials.

## Your Letterhead

Your letterhead is often your first contact with a photobuyer. Put special care into designing it. For the lettering, you can experiment with the graphics software that came with your computer. Often a couple dozen fonts will be available to you. If you have a general mood running through your pictures, match it with a typeface that has the same feel to it. And consider incorporating a carefully chosen sample of your photographs themselves in the design. Barter with a graphics student to conjure up some ideas for you to choose from: Outside help is usually more objective. As I mention throughout this book, "You don't get a second chance at a first impression." You are working long-distance with your buyers. The first impression they have of you is the piece of paper with which you contact them. When you initially write for photo guidelines, contact the photobuyer on *deluxe* stationery. If it's costing a dime a sheet, you're on the right track. At a quick-print shop, get only one hundred printed at a time. It's costly, but if you change your address or your mind, an investment in five thousand sheets isn't lost.

## Envelopes

Make your envelope a calling card. How do you decide which logo or photograph to use on your outside envelope? Use one that (1) commands attention and (2) reminds photobuyers and the public of your specialties. If your specialty is agriculture, and an extensive portion of your Market List includes publications in the area of farming, a strong agricultural photograph or logo will serve well. Keep in mind the purpose of your envelope promotion. You want your name to become synonymous with agriculture photography. When photobuyers in the farm-publications industry ask themselves, "Who has good agriculture pictures?" you want your name to come up.

And what if you have two or three specialties? Print two or three different envelopes targeted to the different segments of your Market List.

## Business Cards

A distinctive business card will keep your name circulating. They're inexpensive, and any printer can produce them. But don't fall into the trap of acquiring a couple thousand business cards that are cheap looking and indistinguishable from your competition. Make your next business card something people will remember: a photograph (see figure 10-1). Consult the yellow pages for printers. A good source for photographic business cards is Herff Jones Inc., Suite 82, P.O. Box 100, Lewiston, MN 55952.

# Build a Mailing List

The core of your operation is your Market List—the list of your photobuyers, past, present and future. Your promotional mailing list should start with your publication Market List. Now begin to extend it to camera

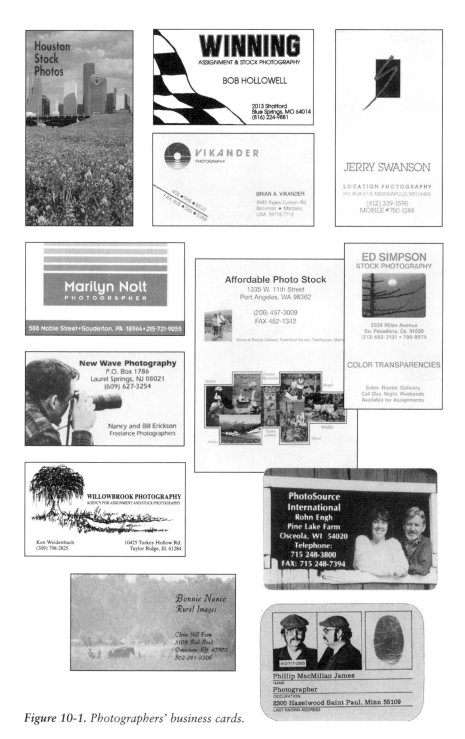

*Figure 10-1. Photographers' business cards.*

columnists, local galleries, photography schools, camera clubs, camera stores, radio and TV stations and newspapers that will receive the press releases you'll periodically circulate.

Generally speaking, these names and addresses should be on one major list. If your list is on file cards or Rolodex cards, you can code by color or symbol those that are markets, those that are columnists, etc. Keeping one list helps you avoid duplication in mailings and time-consuming tracking when an address changes.

Faithfully keep your list up to date. Print "address correction requested" on all of your envelopes. The cost from the Postal Service for the correction is currently fifty cents, but it's worth it. Whenever you make a mailing, code the mailing on your master list with a color, symbol or date so that you'll have a means to measure how many mailing pieces certain markets or columnists are receiving. If your list is on computer, design your program to anticipate categories that may be useful in the future, such as number of sales per individual market and type of sales (book, curriculum or magazine). Clean your list often (i.e., weed out addresses that have changed or are no longer useful).

### Mailers—They Pay for Themselves

Probably the most cost-effective means of self-promotion is the *mailer* (also called *sell sheet*, *flyer*, *insert* or *stuffer*). These promotional pieces are similar to brochures (described later in this chapter), but are less elaborate (thus less costly), and you can make them yourself if you wish. They consist of a grouping of examples of your pictures, in whatever size you wish to make them.

I use mailers as my principal form of advertising. I send them out regularly every three to six months to the photobuyers on my Market List. Dennis Cox, a stock, corporate and editorial photographer in Ann Arbor, Michigan, suggests a mailing every three to four months, minimum. His mailing list includes magazines, book publishers, design firms, corporate communications directors and ad agencies. "Naturally, not every direct-mail piece is going to fit everyone on my list, so I target mailings to only those I think will respond favorably to the particular mailing." Though this is guesswork, Dennis advises to keep your guesses wide, not limiting. "Just when you think it may be time to remove a name because of lack of response, you'll get a call from them. My rule is: If you want to work for them, keep mailing to them."

When William H. Allen, Jr., of Newbern, Alabama, returns from a trip, he reaches a targeted group of photobuyers by making 3″ × 5″ color prints, placing them on an 8½″ × 11″ sheet along with his business cards and running off a couple dozen color photocopies at a local Kinko's. "The color rendition is not always accurate, but the impact of the photo is there," says Allen. The cost comes to a dollar a sheet, depending on volume.

*Figure 10-2.* Here's an example of one of the many "sell sheets" produced by the team of Jim and Mary Whitmer of Wheaton, Illinois. The Whitmers have been marketing their stock photos since the 1970s, and are known throughout the industry as a superbly successful stock-photography source.

In the fast lane of self-produced sell sheets is the digitally generated sheet. Joe Farace, a photo illustrator out of Brighton, Colorado, tailors short-run sell sheets to specific "themes" and then sends them off to photobuyers who are looking for pictures in that theme area. Because the sheets are digitally generated, he can produce one or one hundred, depending on his target market.

His method is to digitize five or six selected images on PhotoCD. He then pastes them into an Aldus PageMaker layout document complete with printed copy. He prints the color results on a Fargo Pictura 310 printer. Each 8½″ × 11″ sheet costs around $3.50.

Other types of mailers are 3″ × 5″ or Rolodex-size cards (2¼″ × 4″) in various colors with promotional reminders on them. Dennis Cox sends Rolodex cards printed on durable plastic. He says, "They attract attention and should be a long-term asset. I've also sent out a series of postcards with good results." Rolodex cards are available through MWM Dexter Inc., P.O. Box 261, 107 Washington, Aurora, MO 65605, (800) 641-3398. A punch-out Rolodex card is available through Ticket Shack, 8625 Xylon Court, Minneapolis, MN 55445-1840, (612) 391-8001. Promotional postcards are available from Pate Poste, Ad Cards, 43 Charles St., Number 5A, Boston, MA 02114, (617) 720-3900, and Clark Cards, 2005 Trott Ave. SW, Willmar, MN 56201, (800) 227-3658. Photolabels, 419 Eisenhower Lane S., Lombard, IL 60148, (708) 691-8181, produces color "stamps."

### Brochures

Design and produce a professional-looking four-page brochure—that is, one large (8½″ × 9½″) sheet folded once. It will be a showcase for you, and it will pull in sales and assignments. Use as guides the brochures or pamphlets found in airline or travel offices. Such a brochure usually pays for itself, whether you invest $100 or $1,000. If you have the cash, courage and marketable pictures available, bend your budget and produce a full-color brochure aimed at a specific market that has both the need for your PMS/A and a pay rate that will make it worthwhile. Look at other brochures to see which ones appeal to you. When you find one, adapt the design, using pictures that will appeal to your Market List.

Handsome, four-color brochures can cost as much as ninety-five cents each. A good place to find a wide selection of samples of these exquisite brochures is in the wastebasket of your local post office. Does this tell you something? Make sure your brochure reaches the right target.

How many brochures should you print and where? Take your mock-up to several four-color printers for quotes on one thousand, three thousand and five thousand copies. The quantity depends on the size of your market. It's better to print more than you think you'll need. It's cheaper per unit; besides, you'll discover new uses for your brochures once you have them. Such brochures need very little copy. Put your photographs into the space.

About the only words you'll need are your name, address and phone number. For assistance on brochures and other self-promotion, write for a copy of the newsletter "The Art of Self-Promotion," by Ilise Benun. Include an SASE.

## Postcards

Four-color postcards that show off a single example of your photography serve to remind buyers who you are and what you can produce. Some suppliers are Mitchell Graphics, 2230 E. Mitchell, Petoskey, MI 49770, (800) 841-6793, and MWM Dexter Inc., P.O. Box 261, 107 Washington, Aurora, MO 65605, (800) 641-3398.

## Catalogs

Have a catalog printed displaying a selection of your stock photos based on your PMS/A. Assign numbers to each picture. Three-hole-punch the left side of each page, and send it to current and prospective editors (see figure 10-2).

The cost for three thousand copies of an eight-page, $8\frac{1}{2}'' \times 11''$ black-and-white catalog runs from $900 to $1,200. Robert Maust of Keezletown, Virginia, a stock photographer, sent out such a catalog and says, "My costs were paid off by sales I made directly related to the catalog in only a few months."

Here's how to put together such a catalog: Place sixteen verticals or fifteen horizontals on one page. Using $8'' \times 10''$s, make a huge pasteup of each half of the page. The printer shoots it in halftone, reduces it, shoots the other half, tapes the upper and lower halves together and prints it.

CD-ROM catalogs—should you produce one yourself? It's possible, and it's costly. The question you should ask first: "Will a photobuyer look at my CD-ROM catalog?" The reality is that most photobuyers stand over a wastebasket when they read their mail. Unless you have produced a first-class carton and mailing label for your digital catalog, photobuyers probably won't open it. More often than not, the disc is not compatible with their own equipment.

Some major stock agencies have produced quality CD-ROM catalogs. If

---

**COLOR**

Color attracts. If your promotional pieces incorporate color—even if it's only one color—you'll experience a better response. "But it's expensive," you say. "It costs twice as much as plain black-and-white printing." True. But your response will not be twice, but five to ten times.

Here's an inexpensive way to add color to your stationery, calling cards and envelopes. With a highlighter (color of your choice), make a swipe of color across your logo or name. Or, for variety, make the swatch in the form of a Z or an N. To be convinced of the power of color, send out fifty of your flyers with color and fifty without, and record the response rate.

your pictures are with the agencies, you may be included on their disc. These agencies include West Stock, PhotoDisc, The Stock Market, Photobank, Stock Workbook, The Black Book, FPG, The Image Bank and Digital Stock Connection.

### The Phone

Telephone marketing is an effective way to sell yourself. Each phone call is actually a self-promotional opportunity. Be sure to prepare for it with a *give* list. If you call a prospective photobuyer with nothing to give, your intended promotion may end up a bust. (For more on dealing with photobuyers by phone, see chapter seven.)

Your local telephone company will have promotional aids available to you, ranging from voice mail, toll-free numbers and Internet connections to literature on how to overcome "phonephobia." Practice your promotional calls on a tape recorder. If your voice sounds too high, too low or unenthusiastic, keep trying until you get it right. Then practice with a few trial calls. You'll know by the response if the phone is for you. A book on this subject is *Power Calling* by Joan Guiducci, P.O. Box 497, Calistoga, CA 94515.

## Credit Lines and Tearsheets—Part of the Sale

Credit lines and tearsheets of your published stock photos are significant self-promotional tools for you. How do you get them? Request them when you are notified that your picture has been purchased. Even better, you can include a courteous statement in your original cover letter to an editor that the terms of sale include use of your credit line and provision of a tearsheet upon publication.

Major markets ordinarily print credit lines as a matter of course; however, they expect you to purchase the publication and get your own tearsheets. Textbook editors also will expect you to make your own photocopies of your published pictures. Photo editors of regional, local or specialized limited-circulation publications work with smaller budgets and will usually supplement the dollars with a credit-line guarantee and forward tearsheets to you. Some of your markets will have the provision of tearsheets built into their standard operating procedures. They automatically send them to all contributors to a given issue to confirm for their own records that the photographer (or writer) has been correctly credited and paid. (To help ensure a correct credit line for your photographs, use the identification system described in chapter thirteen.)

You can use tearsheets for self-promotion in a variety of ways. Make photocopies of them to tuck into your business correspondence, to show prospective clients how other publishers are using your stock photographs and to remind past photobuyers of your existence. Dave Strickler of Newville, Pennsylvania, regularly includes such samplings in his correspondence with editors and art directors. Inexpensive and immediate,

such promotions often pay for themselves through orders of the actual stock photos pictured in the photocopy. You can also use groups of tearsheets (originals or photocopies) to send to a prospective photobuyer to illustrate the depth of work you have available on a given subject.

When you accumulate a number of tearsheets, file and cross-reference them to locate subject matter you've previously photographed.

Credit lines, besides the good advertising they provide for you, can be instruments for additional sales. Art directors and photo editors are always on the lookout for promising new stock photographers. When your credit line appears next to your photo illustration or in the credits section of a publication, it's available for all to see and make note of. If you're doing your self-promotion job correctly, your credit line will be popping up often, and photobuyers will become familiar with your name. In some cases, photobuyers will want to reuse a published photo that catches their eye, and they will seek out the photographer to make arrangements. Without a credit line, this would be a complex detective task that the buyer doesn't have time for.

What if a photobuyer doesn't give you a credit line? Beyond an approach of courteous insistence, your hands are tied. The use of credit lines, in the majority of cases, is left up to the editor or art director of the publishing project. You're fighting City Hall when you vent righteous indignation at the lack of a credit line. But have faith. As in City Hall, administration changes occur in the publishing world, and the next art director you deal with at a particular publishing house may have the "right" attitude toward including credit lines. An examination of magazine and book layouts over the last decade shows that the trend is decidedly moving toward the use of credits. Meanwhile, it is up to you to politely but firmly continue to press for the use of your credit line next to your published photograph.

## Show Yourself Off

Your promotional tools are working to make sales of your pictures for you. Now you want to begin getting some promotional exposure for *you* as a photographer.

### Trade Shows

Publishing trade shows, book fairs and magazine workshops always attract publishers and photobuyers. Invest in trade shows with either an exhibit booth or a ticket to the event to personally meet publishers and photobuyers who represent potential markets and/or new members for your promotional mailing list.

To learn which trade shows would be most productive for you, ask buyers on your Market List which ones they personally attend. Since these people are your target markets, you can be sure the events they deem worthwhile will pay off for you in opportunities to become aware of new, similar market areas.

Carry your business cards and several packets of your stock photographs with you, with each packet representing a separate area of your PMS/A. I went to my first trade fair with a general portfolio. Photobuyers weren't interested in seeing my pretty pictures. The next year, I built three packets, each with twenty-five 8″ × 10″ black and whites and two vinyl pages of color (forty 35mm) enclosed in a plastic folder. Each aimed at a specific market: education, gardening or teens. I talked only with photobuyers in each of those three specific interest areas and showed only the photographs they were interested in seeing. My visit more than paid for itself in the subsequent sale of pictures.

## Website

As the number of photobuyers who use the Internet increases, so will your promotional avenues. The Web offers an inexpensive method of promotion if you use it wisely. Web technology changes as quickly as you turn this page—but marketing principles do not. That's why it's important to avoid the lure of a "Mall" on the Web, where your portfolio is exhibited with hundreds of others. Instead, invest in a low-priced site offered by one of the commercial online services, e.g., CompuServe or America OnLine. Place only your specialized pictures in your site, changing and updating them from time to time. By taking this approach, you attract photobuyers who are looking for content-specific, not general, pictures to your site. (The "tags" on your website allow search engines to browse millions of pages and in seconds come up with highly specific subjects such as "rodeo" + photo, "alligator" + photo, "Lake Como" + photo and so on.) Refer to chapter seventeen for extensive coverage of how you can use the Web to advantage.

## Speaking Engagements

Here's a simple way to promote yourself, and it doesn't cost you anything. If you communicate effectively with your camera, you may have the potential to communicate effectively as a speaker. Take to the platform!

In the trusty yellow pages, you'll find a listing of community and photographic organizations, clubs and associations. Most have a regular need for interesting program speakers. Let the program chairpersons of several groups know that you are available. In most cases, they'll be happy to book you.

How do you get started? What should you talk about? As a stock photographer, you have a wealth of subject material available to you—and since 90 percent of your listeners fancy themselves photographers, too, you'll have a receptive audience. Build your talk around a how-to subject, for example, "How to Take Pictures of Your Family," "How to Take Indoor Natural-Light Pictures," "How a Digital Camera Works" or "How to Make a Photo Illustration." You are welcome to use any of the ideas in this book.

For some ideas on titles for your speech or speeches (there's nothing

wrong with having one basic speech for quite a while), order Kodak's free catalog entitled "Your Programs From Kodak." These are basically movie and slide programs, but their titles alone are enough to stir your imagination for your own speech. (Write to Audio-Visual Library Distribution, Eastman Kodak, Rochester, NY 14650.) Give your speech title this test: "Am I speaking about something that applies directly to my audience?"

Your listeners don't want a lecture, or they'd register at the local adult education center. Be entertaining. Include anecdotes, personal experiences and humor. Use charts, slides or blackboards. You'll get audience response, and this will aid you in refining your speech. Eventually, program chairpersons will seek you out.

At first, charge nothing, except perhaps a fee to cover your out-of-pocket expenses such as baby-sitting, gas and the meal. As you progress, start charging by the hour—for example, $25 per hour. Increase the fee as demand for your services increases. As your good track record grows, so will your fee.

You'll discover some surprising spin-offs from your public appearances. Local publishers will hear of your talents. Assignments will be directed your way. Photobuyers will contact you. Your name as a stock photographer will be catapulted ahead of equally talented but less visible photographers.

For good advice and direction on speaking engagements, there's a newsletter that could be helpful to your speaking career: *Sharing Ideas,* Dottie Walters, Royal Publishing, P.O. Box 1120, Glendora, CA 91740. Walters is also the author of *Speak and Grow Rich.* If you branch out into seminars, you can list them free in the *Shaw Guides,* 10 W. Sixty-sixth St., Suite 30H, New York, NY 10023, (212) 787-6021.

### Radio and TV Interviews

Make yourself available to community radio talk-show hosts. They are usually interested in interviewing people engaged in out-of-the-ordinary pursuits, and you qualify. Photography is an ever-popular subject, as listeners are always eager to learn how they can improve their picture taking. Add some local or farther-afield radio-show hosts to your promotional mailing list. Some radio hosts will phone across the nation for an on-the-air phone interview if they believe that their listeners would be interested in what you have to say.

A good source to locate radio stations and the addresses of hosts of talk shows is *Gebbie Press All-In-One Directory,* P.O. Box 1000, New Paltz, NY 12561. The same organization can give you the names and addresses of TV-show hosts. Television interviews are possible if you can present your story in a five- to nine-minute segment. Since photography can easily hold viewer attention, your chances are better than average for making a TV appearance, particularly in a nearby city. For a fee, you can get yourself listed in a "Talk Show Guest Directory" called the *Directory of Experts, Authorities, & Spokespersons,* Broadcast Interview Source, 2233 Wisconsin Ave., NW,

Washington, DC 20007, (202) 333-4904. Two helpful books are a *Guide to Handling a Press Interview* and *Free PR on TV and Radio,* Pilot Books, P.O. Box 2102, Greenport, NY 11944-0893, (516) 477-1094. For New York radio and TV contacts, refer to *New York Publicity Outlets,* and for California, refer to *Metro California Media.* Both sources can be obtained by writing to P.O. Box 1197, New Milford, CT 06776.

Contact the producer of a local talk show (by letter, e-mail, phone, in person—or all four). You could offer to serve as the resident critic for photography submitted by viewers. Build your format around a how-to theme. Tailor your critiques so that the average snapshooter will understand them and will be able to improve the family's scrapbook photographs.

## Press Releases

If you've been making speeches, giving talks, making appearances at vo-tech graphics or design classes, or giving interviews on radio or TV, someone's going to be mentioning you in your community news media. But whether you've been engaged in these activities or not, you can write your *own* press releases: They are an excellent form of promotion for your stock-photo business. Newspapers and magazines are willing to accept news about you and your photography; so are the specialized newsletters and trade magazines that reach photobuyers and publishers. *You* must contact *them* and send them your press release. About one-third of the media channels you contact will print your release.

When you consider that the average advertising rate is $50 per inch, when your press release is used you receive a sizable amount of advertising space—free. What's more, your release is read as editorial, human-interest material rather than advertising.

When can you send a news release about your photography or yourself? Depending on whether the item would be of interest on a local, regional or national level and whether your target is a trade publication or a general-interest one, your press release can center on a recent trip; your photo exhibit at the local library; an award you received; your move to a farm, garret or former carriage barn; your donation of photo illustrations to a nonprofit publication or auction; your publication of a photo in a national magazine or book; or a recent speech or interview.

Press releases follow a basic format: double-spaced on a half page or a full page. Write your release as if the editor (or radio commentator) were writing it. Remember: It is not an ad. This is not the place to speak in glowing terms about yourself or your photography. A good handbook on this subject is *Bulletproof News Releases—Advice for Small Business From 135 American Newspaper Editors,* by Kay Borden, Franklin-Sarrett Publishers, 3761 Vineyard Trace, #100E, Marietta, GA 30062. See also *The Successful Promoter,* by Ted Schwarz, Contemporary Books, 180 N. Michigan Ave., Chicago, IL 60601. A newsletter that broadcasts the current press needs of

authors, columnists and editors is *PartyLine, Public Relations Newsletter,* 35B Sutton Place, New York, NY 10022.

You don't need to include a cover letter, but do enclose a black-and-white photograph ($5'' \times 7''$ is acceptable) when appropriate and practical. (Don't expect its return.)

Your best teachers for learning your way around press releases are news items you discover in the press. If you find yourself saying, "That could be me!" rewrite the item to reflect your own information and send it to similar media channels.

Occasionally you will learn that a trade magazine in one of your fields of interest will be devoted to a certain subject. If you or your stock photographs can comment on that subject matter, volunteer to contribute (for free). The resulting exposure of your name and your stock photos in both the publication itself and the subsequent press release you write about it will more than compensate for your effort and expense.

Once a press release is used, capitalize on the published article by making copies and sending the news item along in all your business correspondence and/or in a mailing to your market and promotional list.

## Promotional News Features

Local, regional or trade publications often welcome articles or short features (250 to 500 words) on somebody who's doing something interesting—you. Don't wait until a publication contacts you. Write your own material.

Photographer Bill Owens of Livermore, California, gets more mileage out of free advertising by turning a news feature about himself into a productive promotion mailer.

## Free Promotion

It costs nothing but a little time to make sure you're included in a number of directories that photobuyers use. A good directory is *Picture Sources,* edited by Ernest H. Robl, Special Libraries Association, 1700 Eighteenth St., NW, Room 15, Washington, DC 20009, (202) 234-4700. Many of the market directories listed in chapter three include a section entitled "Freelance Photographers" or "Stock Photography." *Literary Market Place, Working Press of the Nation* and *Publisher's Weekly Production Source Book* will all list individual photographers free of charge. Apply to be listed in the photographer sections of their next editions. If you have established a stock agency, you can also be listed in *Photo Marketing Handbook* and *Stock Photo Deskbook.*

## Advertising

Straight advertising is a direct method of self-promotion, but here you'll have to experiment—and it's usually expensive. Ordinarily, ads will not be the most cost-effective route for you as an editorial stock photographer,

unless you have strong depth in an unusual specialty with a known target market.

The following publications can be useful advertising vehicles, as some photobuyers cull photo contacts from them. (Most of the ads are run by stock-photo agencies and commercial stock photographers who have extensive coverage of specific, select subjects.)

*Adweek Creative Services Directory*, 49 E. Twenty-first St., New York, NY 10160-0625

*American Photography Showcase*, 724 Fifth Ave., New York, NY 10019

*American Society of Picture Professionals Newsletter*, 2025 Pennsylvania Ave. NW, Suite 226, Washington, DC 20006

*Chicago Talent Sourcebook*, 212 W. Superior, Room 203, Chicago, IL 60611

*The Creative Black Book*, 115 Fifth Ave., 3rd Floor, New York, NY 10003

*Direct Stock*, 10 E. Twenty-first St., 14th Floor, New York, NY 10010

*Folio*, 911 Hope St., P.O. Box 4949, Stamford, CT 06907-0949

*The Blue Book/The Green Book*, AG Editions, 41 Union Square, #523, New York, NY 10003

*Photo District News*, 1515 Broadway, New York, NY 10036, (212) 536-5222

*The Stock Workbook*, 940 N. Highland Ave., Los Angeles, CA 90038

*Workbook Phonebook*, Scott & Daughters, 940 N. Highland Ave., Los Angeles, CA 90038

Although you may not wish to invest in a costly display ad in any of the above, you could test for response with a classified ad. A typical example, which appeared in *Folio* magazine listed under "Photography, Stock," reads: "Emphasis on the Southwest. 150,000 images. Color and black and white. Write for free catalog [name, address, phone]."

Ask the photobuyers on your Market List which trade publications they read. Assume that other publishers with a similar editorial thrust read the same publications, and there is where you'll want your ad experiments to start. Following are some of the questions you should ask yourself when you're thinking of buying an ad: "Who are the readers of the publication?" "Do they buy photography?" "Will my ad get effective placement in the magazine?" "What do I expect to achieve from this ad?"

Whenever you advertise, key your ad with a code number (for example, add *Dept. 12* to your street address). You'll be able to tally the replies to check how well an ad pulls for you.

To measure the response rate to your ad, divide the number of queries you receive by the circulation of the magazine. Expect a response of between 0.1 and 1 percent. Compare the response from each ad with those from the rest of the ads in your advertising program to weed out ads that are ineffective or reaching the wrong audience.

Another type of advertising tool, which you can use year-round, is a handy calendar of a size you can include in correspondence.

Or you can engineer this kind of arrangement: When I was starting out in business, I cooperated with a Midwest printing firm in a wall-calendar project. In return for the use of twelve of my photos, they paid me with a prominent credit line and five hundred calendars, which I distributed as promotional pieces. The optimum ad is one in which a manufacturer, supplier or photography magazine highlights (promotes) you and your photography. Nikon, for example, featured different photographers and their work in a series of full-color, full-page ads that appeared in national photography magazines. In my own case, features and photographs of me have appeared in *Time, Money* magazine, *Changing Times, USA Today,* many newspaper photo columns, computer magazines and most of the photography magazines. Was this luck? No. I applied the principles outlined in this chapter.

Again, you don't *wait* for things like this to land in your lap. You do something interesting and then let the industry and the media know about it. You keep alert for openings, and *you go for them.*

## Reassess Your Promotional Effectiveness

Periodically monitor the effectiveness of your promotional efforts. Chart the percentage of your releases that are used; document the response to them and any ads you place by including a code; match numbers of mailings to specific markets with numbers of sales; analyze feedback from your photobuyers. Continue to test new ideas: Drop those that show no promise, and produce more of those that have been effective.

## Postscript

The central message of this chapter has been to blow your own horn. Let people know who you are; get your name known and your work seen. The more exposure you give yourself, the more sales you'll make.

"What about portfolios, exhibits or contests?" you may ask. They seem to

---

**FOLLOW UP**

It's said that it takes five times the expense and time to get a new customer than it does to keep a current customer. There's one major element when it comes to keeping customers: Follow up. After you've made a sale to a stock client, follow up with one of your promotions: a sell sheet, calendar, postcard or poster featuring your latest and most popular images. If you are traveling abroad, it's a bona fide reason to phone your buyers. They just might want to piggyback an assignment. Or if you've just returned from a trip, follow up with your request to send them a selection of the results for their consideration. It's a truism: To keep customers, you need only do three things—follow up, follow up, follow up.

be good sales tools and exposure opportunities. For the *stock* photographer, however, these elements, thought of almost synonymously with photography, either don't help at all or do very little to increase sales. Let's examine them.

### Portfolios

A portfolio is an excellent tool for a *commercial stock* photographer because of the types of markets the service photographer works for. A portfolio exhibits the breadth of a photographer's talent and experience to a potential client who may wish to contract for his *services*. Legwork and personal visits are part of establishing credibility when one is selling *oneself*.

On the other hand, for the *editorial stock* photographer—the photo illustrator—a portfolio and personal visits are not necessary. You work primarily by mail, and your photobuyers are not interested in looking at portfolios—they want to see pictures geared to their current layout needs. Your pictures, if they're content specific and on target, sell themselves.

A stock photobuyer isn't interested in your versatility. In fact, he wishes you weren't so versatile. He'd prefer you concentrate more thoroughly on one subject—his favorite, the subject of his magazine or books. It stands to reason that a stock photographer who mails apple-orchard pictures in response to a photo request from the editor of an agriculture magazine is going to make a lot more points with that editor than a stock photographer who takes up time showing him a portfolio of underwater, aerial and architectural photography.

### Exhibitions

Exhibitions are monumental time-consumers and have limited influence on sales, but they don't hurt and they're good PR, especially when you attain national prominence. Your exhibit area can range from your local library, bank, restaurant, insurance office or church to a city gallery or art museum. For the latter, a theme exhibit, rather than a general across-the-board show, will get more response from a gallery director. An exhibit built around a specific theme affords the viewing public insight into aspects of society with which they have little familiarity, or into some *weltanschauung* of your own that they may find entertaining or informative. Once you have pinpointed your PMS/A, your thematic material should build rapidly. Later on, these same photo illustrations can lend themselves to books—another advantage for you as you build your career with marketing precision. (See chapter seventeen for examination of the use of electronic photo galleries.)

Exhibits can run from thirty to fifty mounted prints ranging in size from 8″×10″ to 16″×20″ or larger. Usually an exhibit shows for two to four weeks. Capitalize on the exhibit through news releases and posters, plus

radio, TV and speaking appearances. A helpful book is *The Photographer's Guide to Getting and Having a Successful Exhibition*, by Robert Persky (see bibliography).

## Salons

Salons, usually sponsored by local and national photography organizations such as camera clubs, offer you little promotional value. Salons are a cross between exhibits and contests. They are extremely—I would say unrealistically—formalized. Salons, in fact, perpetuate many of the myths that photo illustrators must unlearn in order to understand what is a marketable picture and what is not. Salon photographs are usually the standard excellent pictures—exquisite clichés. In fact, unless an entry conforms to this pattern, including the utmost technical perfection, the judges usually look on the entry with disdain. Salons remind me of outdated laws that no one ever questions. In a day when photo illustrations are meaningful tools of communication among strata of society that are drifting further and further apart, salons are an anachronism.

## Contests

Contests are somewhat different from salons in that they can offer national publicity plus cash awards to the winners. Contest sponsors tend to judge pictures on their photo-illustrative merit rather than outmoded classical-composition rules that limit a photographer's creativity and expressiveness. If you win a prestigious photo contest, let the photobuyers on your Market List know about it through a press release or photocopy of the news announcement. A book on the subject: *Winning Photo Contests*, by Jeanne Stallman, Images Media, Inc., 89 Fifth Ave., #903, New York, NY 10003. However, enter photo contests with caution. Read the rules carefully. Many times it's the sponsor of the contest who is the *real* winner. Rule Number 6 or Number 7 will sometimes state, "All photos that receive cash awards become the property of the sponsor, including original negatives and transparencies and picture rights." The film or camera manufacturer who sponsors such a contest requires the photographer to give up *all* rights to the picture. In other words, you transfer your copyright, including electronic rights, over to the sponsor—who can then use your picture whatever way he wishes.

Keep in mind that if your picture is good enough to win a national contest, it's good enough to earn you several thousand dollars in the marketplace in its lifetime. (You can even pass the rights to a picture on to your heirs, by the way.)

At PhotoSource International, we are engaged in a long war with the nationally known firms that sponsor such photo contests. To date, about half of them have rescinded their ownership policy regarding the winning pictures.

If you come across any contests that require you to give up the rights to your photo, remind the sponsors that you, the stock photographer, own your own creation. Write them postcards that say, "If my picture is good enough to win a national contest, it is good enough to earn me many dollars over its lifetime. I choose not to relinquish its copyright."

### Decor Photography

Producing artful Track A prints for use in commercial buildings or residences can result in excellent showcases for your talents. As you'll read in chapter twelve, *decor photography* (or *photo decor* or *decor art*, as it's sometimes called) will take special administrative (as well as photographic) talent on your part. One approach is to become associated with an existing decor-photography business that has already solved the administrative problems. Place your Track A pictures with them, much as you would with a stock agency, and receive a percentage. Beware of new outfits, though—they often tie up your pictures for lengthy periods while they learn the ropes themselves.

### Greeting Cards, Calendars and Posters

Greeting card, calendar and poster companies offer you other showcase opportunities, but have drawbacks of their own (see appendix A).

From time to time you may decide it's worth your while to barter for the printing of greeting cards, calendars or posters in return for licensing some of your pictures at no charge. Depending on where you stand on the ladder, such an arrangement may be of self-promotional value to you.

## Some Final Self-Promotion Suggestions

1. Keep several current photographs of yourself on file for promotional use. Often, stock photographers have to make a quick Polaroid of themselves to meet a deadline. Have a press kit handy—one that includes a couple of black-and-white prints of you plus a biography of you that includes your accomplishments.

2. Don't do it all yourself. *Get help.* Promotion is always more effective if you can get someone else to write it for you, or at least read it and suggest corrections.

3. You can't measure promotion such as news releases, interviews and exhibitions as effectively as you can direct advertising. If your business grows, you can assume that your promotional efforts are on the right track and are having an effect.

4. Be helpful. If a writer requests information or an interviewer wants answers, cooperate. *Any* kind of publicity is good. As Huey Long once said, "Say what you want about me, just spell my name correctly."

5. Share the news with others. If an article about you appears in a magazine or newspaper, share it with the photobuyers on your Market List.

They'll be interested in it for the confirmation that they chose correctly in adding you to their available-photographers list.

6. Here today, gone tomorrow. Promotion—like fitness—is short-lived. Your smashing success today will be history tomorrow. Photobuyers forget. Oh, do they forget! Keep reminders flowing their way every three to four months.

7. Your promotional tools—stationery, brochures, catalogs, labels, business card, envelopes—can speak as eloquently as your photographs.

8. Don't expect overnight results. Expect to move mountains, yes, but only stone by stone. Promotion works slowly. But it works.

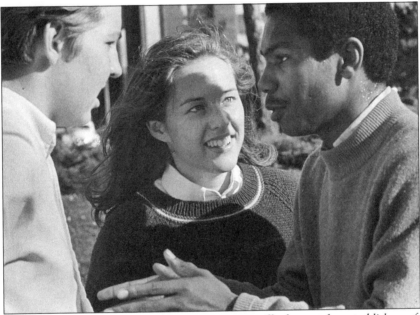

*"Include minorities when possible" is a request you'll often get from publishers of books and magazines. Such pictures will be highly marketable. The young people in this picture were playing a game of touch football and were discussing their next play. By moving in close, the football is eliminated and it appears they are in discussion.*

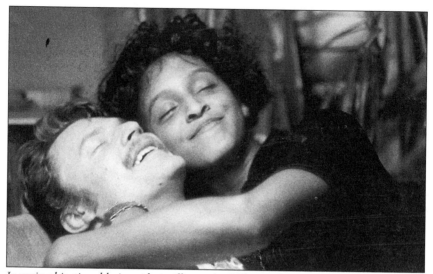

*Is grain objectionable in a photo illustration? Photo editors are more artist than engineer. If the pictures fit their needs, they tend to excuse what a photography purist might call technical imperfection, such as the grain in this picture.*

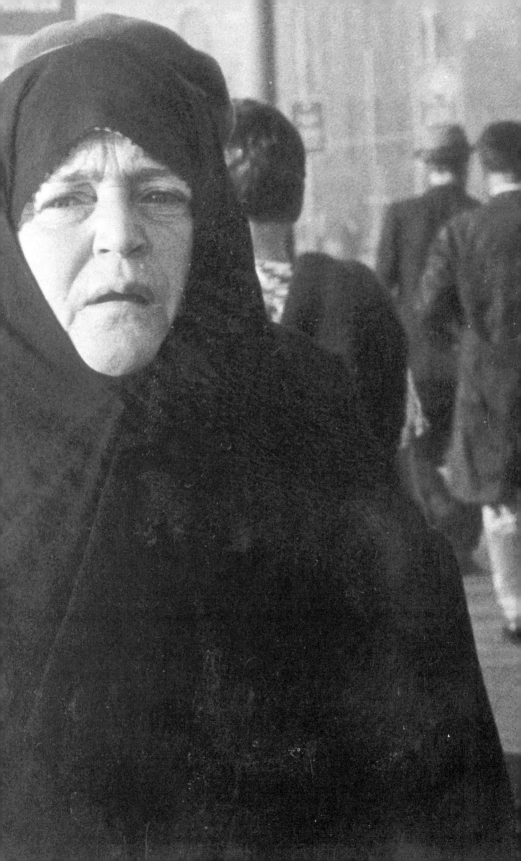

# Assignments

## An Extra Dimension for the Photo Illustrator

Buzz Soard of Denver was taking a family vacation trip to New Zealand, and he decided to query editors on his Market List before he left. The result was a four-page article on New Zealand's flora and fauna for *Adventure Travel*.

Gene Spencer of Virginia queried his Market List before he left for the Northwest and learned that one photobuyer needed a picture of the Olympia brewery in Washington. "I did several other assignments, too," Gene said, "but that one picture nearly paid for all my gas!"

William Neumann received an assignment after a conversation with an art director on an AOL (America OnLine) chat room. Jock Fistick sold a photo from his website and also established inroads to assignments for the *LA Times*.

Assignments can be fun, lucrative and fascinating, and you can generate them yourself, as well as experience those happy times when the phone rings unexpectedly. One of the biggest rewards, even for those workaday situations ("We need a shot of the National Balloon Race winners"), is the satisfaction and, yes, glow, that come from the professional recognition of your competence implicit in any assignment.

As a stock photographer, you can nail plenty of assignments—many of them by mail. Once you have sold several pictures to a photobuyer, you become a valuable resource for that buyer. The situation can arise where the buyer needs a particular picture in a particular part of the country. He consults a list on the Internet or his personal database of available photographers (in much the same way as you consult your Market List) and finds that you live near the area. He contacts you and offers you the assignment.

It also works the other way. You are planning a trip, and you inform several of the photobuyers on your Market List of your itinerary, as Buzz and Gene did. One might respond with a two-day assignment, another might tell you that he needs one picture dependent on the weather ("I need clouds in the sky"), and a third might imply that he needs three different pictures if you'd like to take them on speculation. Assignments come in all varieties and will be limited only by the focus of the markets on your personal Market List.

Are assignments in your future? It all depends on your own personal interest in being mobile in your photo-marketing operation. Some editorial stock photographers thrive on travel; others like to work from their homes. If you opt for assignments, you'll find it rewarding to apply the principles in this chapter.

Because of the proliferation of generic photos on CDs and in online galleries, assignments take on a special meaning for photobuyers who hire you to get a specific picture or series of pictures. Your assignment pictures will be unique and content specific. Photobuyers are willing to pay high fees for assignment photography.

## Negotiating Your Fee

How much should you charge when you get an assignment?

I could give a quick answer to this question by referring you to ASMP's *Professional Business Practices in Photography*, American Society of Media Photographers, 14 Washington Square, Suite 502, Princeton Junction, NJ 08550-1033. But this guide doesn't have all the answers since it reflects top-dollar fees commanded from top-drawer markets by top pros—and pertains primarily to the world of service photography, where fees range from $600 per day for corporate photography to $4,500 per day for national ads.

As in any business, until you have an impressive track record and your name is known, it's unrealistic to expect top dollar. But perhaps the most basic point to keep in mind is this: Many of the markets you deal with as a stock photographer are publishing markets that consistently pay you respectable fees for your photos—but they can't match New York day rates. Your fees will depend entirely on your own mix of markets. Some of the photobuyers on your Market List may indeed have healthy budgets for photography assignments, but feel them out—don't price yourself beyond what they can bear.

Essentially you are left on your own to judge the particular market and your track record with it and to negotiate accordingly. Effective negotiations will make the difference between making or missing an assignment.

Now that I've delivered a caution to not overprice yourself, I want to emphasize on the other hand not to *undervalue* your services. Many creative people tend to put too low a price tag on their talents. A good formula to follow is to take whatever you decide to quote to the photobuyer as your day rate—and quote half again as much. You will be surprised how many will accept your higher fee.

In other words, say you have a chance at a plum assignment from an oil company's regional trade magazine. Taking into consideration that you have already sold two pictures to this magazine and this is your first assignment opportunity, you arrive at a $600-a-day rate for such a market. Instead, quote $900. You're probably worth it—and the photobuyer probably agrees—but you won't know until you start negotiating. In a situation like

this, think big. With assignment work, while you have to walk a fine line and not charge beyond the range for the particular market, if you quote too low a figure, you lose not only the photobuyer's dollars, but also his esteem.

Also, in a situation like this (with the higher paying trade magazines), you probably will be invited to the photobuyer's office rather than having to negotiate by phone or mail. Being there in person is an advantage in this case, because you can watch the photobuyer's expression and body language when you quote your fee. He'll let you know if you're on target.

If your figure is high for his budget, you'll get some resistance. However, he invited *you* to the office; thus, you know he thinks that

1. You are an established photographer.
2. You bring specialized knowledge and talent to the assignment.
3. You have access to a certain profession and/or geographical area in relation to the assignment.

### He Who Speaks First . . .

Keep in mind that there are a dozen other photographers he *could have* invited to his office. It may seem like a disadvantage to have all that competition, but it's actually a plus in this case. By inviting *you,* he has established in his own mind that he has chosen the *right* person. If you quote a low fee, it might lower his estimation of you.

Remember, the photobuyer must report to his superiors. A high fee tends to justify his choice of photographer.

How you state your fee should go like this:

When the photobuyer inquires as to your rate, state your prepared answer confidently—and then remain quiet. Don't say another word. This is a well-established principle of negotiating. The person who speaks next is at a disadvantage in the bargaining process.

Let the buyer do the talking. When he speaks, it'll probably be to commit himself to your fee or to indicate his budget. He'll probably indirectly answer some questions that are important to you:

1. How badly is the picture needed?
2. What is the competition charging?
3. How easily can he get the picture from some other source?

If you discern that the photobuyer is genuinely resistant to your fee, determine the basis for his resistance, and you will be able to figure the direction you should take in the negotiations. There are a lot of tactics you can consider. Here are some possible scenarios, with suggestions about how to handle them:

1. He'll probably come back to you quoting a lower figure (you've tossed the ball to him—now he's tossing it back). Don't immediately accept it. Why? He is probably testing you with a figure lower than what he actually could pay. He'll make some concessions if you press him.

2. Don't concede anything if you can help it, or at least don't be the first to concede ("OK, I'll complete the assignment in two days instead of three . . . "). If you concede first, the picture buyer has the upper hand.

3. If you have to concede something (the buyer tells you he can't cover the cost of developing your film, for example), ask him for a concession, too ("I must have double mileage for this trip. There are a lot of dirt roads out there in West Texas!").

4. If you must match concessions with the picture buyer, remind him that these concessions are valid only if you and he are able to reach a final overall agreement on a contract or a fee for the assignment.

5. Decide beforehand what you want: a minimum and a maximum. (Make sure these figures are realistic.) Keep score as you negotiate.

6. If you come out smelling like roses, don't feel guilty about it. Remember: You don't always win in such negotiations. Enjoy the glow while it lasts. Next time you may not come out so well.

7. What if the photobuyer says, "This is the fee we can pay—you can take it or leave it!"? You can either say, "Thanks, but no thanks," or explore with him the possibility of retracing your steps to either narrow or broaden the scope of the assignment. Offer more or fewer pictures, discuss travel expenses or change the length of the assignment: These are areas where you can concede wisely. Don't agree, however, to give up your negatives or to grant the buyer ownership (all rights) to your pictures. Even in these areas, though, it isn't a case of "never"—you may get in situations where the fee for all rights is sky-high, or where you are eager to get that particular assignment at all costs. (See the discussion of work for hire in chapter fifteen.)

For the stock photographer, an excellent book on how to negotiate a fee is *Negotiating Stock Photo Prices* by Jim Pickerell, 110 Frederick Ave., Suite A-1, Rockville, MD 20850. Negotiating can be challenging—even fun. Practice makes perfect. Try out variations of your routine with your spouse or a friend playing the part of photobuyer. If you will be negotiating by phone, do your practicing on extension phones or in a couple of phone booths. You'll find that just running through your script is a tremendous catalyst to new thoughts and new ways to phrase your points.

In the long run, a photobuyer will appreciate your efforts to get the best fee for your pictures. Even if you come away with $600 a day instead of the $900 you asked for, remember that is the fee you were willing to settle for originally.

# Expenses

The quote you make for your day rate to a photobuyer does not include your expenses. These are over and above the day rate you receive, and they depend on a number of variables.

When negotiations reach the point where you address expenses, your reliability factor will be strengthened if you hand the photobuyer a copy of your Expenses form.

Have a personalized business form that lists expenses involved on assignment work typeset and printed. When I first started out, I had my own form printed on $4\frac{1}{2}'' \times 9\frac{1}{2}''$ paper in three different colors—white, blue and pink—then collated and gum-sealed into a pad. I use carbonless paper above the blue and pink, and I send the first two copies to my client and keep the third for my records. The pad paid for itself on my first assignment.

In a corner of the pad, in small print, is this message: "This sale or assignment is in accord with the code of practices as set forth by ASMP."

Although you may not be an ASMP member, or even if your client cannot afford ASMP rates, your expenses are a fixed cost, and you should expect reimbursement accordingly.

Your expense form should be similar to the one in figure 11-1.

An equally effective approach, if you are computerized, is to present to the photobuyer a printout that includes not only your expense estimates, but other points you agreed upon during the negotiation.

# Extra Mileage From Assignments

Your assignments will take you to locations you might not ordinarily visit. Carry along an extra camera (or two—one for black and white and one for color) and shoot some stock photos for other photobuyers on your Market List. These are called *sister shots*.

This will not be as easy as it sounds. Full concentration on your assignment is essential to producing quality results, which is also the way you maintain a strong reliability factor with your client. Anything less than 100 percent attention to your assignment will give you mediocre, or at least ordinary, results. When you shoot "side" pictures while on assignment, then, plan to shoot them on your time and at your expense.

Many assignments call for only specific pictures. This situation allows you to add the sister shots to your stock file. Some stock photographers arrive early on the scene or stay late on an assignment. As long as the client has paid the transportation expense, you can capitalize on the (sometimes exotic) locale and shoot for your stock file. Some photographers shoot to add to their collection of pictures on special themes. Simon Nathan of New York, for example, snaps pictures of clothes hanging on clotheslines all over

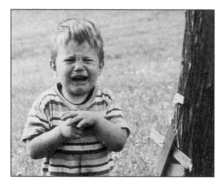

The Photo Essay. *Want to make your picture stories come alive? Learn from the pros. A moviemaker in Africa taught me this trick, which you can apply to your photo stories. "Every story has a beginning, middle and end," he said. "Whenever I get spectacular footage, say of a successful rescue in a river or one of my African crew fending off an attack by an animal, I consider that the climax footage. I then go back and film footage that will lead up to my climax footage. This subsequent footage I then use as my beginning and middle shots." In the case of the little boy at left, I shot the third picture on Saturday, and on Sunday I shot the first two.*

<div style="border:1px solid black">

### YOUR LETTERHEAD
## EXPENSES

From: (Your Name)
TO:
DATE:
SUBJECT:

**TRAVEL**
Taxi ................................................................................. $_____
Auto ( _____¢ per mile) ................................ $_____
*Plane, train, bus ............................................................ $_____
*Car rental ...................................................................... $_____
Tips ................................................................................. $_____
*Meals _____ *Lodging _____ ........ $_____

**PHOTOGRAPHIC**
Processing
*Color: _____ Rolls @ $ _____ ............. $_____
*B&W: _____ Rolls @ $ _____ ............. $_____
*Rental of special equipment ...................................... $_____
*Scanning ....................................................................... $_____
*Digital Transfer ........................................................... $_____
Other:

**PROPS** ......................................................................... $_____
Construction of or rentals)

**MODEL FEES** ............................................................. $_____
(Hiring or nonprofessional releases)

**LOCATION CHARGES** ............................................. $_____

**MAILING, UPS, FEDEX, TRUCKING** ...................... $_____

**INCIDENTALS**
Long-distance phone calls .......................................... $_____
Messenger, porter, assistant, guard ........................... $_____
Liability insurance ....................................................... $_____

**SPECIAL SERVICES**
Casting ........................................................................... $_____
Hair and makeup ........................................................... $_____
Home economist ........................................................... $_____
Costumes, clothing ....................................................... $_____
Location search ............................................................. $_____

**OTHER** ........................................................................ $_____
                        TOTAL EXPENSES:        $_____

*Receipts attached                    This sale or assignment is in accord with the code
                                      of practices as set forth by ASMP.

</div>

*Figure 11-1. A sample expense form.*

the world. "One day I'll have an exhibit—or publish them in book form," says Simon.

Do you own the pictures you take on assignment? It depends on what type of contract, if any, you have signed, or what rights agreement you and your client have arranged (see chapter fifteen).

## Industry-Sponsored Assignments

Funding is available for your trips. Because the article or book you produce as a result of a major self-assignment (which I'll explain in this chapter) will be read by thousands, even millions, you are in a good position to get sponsorship from manufacturers, governments, TV networks and cable companies. Media coverage would normally cost them hundreds of thousands of dollars. You are providing it free. For a 1,500-word report on this subject, "6 Steps to Gain Financial Support for Your Travel Adventure," send $10 to PhotoSource International and I'll send you a copy.

## The Stringer

Another assignment channel is open to the photographer who is on tap for picture-taking services for a trade magazine, news service, newsstand magazine or industry account. The photographer in this situation is usually called a *stringer*. You are, in effect, a part-time freelancer who sometimes works on a retainer basis—that is, for a regular monthly fee. In most cases, however, you work on a per-assignment basis. You get paid only when you produce.

Being a stringer falls primarily into the area of service photography, but stringer opportunities are also there for the stock photographer. By working out flexible contracts with trade publications, you can arrange to supply them on a regular basis with single pictures relating to their subject theme.

For example, if one of your PMS/A areas is purebred dogs and you travel often to dog shows, you would be a valuable resource to editors of various dog magazines, which have audiences ranging from breed associations to veterinarians. (We're talking about good working shots of dogs in action or breed portraits. Remember, if you emphasize cute-puppy pictures, that's crossing over into Track A—pictures that you'll want to place in a photo agency. See chapter twelve.) If you travel often, you could tie in your mobility with other photobuyers on your Market List (recreational pictures for outdoor magazines, horse shows for horse magazines or equipment in use for heavy-equipment magazines).

Your contract need not be more formal than a letter of agreement stating that you will supply them with X pictures a month (week or year) for X dollars. The fee won't be monumental, but if you have several contracts, the sum will more than cover your expenses to those dog shows.

Competing magazines, of course, would not appreciate your supplying the same photographs simultaneously across the market. So by researching

the specific needs of the photobuyers on your Market List, you can guard against inappropriate multiple submissions, yet set up an operation to receive checks with regularity.

As a stringer, you are not "working-for-hire." Avoid any agreements with your client that would allow them to own all rights to your photos.

## Self-Assignments—Where Do You Start?

If assignments aren't coming your way yet, give them to yourself. Such self-assignments will reward you with new insights into lighting, working with models, using the $P = B + P + S + I$ principle (see chapter two) and using varied lens lengths for effect, as well as pulling elements together to make a cohesive and interesting feature.

You can start right away, and give yourself a course on producing the picture story, if you're not afraid to copy. Through the ages, creative people have learned from each other by imitating each other. As the Bible says, "There's nothing new under the sun!" A simple, effective technique based on this principle is *the switch*. Here's how it works:

Let's say you're looking through one of the magazines on your Market List and you come across a one-page, three-photo picture story about a young man from Philadelphia who is spending his summer in the West, earning money for college by working as a wrangler at a dude ranch in Wyoming. The copy block contains about 300 words. The pictures are one close-up of the young man and two middle-view shots, one a vertical and the other a horizontal.

You will use this story as a *blueprint*. It shows you what the requirements are for a similar picture story (not the same story, but one that's similar). In your case, you know of a young Japanese girl down the block who is in the United States for a year as a high school exchange student. In order to improve her English and to earn spending money, she is working as a baby-sitter for your neighbors.

The city-boy-turned-cowboy story showed the young man with a ten-gallon hat. You will picture the Japanese girl in a kimono. The blueprint story showed the boy helping in the early morning roundup of the horses. You will show your subject with neighborhood children showing how a Japanese-style kite is made. The blueprint story showed the boy at breakfast with companions, downing heaps of flapjacks. You will picture the Japanese girl cheering with friends at the local high school basketball game.

The original article is also a blueprint for the writing. Tailor your writing to match the content and style of your blueprint. Insert quotes and anecdotes in much the same proportion as your model. If your writing skills are weak, find a friend who writes well and team together. Or simply amass the details (who, what, where, when, how) and submit them to the editor with your pictures. The editor will find a writer.

Where to market your picture story? Start with the local metropolitan

Sunday paper. The editors are always interested in seeing this slice-of-life kind of story. Also send it off to noncompeting magazines (those that have no cross-readership with each other) on your Market List that accept brief photo stories.

Expand certain aspects of your story to fit other markets. The kimono, emphasized correctly, would appeal to trade magazines in the teen-fashion industry. Periodicals in the educational field would like to see emphasis on the Japanese girl's learning experience in this country. And cultural and children's magazines may like more insight on Japanese kites and their popularity and importance to children in Japan.

Submit at least a half-dozen pictures to give the photobuyer a choice for his layout. Again, tailor your story line to your original blueprint, and you will earn not only the price of this book, but possibly the price you paid for the camera that took the pictures.

The key is to locate your blueprint example in the magazines on your Market List. This way you know you're on target with subject matter and treatment that are coordinated with *your* PMS/A.

While you're learning the ropes of such self-assignments, remember: If your first tries don't prove immediately marketable as picture packages, certain photographs may become individual stock-photo winners.

### Speculation

On self-assignments, you're working on speculation. Is this a "no-no" in stock photography? Not if you've used some savvy and done some homework to identify your PMS/A and become familiar with the kind of pictures needed by those on your individual Market List.

This way, if your stock photo doesn't sell the first time around, it's a valuable addition to your files and stands a good chance of earning its keep over the long haul.

You can also take pictures on speculation in response to a specific photo request by a photobuyer, and this is not a no-no either. In fact, it is especially helpful to the newcomer to the field. When you speculate by following the guidelines of a photobuyer, you are, in effect, receiving free instruction in what makes a good, marketable stock photo. The photobuyer's specifics will tell you what to include and what not to include. Subscribers to our *PHOTOLETTER*, which lists the current needs of photo editors, will often use a current photo-need listing as a guide, take the picture and submit it to the photobuyer, if the deadline is within reason.

There are times, however, when you shouldn't speculate: A timely picture will quickly lose its marketability. A highly specific picture will probably not be marketable to many targets. Going after a picture that entails a good deal of expense (in time, travel or special arrangements) is questionable. The president's visit to Ohio might attract so much freelance and staff-photographer competition that it would not be cost-effective for you to get

involved. Finally, a picture that is outside your PMS/A might reflect your lack of expertise, and that would certainly limit its marketability.

## Take a Free Vacation

One type of self-assignment you can give yourself with assurance, over and over again, is the travel assignment—but with a switch: If you're planning a vacation or a business trip, plan to profit on your trip through your photography. Because your travel can be a business expense when it involves getting pictures to add to your stock-photo files, your travel expenses can be a tax write-off—another way your trip pays for itself. (Chapter sixteen gives more details on the tax benefits of making a business out of your photography expertise.) However, rather than aiming your camera at standard tourist attractions (Track A pictures with limited marketability), concentrate on pictures where the supply is short and demand is great.

Another free vacation is one that is offered to established stock photographers and writers by public relations firms representing ship lines, ski resorts, hotel chains, spas and so on. Invitations are issued regularly in the *PhotoDaily* and *Travelwriter Marketletter* by firms that will provide lodging, meals and often airfare to writers and photographers who have firm assignments relating to areas of the world they represent.

**Who buys travel pictures?** Travel editors, of course, but they are *so* deluged with travel pictures (exquisite clichés) from freelancers, government agencies, stock-photo agencies, PR people and authors of travel stories that this market takes time to break into. At first, you represent more *work* for the travel editor, as someone new that he has to deal with, communicate with and explain his picture needs to—all of which he wants to avoid, since he already has established picture sources that supply his needs. Instead of aiming at travel editors at first, direct your marketing efforts toward the publicity offices of airline, bus, train, ship and hotel organizations; city, state and national tourist offices; PR agencies; CD-ROM companies; video production companies; ad agencies (who represent the country or state); plus encyclopedia and other reference-book publishers who are continually updating their publications. Also, it's helpful in some cases to contact photo agencies. (See figures 11-2 and 11-3.)

Standard travel pictures are difficult to market because of the competition. Do not submit spectacular (in your estimation) pictures of standard tourist sites. The publicity officer or photobuyer has already rejected hundreds of them. You can, however, include pictures of *new* travel attractions or *changes* in existing attractions.

**What does the travel photobuyer really need?** Current pictures in their locales of these areas of interest: agriculture, mining, transportation, cuisine, contemporary architecture, celebrities, communications, recreation, education, industry, labor, sports and special events.

Your travel pictures, then, are not really *travel* pictures at all—but pictures

of factories, airports, new sports facilities, freeways, festivals, open-pit mines, housing, people and skylines.

To know what to take and where to find the subject matter, write to the Department of Economic Development and/or Department of Tourism (or Consulate/Embassy, if foreign) of the area you will be visiting. They will supply you with several pounds of literature—all of which needs updating. Travel agencies can supply similar literature. Consult the encyclopedias at your library, as well as other reference books, maps, CD-ROMs, websites, videos and pamphlets that feature your area of interest. All of this material will serve as a blueprint for the kind of pictures that photobuyers need. Make photocopies of pertinent leads, pictures and details (these will aid you in your query letter).

The agencies you will be working with are actually *promotion agencies.* They want to put their client's best foot forward. In these times, the profile of a city, tourist attraction, national park or monument changes rapidly. *Updated* quality pictures are always of interest to travel-picture buyers. (Note: Remind the photobuyer that your picture is an update.)

Stock agencies (see chapter twelve) are interested in seeing specific-quality travel pictures. If they like your selection, they'll probably ask to see more from other areas of the country or the world that you could take or may have in your files. If your pictures are large-format (120-size, 4″×5″, 8″×10″), you'll probably have a better chance of scoring at an agency than if they are 35mm. However, some agencies will enlarge your 35mm to 70mm or 4″×5″ for you. Other stock agencies deal strictly in 35mm.

But scoring depends on factors other than size. One of the most important is *content.* If they are pictures of a relatively untraveled area of the world or of places currently in the news, they will probably interest an agency more than if they were taken in, say, New York or Paris.

Here's another buyer for your kind of travel pictures: publishers. New books, CD-ROMs and websites focusing on the area you just photographed come out all the time. Why not have your pictures appear in them? The tourism departments and economics development offices mentioned above are often aware of projects in progress. They will steer you in the right direction (since their job is PR) if you mention in your letter to them that you would welcome information on forthcoming features on their area. Photo agencies, too, are aware of new projects in progress because photo researchers are knocking on their doors, looking for a picture from such and such a place. While you're checking at the photo agencies, tell them you have fresh, updated pictures of the place(s) you've visited. Frequently, photo agencies miss a sale because their locale pictures are outdated.

PR agencies will be interested in placing your photos if your pictures match their client's area of interest. Let's say, for example, you just returned from a trip to Venezuela, where you got forty marketable pictures of birds. Using the SATW directory (see pages 57-58), find out which PR agency(s)

represents Venezuela. For example, XYZ Agency will have an in-house writer prepare an article on "Birds of Venezuela." Using your photos, the agency will sell the article to a nature magazine. You will receive payment for your photos, as well as national recognition.

**What about postcards?** Postcard companies (see appendix A) are rarely good markets for your travel pictures. They pay low fees, your picture is bucking hundreds or thousands of others for selection and the companies usually want all rights. The commercial stock-photography competition is stiff in the postcard/gift area, and the fees are generally low. Unless you have a special reason for marketing in these areas, avoid them.

## Making the Contact

When possible, contact picture buyers *before* you go on your trip rather than after you return. Photobuyers, editors and agencies can inform you of their current needs and suggest side trips to collect pictures (on speculation or assignment) to supplement or update their files. Independent photographers do sometimes shoot first and ask questions later (the *shotgun method*). But most veterans inquire first, with a letter like the one shown in figure 11-2, and then shoot (the *rifle method*). The following are some letter-writing guidelines:

1. This is a form letter you will send out to a number of promotion directors or editors, so type an original that includes your address, e-mail address (and website, if you have one) and phone on your professional letterhead, and then photocopy or instant-print it. Leave a blank in the salutation to fill in the name, with space above for each different address. (You can write to "Editor," "Photo Editor" or "Art Director," but if you can find out the name of the individual, this, of course, is preferred.) The form-letter format is an asset in this case because it tells the picture buyer two reliability factors about you: that you deal with many photobuyers who are interested in your pictures—and he gets the impression that if he acts quickly, he can be first to review them; and that you do business in *volume*, so you must be competent and familiar with the marketing process—someone he could develop as a consistent source of pictures. Photobuyers usually aren't interested in dealing with one-shot photographers.

2. In your first paragraph, let the photobuyer know *when* you're going, for *how long*, what your *itinerary* is (only the routes that will relate to his area of interest) and how you'll be traveling (car, plane, train or bus).

3. Never ask if he'd like to see your pictures of *standard* tourist attractions—national monuments, parks, etc. (You should know that he already has these covered.) Instead, ask if he would like his files of these pictures *updated*. Recognizing his need to constantly update his files puts you in a professional light.

4. Explain whether you will shoot in black and white or color, or both.

---

**YOUR LETTERHEAD**

[Date]

Dear _____:

On August 15 through August 20, (year), I will be traveling in the state of Minnesota. My itinerary will include Duluth, the Iron Range, Charles Lindbergh's home, a visit to The Mall of America in Minneapolis and stopping points in between.

May I help you update your files with pictures from these areas? I shoot b&w and color, in both 35mm and 2¼-inch formats.

If you have specialized photo needs along this itinerary, I would be interested in learning about them. Perhaps we could work out an assignment that is mutually beneficial. I would submit my pictures to you, of course, on a satisfaction-guaranteed basis.

My pictures, including the several thousand I have in stock, are available on a one-time basis for publication at your usual rates.

Thank you for your attention, and I look forward to hearing from you.

Yours sincerely,

[Your Name]

---

*Figure 11-2. A typical assignment query letter.*

And tell him the size of your camera(s). In some cases, a photobuyer might prefer that you deliver your image in digital form.

5. Suggest that if he has some upcoming photo needs, you can save him time and expense by shooting them for him—if it's not too much out of the way for you. Assure him that you are not locking him into any definite contractual arrangement. (It's easy to say no to those.) Let him know your pictures will be taken with no obligation or precommitment on his part.

Mention in the next paragraph your stock file of several thousand images. The editor will interpret this to mean there will be no loss to you if he does not accept your pictures—that you are an established stock photographer with a high reliability factor and plenty of available markets. Let him know you are renting these pictures, not selling them. Try to find out the going rate for his publication or publishing house before you contact him, but if you can't, tell him your pictures are available for publication at his usual rates.

Figure 11-2 is a typical assignment query letter—notice that it's brief. No photobuyer wants a history of you or your photography. If your photos fit his needs, he'll buy. If they don't, he won't.

Let's say you didn't contact anyone before your trip, though, and you've just returned from Poland with many fine pictures. What do you do now? Contact all promotion bureaus, offices and agencies that represent Poland. These will include government agencies, as well as private Polish and American agencies such as airlines, ship lines and hotel chains. Your list might also include American ad and PR agencies that handle these accounts. Design a form letter that informs these agencies of your pictures of Poland. Do not send actual pictures or a Poland portfolio until an agency expresses interest to you. Visit the agency in person, if possible, with a portfolio of pictures tailored specifically to the agency's interest. Or download them, if you have a website, and inform potential buyers of your website's address. Use the tips in chapter seven on how to contact photobuyers by e-mail, by phone, by mail and in person. It's on these visits that you might receive referrals for your pictures ("No, we can't use them—but I know Joe Jones is preparing a book on Northern Poland").

Here's how to develop an after-the-trip query letter (see figure 11-3):

1. See number 1 of the instructions for writing a letter of inquiry.

2. In your first paragraph, let the editor or art director know who you are, where you're from (your letterhead will help) and when you were in his state or area. If your pictures are fresh updates, he is going to be interested. Mention specific areas that you have photographed.

3. Ask if you may send a selection of color and/or black-and-white photos for his consideration. (Don't send photos with this first letter.) If you know what he pays, mention this fee in your letter. This will save both of you an extra exchange of negotiating correspondence. If you don't know his fee range, apply some of the pricing tactics outlined in chapter eight.

4. Being an unknown photographer puts you at a disadvantage: Editors sometimes ignore introductory letters such as this. They prefer to stay with their own cadre of familiar and reliable photographers—rather than do the extra work of establishing contact with a new one. It's a good idea, therefore, to insert a line in your letter to this effect: "Requesting review of these pictures does not obligate you to any purchase."

5. Ask outright which pictures (of those you've listed) the photobuyer would like to review.

6. Copywriters tell us that the section of your letter that gets read first (if your letter gets read at all) is the *postscript*. You can attract photobuyers' attention by listing some of the places you have previously (or recently) photographed in his city, state or country. Since these names will be familiar to him, this will help personalize your letter to him.

If the art director or editor *does* ask to see your pictures, you should enclose a cover letter when you submit them for consideration. Again, a form letter is useful both to you (for your own records) and the editor. Your pictures, of course, will sell themselves, but as consumers, we all know that we are not likely to buy a new product (in this case, *you* are the new product) if service and support are not available. In other words, if the editor suspects you are a fly-by-night, that you have no reliability factor or that your business address or telephone number might change next week, he is not likely to give your submission much attention. Photobuyers recognize the professional touch in submissions accompanied by a form cover letter. Again, it must be brief. Editors are faced with the task of sifting through hundreds of photo submissions weekly. They don't appreciate lengthy letters that ask questions or relate irrelevant details about the enclosed submission. If you do feel compelled to ask a specific question (and sometimes it *is* necessary), write it out on a separate sheet of paper and enclose an SASE for easy reply.

If your form letter is neatly typed (never handwrite queries to editors), the editor will greatly appreciate your professionalism. Better yet, have it printed by one of the fast-print services (ask for 70-pound stationery stock), leaving blanks to fill in specific details for each different situation. The editor will then recognize you not as a one-shot photographer, but as someone with a good supply of pictures and, therefore, as an important resource for handling future stock-photo needs and assignments. (The thinking here is that no one would go to the expense of a printed form letter if he had only a few photographs to market.)

A typical form letter to accompany your submissions could be the standard cover letter in chapter nine (figure 9-1). (If your submission is solicited, you can lead the letter off with the line "Thank you for your request to see my coverage of _____.") Be sure to mention in this letter that "captions are included."

Ordinarily, stock photos (unless they are meant for technical or scientific use) do not require identifying captions. But travel and location pictures generally do. In your captions, identify the location and the action/situation in the picture.

As a photo illustrator just starting out, your reliability factor can go up several notches if a selection of your photos can be found on the World Wide Web. Another approach: on-demand printing, which allows you to print a short run of "sell sheets" at a low cost. Marv Dembinsky, Jr., captures a

# YOUR LETTERHEAD

[Date]

Dear _____:

My name is _____, and I recently updated my stock-photo files of several thousand transparencies and b&w prints when I traveled through [state/country] in [month]. My files now include substantial coverage of these points of interest:*

_____

_____

_____

I would be happy to send you a selection of b&w prints and transparencies for your consideration. They are available at $_____ on a one-time-rights basis. Request to review these pictures does not obligate you to any purchase.

Which pictures would you like to receive for consideration?

Yours sincerely,

[Your name]

*P.S. I also have strong coverage in my stock file of these areas:

_____

_____

_____

*Figure 11-3. Sample shotgun (after-the-trip) query letter.*

half-dozen images from a recent trip onto a single sheet using his scanner, Photoshop and a color printer. He then mails or hand delivers the results to his photobuyers.

One final suggestion for *free travel.* If your forte is glamorous pictures of resort areas, Caribbean hotel owners are willing to barter with you. Send a sampling of your work to the sales manager of a Caribbean hotel with the

explanation that you will provide brochure-quality pictures (twenty to forty) of his hotel environs, complete with models and model releases, in return for a one-week stay for you and your models. Provided your sample pictures are good and the friends who accompany you have an All-American look, you will be hosted in the Caribbean next February for a week. In some cases, airfare can also be arranged.

## A Sampling of "Hot Sellers"

Each of your prime travel markets (e.g., mining, transportation, education) will present varied opportunities for stock photos. The following pictures by freelancer Mitch Kezar (see chapter two, "A Gallery of Stock Photos") are a good indication of the style and type of pictures sought by textbook publishers, encyclopedias, TV stations, Bureaus of Tourism and the education industry. Instead of aiming your camera at tourist attractions when you travel, use Mitch Kezar's pictures as a blueprint to follow. In these examples, he captures the spirit of a college campus in the Midwest. His pictures have enjoyed many repeat sales.

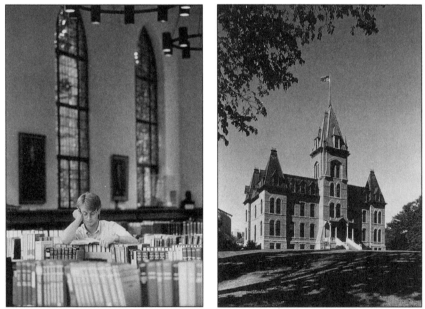

*Photos by Mitch Kezar.*

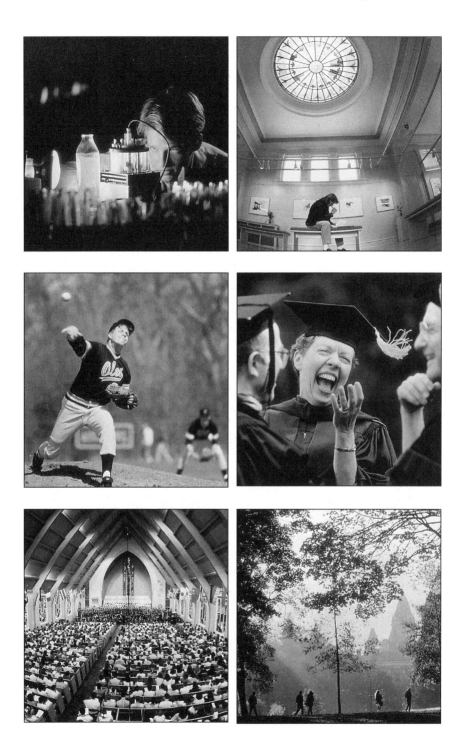

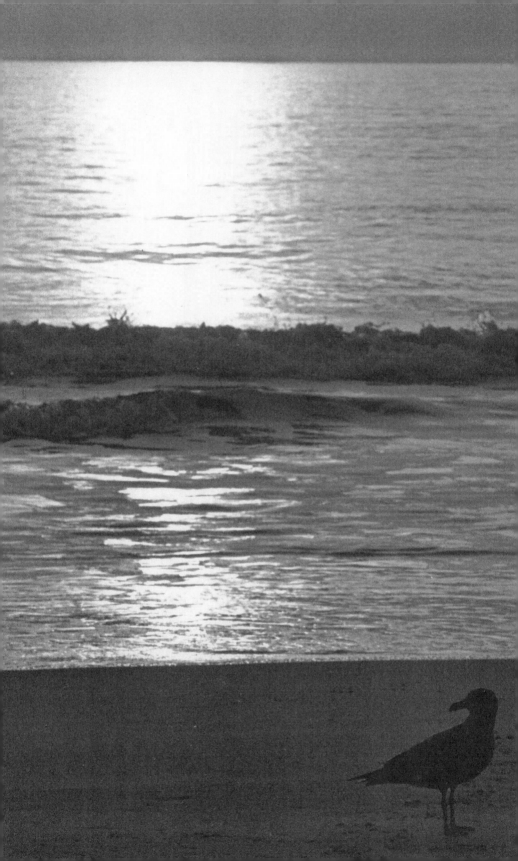

# Stock-Photo Agencies and Decor Photography

## Outlets for Track A

Stock-photo agencies can offer opportunities or headaches. This chapter will help you avoid the "stock-agency blues" and capitalize on the dollars available to the photographer with the right kind of stock photographs at the right agency.

If you choose wisely, you can approach agencies as an investment—one that should pay off in time.

You will gain most by selling your prime Track B pictures yourself to your hot Market List. Let agencies handle your Track A pictures—those standard excellent photos that are so difficult to market on your own because of excessive competition and the fact that the buyers who look for those types of shots are the ones who usually turn to agencies or their own list of favorite pros, not to a lesser known freelancer.

I myself have pictures at three agencies. My first contact with a stock-photo agency was in 1958, when I had just returned from a trip through Africa. In New York, a friend introduced me to Anita Beer (who later merged her stock-photography agency with Photo Researchers, Inc., New York City). In those days, agencies were not plentiful, and they attempted to be all things to all people. Emphasis was on black and white. Today, the emphasis has moved to color, computerization and specialization. Although some large, prestigious agencies still hold out as general agencies, new ones have seen what happened in the magazine industry to general magazines and have taken the hint to specialize.

Most of the better known stock-photo agencies (sometimes called *picture-rental libraries*) are located in New York. The directory published by The Photographic Arts Center Ltd., the *Stock Photo Deskbook*, lists eighty-one stock agencies in New York City (one-third of the total number of stock agencies listed for the United States). The photobuyers who use stock agencies range from book and magazine publishers to ad agencies and PR firms.

These photobuyers have one thing in common: They can pay the high fee stock agencies demand.

## Nothing New Under the Sun

The best-sellers in stock agencies are *generic* pictures. It's not surprising that Jim Ong's book *Photography Best Sellers* points out that the top seller is a picture of clouds. The second-best-selling picture is also a picture of clouds.

So there you have it—the secret to stock-photography success: Take pictures of clouds. You can now close this book. Your search is finished.

But is that why you got into this field of stock photography? If you've read this far in this book, I doubt it.

It's true that generic photos will sell well through stock agencies, just as "clip art" sells well at graphic houses and canned elevator music sells well to corporations.

Because it can bring in big dollars, you might want to pursue this aspect of commercial stock photography, knowing that it will at least help to support your real love: your PMS/A (personal photographic marketing strength/areas).

But a word of caution: Generic photos present an ethical and legal problem. They are wide open to copy and to be copied. Jack Reznicki writes in a letter to the editor in *Photo District News*, "I know without looking what is in [Agency X's] catalog: a grandfather and grandson fishing; a three-generation shot; three businesspeople talking—one of them a woman, someone using a laptop computer in a kitchen or a nonoffice setting. . . . And I wonder if anyone in (the agency's) stable of photographers has shot Norman Rockwell's famous Thanksgiving scene from his 'Four Freedoms' series. Again, where do you draw the line between influence and infringement?"

As a creative person, you are inspired not only by the world around you, but by other photographs as well. If you venture into the field of commercial Track A generic pictures, be prepared to look for well-worn tripod marks when you choose your photo vantage point. Otherwise, you might have a fellow commercial stock photographer crying, "Infringement!"

## Prepare to Share Your Profit

Stock agencies do demand high fees. They can afford to, because they offer the photobuyer something he can't get anywhere else—a huge selection at his fingertips. It's this fact, so attractive to photobuyers, that is your disadvantage. If your picture of a windmill or frog or seagull is being considered for purchase among dozens and dozens of others in the same agency—never mind competing agencies—your chance of scoring is minimal.

Even against this reality, however, the chances of that kind of Track A picture selling are greater at an agency than if you tried to market such shots yourself. Does big money await you when you go with an agency? It depends on how well you choose your agencies and how often you supply them with

your targeted photos. Agencies will tally their sales for you on a monthly, quarterly or semiannually basis and send you a check. And although this check is for only 40 to 50 (sometimes 60) percent of the agency's sales (the agency receives the remainder), it's always welcome. (From $40 to $150 is the present range of your share of an average transparency sale.) Most photographers, whether they are service or stock photographers, count on agency sales only as a supplement to the rest of their photography business.

A good rule of thumb, according to stock-photographer Spencer Grant, is that you can expect one dollar annually for every photo you have in an agency. If you have 500 photos with the agency, you can expect annual revenues of $500; if you have 5,000 you can expect $5,000 and so on.

Newcomers to photo marketing (and some not so new) sometimes think they can relax once their pictures are with an agency—they believe that now they can concentrate on the fun of shooting and printing and check cashing and let the agency handle the administrative hassles of marketing.

## Agencies: A Plus With Limitations

It just doesn't work that way. In fact, it's a bit like gambling. You can increase your chances of making regular sales through agencies if, as at the baccarat table, you study the game.

Agencies offer the pluses of good prices and lots of contacts, but they have limitations that affect the sale of *your* pictures. One is that monumental competition faced by any one picture. Another is that no agency is going to market *your* pictures as aggressively as you do. The agency has something to gain from selling, yes, but it spreads its efforts over many photographers.

Another limitation, which you can turn to a plus once you're aware of it, is that different agencies become known among photobuyers as good suppliers in some categories of pictures but not others. Like art galleries, agencies tend to be strong in certain types of pictures. Sometimes, however, an agency will accept photos in categories outside its known specialties. If you place your pictures in the *wrong* agency, they won't move (sell) for you.

When a photobuyer at a magazine or book publishing house needs a picture, he assigns the job of obtaining that picture to a photo researcher, a person (often a freelancer) who is adept at finding pictures quickly, for a fee. The researcher makes a beeline for an agency that he knows is strong in the category on the needs sheet.

If a book publisher, for example, is preparing a coffee-table book on songbirds, the researcher will know which agency to visit, and it might not be an agency you or I have ever heard of. And it might not even be in New York.

Photo researchers know that agencies, like magazine and book publishers, have moved toward specialization. By going to an agency that he knows is strong in songbirds, the researcher knows he'll have not a handful of pictures to choose from, but several hundred. Often the picture requirements will

demand more than simply "a blackbird"—they'll specify the background, the type (Brewer's or red-winged), the time of the year (courtship, nesting, plumage changes), the action involved (in flight, perching or a certain close-up position)—and the wide selection will be particularly necessary.

Researchers feel that they're doing their clients justice in choosing agencies they know will have a wide selection. If your pictures of birds or alligators are in a different agency, they may never be seen.

The first order of business in regard to agencies, then, is to research the field and pick the right ones for your mix of categories. You can have your picture in several agencies at once, chosen on the basis of geographical distribution (an agency in Denver, one in Chicago and one in New York) and on the basis of picture-category specialization (scenics at one, African wildlife at another, horses at another).

## How to Find the Right Agency

If your photography is good, just about *any* agency will accept it, whether or not they're looked to by photobuyers as strong in your particular categories. That's where the danger lies. How, then, can you find the right agency—or agencies—for you?

It takes time, but here's one approach. Part of your task on the second weekend of your Four Weekend Action Plan (see chapter four) is to separate your pictures into Track A categories on the one hand and your PMS/A on the other. Take both your Track A and PMS/A lists and narrow them down to the areas where you have the largest number of pictures.

Let's invent an example. Let's say that in Track A (the standard excellents) you isolate three areas in which you are very strong: squirrels, covered bridges and underwater pictures. In your Track B PMS/A you isolate five strong areas: skiing, gardening, camping, aviation and agriculture. Taking your Track A pictures first, do some research and find which agencies in the country are strongest in each of your three categories, rather than placing all three Track A categories with one general agency.

You might find that your covered-bridge pictures land in a prestigious general agency in New York that happens to have a strong covered-bridge library. You will supply that agency with a continuing fresh stock of covered bridges, and they will move your pictures aggressively. Your underwater pictures might land in a small agency in Colorado that is noted for its underwater collection. Again, your pictures should move, since photo researchers will know to look to this agency for underwater shots.

Your covered-bridge pictures fall into Track A; you would probably have difficulty marketing them on your own. But how about your Track B pictures, like your camping or agriculture shots? Should you ever place them in an agency, too—or will you be competing against yourself, since you will be aggressively marketing your Track B pictures to your own Market List?

Your answer will depend on your Track B pictures themselves, their par-

ticular categories and your Market List. If your own marketing efforts are fruitful, you will do best to continue to market your Track B categories yourself. If certain that your Track B pictures move slowly for you, you might find it advantageous to put them in an agency. (If you do, place your slower moving Track B categories in different agencies, with the same fore-thought you gave to your Track A categories.)

## Researching the Agencies

Tracking down the strengths of individual agencies will take some research on your part. The magazines and books that are already using pictures simi-lar to yours will be your best aid. As an example, let's take your Track A squirrel pictures.

Being a squirrel photographer, you naturally gravitate to pictures of squir-rels. If you see one in a newspaper, encyclopedia or textbook, it attracts your eye. Make a note of the credit line (if there is one) on each squirrel photograph. It will be credited with a photographer's or agency's name in about a third of the cases. (Picture credits are sometimes grouped together in the back or front of a magazine or book.) If, after six months of this kind of research, the same stock-photo agency name keeps popping up, your detective work is paying off. (Sometimes, depending on your Track A cate-gory, two or three agency names will appear. This is a plus—it means you can be choosy about whom you eventually contact, basing your decision on how long each agency has been in business, its location, whether it has a toll-free number, etc.) Locate the photo agency's address in a directory such as *Photographer's Market, Photomarketing Handbook* or *Stock Photo Deskbook.*

You can also check agencies out by contacting the Picture Agency Council of America (PACA). Send $15 plus an SASE for a list showing membership's specialties. (This list will prove helpful in locating agencies and the categories of pictures they carry, but you'll learn more about where photobuyers go for what through your own research.) Contact PACA at P.O. Box 308, Northfield, MN 55057-0308, (800) 457-7222.

The following is a list of directories that list stock-photo agencies. No one directory lists all of them, so research as many as you can find. Some of the directories will mention each agency's photo emphasis. To save you time, we produce a computerized printout of agency strength areas. Send me an SASE at PhotoSource International and ask for information about our report "Stock Photo Agency Strategies."

*American Society of Picture Professionals Directory*, 2025 Pennsylvania Ave. NW, Suite 226, Washington, DC 20006
*ASMP Stock Photo Handbook*, 14 Washington Square, Suite 503, Princeton Junction, NJ 08550-1033

*Photographer's Market*, Writer's Digest Books, 1507 Dana Ave., Cincinnati, OH 45207

*Photomarketing Handbook*, Images Media Inc., 89 Fifth Ave., #903, New York, NY 10003-3020

*Picture Research, Photo Agencies & Libraries*, Brian Seed & Associates, 7432 Laymon Ave., Skokie, IL 60077

*Stock Photo Deskbook*, The Photographic Arts Center, 163 Amsterdam Ave., Suite 201, New York, NY 10023

## How to Contact a Stock-Photo Agency

Agencies, like photobuyers, expect a high reliability factor from you. If you are certain you have discovered an agency that is strong in one or more of your categories, contact the agency with a forceful letter.

Your first paragraph should make the agency director aware that you have been doing some professional research, and that you aren't a fly-by-night who just happened to stumble onto his agency's address.

Let the agency know the size and format of the collection you are offering and whether it's black and white or color (a surprising number of agencies require black and white in addition to color). If you place special emphasis on a certain category or you live in or photograph in a unique environment, state this also.

Impress upon the agency that your group of pictures is not static, that you continually add fresh images. (Some photographers hope to dump an outdated collection on an agency.)

Tell the director you are considering placing this particular collection in a stock house. Give the impression that you are shopping, *not* that you are expecting or wishing to place your pictures with him.

If your research is accurate and your letter professional in tone and appearance, the photo agency will welcome your contribution to its library. More important, your pictures will be at an agency known for a specialty—that happens to be *your* specialty.

In some cases, you can make a personal visit to an agency instead of writing a letter. A few agencies in the large cities designate one day of the week as a day when photographers can come in to display their photos for consideration.

One photographer I know walked into a New York agency with ten notebooks of vinyl pages (about four thousand slides). The director said, "I can't look at that many slides. Weed them down to one book and come back tomorrow." The photographer went back to his hotel room and spent until 3:00 A.M. narrowing down the selection to one book representing his best. He returned the next day, and the director said, "This is nice stuff. Do you have any more of these 'people having fun in winter sports'? We get a lot of calls for outdoor recreation."

The photographer went back to his hotel, went through the selection

process again and rushed back to the director with a book of outdoor-recreation pictures. The photographer has since sold outdoor-recreation scenes through the agency and continues to update his file there. Learn from this example. Categorize your pictures before you step into an agency. The director will want to see the best you have—on the subjects that interest him.

Once an agency says, "OK, we'll carry your pictures," how many should you leave for their files? If it is a highly specialized agency, a minimum of forty black-and-white prints or slides (two vinyl sheets) is acceptable. A general agency would expect ten to fifteen of your vinyl pages and/or two hundred to three hundred black and whites. You would be expected to update this selection with twenty to forty new photos at a time, every six months to a year.

The agency will specify how your pictures should be identified and captioned. For example, on slides, most agencies want their agencies' names at the top and the caption information at the bottom. Your identification code, name, address and telephone number should appear on the sides. They'll want to know which pictures have a model release (MR) or a model release possible (MRP).

Agencies will send you their standard contract form in which they'll stipulate, among other things, that they will take 50 (sometimes 40, sometimes 60) percent of the revenue from picture sales. Expect them to require you to keep your pictures on file with them for a minimum of five years. (If after a period of time you want your pictures returned, an agency may take up to three years to get them back to you.)

## The Timely Stock Agencies

A few editorial-picture agencies deal in current photojournalism and sell for the service photographer who supplies fresh, news-oriented pictures. The agencies, again, are based in New York, and they send individuals or teams to trouble spots or disaster areas, much as a local or regional TV camera crew covers news of immediate interest. Most of these agencies, with channels or sometimes headquarters in Europe, sell single photographs and provide feature assignments around the globe for their top-ranking photographers. If you happen to photograph a subject, situation or celebrity that you think has timely national impact, phone one of the following agencies and feel them out:

Black Star, 116 E. Twenty-seventh St., New York, NY 10016, (212) 679-3288, Fax: (212) 447-9732.

Contact Press Images, 116 E. Twenty-seventh St., New York, NY 10016, (212) 481-6910.

Gamma-Liaison, 11 E. Twenty-sixth St., New York, NY 10010, (212) 779-6300.

**Sygma Photo News**, 322 Eighth Ave., 11th Floor, New York, NY 10001, (212) 675-7900.

Payment for your picture or picture story is based on several factors: (1) exclusivity (has the rest of the world seen it yet?); (2) impact (would a viewer find your picture[s] of interest?); (3) your name (if your name is Rick Smolan, add 200 percent to the bill); (4) timeliness (is it of immediate interest?). The following agencies will accept the kind of pictures and picture stories mentioned above, but will also accept nondeadline human-interest pictures and stories:

**Associated Press (AP)**, 50 Rockefeller Plaza, New York, NY 10020, (212) 621-1500.

**The International Herald Tribune**, 850 Third Ave., Station B, New York, NY 10022, (212) 752-3890, Overseas (Paris): (331) 4637-9370.

**United Press International (UPI)**, 1400 I St. NW, Washington, DC 20005, (202) 898-8200.

## Stock-Agency Catalogs

Most of the major stock agencies produce print catalogs. In most cases you'll have to pay, by the page, to be included. All things being equal, the venture generally turns out profitable for the photographer. Some agencies also produce a catalog on a CD-ROM. The jury is still out on whether these are cost-effective for both the agency and the photographer. As online galleries become more popular, CD-ROM catalogs may lose their effectiveness.

## Possible Problems in Dealing With Stock Agencies

In dealing with a stock-photo agency, remember: You are the creator, you are in control and *you* own your picture.

### Contracts

Read any stock-agency contract *carefully*. Most photo-agency contracts ask you to sign with them exclusively. Some stipulate that if you market any picture on your own, 50 percent of those revenues become theirs. Some agencies ask that you shoot stock pictures on a regular basis and send the results to them. If you fail to do so, they assess a maintenance charge to your account.

Contracts should be treated as agreements to be modified by both parties. Draw a line through any section in the contract that you disapprove of, and initial it. If your pictures aren't returned to you shortly thereafter, you'll know that the agency values the opportunity to market your pictures more than having agreement from you on the point or points you deleted from the contract. (Be prepared for possible negotiation and sharing of concessions with the agency.)

## Conflicts

Some photo agencies may express wariness of a possible sale conflict—say, two competing greeting card companies buying the same picture—if the agency, plus you, plus one or two other agencies in the country are marketing your pictures. Explain to the agency that you have placed your pictures *by category* with agencies who are strong in these differing categories—and have not placed the same picture (or a duplicate) in competing agencies, and don't intend to.

Could a problem still arise on a major account where significant dollars are involved? In such a case, the art director would thoroughly research the pictures with you for releases, history of the picture, previous uses of it, etc., before it is used, and any inadvertent duplication or possible sale conflict would come to the fore at that time.

In any case, if you have signed up on a nonexclusive arrangement with a stock agency, you put the burden of follow-up on the history of sales of a particular picture with the stock agency that handles your photos, not on yourself.

## Delays

You'll be more likely to run across a problem in the area of delays: By far the highest percentage of complaints that come into my PhotoSource office are about the slowness of stock agencies to move pictures. ("I know they could sell my stuff, but they don't try. They don't actively keep my pictures moving for sales. They're selling other photographers' work, but not mine!")

I've followed up on every complaint and have found that in all cases the grief could have been avoided. The problem usually lies in the *eagerness* of both parties.

The eagerness of stock-photo agencies to supplement their stock of pictures by accepting categories of photos outside their known strength areas can be likened to the well-run garage that keeps its well-paid mechanics busy. They accept any job, any make vehicle, foreign or domestic. They pride themselves on their versatility. The fact is, no one is *that* versatile. Someone usually loses—the customer. With a little research, the auto owner could have found the *right* garage for his car and his pocketbook.

By the same token, the eagerness of photographers to have their photos accepted into a prestigious stock-photo agency for the name, rather than on the basis of research showing the agency as strong in their specific categories, gives rise to the complaint, "They don't aggressively move my material!"

If your pictures of Alaskan wildlife, for example, were placed in the ABC Agency—a well-known, prestigious agency—a photo researcher seeking wildlife pictures would bypass that agency if it were *not* known for a strong wildlife selection, and instead head for the little-known XYZ Agency, strong on wildlife. Do your research, and choose your agencies with care.

### Honesty

There are other complaints and problems. I often hear them in this form: "Are they honest? I'm not receiving checks for *all* the pictures of mine the agency is selling."

If it is any consolation, I have heard of only one documented case in which it turned out that a major stock-photo agency purposely attempted to carry out the above. I know it happens, but I believe it rarely happens on purpose. Stock agencies trade on their own reliability factor, just as you do.

As a free-agent stock photographer, you place yourself at the mercy of the basic honesty of all the contacts you make in the world of business. That's one of the disadvantages of being a freelancer, and probably a good reason that there aren't too many of us. Before you place your pictures with a stock-photo agency, find out as much as you can about the agency—and then take a leap of faith.

## Do You Need a Personal Rep?

What stock-photo agencies do for photographers on a collective basis, representatives do on an individualized basis. A rep earns a living by securing the best price for your single pictures and the best fee for your photographing services. There's an old saying in the business, "You'll know if you qualify for a rep because the rep will come to *you*—just when your photography has finally arrived and you don't need him anymore."

Can a rep be of benefit to you? Yes, especially by freeing you from the confinements of administering your sales: You'll have more time to take pictures. But reps can be expensive. Depending on the services they provide to you, they take from 20 to 50 percent of the fee. Most reps are in New York, where so many commercial photobuyers are.

Unless you live in a city of over a million population and your name is well established in the industry, you and a rep would not find each other mutually beneficial. For further information on reps, contact the Society of Photographers and Artists Representatives (SPAR), 1123 Broadway, Room 914, New York, NY 10010, (212) 924-6023, Fax: (203) 866-3321.[1]

## Will Stock-Photo Agencies Go Out of Style?

Thanks to advances in telecommunications, photobuyers will have the choice of dealing with a massive agency (Corbis Media, Getty Communications) or a small specialty agency. Depending on where you choose to place your pictures, the photobuyer will find your agency. If you choose to set up your own website and develop a highly specialized collection of photos, you may fare better than if you join a massive agency.

---

[1]For a list of reps: *Photographer's Market*, published by WD Books.

*Figure 12-1. Ways to identify transparencies left at stock-photo agencies.*

## Start Your Own Mini-Agency

If a stock agency or a rep is not for you, but you want the photo-agency system for marketing your pictures (i.e., you want someone other than yourself to handle the selling) and you want a more aggressive approach to the sale of your photographs than you get with a regular agency, then establish a mini-stock-photo agency of your own to handle your pictures. You can do this on an individual basis, or get together with one or more other photographers to form a co-op agency. Both forms of mini-agencies have advantages. Both can be set up as websites.

### The Individual Agency

Find a person (friend, neighbor, spouse or relative) who has spare time, an aptitude for elementary business procedures and a desire to make some money. An interest in photography is helpful, but not necessary. More important, the person should have the temperament for recordkeeping and the ability to work solo.

Your job will be to supply the finished pictures. (You absorb all costs for film and processing.) Your cohort's job will be to search out markets, send out the photos, keep the records and process the mail. From the gross sales each month, subtract the expenses off the top and split the net fifty-fifty. (There won't be many expenses: postage, phone, mailing envelopes, stationery, invoices and miscellaneous office supplies, such as rubber bands and paper clips.)

Before you start up your mini-agency, decide on a name and design a letterhead and invoice form. Open a business checking account. Work up a letter of agreement with your colleague that in effect will say

1. You will split the proceeds fifty-fifty after business expenses, and all pictures, transparencies and the *name* of the agency will revert to you, the photographer, in case of termination of your business arrangement. Also, the back of your prints will show *your* personal copyright—not the agency's.

2. Bookkeeping records will be kept by your colleague, who will pay you from the business checkbook. Major purchases will be mutually agreed upon and the cost divided between the two of you. (Should you incorporate at this point? Probably not, but it depends on many variables that only you can answer. See the list of business information books in the bibliography.)

3. Other photographers' work may also be collected by your colleague to market. Reason? IRS rules state that if other photographers' work is also represented, then your colleague is not an employee of yours (which requires employment records), but rather an independent contractor, which requires no government paperwork on your part. Your colleague fills out his own tax forms. You fill out Form 1099.

Personalized photography business forms are available from the New England Business Service, 500 Main St., Groton, MA 01471. This service may have photography forms adaptable to your mini stock agency. Call toll-free at (800) 225-9550.

The success of your mini-agency will depend on the efficiency of your retrieval system—designed for the convenience of both the office help and the walk-ins (i.e., photo researchers looking for pictures). Pictures should be categorized and filed with attention to physical ease of retrieval. (Chapter thirteen will give you help on this.)

For business reasons, as a mini stock agency, you may want to explore joining the following three organizations. (Membership can add credibility on your business stationery, and all three provide newsletters with information from the picture-buying point of view that can be valuable to your operation.)

**Picture Agency Council of America (PACA)**, P.O. Box 308, Northfield, MN 55057-0308, (800) 457-7222 or (507) 645-6988.

**American Society of Picture Professionals (ASPP)**, 2025 Pennsylvania Ave. NW, Suite 226, Washington, DC 20006, (202) 223-8442.

**Society of Photographers and Artists Representatives (SPAR)**, 208 5th Ave., 7W, New York, NY 10010, (212) 684-0245.

If you've chosen a good, aggressive colleague, once your one-person agency is set up and rolling, you'll find you'll be able to concentrate more on picture taking and less on administration.

## The Co-Op Agency

Some photographers prefer to band together and form a cooperative agency, an establishment in which nonphotographer members handle the administration and photographers handle the picture taking. They share office-sitting chores, and they are compensated on a total-hours-contributed basis.

I have watched the demise of many such agencies—and the failure can always be traced to a concept problem: They attempted to be a general

agency servicing local accounts. This seems logical enough, but a local account figures if it's going to pay national prices, it ought to get its pictures from a national source—and it does. Using convenient express services, such as UPS or FedEx, it bypasses the local agency.

The *solution* for a small regional agency is to specialize. For example, a small agency in Nebraska might specialize in submarines, an agency in Vermont might specialize in things Mexican and an agency in Florida might specialize in pro-football celebrities. In today's world, where distance has been annihilated by telecommunications, Express Mail and computers, there's little reason for a Montana agency to specialize in the obvious—cowboys. It's more important to be a mini-expert on one subject. You'll then gather the pictures from all over the country, and the world, if need be. Here is a list of popular request categories, any one of which could be the specialty of a co-op mini-agency: celebrities, movie stills, historical, natural history, fine art, industrial, agricultural, food, sports, glamour, scientific, geographic and still lifes.

The local accounts might continue to ignore you—but not when they need your specialty. You'll find them standing in line with the rest of your national accounts.

How many pictures should you have on file to start your mini-agency? At least 5,000 if you specialize, and 20,000 if you are a *general* agency. How do you find qualified stock photographers? A few will come out of the woodwork locally, but the majority you will find through directories (see table 3-1) such as *Literary Market Place* and *Stock Photo Deskbook* or ASPP, APA and ASMP membership directories.

Many stock-photo agencies, large and small, are finding out (like the banking industry) that to stay competitive they must form strategic alliances with rival players. For an insight on how Allen Russell, of Profiles West, teamed up with the New York agency Index Stock, read the article "The Nitty Gritty of Stock" (*Photo District News*, June 1996, page 62).

## Decor Photography:
## Another Outlet for Your Standards

As a stock photographer, you will find that many of your Track A pictures lend themselves to a photo-marketing cousin of stock agencies: decor photography (or *photo decor, decor art* or *wall decor,* as it's sometimes called)—photographs that decorate the walls of homes, public places and commercial buildings. In contrast to your work in stock photography, you will be selling color *prints*, not slides.

The two basic ways to sell photography for decoration are (1) *single sales* (yourself as the salesperson) and (2) *multiple sales* (an agent as the salesperson). In either case, you, or the person you appoint to select your prints for marketing, should have a feel for the art tastes of the everyday

consumer. You are headed for disaster if you choose to market prints that appeal only to your sophisticated friends. You'll ring up good decor sales if you can match the kind of photos found on greeting card racks.

I suggest that, as a beginner, you offer your photo decor *on consignment*. You can expect to receive a 50 percent commission from your retail outlets for your decor photography.

### Single Sales

Art shows, craft shows and photo exhibits of all kinds are typical outlets for single sales of your decor photography.

Aggressively contact home designers, architects, remodelers and interior decorators. They are in constant need of fresh decorating ideas. Your pictures can add a "local" touch. Gift shops, frame shops and boutiques can be regular outlets.

Art fairs provide an opening into the decor-photography market. Offer your pictures at modest fees. (Most visitors come to an art fair expecting to spend no more than a total of $60 to $70. Let this be your guide.) You'll find you can make important contacts at art fairs that will lead to future sales. Pass out your business cards vigorously.

There are two categories of decor photographers at major art fairs: Those that net $40 for the weekend, and those that net $4,000. The former, in work jeans, relax at their booths in beach chairs. The latter are equally excellent photographers who have studied the needs of consumers, present their work in a professional-looking booth and are aggressive salespersons.

Miller Outcalt, writing in *PHOTOLETTER*, says that entrance fees at art fairs range from $25 to $250, with the average being $90. Most fairs are held on weekends, usually from 10:00 A.M. to 5:00 P.M. Setup time is at 7:30 A.M. A matted 8″×10″ color print will bring $20 (2 for $35); an 11″×14″, $35; and 16″×20″, $60.

Photo galleries offer important exposure and sales opportunities for your decor photography. The Photographic Arts Center, 602 Commonwealth Ave., Boston, MA 02215 (http://www.web.bu.edu/PRC) produces aids for photographers, including *The Photographer's Guide to Getting & Having a Successful Exhibition*, 163 Amsterdam Ave., New York, NY 10023.

Visible Spectrum, 2660 Third St., Room 205, San Francisco, CA 94107, produces catalogs of fine-art photography. ArtView, an electronic service, HoniCorp, Inc., 379 W. Broadway, 2nd Floor, New York, NY 10012, provides on-screen viewing and buying of fine-art photography.

The single-print-sales system that requires person-to-person contact can be time-consuming, cutting into your profits. However, if you enjoy the excitement and camaraderie of art fairs and public art exhibits, it can be rewarding. Probably the most lucrative market channel for single sales

would be architects and interior designers. They are in a position to sell your pictures for you.

## What Makes a Marketable Decor Photograph?

One that makes your viewers *wish they were there*. Choose a view or subject you would enjoy looking at 365 days a year. If *you* don't like the view or subject, chances are your customers won't, either. Keep in mind that most buyers of decor photography enjoy pictures of *pleasant subjects* because they find in such pictures an escape from the hassle and routine of everyday living. That's why, for this market, it's important to take your scenics without people in them. Your viewers would like to imagine *themselves* strolling through the meadow or along the beach. Figures that are recognizable as humans in your picture are an intrusion on their own quietude and privacy. In addition, people included in decor-photography pictures can date the pictures with their clothes, hairstyles, etc. Here are some excellent standards that sell over and over again for decor-photography purposes:

**Nature close-ups.**[2] Zooming in on the details of the natural world at the correct F-stop always produces a sure seller. These subjects rarely become outdated: dandelion seeds, frost patterns, lichen designs, the eye of a peacock feather, the quills of a porcupine or a crystal-studded geode.

Decor-photography buyers tend to buy *easily recognizable subjects*. An antique windmill would consistently sell better than an antique wind generator (the kind with propeller blades); a still life of a daisy would sell better than a still life of potentilla. Keep your photography salable by keeping your subject matter simple. Feature only one thing at a time, or one playing off another, rather than a group of things.

**Animals.** Both wild animals and pets are perennially popular. Choose handsome and healthy subjects. Keep the background simple so it will enhance, rather than overpower, your subject.

**Dramatic landscapes.** Shoot landscapes in all seasons, especially with approaching storms, complete with lightning and rolling thunderclouds. The effects of ice storms are always popular, as are New England pathways in the fall and rural snow scenes.

Len Nemeth of Northfield, Ohio, sells landscapes to hospitals. "They use them for the ceilings of intensive-care rooms," says Len. "I find that the scenics that work best are those that have a splash of *light* somewhere off in the distance. If a path or road in the scene leads to the horizon, it must lead to a light area rather than a dark area. This seems to have a positive psychological effect on patients who have little to do all day but to look at my scenic above them on the ceiling. The light area seems to represent hope."

[2]An excellent quarterly that brings wildlife and nature photographers up to date is *Guilfoyle Report*. (See bibliography.) Bill Thomas's "Nature Photojournalism" seminars come highly recommended: write to "Touch of Success," Bill Thomas Photography, P.O. Box 194, Lowell, FL 32663-0194.

Bill Ellzey of Telluride, Colorado, also sells art photography for use in hospital waiting rooms, hallways and patients' rooms. "Local scenes offer more than decoration," Bill says. "Administrators know the cheering effect photography art can have on both patients and their relatives, not to mention the staff." Bill also sells to insurance companies, professional offices and government offices.

**Nostalgia.** This is a winner—if you can find the right rustic pioneer's cabin or antique front-porch swing; historical sites with patriotic significance, such as Paul Revere's home or Francis Scott Key's Fort McHenry; still lifes containing memorabilia such as Civil War weapons or whaling ship artifacts. Again, choose the easily recognized subject.

**Abstracts.** Your pictures can range from bold, urban shadow patterns to the delicate network of filaments in a spider's web. Abstracts lend themselves well to waiting rooms, attorneys' offices and professional buildings, as well as homes.

**Sports.** Capitalize on the nation's avid interest in sports personalities and the games they play. Close-ups sell best. Scenes of sporting events such as football, soccer, tennis and skating lend themselves to game rooms and family playrooms.

**Portraits.** Model releases are necessary. Close-ups sell best. Exotic, interesting, quizzical, yet pleasant (Mona Lisa) faces sell to legal suites and corporation offices.

**Erotic.** Eroticism finds a market in private clubs. Subject matter can range from newsstand pornography to esoteric nude studies.

**Industrial.** Sell your best industrial scenes to engineers' offices. It goes without saying that your pictures should be well composed, visually exciting but easy to look at, and of high technical quality. Sell to industry itself. Capture the strength of industry (a la Ayn Rand) or its contributions to society: visually appealing abstract patterns, close-ups of computer chips, laborers in meaningful work or factories at sunset after a fresh rainfall. De-emphasize the negative aspects of industry.

**Underwater.** The quietude and exotic nature of underwater scenes are appealing to consumers. For an example of excellent decor photos, many of which include underwater scenes, send $10 to Creative Color, Station 17, 4911 W. Grace St., Tampa, FL 33607, and ask for the catalog *Beautiful Photography*. For a how-to book on underwater photography, read *The Nikonos Handbook*, by Cathy Church, Sunset Underwater Photo Center, Sunset House, P.O. Box 479, Grand Cayman, British West Indies.

### What to Charge

Prices depend on whether you sell in volume or individually. In either case, the buying public will pay about $45 for an 11″ × 14″ and $25 for an 8″ × 10″, after markup. Before you decide on your own price, see what the local de-

partment stores are getting for similar decor photography. Also, check out the fees in catalogs such as *Beautiful Photography*.

Limited editions are another question: You can demand a higher fee. And, of course, if you keep a couple prints for the grandchildren, they just might become heirs to *very* valuable prints. How do you limit the edition? As with other printmaking (silkscreen, etching or lithography), you destroy the original after making 100 to 500 prints. In decor photography, you destroy the negative.

What to charge for limited editions? Keep in mind the professional artist who once said, "If you are going to price your watercolor at $15, you'll find a $15 buyer. If you price it at $75, you'll find a $75 buyer. And if you price it at $850—you'll find an $850 buyer. Just takes time." The going rate for a 16″×20″ color limited-edition photograph is between $75 and $150.

**Black and white or color?** Surprisingly, black-and-white prints sell well as decor photography if they are sepia toned. But color probably has the edge over black and white. Shoot in transparencies rather than negatives—for three reasons:

1. You can project them effectively when you are demonstrating your subjects to a potential client.
2. Processing-lab technology can handle transparencies cheaper than negs and prints.
3. As a photo illustrator, you'll also want to market your color through regular publishing channels, and they require transparencies.

**Size.** If you sell your prints on a single-sales basis, you'll find that the larger 16″×20″ print (and higher fee) will result in more year-end profit than smaller (11″×14″ or 8″×10″) prints (and lower fees). On the other hand, if you go to *multiple sales* and smaller prints and aim for the volume market in high-traffic areas such as arts-and-crafts fairs or shopping malls, you will be equally successful.

**Production.** The resin-coated papers make black-and-white production on your own very easy. Color production is usually best accomplished by a lab. Shop around. In New York, for example, an 11″×14″ costs $24 and a 16″×20″ costs $45 to print. Quality is superb, and the delivery is one-day. However, having someone else do your printing for you will eat away at your profits.

## Decor Online

Photo decor and paintings are featured online on a system called ArtView. ArtView handles only fine-art photography priced at $1,000 and up. Here's how it works. An art gallery in Denver has a potential buyer who's looking for a fine-art photograph that includes a snow scene, a rustic cabin, mountains, and a horse and sleigh. Other criteria: The photographer must be

Canadian, and the price range between $1,500 and $2,000. The gallery in Denver doesn't have such a photograph, but can find it through ArtView's electronic search process, which quickly locates six photographs that fit the buyer's description. The buyer previews the on-screen digitized images and makes a choice. ArtView arranges the insurance, credit check, shipping and delivery. Contact ArtView at 379 W. Broadway, 2nd Floor, New York, NY 10012, (212) 219-8900.

### How to Make Your Decor Photography More Salable

**Frames.** Framing or matting your print definitely enhances its appearance and salability. Some prints can be improved by using textured or silk-finish print surfaces. Dry-mounting materials, glass and hinge mattes are available everywhere. Some processors offer protective *shrink wrap* (a thin, close-fitting, clear plastic covering). Check photography magazines for advertisements for do-it-yourself frames. How-to series are often featured in photo and hobby-and-craft magazines; search the Web; consult your library's *Reader's Guide to Periodical Literature* for back issues. If all else fails, team up with a frame shop and split the profits.

**Promotion.** This is the key to your selling success. If you've sold a series of prints to one bank in town, let the other banks know about your decor photography. Work for ways and places to exhibit your pictures often. Sign your prints or mattes for added promotion and referrals. Offer your services as a guest speaker or local TV talk-show guest. Here are two helpful books: *Guide to Handling a Press Interview* and *Free PR on TV and Radio*, Pilot Books, 103 Cooper St., Bldg. 3, Babylon, NY 11702. Produce brochures, flyers or catalogs of your work. (For more hints on self-promotion, see chapter ten.)

**Leasing.** Start your own leasing gallery. Businesses know that leasing anything can be charged against expenses. By leasing decor photos to corporations, small businesses or professionals, you'll get more mileage out of your photos.

**More information on decor photography.** Kodak has produced *Photo Decor* (available for $10.95 plus $3.25 postage and handling). Write to Eastman Kodak, Dept. PSI, 343 State St., Rochester, NY 14650.

Decor-photography and stock-photo agencies both offer opportunities as outlets for your Track A pictures. The main message of this chapter has been to emphasize that success with these two secondary marketing channels takes research and time on your part. If you're willing to give what it takes, you can realize rewards.

*"I have a room all to myself; it is nature. It is a place beyond the jurisdiction of human governments."* —HENRY DAVID THOREAU *THE JOURNALS*

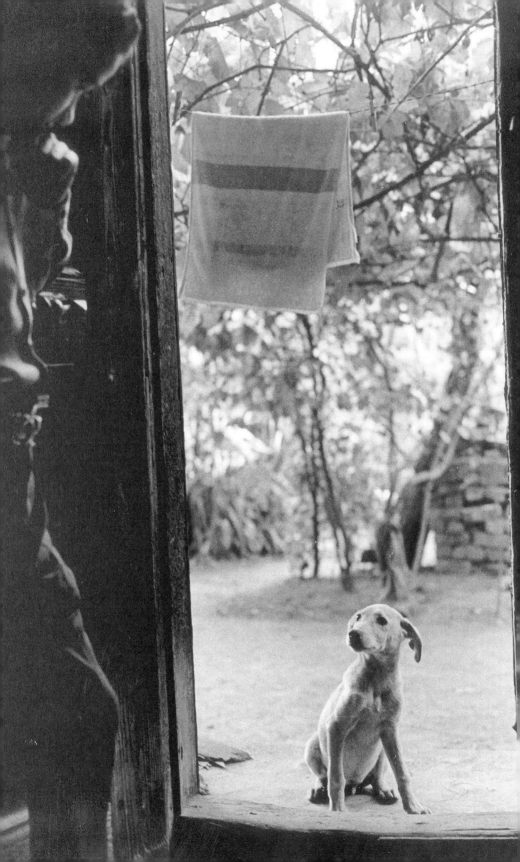

# Keeping Records: Knowing Where Everything Is

## The Lazy Person's Way to Extra Sales— Knowing What Is Selling

I'm lazy at heart. I like to put the lawn rake back when I'm done with it, because I've learned it's a lot *more* work next time to search for it, and possibly not even find it, when I really need it.

This lazy kind of thinking got me into a very good habit after a while. By having (or finding) a place for everything here at the farm, I got into the habit of putting *everything* away.

I take the same approach to filing away computer disks, slides, negs and black-and-white prints. If something's worth having, I figure, it's worth knowing where it is when you need it.

I was happily spurred along in this principle when I inherited several hundred used file folders from a businessman who was retiring. By using a separate folder for each separate photo illustration, I could note right on the folder whenever a picture sold. For black and whites or color negs, I put a matching contact print on each folder, thus giving myself an immediate visual reminder of what's selling.

After a few years, my recordkeeping system was teaching me what pictures sold best, and therefore which pictures I should take more of. By continually supplying my Market List's buyers with the kind of pictures they needed, I survived as a stock photographer.

### File It! How to Avoid Excessive Recordkeeping

One method I use to minimize recordkeeping is to direct new projects to a mini-file rather than into the central files. I find that mini-projects are usually completed in about a year. Researching for and purchasing our computer (Novell) network was a mini-project; so was remodeling our office in the barn. Other mini-projects revolve around collecting material for future photo stories or photo essays.

Here's a simple technique for a mini-file. The essential ingredients: two sets of file folders numbered 1 through 24 and lettered A to Z; a temporary portable open file cabinet (like a box), usually made of pressed cardboard or metal and available at stationery stores; and two sheets of paper (8½″ × 11″)—one numbered in two columns from 1 through 24, and the other in two columns from A through Z.

Let's say that you are compiling some research on CD-ROM stock-photography disc producers. Each entry is given a numerical designation, filed numerically and entered on the "number" sheet. The category is also cross-referenced by title and subject on the alphabetical sheet, with its numbered designation under the appropriate alphabet letter. The alphabetical listing also allows you to cross-reference the subject of the project or category. For example, if a Corel stock-photo disk advertisement you've torn from a magazine is filed under the number "34" (that's the numerical designation for Corel Corporation) and it contains three categories (birds, reptiles and horses), you would list those three categories on the alphabetical list and designate "34" as the file folder you could find those categories in.

Since the file box is small and portable, you can carry it between home and office or store it in a regular file drawer. I often have as many as six or seven projects going at one time, with information building in twelve to fifteen others, and the mini-file system aids me in being a lazy shopkeeper. I never have to work at finding anything. When the project is completed, the file either earns a spot on my central files or is tossed away.

Eventually, you might outgrow this system and want to computerize with software like TIME LINE 6.5, (800) 222-8572, which is a project manager.

## Knowing How to Put Your Finger on It: Cataloging Your Black and Whites and Transparencies

Efficiency is essential if you market your pictures by mail. Establish a workable identification system—and stick to it. But which system should you use? I once asked Jane Kinne, former Director at Comstock, Inc., what system proved best to locate pictures. A computer? An elaborate access-point system? Her answer: No system replaces the device we all carry between our ears. "The nuances inherent in both the photo request and the image itself can't be captured by existing personal computers. I depend on our cataloging system to bring us to a certain point. From there on, I depend on the judgment of our researchers."

A book of interest for you will be *Classification of Pictures and Slides*, by Stanford J. Green ($19, including postage and handling) PhotoTrack, 6392 S. Yellowstone Way, Aurora, CO 80016, (303) 690-6664.

If you follow the marketing principles in this book and resist snapping pictures of every subject that comes into your viewfinder, limiting your picture taking to your PMS/A instead, you will find you are spending more time at picture taking than at picture filing.

Stock-photo sales come from photos that you can access quickly. If finding a picture for a photobuyer takes a long time, the business of stock photography soon becomes discouraging to you.

Photobuyers want to see a selection of photos and then choose one. That's why your photos should be filed by PMS/A. You can quickly browse through your file on, say, aviation, when an editor requests jet engines. You'll also come across other jet engines that might not have been cross-referenced in your filing system.

Your filing system should meet the needs of your marketing system, not the other way around. With that in mind, I will describe a general example of a photographer whose file ranges from 100 to 3,000 marketable pictures, and who plans to follow the principles in this book and limit his weekday shooting to his PMS/A. What follows is a cataloging system that is flexible, simple and photographer-tested.

### Black-and-White/Color Prints

Here is the heart of your black-and-white and color prints cataloging system: negative sleeves, contact prints of each roll, PMS/A identification system, a $3'' \times 5''$-card cross-reference system (or computerized, if you wish, on today's available programs—see chapter seventeen) and a contact-sheet file. Your system can begin inexpensively with these essentials. You can add on as your stock of pictures increases.

One of the best ways I've seen to identify your black-and-white or color negs is the letter/number system. Here's how to set it up: For your identification on each print, use a letter of the alphabet to signify which category of your PMS/A the print is in. For example: A = Camping, B = Rural/Agriculture, C = Aviation, D = Family Living, E = Automotive, F = Construction, G = Underwater Photography. Follow the letter with a number to signify the number of rolls you've taken in that category. Since each roll (in editorial stock photography) is generally of the same subject matter (your specialization), filing by sequential roll number allows you to keep your subject matter limited physically on one neg sheet or one contact sheet. Example: You are on your fifteenth roll of black-and-white or color (neg) underwater photography, and you are printing from frame number 24. The number of your print would be G-15-24 (the contact sheet number would be G-15). The next roll of underwater pictures you take would be roll 16.

Incidentally, the APS (Advanced Photo System) brought into the market in 1996 will enhance this filing process, because you can remove a roll of film in the middle of a roll and replace it with a different, partially used roll when you change your venue or subject matter. This will allow the APS contact sheet to contain images of the same general subject matter. You can then send copies of these APS contact sheets (cards) off to photo editors on your Market List who accept color prints or digitized photos made from color negs.

Table 13-1 will give you some examples of filing alphabetically and numerically.

Of course, there are times you do not devote a complete roll of color or black-and-white film to one subject. In this case, you can cut the film and make two or more contact sheets (each with a different ID number), or you can go ahead and let the subsequent subject matter remain on your underwater-photography roll and cross-reference it by 3″ × 5″ card. No big problem.

In any case, identify your color and black-and-white negs. If you already have a large collection of color or black and whites taken over several years, you can still use this system. Arbitrarily assign a neg number to all your negatives.

I have seen some photographers use a month/year system to identify prints. However, this doesn't work out well for the stock photographer. For one thing, since the first number in this system should denote the number of rolls you have taken to date in that category, after a few years of taking many rolls of film, your left-hand number will get quite lengthy (somewhat like how unwieldy the number on your checks in your checkbook can get). For example, 3675-24. If you added a date in front of this, say April 1997, your number would read 4-97-3675-24. As a stock photographer, you might make a dozen prints of the same picture for multiple-submission purposes. That's a lot of numbers to be written on invoices and the backs of prints, not to mention negs and neg sleeves. If *you* need to know when a picture

| Letters | PMS/A Categories | No. of Rolls Taken | Negative Frame No. | Print No. |
|---|---|---|---|---|
| A | (Camping) | 708 | 12 | A-708-12 |
| B | (Rural/ Agriculture) | 556 | 6 | B-556-6 |
| C | (Aviation) | 28 | 36 | C-28-36 |
| D | (Family Living) | 28 | 30 | D-28-30 |
| E | (Automotive) | 138 | 6 | E-138-6 |
| F | (Construction) | 250 | 15 | F-250-15 |
| G | (Underwater Photography) | 15 | 24 | G-15-24 |

Note: File your black-and-white/color *negs* alphabetically. File your black-and-white/color *prints* in manila folders either alphabetically or numerically by first number. Numerically: G-15-24 goes before C-28-36, which is followed by D-28-30, then E-138-6, F-250-15, B-556-6 and A-708-12. (See pages 245-248.)

*Table 13-1. Sample print ID numbers for black and whites.*

was taken, write it on the back (or front) of the contact sheet.

The biggest hazard with the date system is that you reveal the age of your pictures. Labeling a picture "4-97" will dampen its reception by a photobuyer. (Like day-old bread at the bakery, somehow it's not fresh.) Out of a selection of equally excellent pictures, a photobuyer tends to purchase the most recent. A photobuyer may not be fully conversant with equipment that is pictured or current trends in clothing, and feels safest buying the most recent. If you are compelled to include the date, put it in Roman numerals or use the letter system explained on page 246.

For ease in writing your ID numbers on your negs and contact sheets, shoot the first two frames of your roll (numbers 1 and 2) blank. Cut off frame number 1, and write your number and any other identification on frame number 2 with permanent ink or pen. When it's dry, make a contact print. (Since black-and-white/color neg rolls are actually thirty-seven frames long, if you didn't snip off the first frame, you would have to snip off the thirty-seventh frame and have it float loose in your negative sleeve. The last picture on a roll is very often an important one.) Your shortened roll of developed film will fit exactly (cut into groups of six frames) in your neg sleeve. Store your negs in flat or fold-up (accordion-style) sleeves. I found that trying to save film by writing my ID number in tiny letters on some unused portion of the film was counterproductive. In the long run, it cost me more in time spent deciphering my numbers. Also, by allowing myself a full frame for identification purposes, I had more room for identification of the subject matter—for example, "WPBA Tournament, Aug '98" and so on.

Your ID number should also be written on the back of each print with a china marker or a *very* soft pencil and very light pressure. In a corner near the edge of the print (but not too near, to leave space for trimming the edges later), gently press your rubber stamp or label with © your name, address and phone number. Do not enter the year on your copyright notice (again so that you don't date your photo). If you are using RC paper, place a blank label on your print and then rubber-stamp the label. Eventually you may find it expedient to bar-code your filing system (see chapter seventeen). The bar-coded label can be affixed on both black and whites and slide mounts. Again, leave off the date.

After you've made and coded a black-and-white/color print, you're ready to file it. Here's where your photocopy of your contact sheet comes in handy. Cut out the photocopy contact print of the picture you just printed, paste it under the file tab on a manila file folder and mark the tab with the print number. This will readily identify the print inside the folder, plus serve as a visual guide when the folder becomes empty because the print is out making the rounds.

Note that the manila file folder system works better than storing pictures in, say, 8″×10″ Kodak boxes. Used manila folders are often available (cheap) from companies switching over to hanging file folders or computers.

So are used dental X-ray cabinets, for prints, negatives or slides. Or if you want to go first class, order a prebuilt slide cabinet from Elden Enterprises, P.O. Box 3201C, Charleston, WV 25332, (800) 950-7775, Fax: (304) 344-4764. Request their booklet "Helpful Hints."

The are two ways to file your black-and-white/color neg stock-photo file folders: alphabetically or numerically. If you file in numerical order, use the first number in your number identification code. For example, A-708-12 would be filed somewhere after your earlier example of G-15-24 (as in table 13-1). Z-8-36 would be filed in front of both A-708-12 and G-15-24. If you file alphabetically, all of your PMS/As (your specialty areas) would be filed together. The disadvantage to filing alphabetically is that each time you add on a new letter of the alphabet, you have to restart your numerical system.

Print your black and whites on double-weight (or RC) paper: They last longer, and they just plain look and feel better to a photobuyer. Print four or five at a time. Store the extras in your manila file folders. When a picture is sold, indicate it on the file folder. This will be your best sales barometer. For example, if sales are brisk on a certain picture—and it is a timeless picture—this system will visually suggest to you that you ought to make ten or fifteen more prints of it when you're next in the darkroom.

Keep a running record of your submissions to your Market List. A simple *in/out* ledger is all you'll need.

### Transparencies

Here's the best system for the newcomer to stock photography I've come across to date: Use the alphabet/number system. File your transparencies numerically in plastic three-ring sleeve pages and a three-ring hanging-style notebook. This type of three-ring binder—usually free when you buy a couple dozen vinyl (plastic) pages—hangs upside down in a letter-size filing cabinet. Since they hang free, the vinyl pages do not buckle and curl, as they do when in an upright notebook. Figure out basic categories that reflect your picture-taking interests: camping, rural subjects, classroom, snow skiing and fishing. Decide on your categories when you evaluate your PMS/A, in the beginning, and prepare several three-ring books. When you expand your supply of pictures, your numbering system will grow along with you. (Three-ring hanging notebooks are available at stationery stores. See chapter nine for addresses of suppliers of plastic pages.) Tom Stack, who operates a stock agency out of Colorado Springs, prefers to use a Pendaflex holder, a plastic spine available at camera stores. The spine will hold as many as ten hanging vinyl sheets and can be flipped over a light table to locate a picture quickly. A similar product is the Snap-Hinge, available from Bardes Products, 5245 W. Clinton Ave., Suite 3, Milwaukee, WI 53223.

Toss away all (technically) inferior slides—but keep in mind that digital enhancement can sometimes revive an otherwise useless photo. Hand-letter

the code numbers (neatly!) on your slides on either vertical side, near the top. You can file in-camera duplicates (or reproduction-quality dupes) in sequential order by giving them subsequent numbers. If you aren't using a computerized labeling system (see chapter seventeen), handwrite (neatly) the information. The slides should always remain in plastic sleeves. If your budget can afford it, encase each slide in a single-slide protective sleeve before inserting it into your plastic page.

To be able to locate specific pictures, cross-reference your picture subjects on your computer or 3″ × 5″ file-card system.

Rubber-stamp the right-hand or left-hand vertical side of your slide mount (as you look at it, right side up) with the copyright notice (© Your Name).[1] Include your address and, if possible, your phone number. The top and bottom of the slide should be left clear in case it ends up in a stock-photo agency. The agency will want that space for their identification system and description.

If your mounts have a date imprinted on them, place a label with your name and the copyright symbol over the top of this date. Use self-apply labels, such as Avery (http://www.avery.com/index.com): Rubber-stamp a whole page of them at a time with your name and address, etc. Printed labels are available from stationery houses mentioned elsewhere in this book.

As you increase the number of slides in a particular category, you'll find you're developing a substantial portfolio of pictures on a single subject—for example, agriculture—so that when a photobuyer calls for farm scenes, you'll be able to efficiently sort out specific pictures to send off. Since all your agriculture slides are filed under one category, selecting pictures becomes less of a chore than if you had to search through your whole selection of slides. If you computerize, choose software that allows you to categorize by PMS/A and not sequentially by number, as a large library would do.

## A Cross-Referencing System for Retrieving Your Pictures

A photobuyer contacts you and wants a certain item—a lake in Utah or a picture of a bulldog, for example. Can you locate it readily? If not, it might mean a missed sale. However, if you are able to consult your computer or a 3″ × 5″-card cross-referencing system that will pinpoint these subjects quickly for you, the sale could be yours.

---

[1]The Copyright Act (thanks to the Berne Convention—see chapter fifteen) no longer requires you to display your copyright notice on your slide in order to be legally protected. However, for the sake of ID and extra sales, I encourage you to affix the copyright notice to your pictures. Again, do not enter the last two digits of the year so as not to date your photo and diminish its sale potential. In your cover letter to a photobuyer, you should always request the © and credit line, both for your use of the tearsheets later for self-promotion and possible copyright registration, and for documentation of the picture as your property.

## Here's How to Do It

**Prints (Black and white/color).** After you develop each roll of film, make a contact sheet on 8½" × 11" paper. Always place your print number (as shown in table 13-1) on the upper left of the sheet so that when you're looking for a particular picture, you can flip through the upper-left corners of the contact sheets rapidly (a Graphics box usually holds forty to fifty contact sheets). Next, make a photocopy of your original contact sheet. File the original alphabetically, then in numerical order, in a contact-sheet carton.

On the back of the photocopy, jot down several subject titles that could be used to refer to the subject matter of the pictures on that contact sheet. Be liberal with your cross-referencing. For example, *aviation* could also be cross-referenced as *flying*. On the other hand, keep it simple, too. *You* should manage the files, not the other way around. A complicated filing system geometrically expands its complexity as your files grow.

When making subject references, keep in mind that photobuyers are usually seeking out prominent aspects—nothing obscure—in each of your images.

Set the photocopy in a special file or shelf. When you have amassed a few dozen photocopies of contact sheets in this way, set aside an evening to enter the lists of subjects and their ID roll numbers in your cross-reference 3" × 5"-card system. (Keep the photocopy sheets; don't toss them away.)

I found that by paying our baby-sitter an extra fee per hour to tackle the cross-referencing chore, I could get the job done efficiently. By selecting the right baby-sitters, I found few errors or omissions. If your family situation doesn't include a baby-sitter, you'll find that time passes quickly on this tedious job if you plug in your favorite videotape or stereo program.

**Color Transparencies.** If you stick to only a few specialties (as I have recommended in this book), your filing chores will be much easier than trying to file and retrieve a wide assortment of categories. Cross-reference your color basically by the same system as the black-and-white/color negs and prints.

For example, assign a letter of the alphabet to each of your categories. Put numbers on your transparencies in sequence (e.g., 5 for the fifth horse picture in your files; 52 for the fifty-second).

On your cross-reference 3" × 5" cards, you'll recognize which are referring to color and which to black and white if you put a *c* (for color) beside the entry or use a colored pen to make the entry.

Should you designate different format sizes? You could. Your color may consist of different formats (35mm, 120, 70mm). If you plan on amassing a large collection of color transparencies, you may want to allow space on each index card and give each size a characteristic number. For example, under the category of A (we used "camping"), start your 35mms at number 1; your 120s at number 5001; your 70mms at 8001; and your digitals at

10,001. This will also give you a quick reference—if a photo editor refers to one of your transparencies over the phone by ID number, you'll know the size. Of course, if your picture collection is weighted more to digital pictures and less to 35mm film, you might want to reverse the order of the numbering system. And in the early stages of your photo-marketing career, you might just want to hold off on any library science and use a plain-vanilla alpha-numerical system that tells you simply the category (alpha) and the sequence (number).

Not every picture on your roll of film is going to be correctly lighted or composed—or marketable. In fact, maybe only one-tenth might qualify for a file you will eventually send to a photobuyer. You can toss the "nixies" and file the quality remainders. Again, though, remember that some transparencies can be "saved" through computer enhancement.

If your collection in any one PMS/A category or size grows beyond 5,000, you can revert to the beginning and assign a small letter *a* to the next series of 5,000.

Again, use the hanging file folder system and vinyl pages to store your transparencies. File them in the notebook pages or Pendaflex spine by letter, and then within the pages by number.

---

If you don't know where you are going, how are you going to get there?" is an adage we hear often. Numbers let you know where you are, where you've been and where you're going. They can also predict how soon you will be there and which buyers are producing the most sales and the greatest revenue. Tracking results of your photo sales is made easier and less boring these days with computer accounting, spreadsheet and photo-tracking software.

---

## Counting the Beans

Knowing where the dollars are coming from and how many are staying at home is an important part of your operation. By not having a system, you could be pouring dollars into the wrong area of marketing. Bad business decisions usually come from faulty information.

At the stationery store, you can buy an accounting ledger that you can tailor to your needs. If you're computerized, you can start with an accounting program such as DacEasy Instant Accounting for Windows, 17950 Preston Rd., Suite 803, Dallas, TX 75252, (800) 322-3279. We did this and have now gone to its network version.

Photographer William Hopkins uses a simple graphics program to chart progress. He tracks the number of submissions he makes, and then charts the number of photos sold and dollars that came in. He puts these figures all together in a pie chart (see table 13-2).

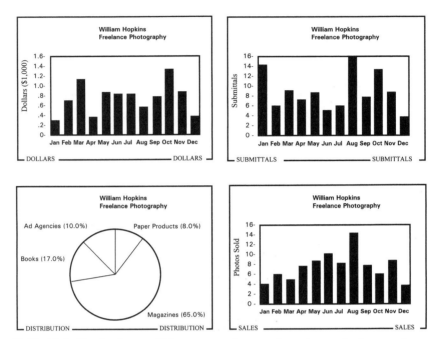

*Table 13-2. Simple charts will let you see where you're going, and where you've been.*

## Protecting Your Files

Humidity is the greatest enemy of your transparencies (and sometimes of your prints). For ten dollars you can buy a humidistat (from the hardware store) to locate near your storage area; it should read between 55 and 58. If the reading is lower, you'll need a humidifier; if it's higher, a dehumidifier. Moisture settles to the lower part of a room. Depending on the area of the country you live in, store your negatives and transparencies accordingly.

Damage from fire, smoke or water can put you out of business. Locate your negs and transparencies near an exit with easy access. If your budget permits, invest in fireproof cabinets. If you live in a flood-prone area, store your film as high as possible. Excessive temperatures will also damage your transparencies and negatives. Store them where the range of temperature is between 60° and 80°F.

## Everything Has Its Place

We've all seen cartoons picturing busy editors, their desks piled high with terribly important papers. The caption usually quotes the editor in some defense of his "filing" system.

Stock photographers can't afford the luxury of an editor's haphazard filing system. As your stock-photo library grows, so will your need to be

able to locate everything, from pictures to contact sheets, negs to notes.

Keep in control. If everything has its place, nothing should get lost. If you use an item, put it back when you're finished. The editor's desk got that way because he didn't follow these two principles:

1. Make a place for it.
2. Put it back when you're finished.

Is the editor lazy? To the contrary. It's a lot more work to shuffle through that heap on his desk to locate something.

Time lost can mean lost sales for the stock photographer. Take the lazy person's approach—know where everything is.

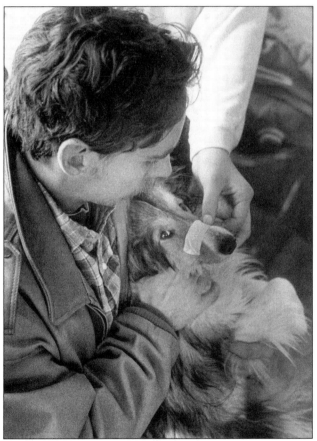

*Cute animal shots are usually Track A pictures, but when people are involved with the animals in a meaningful way, the pictures become something more than "cute animal" pictures.*

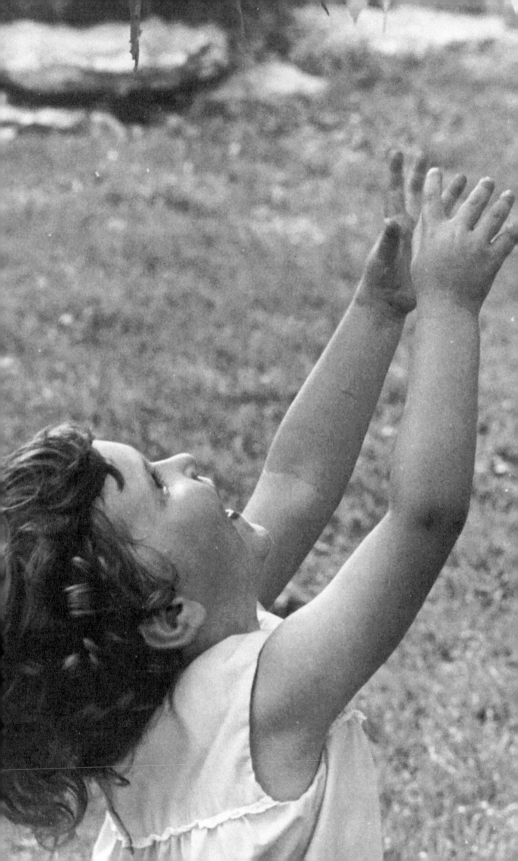

# Working Smart

## The Success Habit: Following Through

"There's no big secret about how to succeed as a stock photographer. You simply take good pictures. They'll sell themselves."

Wrong.

For every picture that sells by itself, there are about 100,000 waiting in files, unsold, because the photographer believed the above. Good pictures are only half of what you need: The other half is *working smart*.

Photo marketing is a business. And the principles that help business-people to make a success of their efforts will also help you. Imagine your business as a locomotive. It rides on two rails. One rail is the quality of your photos; the other your business know-how. One supports the other.

Knowledge is useless unless it is applied. That's the first thing novices learn when they venture into the business world. Photographers who succeed do so not because of their knowledge of photography or photo marketing, but because they apply what they know.

Sounds simple. But wisdom in business is not a one-time move; it's a continuing movement, a momentum, a follow-through, until it becomes habit. If you take the principles in this chapter and make them habits of your photo-marketing lifestyle and work style, you are on the road to success.

### Setting Goals

Where is your ship headed? Are you on a fishing expedition, heading out in the bay and hoping to get a bite? Or do you have a definite destination, a well-researched spot where "they're bitin' "?

The Small Business Administration (SBA) tells us that most newcomers venture into a new business as if they were going fishing, with a lot of antici-pation and enthusiasm, and most of the emphasis on externals instead of on precisely where they want to go and how to get results.

Your chances of getting your stock photos published and your photo-graphic talent recognized will be excellent if you form the winning habit of setting goals for yourself *before* each move you take in your business development.

## Getting Organized

Have you ever tried to enter a sailing race without checking for torn sails, sizing up your competition, charting the course, figuring what currents and river traffic you'll have to buck, knowing when and where to tack and being prepared to adjust to the vagaries of the weather, sandbars or reefs? An organized and efficiency-conscious person will be on the dock, enjoying wine and cheese, while the person who thinks he can enter the race without setting goals and making plans will still be out in the elements attempting to get to shore, paying the price for his lack of preparation.

As you build your photo-marketing business, set your goals, follow through, and be prepared when opportunity beckons. These are the secrets of creative success.

## Time Your Goals

Set short-term and long-term goals. Make them realistic.

For a short-term goal, aim to be sending out a certain number of pictures by a certain month. Aim to cut your processing, film and paper costs by a certain percentage within the same month (by shopping for the best price and streamlining your buying procedures—order by mail or phone rather than in person, and order in quantity).

For a long-term goal, aim to be selling, within two years, three times the number of pictures you are currently selling.

Goals need not be rigid and inflexible. They can be changed—upward or downward—depending on many variables. Write them down, though. Spoken goals don't have the same impact.

Write down a few dream goals, also. They're free.

I'd advise you not to share your written goals with anyone, save your spouse or cherished friend. Few people will share your enthusiasm. Friends, colleagues and relatives are often experts at giving advice, though their experience and personal life situations may not justify it. Keep your goals to yourself, and share them by accomplishing them.

## Is It Easy? A Survival Secret

Probably the most frequent question put to me is, "How can I become successful at publishing my pictures?" The answer is simple, though it's not the answer most photographers expect. And that may be one reason the answer is so elusive to so many.

We might expect the answer to be, "Be born with *talent*" or "Work hard!" Having talent and working hard can help, of course. But we all know photographers with a lot of talent who are going nowhere. We also know a lot of hard workers who are headed for the same place. To get to the point: If your desire to become a published photographer is so strong that your per-

sonal constitution will allow you to "put up with and do without," then success is just around the corner.

Whenever I follow up photographers who in the past expressed dreams and aspirations of publishing their pictures, I find that the ones who have met with success are the ones who have persisted and endured.

First of all, they have "put up with" the unglamorous chores inherent in this business. As they faced each day, they didn't avoid the tedious tasks. They had *true grit.* They knew that if they avoided an irksome job, it wouldn't go away, but would grow into a larger problem the next day, and by the end of the month, it would be an insurmountable barrier.

And what are these unpleasantries? As a stock photographer, you face them daily: retyping a poorly composed letter to a prospective photo editor, rescanning a slide, making a phone call that will straighten out a disagreement, cross-referencing your pictures, filing your transparencies, packaging photos and licking stamps.

If you are new to the field of stock photography, you'll nevertheless recognize those drudgery jobs in a different form at your household. Every uncleaned paintbrush or tool unreturned to its shelf, that unbalanced checkbook and every unanswered letter in that pile of important letters—all are examples of things we don't like to do, things that pile up until it becomes a habit to *not* get them done. That habit then becomes our style, or *us.* Wishing away drudgery jobs never works. We cannot become a success at anything until we face the fact that a goal or a purpose must be worth *more* than the inconvenience of tackling the chores most people just don't like to do.

In my experience, I find that photo illustrators who throw in the towel do so not for lack of talent, but because they are victims of their own failure to recognize this essential point: *They must put up with the drudgery.*

The second dictum: Do without the creature comforts. Hopefully, this will be necessary only in the initial stages of your career. How long you will do without depends on the goals you have set for yourself. Some goals are short-range and easily attainable. Other goals are long-range, worthwhile and rewarding to the soul, but not necessarily immediately rewarding to the pocketbook.

In order to get established as a photo illustrator, one must frequently do without the conveniences Madison Avenue continually reminds us we must possess: a VCR, a color TV, the latest-model car and a new wardrobe. In order to meet film or postage costs or to purchase a new enlarger, we must often change lifestyle or supermarket habits to economize. We must do without.

If you begin today to economize, and tackle each drudgery chore as it comes along, you'll be surprised to find that you'll get into the habit of successfully meeting challenges. What was once an annoying task will become a joyous one for you, because you'll welcome and recognize it as

another milepost on your journey to your goal as a successful photo illustrator. If you persist and develop the inner constitution to "put up with and do without," you will begin your success where others failed.

*"Victory belongs to the most persevering."* —NAPOLEON

## Think Small

In a few pages, I'll be asking you to think big, once you get your stock-photo–marketing operation rolling. But Rome wasn't built in a day. Aim high in your photography aspirations, but aim low in your sales targets—initially. Make your first mistakes where large audiences and your later-market photobuyers won't see them.

I'm not proposing mediocrity, simply advising you not to fall into the "glory" trap: You'll run up against the wall built by experienced competitors, only to become discouraged and take that lucrative job offer at the local car wash. The result: You'll become another name in the Directory of Also-Rans. *Work smart = Think small* in the early stages. Give yourself production and fee goals that are immediately reachable, and then move along in steps on your way to thinking big.

### Don't Misdirect Your Work

Working smart includes not working on projects or in directions that offer little promise. If you gauge in advance what to avoid, you can save yourself money and time. As an editorial photo illustrator breaking into the markets, assess beforehand the degree of difficulty you will face when approaching a particular magazine or publishing company. Is the market crowded? (For example, *Ski* magazine, in New York, stated in an edition of *Photographer's Market:* "Presently overstocked with photos.") Is it a closed market for you, such as *Time, People* or *National Geographic*? Or is it wide open? (Open markets include local magazine supplements for Sunday newspapers; denominational publishers, listed in *Photographer's Market* under Book Publishers, which publish dozens of magazines and periodicals; association and organization magazines like the *Rotarian* or *Kiwanis* magazine.)

What is the supply/demand ratio involved for each type of market? Some photographers do not learn the answer until they have uselessly spent a fortune trying to market pictures to a virtually closed market. Read the cues: "No use for this type of photography." "We're overstocked on those." "Bring more detail into your pictures if you want to sell to us." "We have a photographer who does those and don't need any more."

When you fill in your yearly assessment of your best markets, you'll know which ones to shut out. With each sale, you'll gravitate closer to your ideal markets.

The typically closed markets (see appendix A) are the calendar, greeting

card, poster and place mat areas. The market is glutted with fine photographs and fine photographers, many of whom have worked for a particular company for decades. Why try to drive through a stone wall for occasional sales, when lucrative avenues await you? Magazine and book publishers with $10,000-, $20,000- and $30,000-a-month budgets for photography await the editorial photo illustrator who has discovered his own PMS/A and has zeroed in on a specific Market List.

Your research and personal experience will determine which markets are closed to you. If the situation doesn't look promising in light of your current degree of expertise or depth in a certain photographic area, don't knock fruitlessly at a door that isn't ready to open to you yet. Put your energies and your dollars into tapping the lesser-known markets first. You'll save money, gain experience, build your picture files and sell photos—and that's *working smart.*

Draw up a weekly report that tallies work activity scores, such as how many shipments were sent out, how many pictures were sold and so on. Analyze these on a continuing basis to see if your sales are growing and what categories and which shipments have been most successful. Continue to revise your Market List priorities from these figures.

In the bibliography, you'll find several names and numbers of Small Office/Home Office organizations that offer help to entrepreneurs. Check out the Paul and Sarah Edwards Forum on CompuServe. Here is a helpful article: "The One Person Office," by Sharon Cohen (*Studio Photography*, November 1992, page 14).

## You Manage the Business—Not the Other Way Around

Being one step ahead of the competition, whether in a footrace or a pass pattern in football, makes all the difference between winning and losing. In business, it works the same way. If you get behind, you lose control, and get "behinder and behinder." The business begins to manage *you.* You can be out front, even if it's by inches, if you adopt the winning habit of daily keeping your ship on course.

In photo illustration, this applies especially to the routine you establish to get your shipments out to photobuyers. Establish a written plan (this will help to crystallize your thinking) and follow through.

If you are not a self-starter, here's a technique many people have used effectively: Hire a part-time assistant to come to your office certain days of the week to send out shipments of pictures. To keep your helper productive, you must always have new work ready to send out.

## A Self-Evaluation Guide

How do you tell if you're making any progress? By measuring it. Too often, photographers and other creative people find one year running into the next without ever analyzing their efforts to see if they're really moving or just

running in place. A well-received exhibit or a TV interview might create an illusion of success, but if the bottom line shows zero at the end of the year, it's time to assess your efforts.

Your measuring system doesn't have to be elaborate, but to be effective it should encompass at least a three-year span, so that you have a meaningful basis of comparison. (Quarterly or monthly assessments—based on your photo submissions *in/out* ledger—will be helpful until you reach the three-year mark.)

You will want to keep a running tally on four areas: pictures sent out; pictures bought; money received; and film, paper, software and processing costs. Chart these monthly, and at the end of three years, you will see your progress. (*Pictures bought* in one month may include many pictures actually sent out during previous months.)

## How to Measure Your Sales Strengths

Here's how to chart your sales strength areas your first year. A spreadsheet program on your computer will tally these figures for you. Otherwise, use a simple ledger sheet and a pencil.

Start with any month of the year.

1. Assign a code number to each of your sales areas.
2. Make a sales slip (use carbon paper, a photocopy or a computer form) that includes a blank space for
     Date:
     Amount:
     Code Number:
3. Each time you receive a check for one of your pictures, record the above information. If one check is for two or three different sales areas (code numbers), make two or three sales slips.
4. File your sales slips in a drawer until the end of the month.

---

### PROFIT PREDICTION

Every time you hand a ten-dollar bill to a chain store, retail clothing store or hardware store, you are handing that store owner a two- to three-dollar profit. The owner has structured his business so that over the long haul he can expect a two- to three-dollar profit (or more) on every ten dollars that comes in, based on the markup of the original cost to buy and sell the item. Can you do the same for your stock photography? You can if you are working with long-term (repeat) customers. If you do, you can predict not only the annual profit you'll get from a new customer, but the promotional discounts you can afford to entice them to try out your stock photography. Cost-accounting software can help you work out the complexities of this technique, which can lead to long-term profits for you.

5. At the end of the month, enter information from the sales slips onto a chart (ledger) similar to the example in table 14-1.
6. Total the previous months and the current month for a year-to-date total.

Your sales totals are your best marketing teacher. Which code area(s) shows the highest income? By monitoring these statistics, you will be able to accurately document in which areas you should concentrate your sales efforts.

## Pictures Just Aren't Selling?

Working smart includes reevaluating your working procedures now and again, too. Start with your packaging presentation. Here's a trick you can use to ensure that you're maintaining top quality: Ask the person closest to you to be your quality-control engineer. Every so often, when you prepare a package for a photo editor, don't let it out of the house until your spouse or special friend has given it the quality-control go-ahead. Let this person critique it, acting out the role of photobuyer. Painful as it might be, you'll form the habit of giving every detail of your presentation your best.

### The Five Reasons for Rejection

If you're not getting the sales you feel you ought to be getting, give the following points some serious thought. Often, success can be a process of elimination. By avoiding failure, you succeed. Get back to the basics, and turn your marketing sales spiraling upward.

There are five basic reasons for photographs being rejected. If you are guilty of any of them, you should reassess your marketing methods.

**1. Poor presentation.** Are you mailing in a crisp, white, cardboard envelope? Are you using a professional label or imprinted logo? Did you include an SASE with your submission (if you are a new contributor to the publication)? Are your transparencies packaged in protective sleeves? Are they clearly identified? Have you checked for the current address and photobuyer's name? Is your cover letter a professional-looking printed form letter (which saves your time and the editor's) rather than a rambling handwritten letter?

It may seem unfair that the outside appearance of your package is so important. But photo editors are busy people and have found through experience that amateurish packaging usually reflects the contents. Often they relegate a sloppy package to the *return* bin—without opening it. If you want first-class treatment from photobuyers, give them first-class treatment.

**2. Off-target and unrelated submissions.** Does the material you've submitted stick to the point of the buyer's request? Do your pictures hit the mark? Or has the buyer asked for pictures of waterfalls and you've submitted pictures of brooks and streams just in case the buyer might want to see them?

| MONTH: _____ | CODE NO. | TOTAL SALES PREVIOUS MONTH | TOTAL SALES THIS MONTH | TOTAL SALES YEAR TO DATE | TOTALS FOR 12 MONTHS BEGINNING: ____ ENDING:____ |
|---|---|---|---|---|---|
| **PRIMARY MARKETS — MAGAZINES** SPECIAL INTEREST | 100 | | | | |
| TRADE | 101 | | | | |
| BUSINESS | 102 | | | | |
| DENOMINATIONAL | 103 | | | | |
| ASSOCIATIONS, ORGANIZATIONS | 104 | | | | |
| LOCAL MAGAZINES | 105 | | | | |
| STATE & REGIONAL MAGAZINES | 106 | | | | |
| NEWS SERVICES | 107 | | | | |
| OTHER | 108 | | | | |
| **BOOKS** TEXTBOOKS | 200 | | | | |
| CHURCH RELATED BOOKS | 201 | | | | |
| ENCYCLOPEDIA | 202 | | | | |
| CONSUMER TRADE | 203 | | | | |
| OTHER | 204 | | | | |
| **SECONDARY MARKETS — STOCK PHOTO AGENCIES** AGENCY A | 300 | | | | |
| AGENCY B | 301 | | | | |
| AGENCY C | 302 | | | | |
| AGENCY D | 303 | | | | |
| OTHER | 304 | | | | |
| MAJOR NEWSSTAND MAGAZINES | 400 | | | | |
| **DECOR PHOTOGRAPHY** MARKET A | 500 | | | | |
| MARKET B | 501 | | | | |
| MARKET C | 502 | | | | |
| MARKET D | 503 | | | | |
| OTHER | 504 | | | | |
| **THIRD CHOICE MARKETS — PAPER PRODUCTS** CALENDARS | 600 | | | | |
| GREETING CARDS | 601 | | | | |
| POSTERS | 602 | | | | |
| POSTCARDS | 603 | | | | |
| OTHER | 604 | | | | |
| **COMMERCIAL ACCOUNTS** ADVERTISING AGENCIES | 700 | | | | |
| PUBLIC RELATIONS FIRMS | 701 | | | | |
| RECORD COMPANIES | 702 | | | | |
| AUDIO/VISUAL HOUSES | 703 | | | | |
| GRAPHIC DESIGN STUDIOS | 704 | | | | |
| OTHER | 705 | | | | |
| **ART PHOTO SALES** MUSEUMS | 800 | | | | |
| PRIVATE INDIVIDUALS | 801 | | | | |
| OTHER | | | | | |
| **OTHER** GOVERNMENT AGENCIES | 900 | | | | |
| NEWSPAPERS | 901 | | | | |

**Table 14-1.** *A simple ledger can help you assess your sales strengths. We use the computer program Q&A to pinpoint similar strength and weakness areas.*

Also, are your pictures *cohesive in style?* Do the pictures themselves have a consistent, professional appearance? That is, do they all look like they came from the same photographer? A good way to test the cohesiveness of your pictures, and their professionalism, is to gather editorial stock photos from magazines and periodicals on your Market List, lay about twenty of them on the living room floor and then place *your* pictures beside them (or if you deal in slides, project them on a screen with the tearsheets taped to a nearby wall). Do your pictures fit in? If so, you are on target. If not, retake the same pictures, incorporating into your new pictures what you have learned from this exercise.

**3. Poor quality.** Take a look at your pictures again. Assuming you are using a top-quality lens, is your color vibrant and appropriate for the mood and scene? Have you properly filtered your indoor shots where fluorescents are involved? If you've used flash or lights, have you avoided hot spots?

How sharp are your color and black-and-white prints? Published pictures must go through several generations before they reach the printed page. Your pictures must be appropriately in focus, with good film resolution (sharpness), with no grain (unless appropriate) and no camera shake, as these faults will be magnified in your published picture.

Are your prints technically good? Have you achieved the best possible gradation in your black-and-white prints: a stark white (with some details), several gradations of grays, all the way down to a deep, rich black (also with some details)? If you've used burning/dodging techniques, they shouldn't be apparent to the photobuyer. Have you spotted your prints, especially the 35mms?

Are your black-and-white pictures dog-eared, with rough edges, cracks, stains, folds, tears or scratches?

All of the above, to a photobuyer, are quick evidence of poor craftsmanship and a low reliability factor.

**4. Outdated pictures.** Outdated pictures can be another enemy to your sales. Photo editors expect a fresh batch of new pictures from you on each shipment. Some pictures are long-lived, timeless: Fifty years from now, your heirs could continue to benefit by their sales. The majority of pictures, however, are short-lived, because they reflect the *now*. In a matter of years (usually between five and ten), you will want to extract these pictures from your files because they are dated by clothing and hair styles, equipment, machinery, furnishings and so on.

Some stock photographers have attempted to circumvent this problem by eliminating anything from their pictures that would date them. This (generally speaking) means excluding people. However, the one most essential element in a successful photo illustration *is* people. Exclude them, and sales diminish.

Putting your dated pictures out to pasture is not an enjoyable prospect. Be as objective as possible in your weeding-out process. If you find it difficult

to eliminate pictures, ask a friend to look through a group and to try to guess what year the pictures were taken. Your friend's objective assessment will be very similar to a photobuyer's.

We all have a tendency to rationalize our pictures' usefulness and stretch their life spans beyond marketing reality. It's no fun sending them to the incinerator. At the risk of sounding like dial-a-mortician, I'm asking you to be *realistic*. Photo editors are. Outdated pictures will outdate your business operation and will possibly eliminate you from the photobuyer's roster.

**5. Poor composition.** Assess the *composition* of your pictures. Do they adhere to the $P = B + P + S + I$ formula? (See chapter two.) Do you zero in on your subject matter with the appropriate emphasis for each situation? When you work with people in your pictures, do you orchestrate the scene so that the results are natural and unposed? In other words, are you producing marketable editorial stock photos?

If this section on why pictures fail to get published is discouraging to you, it shouldn't be. Remember that editorial stock photographers successful at photo marketing are not those who occasionally produce a brilliant photograph, but those who periodically assess and evaluate their progress. If they find deficiencies, they take the next step: They do something about it.

Please be cautioned that some photographers take my suggestions for avoiding failure to extremes. These folks are *perfectionists*. "Do it right or not at all." This admonition is certainly well-founded, and many successful stock photographers can trace their success to adherence to such good rules. The paradox is that many unsuccessful stock photographers can trace their failures to them, also. Why? The procrastinator, under the guise of perfectionism, accomplishes nothing for fear of not doing it flawlessly.

Procrastinators spin their wheels reading about and studying cameras and equipment and how to take pictures. They keep telling themselves they don't know enough to start, that their pictures aren't good enough yet to send to an editor.

If you find yourself justifying procrastination, ask yourself to redefine *quality*. You can pride yourself on quality presentations without crippling yourself by equating quality with perfection.

## A Potpourri of Additional Aids in Working Smart

### Remember the Law of 125

When you get upset with a photobuyer, remember the Law of 125. Each person you deal with influences 125 other friends, neighbors, relatives or business colleagues. It works this way: If you produce a good product for a person, that person will probably tell five people (5), who may each tell five people (25) who may tell five people (125).

$$1 \times 5 = 5 \times 5 = 25 \times 5 = 125.$$

If you turn a prospective customer away with an angry remark or letter, or a poor attitude, you may be turning away 125 prospects.

### Insurance

Are you insurance-poor? That is, are you putting a disproportionate amount of your dollars into insurance instead of film and photo supplies? Don't allow yourself to be talked into equipment-insurance plans that will put you in a bind. Talk with other photographers. If you hear of many instances of stolen equipment, then a solid equipment or business protection plan might be in order for you. Reexamine your policy from time to time. Some of your equipment may have depreciated to the point where it isn't cost-effective to continue to insure it. On the other side of the coin, the incidence of theft may have increased in your neighborhood. Protect yourself accordingly.

Here's an interesting fact: The *Milwaukee Journal* does not insure its cameras and equipment. They have found it isn't cost-effective.

If you are a member of ASMP, 14 Washington Square, Suite 502, Princeton Junction, NJ 08550-1033, you are eligible for a comprehensive insurance package. The cost ranges from $650 to $850 if you're living in New York City.

Your camera equipment can usually be insured as part of your business insurance package, or can be negotiated by a broker who handles your other insurance, such as your homeowner's policy. An example of a broker who will handle photographer's insurance is The Hoffberger Insurance Group, 5700 Smith Ave., Baltimore, MD 21209, (410) 542-3300.

Buying insurance is like gambling. You play the odds. However, some careful research on your part can establish how much insurance is enough for you. Shop around. If you're quoted disproportionately different rates, read the fine print and investigate the company through *Consumer Reports* or your local Better Business Bureau.

The best insurance is the daily habit of prevention. *That's* affordable.

1. Know the high-risk areas for thievery.
2. Don't tempt thieves with flashy camera bags or unlocked car doors.
3. Invest in a burglar-alarm system or a dog who likes to bark.
4. Inscribe your name on your equipment. Your local police department will help you with this.
5. Ask for references from the people you consider hiring.
6. Keep receipts and serial numbers for all your equipment.

### Low-Cost Equipment

Darkroom and camera equipment (new) can dent your budget. Use the want ads to find fairly new equipment at half the price. Government auctions are another source of bargains. A *Reader's Digest* article pointed out that computers go for sixty dollars, VCRs for twenty dollars and an office swivel

chair for three dollars at these auctions. The equipment is "contributed" to the auctions by such government agencies as the U.S. Postal Service, IRS, federal bank insurers, Defense Revitalization and Marketing Service (DRMS), General Accounting Office, Defense Logistics Agency and so on.

If you enter the maze of trying to find out when an upcoming auction is scheduled in your area, be prepared to make about seven phone calls. The best place to start is to call the Federal Information Center in your area. Call (800) 688-9889 and let them know the name of the agency you want to contact.

Several auctions are available on the Web. A computer will start at $50 and end up at $175. If the price is right, you might find good-quality equipment at low prices.

## Toll-Free Numbers

The telephone is rapidly becoming an important resource for the stock photographer. For toll-free numbers available to you, call the toll-free information operator at (800) 555-1212 and ask if the company has a toll-free number. You'll save on your phone bill, and you'll get your answers from the experts, fast. The major photography magazines often list toll-free numbers in the ads for camera equipment and film processing. A toll-free directory is available from AT&T, (800) 222-0400. Companies will change their toll-free numbers. If this happens, just call (800) 555-1212 and ask for the new numbers. Note: If the business has an 888 toll-free number, you would still dial (800) 555-1212 to find it.

A toll-free number telephone directory ($9.95) is available by calling (800) 426-8686.

## Search the Web

Another resource available to search out information is the World Wide Web (WWW). Using your computer, modem search engine and a browser program, you can find arcane subject matter and answers to highly specific questions.

## Search a CD-ROM

Several companies now produce a compilation of all of the (current) phone numbers in the United States. Check out the ads in a computer magazine for the cost of the CD-ROM.

## Grants, Loans, Scholarships, Fellowships and Aid

Assistance is available to photographers on local, regional and national levels. The funds come from state and federal agencies, as well as private corporations and foundations. The monies usually are awarded for specialized photographic projects. If your idea for a grant, fellowship, etc., is accepted,

the grant can provide a boost for your supply of stock photos in one of your PMS/As.

To apply, photographers propose a photographic project, and if selected, they receive stipends ranging from $500 to $1,000 a month for a period of several months.

You can learn more about how to write proposals for and receive such funds through the following books:

*Foundation Grants to Individuals*, The Foundation Center, 79 Fifth Ave., New York, NY 10003

*Gadney's Guide to Contests, Festivals, & Grants*, Festival Publications, P.O. Box 4940, West Hill, CA 91308

*Getting a Grant*, by Robert Lefferts, Prentice-Hall, Route 9 West, Englewood Cliffs, NJ 07632

*Grants in Photography—How to Get Them*, by Lida Moser, Amphoto Books, 1515 Broadway, New York, NY 10036

*Grants Register*, St. Martin's Press, 175 Fifth Ave., New York, NY 10010

*National Endowment for the Arts*, 1100 Pennsylvania Ave. NW, Washington, DC 20506

The ultimate in working smart, of course, is doing work that you don't consider work at all. If you've defined your PMS/A well and tailored your Market List to markets that offer you the best potential, you'll find that you'll automatically be working smart.

# Rights and Regulations

## Copyright

Who owns your picture? You do! The Copyright Law speaks loud and clear.

Copyright law generally gives you, as the author of your photos, copyright for each picture from the moment you snap it. Ownership of the copyright enables you to determine or limit the use of every photo in whatever way you specify, to resell various rights in the work and to have your rights in your work protected by a court of law in case of infringement.

The easiest way to assert your claim is to affix a copyright notice— © Your Name—to each photo. You can also formally register your picture with the Copyright Office for a fee (currently twenty dollars). You then receive a registration certificate, the prerequisite for taking an infringer (one who has used or reused your picture without authorization) to court. If you don't register your picture, it is still protected by copyright, as your property, and you still have legal claim to it. However, formal registration helps to cement your claim, and if you register within three months of the first publication of your work, you have a better chance at receiving full financial recompense in the event of infringement.

The familiar *c* within a circle © is no longer necessary to preserve copyrights. Late in 1988, the United States ratified an international copyright treaty known as the *Berne Convention*. This put the final nail in the coffin of the former long-standing rule that a copyright in a published work could be lost if the work didn't carry a valid copyright notice. (The old rule still applies to photos published before March 1, 1989.) However, using the © will strengthen your copyright protection. It is still advisable to use it. By doing so you give notice to the public that you are claiming copyright and you are alerting any potential user as to who the owner is and how to contact you. Print your copyright notice on your new slides and prints to eliminate any doubt as to who owns the copyright, and to broadcast a warning that infringement will be prosecuted. But for the record, the copyright in any photo you published after the March 1, 1989, deadline will be automatically protected, whether you have printed the copyright notice on it or not.

## Copyright Infringement

Let me say at the outset that I believe that the spirit of the Copyright Law is to encourage the free flow of information in our society, and that the law is a basic protection for that exchange. It was written to protect not just photographers, but the users of photographs as well: the photobuyers. Copyright infringement in stock photography is rare (as opposed to service photography, where infringement does happen). In thirty years as a stock photographer, I have personally experienced only one instance of possible infringement. And in that case an art director, new on the job, made an honest mistake.

If you wish to be supersafe, you can register your extra-special marketable pictures. When you do, you'll receive the benefit of the Copyright Office's documentation and recording, and you'll have copies of your work filed with the Library of Congress. But generally, in stock-photography work, you won't find it necessary to register many pictures. The © symbol affixed to the back of your picture (or the front if you wish) or next to your credit line in a layout offers a warning to would-be infringers. The right to use the © is yours; it costs you nothing. The law recognizes that you own your picture once you have it on film. The 1978 law is, in effect, a photographer's law rather than a publisher's law, as it was prior to 1978.

Remember, a copyright protects only your picture, not the *idea* your picture expresses (Section 102[b]). If you improve someone else's idea with your picture, that's not necessarily copyright infringement: That's free enterprise. The test for infringement is "access plus *substantial* similarity." How similar is substantial similarity? That's anybody's guess, but bear in mind that the jury that decides the case is drawn from ordinary citizens. How do you think such persons would feel about a photo you've created that shows similarity to another? Keep in mind also that, among the rights of the copyright owner, he has the right to prepare "derivative works." If your photo appears to be *derived* from someone else's photo to which you had access, you may be infringing. On the other hand, don't be intimidated or deterred from creating or re-creating a new photo on the remote chance it may infringe on an existing photo. After all, the engine of the world of art is fueled by creative improvements to old ideas.

## Group Registration

Another option—and to the photographer, quite an advantage—is that under the revision, you can "group-register" photographs that have been published in periodicals. Whether you're registering five pictures or fifty, as long as they're all in *one* magazine, newspaper or other publication, a single fee (currently twenty dollars) is charged. You need to file one copy of the entire issue in which the photo appeared for each photo you are registering, along with the appropriate forms and fees. Group registration for photos in a

book, however, is not possible. Those photos must be registered separately.

Again, omission of a © notice adjacent to your photo does not void your copyright. In addition, the picture will still be protected by the publisher's copyright notice, usually included in the masthead, which protects all editorial matter and photographs (except advertising) within the publication.[1]

Group registration is also possible for your *unpublished* photos. You can register an unlimited number of photos for the one twenty-dollar fee. Unpublished works may be reregistered after publication. Registering unpublished works is usually unnecessary, but can expedite getting into court in the event a work is infringed.

## How to Contact the Copyright Office

For more details on specific points in this chapter, phone the Copyright Public Information Office, (202) 707-3000 [also, Forms Hot Line: (202) 707-9100], between 8:00 A.M. and 4:00 P.M. (eastern time), or write: Register of Copyrights, Library of Congress, Washington, DC 20559. To register your photos, the fee is twenty dollars.

The Copyright Law is lengthy (the official law is 117 pages) and covers all aspects of creative endeavor, from book publishing to motion pictures. We'll be addressing here only the portions of the law that relate to stock photography.

## Interpreting the Law

Writing and commenting on "the law"—any law—is like discussing philosophy or religion. A point of law might be stated one way, but it's open to different interpretations. Only time and court tests solidify the interpretation. Even then, there are exceptions to the rule. As each stock photographer's Market List and PMS/A are different, so is the photographer's need to interpret the Copyright Law. I have made every effort to ensure the accuracy of the information contained in this chapter, checking it with copyright officials and attorneys, but I cannot guarantee the absence of error or hold myself liable for the use or misuse of this information.

To sum up the points of law covered so far:

— You own your picture (unless you have signed a "work-for-hire" agreement, discussed later in this chapter).
— You can register your pictures for added protection.
— You can group-register your photos for a reasonable fee.

---

[1]Service photographers, take note. Since noneditorial photographs (ads) are not protected by the blanket copyright, insist that your copyright notice (unless you worked "for hire") be included with your picture.

## Be Wary of Dates

Note that copyright of your pictures published in copyrighted publications prior to *January 1, 1978,* when a new, broader copyright law (which I'll address in a moment) went into effect, belongs to the public, in each case, unless you can show proof that you leased the pictures on a one-time basis or that the publisher reassigned all copyright privileges to you. It is doubtful that this situation will cause you any problems, unless the picture concerned is one with great market potential (such as a photo of a person who recently catapulted to fame). Nevertheless, pre-1978 pictures generally have copyright protection from infringement if they were published with the © symbol, and it may even be possible for you to assert your sole right to them at the time of renewal (more about this later).

Though your rights in pictures published before 1978 may be limited by the arrangements you originally made with the publisher, pictures taken before 1978 but not published until after 1978 will enjoy the benefits of the revised Copyright Law.

Now for the bad news. It is possible for you to lose the right to your pictures and for them to fall into public domain. Here's how it can happen: If your work was published without your copyright notice before 1978, or if it was published before March 1, 1989, and neither your copyright notice nor a general notice for the entire publication (such as in the masthead) was involved, *and* if you did not register that picture within a period of five years from the date your picture was published, then the Copyright Office will now refuse to register your picture. The Copyright Office takes the position that your copyright has expired and that your picture belongs to "the people." It is in the public domain: Anyone can use it.

In order to register a work that has been published without notice (before March 1, 1989), in addition to the requirement that it must be within five years of publication, you will have to show the Copyright Office that either (1) the notice was omitted from only a relatively small number of copies distributed to the public, (2) a reasonable effort has been made to add notice to all copies distributed once the omission was discovered, or (3) the notice was omitted in violation of your express requirement, in writing, that your notice appear.

For current work, after March 1, 1989, the Berne Convention makes it unnecessary *legally* to have to include a © notice, but as I stated in the beginning of this chapter, for the public it's still a good safeguard to stamp (or write) your © notice on all photos you send out. In your cover letter, state that if the photos are published, your © notice must appear beside them. An official © notice consists of the word *copyright* or the abbreviation *copr.* or a © symbol and your name (© Your Name).

Since the Berne Convention relieves you of the *necessity* of having a copyright notice on your photos published after March 1, 1989, it is no longer critical for you to insist that your © notice be published alongside your photo

Stamp 1                                          Stamp 2

| © Your Name<br>This Picture is licensed for<br>one-time inside-editorial<br>use only. Publication of ©<br>is requested. | Your Name<br>Name of Business (optional)<br>Your Address<br>Your Phone Number |

*Figure 15-1. Stamps to protect your prints.*

for the purpose of establishing that you hold the copyright. But again, it's still helpful to attach the © notice to your photos to give warning to would-be infringers.

The revised Copyright Law offers the machinery to protect your ownership of your pictures, but ultimately the burden of protecting your rights is on you.

The Copyright Office can offer you no protection if you have relinquished your rights through neglect, ignorance or your own wishes. And the U.S. District Attorney can prosecute only if an infringement is willful and for commercial advantage.

Your © notice on your slide or print is your first order of protection.

## Laying Claim to Your Picture

The Copyright Law doesn't specify what else you should have on your picture for identification, other than the notice. (Always copyright under your name, not the name of your business. Otherwise, if you sell your business, the copyright to all your pictures would go with it.) For your own ID purposes, however, always include your address and phone number. I also advise ordering a stamp with the memo shown in figure 15-1. (Use two stamps—the other for your address and phone.)

(Your slides will require an abbreviated form of the stamps shown in figure 15-1 because of the border-size limitation, but be sure to include all the information on your accompanying invoice. Computer labeling programs like those mentioned in chapter seventeen can also be used to accomplish this.)

There are sound reasons for going to the trouble of a memo stamp:

1. *Licensed* implies that this picture is not work for hire.[2] (In work for

---

[2]If the purchase order or agreement—or even the check—you receive from your client requires you to sign anything that implies that you are offering more than one-time publishing rights, or states a work-for-hire arrangement, don't sign it. Cross out and initial that portion of the purchase agreement, stamp your rubber stamp on the margin, send it off with the picture (also stamped) and let your client carry the ball from there.

hire, the copyright may not belong to you.) *Licensed* implies that you have not entered into any separate sales arrangement with your client, that you want any transparency returned to you and, when practical, you'd like any black-and-white print returned to you.

2. *One-time* ensures that you are not assigning any rights other than rights to one-time use. If you wish, include this sentence in your invoice: "Additional rights available."

3. *Inside-editorial use* simply lets the client know that if he decides to use your picture on a cover, he must pay extra. (See table 8-2 for how to increase your fee when a picture is used for a cover, advertising, etc.) This phrase will also protect you in the future if an art director happens to use your picture without authorization for commercial (trade) purposes or advertising. If a suit were to arise relating to trade and advertising use because of the people pictured in the photograph, you could show proof that the picture was leased only for editorial purposes (which usually require no model release).

4. Include © credit. This shows proof, in case of infringement, that you asked the publisher to name you as copyright owner.

## Some Drawbacks of the Copyright Law

> INFRINGER (Section 501[a]): Someone who violates any of the exclusive rights of a copyright owner.

Prosecuting an infringement may be costly, and you may never recover all the money you expend, but if you prevail, you may be able to seize and destroy the infringing articles, or enjoin the infringer from further production and distribution. This may be worth more than money to you.

Your greatest protection may be to place the copyright notice on *each* of your pictures. (Remember, the notice costs you nothing.) An infringer is not "innocent" if she pirates a picture that bears your copyright notice. It carries clout. Like the average citizen who never removes the mattress label "Do Not Remove Under Penalty of Law," the infringer is likely to shy away from anything that looks like a federal offense.

In the rare instance where you might discover an infringer within three months after you have published an unregistered picture, if you choose to press charges, you can get your picture registered at the Copyright Office (special speedy handling will cost you [at this writing] an extra $320 [Special Handling Fee]—by certified check!) and haul the infringer into any court having jurisdiction in a federal civil action. If it's past the three-month deadline, you can still register your picture, but damages you would receive if you won the case would be limited.

The process of registration is simple for authors who register an entire book for twenty dollars. For stock photographers, who produce thousands

of pictures, the administration and expense of registering each photo might be likened to separately registering each paragraph in a novel or textbook. As stock photographers, then, we continue to be left to the mercy and basic honesty inherent in most people. God won't save us from "innocent infringers," but we can do a lot to eliminate their "innocent" status by putting notice on every photograph that leaves our hands.

## A Remedy

If you discover someone or some business or organization has used your picture without your permission, send the person a bill. How much? The normal $300 to $500. If the person has "deep pockets," go ahead and charge him $1,500, an acceptable fee for color transparencies in the commercial photo community.

Under copyright law (Section 113[c], 107, the "fair use" doctrine), libraries, schools and noncommercial broadcasters (such as public television) can sometimes use your pictures without requesting your permission, provided their use is limited to educational and noncommercial activities and does not diminish the future marketing potential of your picture.

This latter ruling will need further interpretation because of the paradox involved when a picture receives wide exposure. Consider the broadcasting of pro football: Leagues are still not sure whether broadcasting enhances or decreases gate sales. Hence the blackout provision. This provision of "fair use" by the nonprofit sector, which has yet to be fully tested in court, could prove to be a great disadvantage to the stock photographer. "Fair use" is, however, limited by many of the provisions detailed in a free IRS publication, R-21, which describes some of the limitations on fair use. If your work has been used extensively, the use may not be "fair" (reading Publication R-21 may shed some light on this for you).

## Q&A Forum on Copyright

In the following Q&A forum, I'll give detailed answers to some significant questions as they apply to you, the stock photographer, first citing the source in the Copyright Law of 1978 (Title 17 of the U.S. Code).

**Is it necessary to place a © notice on all**          **Sections 401,**
**of my photos to preserve my copyright?**          **402 and 405**

No. As of March 1, 1989 (per the Berne Convention agreement), the familiar © is no longer necessary to establish proof that you own the copyright. The law recognizes you, as the photographer, as owner of copyrights of your photos. However, I repeat, it is wise to use the © notice to eliminate any doubt in viewers' minds (i.e., the public) as to who owns the copyright to your photo. The © notice broadcasts a warning that infringers will be prosecuted.

**Can the © be placed on the back of my**          Section 401(c)
**picture, or must it appear on the front?**          and House
                                                      Report ML-182

Your copyright notice can be rubber-stamped, printed on a label or hand-written on the back or on the front of your prints. In the case of a transparency, it can be placed on the border (back or front). Be sure the © is enclosed in a circle, not just parentheses. Thanks to the Berne Convention, the copyright notice doesn't even have to appear anywhere. Nevertheless, place it on each of your photos. It broadcasts a warning to would-be infringers.

**Who owns my picture?**                             Sections 201(a)
                                                      (b)(c) and
                                                      203(a)(3)

You do, from the moment you snap the shutter ("fix the image in a tangible form"). Before 1978, it was assumed the person you authorized to use your picture (publisher, ad agency, client) owned the copyright. The new law assumes *you* own all the rights to your pictures unless you have signed those rights away. Except in a case where you have entered into some kind of transfer-of-rights agreement, in writing, with a client or publisher, such as a work-for-hire agreement, no one else can exercise any ownership rights to your picture. Even if you do sell "all" rights to your picture, in thirty-five years, if you or your heirs take appropriate action, the copyright can be taken back.

**How long do I own the copyright on**               Sections 302(a)
**my photograph?**                                    and 304(a)(b)

The 1978 Copyright Law says copyright in your picture "subsists from its creation" (when you snap the shutter), and you own copyright to it for as long as you live, plus fifty years. The old law, by the way, allowed you only twenty-eight years to own your picture, plus a renewal period of twenty-eight years—for a total of fifty-six years. If you register, that renewal has been extended to forty-seven years—for a total of seventy-five years. If you don't register your copyright in a pre-1978 work, you can't renew it, and at the end of twenty-eight years it will fall into public domain. To register pictures that hold special importance for you, the current fee is twenty dollars. Ask for Form VA. If you wish to register nonphotographic work, such as writing, ask the Copyright Office for Form TX.

**How can my picture fall into the public**          Sections 405 and
**domain?**                                           406

Publication without notice before 1978 meant your picture was in the public domain—that is, anyone could use it and not be required to pay you for it.

From 1978 to March 1989, publication without proper notice put your picture in the public domain unless you took steps to "cure" the omission or defect. Under present law, for your post-1989 photos, you needn't worry about your pictures falling into public domain—not until your copyright expires (your lifetime plus 50 years).

| What is group-registration and how do I do it? | Section 408(c)(2) |
|---|---|

This provision of the law says you can register any number of pictures published in one publication for one price. Whether you're registering five pictures or fifty, as long as they're all in one magazine, newspaper or publication, the fee is currently only twenty dollars. (Group-registration for your pictures appearing in books, however, is not possible. They must be registered separately.)

*How to do it:* For each photo you choose, obtain one copy of the entire periodical in which it appeared.

To group-register, fill out Forms VA and GR/CP (available from the Copyright Office, Library of Congress, Washington DC 20559) and send them, along with your twenty-dollar fee (in check or money order payable to the Register of Copyrights) and copies of the periodicals or newspapers in which your published pictures appeared, to the Copyright Office. (The U.S. Copyright Office has been a part of the Library of Congress since 1870.)

*For unpublished pictures:* Submit several contact-size pictures on one 8″ × 10″ sheet, or submit photocopies of transparencies or black-and-white prints (not photocopies) of the pictures you wish to register. Since unpublished works must be in the form of a collection, title this collection of pictures "Collection of Photographs by [Your Name]." A handy way to group-register a collection of slides is to put twenty images in a plastic sleeve, photograph them in color on your light stand and then blow them up to 11″ × 14″. You can submit any number of multiple sets under one title and the cost is twenty dollars (at this writing.) Fill this title in at space number 1 on Form VA.

Note: Because the Copyright Law is an ever-changing document, be sure to request updates from the Copyright Office from time to time.

| If I ask a publisher to include my © notice alongside my picture when he publishes it, but the © is omitted, does this invalidate my copyright protection? | Sections 401(a)(c), 405(a)(2)(3), 407(a)(2) and 408(a) |
|---|---|

No. Since March 1, 1989, no notice is required to preserve a copyright. For earlier work, first published between January 1, 1978, and March 1, 1989, your copyright protection exists if you can show proof that your picture

(1) was rubber-stamped, labeled, printed or handwritten with the copyright notice on the front or back before it was published, (2) was accompanied by a letter from you asking for publication of your notice with the photo in the publication or (3) was published in a copyrighted publication. Since *all* of the pictures (except advertisements) in a publication are covered by the blanket copyright notice in the masthead, copyright protection for you was implied—but make sure that the publication's copyright notice was correct (you'd be amazed at how many publications print partial notices—or errone-ous ones!).

| | |
|---|---|
| **Can I place the © notice on my slides and photographs and be protected even if I don't register my picture with the Copyright Office?** | Sections 401(a)(c), 405(a)(2)(3), 407(a)(2) and 408(a) |

Yes. The © notice that you put on it is "official," and it is free. It gives notice to the world that you own the copyright to your picture. But you don't *need* the © notice for your picture to be protected. The revised Copyright Law recognizes you as copyright owner, with or without the © notice and with or without registering the photo. If a picture is not registered with the Copy-right Office, it does not mean it is not copyrighted. But, like your automo-bile, if it is stolen, it is a lot easier to prove it's yours if your automobile is registered with the Department of Motor Vehicles. You have more immediate clout than if you can produce only your title to your car but no registration. Of course, the big reason to register any photos is so you can set attorneys' fees (statutory damages in an infringement suit). In cases of your very special pictures, you may wish the extra clout you would have against possible infringers if such pictures are registered.

| | |
|---|---|
| **If I do not register my pictures, but I publish them anyway with the © notice, can I be ordered to send them in to the Copyright Office?** | Sections 407(a)(d)(1)(2)(3) and 704 Title 44 (2901) |

Yes. Under the 1978 system, the photographer will not be forced to register his pictures, but he can still be ordered to submit two copies of a published work in which a © notice appears to the Library of Congress (the parent office of the Copyright Office). If, after being ordered to send them, the photographer does not do so *within three months,* he can be fined up to $250 (for each picture) for the first offense, plus the retail cost of acquiring the picture(s). If the photographer fails to or refuses to comply with the demand of the Copyright Office, an additional fine of $2,500 can be im-

posed.[3] All deposited pictures become the property of the Library of Congress, but you retain the copyright, since copyright is distinct from ownership of any copy. Incidentally, if you register your work, the copies sent in with the registration satisfy the deposit requirement—but the reverse is not true. Even if a work has been deposited, two additional copies must accompany any registration application.

| **What does "work for hire" mean?** | Section 101(1)(2) |

If you are employed by a company and take a picture for that company *as an employee,* generally speaking, that's work for hire. The company owns the picture. You may have, somewhere along the line, signed a work-for-hire agreement with your employer. But even if you haven't, and your work was done within the scope of your employment, total ownership of your pictures belongs to your employer. If you are a freelancer and a picture is specifically commissioned or ordered by a company, and you have signed an agreement saying so, your photos may be works made for hire. However, if a magazine gives you an assignment and pays for the film and expenses, this is not working for hire unless you sign a document saying so. If you receive such an assignment, avoid signing a work-for-hire statement. Instead, agree to allow exclusive rights to the client for a limited time. If the client insists on all rights, increase your fee. A good test for work for hire is to ask, "If someone were to be sued regarding this, who would be liable—the photographer or the entity commissioning the photographer?" For an in-depth discussion on work for hire as it applies to publishing and multimedia development, consult the bibliography for *Multimedia Law and Business Handbook*, by J. Dianne Brinson and Mark F. Radcliffe.

| **Are the pictures I submit to a photo editor who's listed in *Photographer's Market* or similar reference works considered work for hire?** | Sections 101(1)(2) and 201(b) |

No, unless you have signed a work-for-hire letter, slip, form or statement. And remember, if the pictures existed before you made contact with the photobuyer, they were not "specifically ordered and commissioned" and cannot be works made for hire.

| **What if a magazine publisher wants to reprint my picture a second time as a reprint of the original article, wants to** | Section 201(c) |

---

[3]Random published photographs, under this system, are arbitrarily requested for deposit by researchers at the Copyright Office. By the way, I haven't heard of any cases where someone was fined $250, or $2,500, for not submitting the requested pictures.

**use my picture to advertise his publication or wants to use my picture a second time in an anthology? Does the publisher have the right?**

As a stock photographer, you should license only one-time publishing rights to a photobuyer. Unless something different is stipulated in writing, the law assumes that you have licensed your picture to the photobuyer only for use in the magazine, any revision of that magazine or any subsequent edition of that same magazine issue—which could mean more than one use, but not in another publication or for a different usage. In no other case may the photobuyer presume to use your pictures without your consent and/or compensation to you. If a photobuyer would like your picture for additional use, refer to the pricing guide for photo reuse in table 8-3. Note: In the stock-photo industry, we use the term *photobuyer*. This term designates that the buyer is buying certain *rights* (usually one-time rights), not the copyright, and not the physical black-and-white photo or slide itself. These photos and slides are usually returned after the transaction. (Slides should *always* be returned.)

**What penalties does infringement (unauthorized use of a photo illustration) call for?**

Sections 412(1)(2), 205(d), 411 and 504

The owner of a registered copyrighted picture on which infringement has been proved may receive, in addition to the actual damages he has suffered (lost sales, for example), the amount in cash of the profits received by the infringer. If the copyright owner can prove the infringement was willful, he can receive as much as $100,000 for each infringement if he wins. But if the infringer proves that he infringed innocently, the award to the copyright owner could be as low as $200 or less—or even zero. If the copyright is registered within three months of publication, the copyright owner can receive statutory damages instead of lost profits. Thus, even if the infringer earned only $50, the award could be between $500 and $20,000. Legal fees may also be reimbursed, but only if the copyright was registered within three months after publication or before the infringement occurred. If you do not register your picture and your picture is used without permission, you must register before you can go to court—and you may lose the right to statutory damages and attorneys' fees by procrastinating in your registration.

However, other remedies, such as impoundment or injunction, are available and may be worth the cost of going to court for the satisfaction. And, on occasion, the government will even prosecute an infringer—criminal penalties include fines (of which you get no share; the government gets it all) and imprisonment.

| What is the statute of limitations on infringement? | Section 507(a)(b) |

If you don't discover infringement within three years, you have no recourse for damages.

| Can I take a picture of a photograph or an object that is copyrighted? | Sections 113(c) and 107 |

Yes. Under the "fair use" doctrine, a photograph or other copyrighted work can be copied or photographed for uses such as criticism, comment, news reporting, teaching or research. The court is more likely to consider your use as "fair use" if you use it for a noncommercial purpose rather than commercial. For example, your one-time use of a copyrighted picture in a slide program for a nonprofit lecture series or camera club demonstration would likely be considered fair use. However, if the picture were to be used by you for self-promotion or advertising purposes, or if the picture of the copyrighted object were to be given such widespread distribution as to reduce the effective market value of the original copyrighted photograph or article, you would probably be guilty of infringement. As a stock photographer, if your pictures are used basically to educate and inform the public, taking a photograph of a copyrighted object or picture might not be infringement—but one of the criteria for fair use is the amount of the work you reproduce. A photograph of someone else's entire photo or painting might well be infringement. Of course, you must keep in mind that your interpretation might be different from the court's, and consider each case in its own context.

For a more thorough discussion of "fair use," see Copyright Office Publication R-21, or consult chapter eleven in the *Multimedia Law and Business Handbook* listed in the bibliography.

| Should I register all my best pictures? | Sections 411(b)(2) and 412(1)(2) |

That's like asking, "What kind of boat should I buy?" It depends on whether you'll use it on a lake or an ocean, how large your family is and your pocketbook. If you register your picture with the Copyright Office within *three months* of publication, you can claim any of the remedies for infringement that the law allows. But if you register after three months have elapsed, your legal remedies will be limited.

The cost of registering your copyright(s) must be considered a disadvantage. The average stock photographer owns at least 5,000 excellent pictures; $20 \times 5,000 = \$100,000$. Remember, registering your pictures is optional. Registered pictures do receive better protection under the law. You can save costs by group-registering your published pictures when possible.

| How long can I wait to register a published picture? | Sections 104(a) 405, 406, 408(a) and 412(2) |

Any length of time. Pictures registered within *three months* of first publication receive broader legal remedies than those registered later, and registration is the prerequisite for any suit. But your copyright exists whether your picture is registered or not. If your pictures were published before March 1, 1989, and no copyright notice was applied to them, you had five years to register the pictures in order to correct the omission. If the copyright notice was erroneous (e.g., if your name or the date was incorrect), you may not be protected against those who rely on the information in the notice until you have registered.

| If my picture is included in a magazine or book that is copyrighted, does that mean the publication owns the copyright to my picture? | Section 201(c) |

No, *you* own the copyright, unless you've made and *signed* some special arrangement with the publisher. If you've leased a picture on a one-time-rights basis, then it is assumed that the publisher has only leased your picture for temporary use in that publication.

| If I don't have my picture registered and it is included in a copyrighted publication without my copyright notice on it, am I protected by the blanket copyright of all the (editorial) material in the publication? | Section 201(c) |

You are protected.

| Are pictures used in advertising also covered by the blanket copyright notice on a copyrighted publication? | Section 404(a) |

No. The publisher can claim copyright only on that material over which he has editorial authority. If your picture is used for advertising purposes, request that the advertising agency include your notice. Although the notice is not required, using it alongside your photo might result in additional sales.

| What is the copyright status of all the pictures I published before the new law came into effect on January 1, 1978? | Section 408(c)(3)(c) |

Under the old law, unless you *registered* and renewed those pictures, your pictures would have copyright protection limited to twenty-eight years. Re-

newal would have extended the protection to fifty-six years. Since 1978, works that are or have been renewed have their copyrights extended for a total of seventy-five years.

Prior to 1978, unless you had an agreement limiting the rights you were granting, or unless the publication reverted the rights to you after publication, copyright for the first twenty-eight years belonged to the publication as work made for hire.

Note: As mentioned, the Copyright Law is an ever-changing instrument. Great effort has been made to make this section as up to date as possible. This section is not designed to be a legal reference, however, and it would be wise to check any point with the Copyright Office for its up-to-the-minute status.

## Work for Hire

Although the Q&A forum touches on work for hire, you should know more about this subject, especially if you will be accepting an occasional service assignment that could fall into a work-for-hire situation.

Before 1978, the courts generally assumed that if a freelancer did a specific photographic job for a person or company, the photographer did not own the resulting pictures: The company or client owned them. The 1978 Copyright Law reverses this, and the courts assume the photographer owns the pictures, not the client. This alone clearly indicates the growing awareness of the resale value of stock photos.

The law now says that except for employees acting within the scope of their employment, unless there is a written agreement signed by both parties stating the photographer's work is work for hire, claims to ownership of the resulting pictures must be based on the rights (ranging from "one-time" to "all") that you assign to the client.

A client *could* assume ownership of your pictures under the following circumstances:

1. Your client is actually your employer, and you have made no provision to transfer copyright ownership of your pictures over to yourself while under his employ. (Note: It is possible to have the copyright of your pictures assigned to you after an agreed-upon time.) An employer owns the copyright in works created by an employee within the scope of employment.

2. The client is not your employer, but claims to be. The U.S. Supreme Court ruled, in *Community for Creative Nonviolence vs. Reid* (1989), that the tests for *employment* found in agency law apply to work for hire. These would include who paid for the supplies and equipment, whether you could hire assistants, where the work took place, whether the employer could order you to do additional work and whether you are in business.

3. If you do not fit these definitions of employee, a work for hire must meet three conditions: (1) It must be specially ordered and commissioned; (2) there must be an agreement in writing, signed by both parties, specifying

that this is a work for hire; and (3) the work must fall into one of nine specific categories, such as contributions to a collective work or atlas. For a more thorough discussion: *Multimedia Law and Business Handbook* (1996), Ladera Press, Port City Fulfillment, P.O. Box 5030, Port Huron, MI 48061.

At all costs, as stock photographers, we should protect and defend our rights provided by the Copyright Law. We need to be ever-vigilant. As an example, in 1985 the American Association of Advertising Agencies called for (but did not get) a return to the "traditional understanding" of the 1909 Copyright Law, which made the client, not the photographer, the presumed copyright owner. "Work for Hire" in the present Copyright Law presumes that *you* own the copyright. Let's keep it that way.

4. If you have signed a purchase order, assignment sheet or similar form that states (sometimes in an ambiguous or roundabout way) that you are assigning the copyright in the work to the client. The statement might read, "All rights to photographs covered in this contract become the sole property of the client." If you give away all rights, you give away your copyright. A work-made-for-hire agreement is effective only for eight types of specially commissioned works:

1. contributions to collective works
2. part of a motion picture or other audiovisual work (many multimedia works are audiovisual works)
3. translations
4. supplementary works (works prepared as adjuncts to other work)
5. compilations
6. instructional texts
7. tests or answer material for tests
8. atlases

5. If you have endorsed a check that has printed on it a statement that says by endorsing the check you relinquish all claims to ownership of your pictures, you may be assigning all rights: "Endorsement below constitutes release of ownership of all rights to manuscripts, photographs, illustrations or drawings covered by this payment." A statement after the fact that the work was made for hire might have the same effect. Your recourse here would depend on various circumstances. You might cross out the offending lines, initial and endorse the check. You might send the check back and ask the client to issue a new check minus the offending phrase. Each situation is different. If possible, consult with other photographers who have completed assignments for the same company and compare notes on how arrangements with the client have been worked out.

In some cases, the client may be testing you. Handle with care. With

diplomacy, you could get full copyright ownership and remain in the client's good graces.

The Work for Hire provision of the Copyright Act of 1978 is a benefit to the stock photographer because it makes the assumption that the photographer owns the picture, not the client. If you find yourself in a game of politics in a service-photography situation and your client insists on "all rights" (that is, Work for Hire), ask the client this question: "If I were to be negligent and be sued, who would be liable—me or you?" The client might back off from insisting on all rights.

## Electronic Rights—Be Careful

A new medium has emerged for the use of your pictures: electronic. CD-ROM programs for training, education, research and entertainment plus websites of all description, now demand graphic images. Some publishers will assume that because they have used your picture for a print project, they can also use it for electronic purposes. No so. They need to contract with you for its electronic use as a separate transaction. As picture use in this new medium unfolds, new court interpretations of copyright law will build protection for stock photographers.

In the meantime, be careful. For example, if you allow electronic rights to a publisher who then modifies (electronically) your original photo through digital manipulation, that new image may be copyrightable by the publisher ("added authorship").

This principle also extends to public-domain photos. You or a desktop publisher could take a NASA photo and, with original manipulation, change the photo to the point where the result would be copyrightable as an "original" photo.

## Which Usage Rights Do You Sell?

The title of this book is *Sell & Re-Sell Your Photos*. It should be *Sell & Re-Sell the Rights to Your Photos*. As a copyright owner, you have the exclusive right to reproduce, distribute and modify your photos.

You don't want to sell all usage rights, as in a work-for-hire situation. You want to *rent* your photos, granting people permission for specific usage rights. There are different sizes, shapes and extents of rights—but primarily

---

**ELECTRONIC RIGHTS**

Some magazines and book publishers will attempt to grab electronic rights from you when they use one of your photos. To make it clear that you are selling only one-time inside-editorial rights, include a phrase on your invoice or correspondence similar to this: "the right to one-time use of this photo in the print version of [name of project]."

you want to base your sales on *one-time-use* rights. Any other rights of use should require separate negotiation and additional payment.

## Read the Fine Print

The different designations of usage rights commonly accepted:

**One-Time Rights.** The client or publication has permission to use the picture only once. You *license* the picture for that one use.

**First Rights.** These are the same as one-time rights, except that the client or publication pays a little more for the opportunity to be the first to publish your picture(s).

**Exclusive Rights.** The client or publication has exclusive rights to your photograph. This can be for a *specified amount of time,* such as one or two years. After that time, the rights return to you. Calendar companies often ask for exclusive rights. You may also limit this by territory or type of use (for example, North America, or calendar but not book use). Again, the client pays more for these rights.

**Electronic Rights.** With the proliferation of New Media, some publishers will want to extend use of your images to use on their Web pages, CD-ROMs, etc. Or they might wish to use your image(s) exclusively for electronic use. You can arrange to lease your image on an exclusive-rights or an all-rights basis, for an appropriate fee.

**Reserved Rights.** A client or publication may wish to pay you extra to be the only purchaser to have the privilege of using your picture in a particular manner—such as on a poster or as a bookmark—in which case you would reserve that use specifically for them.

**All Rights.** This is the outright assignment (transfer) of copyright to a client. After thirty-five years, if you wish the rights to the photo to return to you, or to your heirs, you or your heirs have the right to reclaim them.

As a stock photographer, you should avoid assigning all rights to a client or publication if the picture has marketing potential as a stock photograph. If the picture, however, is timely, it may be wiser to accept the substantial payment that an all-rights arrangement commands and relinquish your rights to the picture. Examples of pictures that might soon become outdated, and therefore unsalable, are photos of sports events, festivals and fairs.

**World Rights.** The client or publication is granted a license to use the photograph in international markets.

**First-Edition Rights.** You sell rights to only the first printing of a book, periodical, etc. After that, you negotiate for other editions.

**Related Rights.** These rights allow the use of a photo for related purposes, such as advertising use.

**Specific Rights.** Certain individualized rights are outlined and granted.

Your standard cover letter (see figure 9-1) can serve as an invoice to your photobuyer. In some cases, however, you will come to an agreement with a buyer regarding certain other rights and/or arrangements that are not cov-

ered by your standard letter. Spell out these terms in a separate letter to the buyer confirming the understandings. Also send an invoice with your shipment that reiterates all of the pertinent details of the transaction, such as rights being offered, number of pictures and their ID numbers, size, color or black and white, date and so on. Invoices are available at stationery stores. Professional-looking invoices are available from mail-order stationers (write for a free catalog) such as New England Business Service, 49 Vose Farm Rd., Peterborough, NH 03458; Grayarc, Greenwoods Industrial Park, P.O. Box 2944, New Hartford, CT 06104; The Drawing Board, P.O. Box 5028, Hartford, CT 06102-5028; and Stationery House, 1000 Florida Ave., Hagerstown, MD 21741. For a free copy of the transmittal form we offer our PhotoSource International subscribers, send an SASE to me at the address listed at the end of the bibliography.

## Forms to Protect Your Rights

Up to this point, we've been discussing the rights of photo usage that you sell. What about *your* rights with regard to damage, loss or pictures being held for lengthy periods of time? Your photo-marketing endeavor necessitates submitting valuable photographic materials to persons with whom you've never had personal contact. Is this taking a risk?

Is it a risk to travel down a road at 55 mph and face the oncoming traffic? Any one of those cars could cross over into your lane. What makes you continually take this risk?

You take it because the benefits of driving your car outweigh the risks involved.

You are likewise going to have to put a lot of *faith* in the honesty of the photobuyers you're dealing with. You're continually going to have to risk damage or loss to reap the benefits of getting wide exposure for your pictures.

There are contract forms available—also called "Terms and Conditions" agreements—that a photographer can issue to a photobuyer to specify terms of compensation in the event of damage or loss of photos while in the hands of the photobuyer or his company. But newcomers (or sometimes anyone— veteran *or* neophyte) have little chance of getting a photobuyer to sign a "Terms and Conditions" agreement. The disadvantages to the buyer outweigh the potential benefits. In fact, he might turn the tables and ask *you* to sign an indemnification statement that will free him of any liability as a consequence of using your pictures.

Keep in mind that others you depend on to handle your prints and transparencies—the U.S. Postal Service, Federal Express, United Parcel Service and your film processor—refuse to reimburse you more than the actual film cost in the event of damage or loss beyond their control. Also, the IRS, in assessing the depreciation of your slide inventory, sets the value not at intrinsic value, but only at actual film cost.

My advice: If you are an entry-level editorial stock photographer, lay out your terms and conditions to a photobuyer in a friendly, easy-to-understand cover letter, as shown in figure 9-1. Once you attain stature in your stock-photo operation, if you wish—or in special instances—you can test the waters by submitting a formal "Terms and Conditions" statement. This kind of statement, however, might tend to intimidate, turn off or actually anger a publisher, unless presented by a "name" photographer. Politics, of course, is involved, and you'll have to judge how to handle each situation on an individual basis.

Even a "name" photographer will think twice before using these agreements, however. For example, such agreements usually include a provision that calls for reimbursement of $1,500 for each transparency lost or damaged. This fee has indeed been collected, but subsequent communication between photobuyer and photographer is usually not quite the same, if it exists at all. If you find yourself in a similar situation, you will probably want to weigh your loss against your relationship with the photobuyer, and determine whether you wish to press such a payment from a good client for the result of an unusual accident or an honest mistake. The photobuyers who seem to make 90 percent of the mistakes in this industry are those who are new in the field. A good rule: Don't deal with a photobuyer or publisher unless he has a track record of three years, minimum.

If you wish to research these forms further, particularly as an aid in dealings with clients or companies you're not familiar with or whose proven track records are questionable, *ASMP—Professional Business Practices in Photography* (includes tear-out sample forms), listed in the bibliography, offers sound examples.

## Legal Help

If you run into a situation in which you need legal help in dealing with a photobuyer, a publisher or the IRS, the following organizations offer assistance. To consult with just *any* attorney on a legal problem concerning the arts and publication is like offering him a blank check to finance his education in the matter. Different attorneys are well versed in some areas, less informed in others. Before you contact an attorney, make a call to one of the organizations listed below. Volunteer Lawyers for the Arts (VLA) includes more than eight hundred volunteer attorneys across the nation who handle a variety of arts-related situations. For more information and a directory of VLA offices nationwide, contact the New York office, listed below. In some cases, the consultations are free. In other cases, there are the predicted fees, but at least you'll know going in that the VLA attorneys have a good track record in dealing in the area of intellectual properties.

**California Lawyers for the Arts,** Fort Mason Center, Bldg. C, Room 255, San Francisco, CA 94123, (415) 775-7200
**Lawyers for the Creative Arts,** 213 W. Institute Place, Suite 411, Chicago, IL 60610, (312) 944-2787
**Volunteer Lawyers for the Arts,** 1285 Avenue of the Americas, 3rd Floor, New York, NY 10019, (718) 622-4717

A "Copyright Information Kit" is available free from the Library of Congress, Washington, DC 20559, (202) 707-9100.

# Model Releases

There is perhaps no area of photography more fraught with controversy and misconception among equally competent experts than the issue of when model releases are required. A photography magazine states, "So, at present, we are all forced by this ambiguity in the law to obtain model release forms from virtually everyone we photograph if publication is intended. It is much better to be safe than sorry, so obtain a release beforehand, regardless of the hardship, and save yourself a lot of aggravation."

The above was written by a respected columnist in a national magazine for amateur photographers. It is misleading and does a disservice to photography and to impressionable newcomers to the field.

Where do great photographs come from? From great photographers who were once amateurs. What if Alfred Eisenstadt, Margaret Bourke-White, Eugene Smith, Henri-Cartier Bresson or Irving Penn had been exposed to such misinformation as youngsters? Would it have inhibited their own photography?

What about the promising photographers of today who will be photographing (for publication) topics such as poverty, agriculture, the environment, industry and our social and political institutions? Will they be influenced by what appears to be an authoritative dictum from a nationally respected industry magazine? This is only one of many admonitions from equally credible platforms that advise carrying a model release pad in your back pocket wherever you go.

Photographers are confused and, as a result, often hesitate to take or use a picture because model releases will be too difficult to obtain. This uncertainty seriously limits the photographer, and in the end it limits you and me—the public.

# Freedom of the Press

*"A free press stands as one of the great interpreters between government and the people. To allow it to be fettered is to fetter ourselves."* —U.S. SUPREME COURT JUSTICE GEORGE SUTHERLAND

## WHEN YOU PHOTOGRAPH IN PUBLIC

You've often heard two warnings from the photography press when it comes to photographing in public: (1) Government officials will pounce on you and require authorized permits and (2) you will need model releases for every recognizable person in your pictures.

Both of these guidelines are true, but they apply to the commercial stock photographer—the person who makes generic pictures for the advertising trade.

Most photographers new to the editorial stock-photo field think they, also, need to apply these principles they learned in commercial photography. Yes, to repeat, model releases and special permissions are needed when you photograph in public for commercial stock photography. Model releases are needed because the pictures will be used for ads and promotion and will imply endorsement, and the buyers need the protection of the models' permission for pictures of them to be used for commercial purposes. Special permissions are needed because commercial stock shoots usually involve equipment and staff that can be an intrusion in an area.

**The Good News.** As an editorial photographer, photographing for magazines, books and the New Media, you have a separate set of rules.

The rules are much more relaxed. Reason? In our free society, the Constitution allows for a free flow of information. If editorial stock photographers were hampered by having to get model releases each time they took a picture, the flow of those pictures would soon slow down to a trickle. Accordingly, the multimillion-dollar publishing industry is quick to jump on its First Amendment privilege when it comes to model releases—when the pictures are used to *inform* and to *educate*.

Since it's not your job to elaborate to security guards about First Amendment rights, here are three important photographer-tested techniques you'll want to use when you are snapping pictures in public:

When you are in a city, state or national park, historic site, town square, shopping mall or college campus: (1) Do your best to look like a tourist (uniformed people with badges don't bother law-abiding tourists). (2) Don't use ostentatious equipment (long lenses, tripods or fancy photo bags). If the picture is important to you, you'll figure out how to work with a minimum of equipment. For example, a walking stick can be used as a monopod. By the way, government officials detest tripods and wires because people trip over them. (3) If possible, carry a cell phone. If you are confronted, you can always talk to the official's supervisor. Of course, in sensitive areas, if time permits, check in with authorities beforehand and get a letter of introduction. Be sure to emphasize that you are an editorial photographer and not making the pictures for commercial (advertising) use. And explain, too, that you understand the need these days for increased security. But time marches

on—and as an editorial stock photographer, you are recording that march. It's important to remember that city sidewalks, national parks and government (state and federal) buildings belong to you. Your tax dollars pay for their upkeep and your ancestors built them. They are yours to photograph as long as you are courteous and law abiding.

In the last decade, we, as photographers, have let increasing distance slip between us and a basic right conferred by our Constitution. The First Amendment affords us the right, not shared by closed societies of the world, to freedom of the press—to know what's going on around us. The First Amendment recognizes the dangers of restricting the ability of the press to report in good faith on matters of public concern. We need to be ever on guard, not only against constricting laws, but also against the more subtle, binding practices that the government can impose on photographers.

To wit: In past years, the court has approved searches of newsrooms (*Zurcher v. Stanford Daily*) and of the minds of reporters (*Herbert v. Lando*). It has narrowed the public-figure concept in libel cases (*Hutchinson v. Proxmire; Wolston v. Reader's Digest*) and sanctioned closings of courtrooms to the press and the public (*Gannett v. DePasquale*).

As we all know, model releases are required when pictures are used for commercial purposes such as advertising and endorsement. By also requiring a model release for editorial photographs, a publication or an institution opens itself to tyranny. Who's to say what restrictions would be placed on a photographer if we didn't have the First Amendment on our side?

Camera columnists who perpetuate the model-release myth become unwitting partners in a disturbing trend that would put a muzzle—or a lens cap—on every media person, including you.

How, then, has this myth about model releases evolved? Much of the confusion arises because the information in how-to photography books is slanted to the service photographer, who definitely requires model releases for his commercial work. Little is written for the editorial stock photographer, whose target markets are magazines and books, where editorial content slated to *inform* or *educate* does not require model releases.

Two surprising further perpetrators of the model-release myth emerge: photography magazines and prestigious film and camera companies.

Photography magazines are essentially trade magazines. In the interest of being supersafe, a growing number of corporate attorneys for trade magazines have made it a practice to advise a blanket model-release statement for all pictures published in the magazine, whether commercial or editorial. This kind of statement protects the magazine from the possibility of nuisance suits, of persons writing and saying, "You used a picture of me and it put me in a bad light and I want compensation."

Timid corporate attorneys, who would advise driving to work in a tank to be safe, should not be in a position to dictate the editorial content of the magazines that influence up-and-coming photographers. The blanket model-release decree is an easy way out for corporate attorneys. But in making their own jobs easier, they diminish your freedom. If you've noticed how photography magazines have moved steadily toward abstract, soft-focus and artificial-looking people pictures, you will understand the influences that have been at work.

Don't be intimidated by the cage-rattling of corporate attorneys—usually not photographers themselves—who are paid to protect the profit picture, not your picture.

As for film and camera companies, it is astonishing to learn of their direct role in engendering and continuing the model-release myth. They accomplish this through the annual photography contests they sponsor. The contests attract thousands upon thousands of student photographers. Because the contests are sponsored by big names in the industry, photographers are eager to win the trophies and ribbons offered, not to mention the cash. Some of the contests have been annual traditions for decades. Photography instructors receive special literature to explain the rules to the students, one of which never fails to state that "Model releases must be available for recognizable people in any entry."

Thus, photography instructors as well as students believe that model re-leases are indeed always necessary. After all, it came from The Source.

### The Sponsor Is the Winner

Why *are* the model releases required by the sponsor? Take a look at one of the other standard rules: "Winning entries become the property of the spon-sor." These large companies have discovered an effective way to acquire excellent photography—cheap. The real winners in these contests are the sponsors, who find many uses for the winning entries: magazine ads, promo-tional brochures, flyers, billboards, TV ads and so on. Because the winning entries are used for commercial purposes, model releases must be on file for all recognizable people in them.

So you see, your picture is no longer yours if you win. It's theirs. Including electronic rights. And since they will use the picture to promote *their* prod-ucts, it is now a *commercial* photograph—which requires a model release.

Again, the distinction hasn't been made for newcomers that model re-leases aren't necessary in the normal course of taking pictures in the public interest. Such contests should state the difference and the reasons for the releases for contest entries, and they should also award royalties to the win-ning entries. (For more on contests, see chapter ten.)

It may appear that I am belaboring this point on the myth of model releases, but the implications are far-reaching. Photography has advanced to the point where it is one of the most important communication tools. Yet

fewer "people pictures" are being taken in public because of the apprehension instilled in photographers by misinformed camera columnists and a protectionist industry. I hope that I have helped to demythologize the model-release question. If you had lost part of your Bill of Rights before reading this chapter, I hope I have helped you regain it.

## You Will Rarely Need a Model Release for Editorial Use

The Constitution is brief and open to interpretation when, in the First Amendment, it affords us freedom of the press. Freedoms are sometimes abused, and court cases over the years have attempted to interpret and clarify our freedom to photograph. New York State courts have tried many cases over the years. As a consequence, many of the other forty-nine states tend to look toward New York statutes and precedents for guidance. The current spirit of the interpretation of the First Amendment is that we, the public, relinquish our right to be informed if we succumb to a requirement of blanket model releases for everything photographed. If a photograph is used to *inform* or to *educate*, a model release is not required.

What are other books saying about model-release requirements?

It has long been established that photographs reproduced in the editorial portions of a magazine, book, or newspaper do not require model releases for recognizable people. Under the First Amendment of the U.S. Constitution, photographs may be used without releases if they are not libelous, if they relate to the subject they illustrate, or if the captions are related properly to the pictures, and if they are used to inform or educate. These provisions are confined to photographs used for nonadvertising and noncommercial purposes.

—from *Selling Photographs: Rates and Rights*, by Lou Jacobs, Jr. (Amphoto Books, page 174)

Can you include bystanders in the photographs of the parade when the article is published? Yes, you can, and you don't need a release. This is because the parade is newsworthy. When someone joins in a public event, he or she gives up some of the right of privacy.

—from *Selling Your Photography: The Complete Marketing, Business, and Legal Guide*, by Arie Kopelman and Tad Crawford (St. Martin's Press, page 194)

Generally speaking, news pictures that report current happenings or illustrate other items of public interest need not have the model's permission to be used. Sometimes the fine line between what is newsworthy and what is not may be difficult to draw.

—from an article by Richard H. Logan III, in *Law and the Writer*, edited by Kirk Polking and Leonard S. Meranus (Writer's Digest Books, page 111)

If the pictures are sold for editorial use, such as in a nonfiction book or in a magazine in connection with an article or item that is newsworthy or of general interest, it is unlikely that he would be liable if the pictures were misused, even though no releases had been obtained.
—from *Photography and the Law,* by George Chernoff and Hershel B. Sarbin (Amphoto Books, page 35)

Use of photographs in the news, educational, current illustrative areas, generally does not require a release.
—from *Photography: What's the Law?* by Robert M. Cavallo and Stuart Kahan (Crown Publishers, page 44)

Most of your publishing markets are well aware of the fact that they seldom need to require model releases. In my own case, I started out getting model releases whenever I shot, hampering my photography in the process. Once I learned that publishers for the most part take their First Amendment rights seriously and do not require model releases (with the exception of specific instances, which I'll discuss in a moment), I stopped getting written releases and haven't gotten any for thirty-some years. (That's one of the advantages of being an editorial stock photographer and not a commercial photographer.) My model-release file gathers dust in a far corner of my office, and my deposit slips continue to travel to the bank with regularity.

In the course of my photo-marketing career, I've come across publishers now and then (or photobuyers new to the job) who were unaware of their First Amendment rights or were unwittingly surrendering them. If they persist in requiring model releases when they're not necessary, I drop them from my Market List. Such was the case when the Tennessee Legislature passed a law requiring freelancers to submit model releases when submitting to Tennessee publishers (see page 299). Until the law is repealed, I will no longer submit to publishers in Tennessee.

By and large, publishers know and protect their rights. As I've noted, some publishers depend heavily on editorial stock photographers. A blanket model-release policy would only serve to cut them off from a major portion of their valued picture sources. They know that stopping for model releases is a disruption or intrusion contrary to the very nature of photo illustration—capturing the spontaneity and unaffected essence of the human scene.

## Model Releases—When Must You Get Them?

Your photo illustrations are used to inform and to educate. That's why your photobuyers will rarely require a model release. Just when *are* you likely to need one?

Some gray areas have developed over the years, and these instances are the exceptions to the rule. Pictures that might shock what's defined as the

normal sensibilities of ordinary people may be categorized as outside the "inform or educate" interpretation. Some other sensitive areas include mental illness, crime, family or personal strife, chemical dependency, mental retardation, medicine, religion and sex education. Each case has to be interpreted in its own context. For example, a court case involving sex education might be treated differently in Mississippi than it would in California. Take local and regional taboos into consideration when you are publishing your photos.

A model release might be required by the publisher of an industry-sponsored magazine because of implied endorsement. If a picture of you, for example, were to appear on the cover of *World Traveller Magazine*, it might imply that you, indeed, agree that Northwest Airlines "knows how to fly ♫."

As mentioned earlier, model releases *are* usually required in service photography. If a picture of you or your son or daughter is published in a commercial way and a trade benefit is implied, you or your son or daughter should have the right to give permission for such use, on one hand, and should receive compensation for such use, on the other.

As for stock-photo agencies—they sell pictures for both editorial and commercial use, and while they frequently do not require model releases when your pictures are submitted, they will want to know if releases are available. Being in a position to say to an agency, "MRA" (model release available) will make your pictures more salable.

If the target of your stock photography is also commercial accounts, you will want to develop a system for both obtaining and filing model releases. A free report, entitled "How to Get Model Releases," is available from The Stock Solution, % Royce Bair, 307 W. Two-hundred St., #3004, Salt Lake City, UT 84101, (801) 363-9700. If you send an SASE, he'll send you the report and a sample "request card" designed to make the model-release experience easier for both photographer and model.

## Oral Releases

Written model releases are required in New York State, but oral releases are valid in most other states. This means you can verbally ask permission for "release" from the person you photograph. This is to avoid later misunderstanding, even though the way your picture is used might not even require a model release. You can say, for example, "Is it OK if I include this picture in my photography files for possible use in magazines or books?"

However, if you are also a commercial stock photographer and there's a chance the picture may be used for commercial purposes, it's advisable to make your verbal request more encompassing: "If I send you a copy of this picture as payment, would you allow me to include this picture in my files for possible use in advertising and promotion?"

When you read about lawsuits involving the misuse of photographs by

photographers, it's usually a commercial stock photographer who has used a photograph of a person in a manner different from what the model expected. If you are a commercial stock photographer, *don't* rely on a verbal model release. Get a signed release. Spell out exactly how the picture will be used. If the person is under eighteen years of age, obtain a release from a parent or guardian. If the property you are photographing also capitalizes on its notoriety, and you plan to use the photo for commercial use, then definitely get a "property" release. You'll find that in such situations, the property owner will be happy to sign a property release because, in effect, you are serving as a free public relations or publicity agent, who normally might cost them $75 an hour or more.

How do you learn if oral model releases are acceptable in your state? Almost every county in the U.S. has a law library at the county courthouse. Consult the current volumes of state statutes for the laws on invasion of privacy. Ask the law librarian or the county attorney to assist you. For details on cases involving invasion of privacy, consult the volumes entitled "Case Index" or the equivalent. You'll be pleasantly surprised to learn that few cases are recorded.

If you are unable to visit the law library in person, try phoning. If you are not familiar with the terms or descriptions, let the librarian know this. An expert will be more helpful and willing to refer you to additional sources of information if you let her control the conversation.

Many photographers shoot the pictures that they plan to send to an agency, or that might be used from their own files for commercial purposes, within a close geographical area. They can then easily go back later and obtain a written model release, when necessary. Another route is to work with one or several neighboring families and get a blanket model release for the entire family, then barter family portraits over the years in return for the privilege of photographing family members from time to time for your stock files.

Figure 15-2 shows an example of an acceptable model release. Figure 15-3 shows a release for parents and guardians to sign for models under eighteen years old (under twenty-one in some states). These two releases have each been designed to fit onto a pocket-size 3″ × 5″ pad.

## Can We Save Them Both? The Right of Privacy and Our First Amendment Rights

The rights safeguarded by our Constitution include the right of privacy—our individual right to decide whether we want our peace interrupted. Occasionally a photographer violates normal courtesies, laws and decency with his picture taking. Such instances are, of course, exceptions—and all are answerable within the law.

However, we have seen instances in which leaders of political groups,

RELEASE

In consideration for value received,[4] I do hereby authorize _____ ("the photographer") and or parties designated by the photographer (including clients, purchasers, agencies and periodicals or other printed matter and their editors) to use my photograph in conjunction with my name (or fictitious name) for sale to or reproduction in any medium the photographer or his designees see fit for purposes of advertising, display, audiovisual, exhibition or editorial use.
I affirm that I am more than 18 (21) years of age.

Signature _____

Date _____

*Figure 15-2. Model release.*

RELEASE

I, _____, parent / guardian of _____, a minor, in consideration for value received,[4] assign to _____ its customers and representatives, the exclusive right to copy and reproduce for the purpose of illustration, advertising and publication in any manner whatsoever any photograph of said minor in its possession.

Signed _____

Address _____

Witness _____

Date _____

*Figure 15-3. Guardian's consent for model release.*

[4]Value received translates in everyday terms to compensation. The compensation the model receives might be a dollar, a copy of the publication the picture appears in, etc.

militia groups, individuals engaged in medical quackery or religious cults will commit their misdeeds against society and then attempt to take refuge in our right-of-privacy laws. Usually, prominent public figures must surrender such privacy and open themselves to public scrutiny. Such is the price of glory.

One state, Tennessee, has passed a law ("The Personal Rights Protection Act of 1984") that is a bureaucrat's and politician's dream. It states that publishers in Tennessee cannot use photos featuring people if the photographer has not obtained a model release. This means freelancers cannot photograph police brutality, school system wrongdoings, militia activities, highway accidents, city hall personalities, religious rites and so on. Our First Amendment early recognized that the curtailment of information to the public gives invitation to corruption.

But what about the nonpublic figure, the person who is just going about his normal business? Invasion of privacy is not so much a question of whether you should take a picture or not, but whether the publisher should publish it or not, and in what context.

While our Constitution allows us freedom of the press, it also allows us freedom from intrusion on our privacy. Herein lies a conflict, and the courts are left to make the decision whether invasion of privacy was committed by a photographer in any individual instance.

Instances usually considered invasion of privacy would occur if you were to do the following:

1. Trespass on a person's property and photograph him or members of his family without valid reason. (In connection with a newsworthy event would be a valid reason.)
2. Embarrass someone publicly by disclosing private facts about him through your published photographs.
3. Publish a person's picture (without permission) in a manner that implies something that is not true.
4. Use the person's picture or name (without permission) for commercial purposes.

There have been very few cases in U.S. court history involving a photographer with invasion of privacy. Except for number one above, invasion of privacy usually deals with how a picture is *used,* not the actual taking of the picture. When in doubt, rely on the Golden Rule.

### A Turning Point

Privacy is important to all of us. It was an important factor to me in moving to our farm here in western Wisconsin, insulated by acres of rolling hills.

In my early days as a photographer, my views on privacy used to get in the way of my photographing. For example, once, as a young tourist in

France, I photographed two people, a man and his wife, who were so inebriated they had fallen to the ground; one was trying to help the other up. I got two pictures before bystanders began kicking me and tossing rocks at me. I had entered into that picture-taking encounter believing that I was recording insights into the problems of alcoholism in France. I exited with remorse, believing that I had invaded the privacy of two individuals and insulted their compatriots. For several years, I avoided "invading the privacy of people's lives" and took few pictures in public.

Then one day it occurred to me that the moment of life I had captured on film that day in Paris was significant. I realized that the potential impact of that minidrama on those who might view the picture outweighed any invasion of privacy I might have committed, not to mention the guilt I had imposed on myself.

From that day forward, my interpretation of *privacy* was different. Photo illustration has become a powerful communicator for all of us. If privacy is a gift we all cherish, so is the gift of *insight* photography affords us. Whether it's a TV report of a heroic teenager or the treatment of Rodney King by Los Angeles policemen, photography is the medium. Our lives become richer each time we move closer to understanding ourselves, our fellow creatures, our society and the planet we live on.

As an editorial stock photographer, you will affect the lives of others. Closed societies are aware of this and severely limit the rights of photographers and the press. In our free society, we photographers have the responsibility of not abusing our freedom of the press. We owe it to our profession to respect the rights of our models. Your mission as an editorial stock photographer is to inform and educate, not to libel and slander. You can reassure your models with courtesy and the explanation that your photograph(s) will "be in the public interest." By making it clear how the photo will be used, and sticking to your statement, you build your reliability factor (and the reliability factor of photographers in general) in the eyes of the people you photograph.

The definition of *rights* expands and shrinks with changes in government, society and culture. We are fortunate to live in a society that guarantees both freedom of expression and the right to privacy. Photography, at times, walks a fine line between those two rights.

Lest you be overwhelmed by all of this legalese:

## "Fruity" Question

According to Robert H. Mundheim, former general counsel of the Treasury Department, when an ordinary person wants to give an orange to another, she would merely say, "I give you this orange." But when a lawyer does it, she says it this way:

Know all men by these presents that I hereby give, grant, bargain, sell, release, convey, transfer, and quitclaim all my right, title, interest, benefit, and use whatever in, of, and concerning this chattel, otherwise known as an orange, or *citrus orantium*, together with all the appurtenances thereto of skin, pulp, pip, rind, seeds, and juice, to have and to hold the said orange together with its skin, pulp, pip, rind, seeds, and juice for his own use and behoof, to himself and his heirs in fee simple forever, free from all liens, encumbrances, easements, limitations, restraints, or conditions whatsoever, any and all prior deeds, transfers or other documents whatsoever, now or anywhere made to the contrary notwithstanding, with full power to bite, cut, suck, or otherwise eat the said orange or to give away the same, with or without its skin, pulp, pip, rind, seeds or juice.

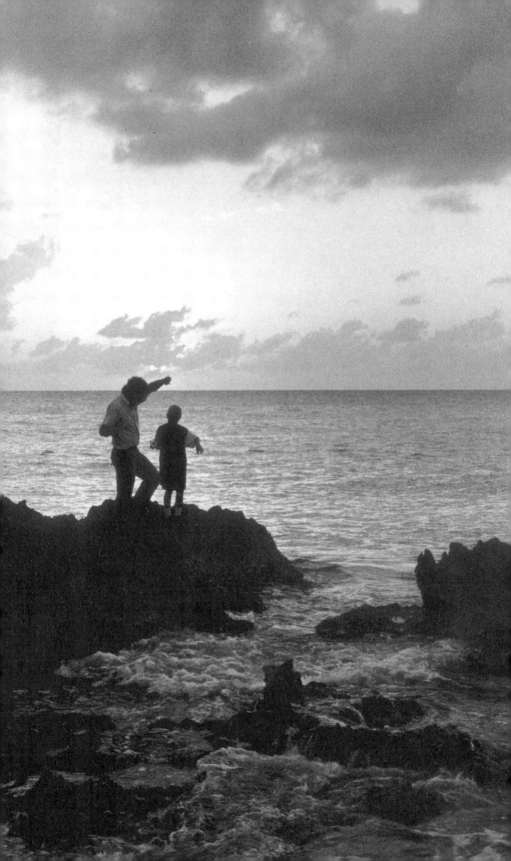

# Your Stock-Photo Business: A Mini Tax Shelter

## The Great Rebate

If, as you read this book, you discover you're missing out on a lot of selling opportunities, then I'm accomplishing my purpose. This chapter shows you another significant and far-reaching opportunity: If you work at a salaried job, you have an annual tax rebate coming to you—when you begin calling your stock photography work a *business*. Your rebate can amount to as much as $1,000 a year, depending on your salaried income, the number of dependents you claim, your photography business deductions and a few other considerations.

What I'm going to say will enable you to buy a new camera every year, new lenses or new darkroom equipment. Listen carefully.

### The Tax Return

I call it the "Tax Rebate System." It is legal, logical and lovely. It is based on the fact that in our free-enterprise system, the government tries to help small businesses get off the ground. Many a flourishing business existing today started as a transfigured hobby—and made it, thanks to the initial tax allowances offered by the IRS.

While it may be your legal obligation to pay taxes, it is never your duty to pay more than you owe. In fact, just the opposite is true: European and American courts alike have recognized both an individual's and a corporation's right to minimize taxes.

If you follow a few simple IRS-approved guidelines, a tax rebate will come to you, you'll get your stock-photography business off the ground and the IRS will give you no heat. In fact, the IRS will be on your side—after all, your business will one day be in a position to pay taxes, too. Up to now you may have called your photography a *hobby*, but Uncle Sam will "pay" you as much as $1,000 a year or more to call it a business.

Declaring your photography as a business is easy. You simply say, "My

---

**HIRE YOUR KIDS**

Is your stock photography a family business? Put your youngsters on the payroll to perform clerical work or chores like filing slides, or as models in your next shoot; let the business pay them compensation that it deducts and which they report on their returns.

Hiring your children provides a way to keep income in the family, but shifts some income out of your higher bracket and into their lower income bracket.

---

photography is now a business." That's it. Then at income-tax time, in addition to the regular 1040 tax form, you also fill out a form called Schedule C (Profit or Loss From a Business or Profession).

Tax professionals suggest that you do at least the following things to give "business status" to your photo-marketing operation:

1. Give a name or title to your business, and open a separate business checking account in this name.
2. Have business stationery printed.
3. Ask the IRS for an employer identification number (EIN). It costs you nothing and it remains your number for as long as your stock-photography business is in operation. Ask for Form SS-4.

These three actions show clear-cut intention for IRS purposes, if any question arises later. Naturally, the IRS does not act kindly toward the person who fabricates a business operation and then enjoys the benefits.

Bear in mind that we are not discussing tax evasion. That's against the law. We *are* talking about making legitimate, legal, justified tax deductions—that's your right. And it's called *tax avoiding.*[1]

If you are still in doubt, call the toll-free IRS number for your local area. Tax information specialists are on hand to answer questions and send you literature. Most IRS operators are knowledgeable and cooperative, but if the information isn't clear to you, ask for the IRS's Tele-Tax information. It's a recorded information system of 140 topics. You can hear up to three topics on each call you make. The IRS will supply you with local and regional 800 numbers to call. Some of the topics: "Taxpayers Starting a Business" (#583); "Business Expenses" (#535); "Travel, Entertainment and Gift Expenses" (#463). Finally, if your question doesn't have a simple answer, ask to speak to the supervisor or the *technical* person.

You can also ask your tax consultant about these guidelines, but be conscious of a need to check the thoroughness of the response. Your questions

---

[1]To AVOID is LEGAL but to EVADE is ILLEGAL. U.S. Supreme Court (*Gregory vs. Helvering,* 293 U.S. 465)

might require some research—that is, extra work—on the consultant's part. Don't open your checkbook to a tax person who has had little experience in dealing with small business in the creative field.

My own experience has been that many tax consultants concern themselves only with the routine elements of standard business situations—not the individualized self-employment questions that may take extra research and study. With this in mind, ask around your area. Speak with successful freelancers, writers and other creative persons. Ask them, "Which tax advisor do you use?" You'll eventually come across the name of a tax advisor who is knowledgeable in the area of "intellectual properties."

By establishing your business status with the IRS, you are establishing intent to make a profit. In your first five years of operation, you should be able to show a profit for any three years out of five. (In other words, you could go as long as two years before you need to show a profit.) The second five-year period, the third and so on, are treated in the same manner by the IRS. However, the law does not say that the profit must be large (or likewise that a loss from your business must be small). The five-year period is not a block of time (first five years, second five years), but instead focuses on the current year plus the prior four years.

The record proves that the IRS does not come down hard on people who don't show a profit, as long as they show reasonable intent to make their business prosper. If you conduct your business in a businesslike manner—with evidence of consistent submission of your photographs, self-promotion activity, reasonable recordkeeping and use of a business letterhead—there's little likelihood you'll be challenged by the IRS.[2]

### A Government Incentive to Start Up Your Business

Even though you might not make a profit the first couple years (on paper), you may have more money available to you, in terms of actual cash flow, than if you never attempted to start up your stock-photography business. Here's how it works: Say you're making $20,000 a year at your regular job. Your weekly paycheck should be $384.62. But after taxes and other deductions (about 28 percent), you could take home as little as $279.12— or $105.50 less than your gross salary. Since your employer has taken taxes out of your wages in advance (withholding tax), you in effect have placed on deposit with the IRS a sum of money (about $15 a day), which, if not

---

[2]The IRS could claim that your business is actually a hobby, in which case you can claim deductions only to the amount of actual gross income from your "hobby." You qualify as a bona fide business if you claim business status and conduct your business with regularity, though as a sideline. If, after the first year, the IRS challenges your "intent" to make a profit, within sixty days after receiving an IRS notice to disallow your business deductions, you can file Form 5213, "Election to Postpone Determination," until the end of the five-year period. You can voluntarily file this form within three years after filing your first return as a business. Publication #334, available from the IRS, gives further details.

---

### BUSINESS LOSS?

Do you expect your business to operate at a loss for the year? Then you need to know how to take advantage of a special tax break related to red-ink years. This frequently overlooked relief provision allows you to use a loss from the active operation of a business to recover or lower taxes paid in other years.

The key to this opportunity is Internal Revenue Code Section 172. It permits a business that suffers an "NOL" (Net Operating Loss, which is tax jargon for when expenses exceed income) to carry that loss back to earlier years or forward to later years.

For a free report on this subject, write to *PhotoStockNotes*, Pine Lake Farm, 1910 Thirty-fifth Rd., Osceola WI 54020. Include a self-addressed stamped envelope with two first-class stamps affixed.

---

owed to the IRS, is returnable to you. (Maybe this is why they originally called it a "tax *return*"!)

Aside from your salaried job, as you are now also a small-business person just starting up a new business, you are going to have a lot of related expenses. This is where the Schedule C (profit or loss form) and Form 4562 (depreciation and amortization) come in when you make out your tax forms.

Let's say that after your first year, when you have deducted the legal tax deductions listed later in this chapter (film, chemicals, car expense, stationery, travel and home office expenses) and enumerated them on your Schedule C form, you find you show a "loss" of $4,000.[3] On your Form 1040, you will deduct this from your regular salary of $20,000, which means your actual net for the year has been $16,000. Since taxes were taken out on $20,000 and not $16,000, you have a rebate coming back to you from the government. (Or if you are self-employed and haven't taken advantage of all of these deductions, it will mean a lower taxable income.) The size and make of the camera you can buy will depend on your tax bracket, exemptions, etc. You could receive anywhere from $10 to $1,000 from the U.S. Treasury Department. Nice going.

It might sound almost un-American to suggest that you come out with a loss in your business. Sometimes, however, it's more profitable not to make a profit. The popular newsstand magazine *Money*, which advises how to

---

[3]Remember, this is an "academic loss" in that you probably would have had similar photo, car, film, travel, heat and light expenses (deductions) whether or not you called yourself a *business*. Your wife's (or husband's) expenses are now also deductible if you can show that your spouse's presence on a trip (or at a dinner, seminar, etc.) had a bona fide business purpose (e.g., assisting you in some manner). By establishing yourself as a business, you can now legally deduct these as business expenses from your total income, thus reducing your taxes. When large corporations talk about taking a "paper loss," this is what they're referring to.

handle financial matters, was launched by Time-Life in 1972: It didn't show a profit until 1981.

## Carrybacks

You have another option when your business experiences a loss for the year. You can use an often-overlooked tax technique called Net Operating Loss Carrybacks. You are allowed by law to carry back any loss to the three previous years (IRS Code Section 172). In effect, you generate a refund of taxes already paid for those years.

Let's say in your first year of business, when you subtract your expenses (equipment, film, travel, etc.) from your income, your Schedule C shows a loss of $10,000 (your Net Operating Loss, or NOL). This is where the "carryback" comes in. You carry back and deduct your current NOL ($10,000) on your tax return of three years ago, and obtain a refund of part or all of the taxes you paid for that particular year. If your NOL surpasses your income of three years ago, the unused part can be carried to your tax return of *two* years ago. If there is *still* a part of your NOL left, it can be carried to your return of *last year*. If your NOL is greater than your past three years' income, then you can carry the rest of the loss *forward* to future years. Check with a tax professional on how this might apply to your situation.

You can expect an additional rebate if you live in a state that also has a carryback feature.

When you elect to carry a loss *forward*, you can decrease your taxable income and have fewer taxes to pay initially as you're getting your business started. You can carry a loss forward over a total of fifteen years.

## Your Stock-Photography Business Deductions

Like no other business, the stock-photography business requires travel to distant places to get your inventory. It can't only be manufactured locally. Now that you have your own business, you can, in addition to the personal deductions you normally take, allow yourself dozens of other deductions related to your stock-photo enterprise. Your film and processing expenses, magazine subscriptions, business-related seminars, office supplies and even the cost of this book are natural business deductions as long as they aid you in your business goals. If you require amateur or professional models in your pictures, a percentage of their lodging, meals and other expenses on trips is deductible. Incidentally, photographers are the only businesspeople who have a "backup" receipt: a photograph, which gives proof to the IRS that the photographer actually traveled to a certain location and *spent the money* (which is the main reason to collect receipts).

As an independent photographer, you are always on the lookout for stock photographs—whether you take them across town or across the country. You have probably called your trips "vacations." Now that you have a

---

**VACATION TIME!**

When you go on a business trip (no need to call it a *vacation*), forget about any deduction for expenses of a spouse who's tagging along just for fun. But if your spouse or children are models in your stock photos and you have the photos to prove it, ask your tax professional to advise you what percent of the trip's costs you should consider as a deduction. For example, if you stay at a hotel where rooms go for $100 for a single and $120 for a double, you're entitled to a per-day deduction for your hotel room of the entire single rate of $100 plus a prorated deduction for your family. Again, this and any other deductions depend on whether the photos you take during the course of your trip show your family to be significantly involved in your shoots.

---

business, part of your trips are eligible as deductible business trips. You will bring back dozens of pictures of interesting mining operations in Colorado, or agricultural observations in Wisconsin, to add to your stock-photography collection. You will talk an editor into giving you an assignment in one of the villages or cities along your travel route.

The deductions don't occur just on your three-week summer trip, but throughout the year. Your car now becomes your "business transportation." You will keep a daily log of your travel, plus gas, meals and lodging receipts for IRS verification.[4]

It continues. Since you are a photographer, everyone is a potential customer. Whenever you entertain, at home or elsewhere, keep records of your guests and define a business relationship or a potential business relationship (as a buyer of your photos, possible model or possible client). Then you can deduct those expenses, too. Be sure, though, that you *can* show a relationship between your guests and your work to the IRS. If you travel overseas, a log will prove vital in case of an IRS audit. Your *business* time must be 50 percent or greater, or deductions are severely limited. A good booklet on the subject is IRS Publication 463, "Travel, Entertainment and Gift Expenses." It's free, and available by phoning or writing your local IRS office.

Let's look at your new business expenses in some detail.

---

[4]Generally speaking, the IRS won't question expenses for meals and lodging if they're within the limits the government allows its own traveling employees. Receipts: No receipt is required for expenditures less than $75. [Ed. note: IRS rulings change from time to time. Call your local IRS toll-free number, (800) 424-1040, to validate figures in this chapter.] A receipt is required for expenditures of $75 or more. A receipt is required for hotel or motel, *regardless* of amount. A receipt is required for transportation only where such receipts are readily available. Check with your tax advisor on the percentage of write-off you are allowed for your meals, travel and entertainment expenses. In loss situations, for example, the home-office deduction is limited.

Check with a tax professional before you make your first stock-photo-gathering business trip.

## Office in the Home

Because you may use part of your home as the headquarters for your stock-photography business, the IRS allows you deductions for the portion of the house that is used to operate your business. But you cannot use your office-in-the-home expenses to create a net operating loss. If the total of your other business expenses (*not* including home-office expenses) is greater than your income, giving you a loss, that *is* allowable. But if your office-in-the-home expenses, when added to the total of your other business expenses, take you over the top to give you a loss, that is *not* allowable. Only that portion of your home-office expense that takes your total of expenses up to the amount of your gross business income can be deducted. If the total of your home-office expenses added to your other business expenses is *less* than your gross income, the full amount of your home-office expenses *is* deductible.

Here's how that works. Your stock-photography business, operated out of your home, has a gross income of $12,000. Your business incurs home-office expenses of $1,500. Your other normal business expenses, such as office supplies, postage, travel and film, total $11,500. Since your income was $12,000, you can use only $500 of your $1,500 office-in-the-home expenses as a deduction. However, the disallowed $1,000 may be carried forward to subsequent tax years. But these carried-forward home-office expenses are subject to the same restriction each subsequent year; i.e., they are *not* allowable if the addition of their total creates a net loss from the business activity.

The room(s) in your home where you conduct your photo-marketing business must be used exclusively and regularly for your photo-marketing operations. The IRS won't approve the room as a deduction if it's also used as a sewing room or a part-time recreation room, or if it's part of your living room. If you also have a darkroom, consider that room also as tax-deductible. Measure the square footage of your home (don't include the garage unless it's heated or air conditioned), and then measure the square footage of your working space. Divide the latter by the former and you'll determine what portion of your home is used for "profit-making activity." For example, if your working area is a $14' \times 11'$ room (used exclusively and regularly for your photo-marketing business), and the total square footage of your home is 1,232 square feet, you are using one-eighth of your home. "Business Use of Your Home" is the title of IRS Publication 587. It is a clear explanation of what you can and cannot deduct. Also check out Booklet 529, "Miscellaneous Deductions." Write or phone the IRS for a free copy, (800) TAX-FORM.

Formerly, you were unable to use the expenditures in the following list as tax deductions. But now that you are engaged in an intent-to-make-a-profit activity, you may deduct one-eighth (or 50 percent or 100 percent—whatever your particular setup may be) of these expenses. Get advice from

your tax professional as to which of your home deductions would fall under "capital improvement" or normal repair and upkeep expenses. List these deductions on your Schedule C when computing your taxable income (which includes the income from your full-time employment):

## Home

| | | |
|---|---|---|
| Home repairs | Heat | Refuse collection |
| Real estate insurance | Fuel | Painting |
| Carpentry | Depreciation | Decorating |
| Plumbing | Rent | Lighting |
| Masonry | Water | Fire losses |
| Electrical work | Air-conditioning | Sprinkler system |
| Roofing | Maintenance | Burglar alarm system |

## Auto Use

The deductions don't end with home expenses. Your car will be used to travel on assignments, research stock-photo possibilities and deliver packages to the post office. If you have two cars, designate one your business car, and use it for that purpose. Note the mileage at the beginning of the year and on December 31. No matter how many cars you have, keep a perfect record of their use (keep a diary in the glove compartment), and record trips and expenditures related to transportation for your business and professional activities. You can also deduct a percentage of the maintenance and repair of your car equivalent to the percentage of time it is used for business. Some typical deductible expenses:

| | | |
|---|---|---|
| Insurance | Waxing | Tolls |
| Registration | Accessories | Parking |
| Gas and oil | CB radio | Repairs |
| Lubrication | Tires | Depreciation |
| Car washes | Snow tires | License |
| Rental | Garaging | |

## Travel Expenses

In order to get your stock photographs, you may have to travel far and wide—in which case these expenditures are legal tax deductions:

| | | |
|---|---|---|
| Bus | Luggage | Motel |
| Train | Airplane | Meals |
| Boat | Taxi | Passport fee |
| Equipment | Hotel | Business tickets |

---

### TAKE A PHOTOBUYER OUT TO LUNCH

H ome entertaining qualifies as a business-expense deduction as long as you satisfy either of two requirements: The entertaining must be "directly related" or "associated with" active conduct of your stock-photography business. ("Directly related" means business is discussed during the entertaining, and "associated with" means the entertainment directly precedes or follows a substantial and bona fide business discussion.)

There's a noteworthy exception when you're host to business guests (such as a photobuyer) from out of town. You can then deduct entertaining that takes place the day before or after the business discussion.

---

### Entertainment[5]

You'll have all the usual business expenses, including taking clients out to lunch. If the meal is business related, 50 percent is deductible.

| | | |
|---|---|---|
| Meals | Tickets to miscellane- | Nightclubs |
| Theater | ous events | |

### Advertising/Promotion

Getting yourself known is deductible.

| | | |
|---|---|---|
| Design work | Brochures | TV |
| Graphics work | Booklets | Matchbooks |
| Copywriting | Catalogs | Calendars |
| Typesetting | Business cards | Portfolio |
| Mailers | Magazines | Trade shows |
| Flyers | Newspapers | Conventions |
| Business gifts | Telephone (yellow | Donations |
| Christmas cards | pages) | |
| Leaflets | Radio | |

### Photo-Related Items

Those expensive chemicals are now deductible. Document everything carefully.

| | | |
|---|---|---|
| Camera(s) | Processing | Darkroom equipment |
| Lenses | Lights | Paper |
| Accessories | Model fees | Chemicals |
| Film | Props | Instruction manuals |
| Printing | Costumes | |

[5]Must be carefully documented.

## Printing

It's an important expenditure for you, and it's deductible.

| | | |
|---|---|---|
| (see Advertising) | Books | Announcements |
| Business stationery | Ads | Tearsheets |
| Mailers | Catalogs | Office forms |

## Business Education, Self-Improvement and Memberships

If it will help you make a business profit, the IRS says it's deductible.

| | | |
|---|---|---|
| Subscriptions (business related) | Dues to professional organizations | Directories |
| Club memberships | Seminars | Courses |
| Market services | Books and references | Computer networks |
| Business development | Cassettes | |

## Office Equipment and Supplies[6]

"Little" expenditures in this area add up. Be sure to keep track of them.

| | | |
|---|---|---|
| Insurance | Independent | Computer supplies |
| Freight charges | contractors | Diaries |
| Typewriters | Paper clips, erasers | Postage stamp |
| File cabinets | Blotters, pads | envelopes |
| Staples, pencils, pens, ink | Mailing envelopes | International Reply |
| Paper | Rubber bands | Coupons |
| File folders | Return labels | Bookkeeping supplies |
| Typewriter ribbon | Loose-leaf notebooks | Calendars |
| Directories | Computers/software | Modems |
| Cleaning service | Photocopier | Briefcase |
| Printers | Equipment lease | Delivery charges |
| | Refunds to customers | |

## Extra Deductions

A surefire test for any business deduction is to ask yourself, "If I weren't in business, would I have this expense?"

| | | |
|---|---|---|
| Wages to employees | Legal fees | Mailing lists |
| Safe-deposit box | Meter rental | Business-related tools |
| Accounting fees | Permits and licenses | (X-Acto knives, etc.) |
| Self-publishing expenses | Maintenance agreements | Postage |
| | | Telephone calls |

[6]Depreciate major purchases.

| Telegrams | Product displays | Interest |
|---|---|---|
| R&D (research & development) | Professional fees | Commissions |
| | Bad debts/bounced | Consultants |
| Equipment repairs | checks | Contract labor fees |

Keep records of your expenses. (Excellent books on personal tax records are the *Dome Notebook* and the J.K. Lasser *Tax Series*, both published by Pocket Books, New York, and Simon & Schuster, New York. Gather these together at tax time, and list these expenses on Schedule C. These legally deductible expenses are bound to reduce your income from your regular occupation, as listed on your Form 1040. The result will be a rebate for you or if you are self-employed, less taxable income.

### Depreciation

Depreciation (in recent years called "Accelerated Capital Recovery System"—ACRS) allows businesses to replace their business equipment by offering them time-released write-offs over a period of years. For photography equipment, the time period is usually seven years. For your computer or car, it's five years. But check with your tax advisor or the IRS: These provisions change from time to time.

Investment Tax Credit is another incentive sometimes offered by our tax laws to stimulate the economy. At this writing, no ITC is available. But check with your tax advisor.

### The S Corporation

Most stock photographers set up their business as a sole proprietorship. The numbers work out best for them. Others find advantage in setting up as an S corporation.

An S corporation may be the business structure that best fits your needs. As an S corporation (formerly called a Sub Chapter S Corporation), you do not operate as a *self-employed* sole proprietor or partner. Your business income is not subject to self-employment (Social Security) tax. By forming an S Corporation, you legally change the nature of your photo-marketing income. By making the Small Business Corporation Election (on Form 2553), you eliminate corporate taxes on the corporate income. A newly formed S corporation never pays income tax. Instead, the net income of the corporation is reported on each stockholder's (or "owner's") individual tax return(s) as dividends (on a Schedule E). The owners pay the income tax on their corporate S income, but no Social Security tax. With this tax rate continually going up, this can represent a considerable tax savings. When you are an employee of the S corporation, your salary, of course, is subject to the usual employment taxes.

Almost all forms of business have some disadvantages, and the S corporation is not without its drawbacks. Once you check with your tax advisor

---

**DON'T TRY THIS AT HOME**

Some stock photographers attempt to report their stock-photo income on Schedule E. The concept is this: Report your stock-photo sales not as income on the standard Schedule C, but as royalties on Schedule E. The word is that by doing so, you can skip paying the 15.3% self-employment tax, which consists of 2.9% Medicare and 12.4% Social Security.

I ran this concept by Julian Block, tax attorney and former IRS agent.

"You could land in the deepest of tax doo-doo," was his comment.

"Why?"

"The IRS looks unkindly on photographers and other self-employeds who try to escape self-employment tax. Perhaps we have a case of semantics here. Yes, the word *royalties* is used on Schedule E, and yes, the IRS defines royalties as "payment for intangible properties" (e.g., books and artistic works, which would include photos), but the IRS insists that royalties for creative efforts be reported on Schedule C, making that income subject to self-employment tax. Royalties from your coal, oil or gas sites are reported on Schedule E.

"You are playing the 'audit lottery' if you report stock-photo sales as royalties on Schedule E. True, you might never be discovered, but should you be, expect to be hit with a hefty bill for back taxes, interest and penalties."

Julian Block advised Schedule C as the place to report stock-photo income. The bad news is that you'll be subject to self-employment tax. The good news is that (1) you'll also be contributing to your Social Security benefits for your time of retirement and (2) you'll qualify to shelter some of your income with deductible contributions to retirement plans.

---

and gauge your financial situation in relation to the S corporation, you'll know if this business form can prove to be an advantage in your own case.

### Additional Tax Avoidances

Other tax breaks you will want to consider (depending on your circumstances) are Credit for Child Care Expenses (Form 2441), Moving Expense Adjustment (Form 3903) and the tax-sheltered retirement plans, such as an IRA, Keogh or SEP (Simplified Employee Plan). For a detailed discussion of tax-saving strategies, I recommend *Julian Block's Tax Avoidance Secrets*, 3 Washington Square, Larchmont, NY 10538-2032, (914) 834-3227. Block is an attorney and a nationally syndicated columnist.

Also, two other provisions might result in the return of money to you:

1. *Earned Income Credit.* This credit is available to certain low-income people. Information on how to apply for this is in the filing instructions that accompany Form 1040.

2. On the *state* level, about half the states offer *Homestead Tax Credit* (in Wisconsin, for example, use Schedule H, Homestead Claim). This is a

rebate on your property tax if you are in a low-income bracket. If you rent, you also receive a proportionate refund.

As noted earlier, in order to be recognized as a bona fide pro in the eyes of the IRS, you have to, in good faith, be operating your business with regularity. As I mention elsewhere in this chapter, the IRS will provide you with some excellent free booklets on operating professionally: 583 and 552 deal with recordkeeping; 587 is on using your home for your business; 917 deals with business use of a car; and 334 deals with small-business taxes. Ask for "Your Business Tax Kit," written for anyone thinking about starting up a business.

Here's some recommended reading: The Small Business Administration offers a library of how-to books, some of which are free (contact Superintendent of Documents, Government Printing Office, Washington, DC 20402); *Planning Your Home Business*, Kern & Wolfgram, 4255 W. Touhy Ave., Lincolnwood, IL 60646; *Julian Block's Tax Avoidance Secrets*, 3 Washington Square, Larchmont, NY 10538-2032; *Home Office Magazine*, Time-Life Inc., Rockefeller Plaza, New York, NY 10020; *Volunteer Lawyers for the Arts Directory*, 1285 Avenue of the Americas, 3rd Floor, New York, NY 10019; *The Photographer's Business and Legal Handbook*, Leonard DuBoff, Images Press, 89 Fifth Ave., 9th Floor, New York, NY 10003-3020; *Legal Guide for the Visual Artist*, Tad Crawford, Allworth Press, 10 E. Twenty-third St., New York, NY 10010; *The Legal Guide for Starting & Running a Business*, Fred Steingold, NOLO Press, 950 Parker St., Berkeley, CA 94710-9867; *Top Tax-Saving Ideas for Today's Small Business*, Thomas J. Stemmy, The Oasis Press/PSI Research, 300 N. Valley Dr., Grants Pass, OR 97526; *The Homeowner's Property Tax Relief Kit*, Lawrence J. Czaplyski and Vincent P. Czaplyski, McGraw-Hill, 1221 Avenue of the Americas, New York, NY 10020.

*Note:* The information in this chapter can be helpful in getting your stock-photography business off the ground: It will allow you to reinvest money into your business by allowing you to keep more of the money you earn.

I assume you will take this information and apply it in an honest manner. To make sure you don't put yourself in a position to get heat from the IRS, always plan your deduction activities with the IRS in mind. In other words, cover your bases *before* you go on that trip, plan that business entertainment

---

**TAX QUESTIONS**

Got a question about uncommon deductions? See IRS Publication 529, "Miscellaneous Deductions." For a free copy, call (800) TAX-FORM (allow at least ten working days for mailing) or stop by your local IRS office. Many libraries also have copies of this and other helpful IRS tax guides. IRS Publication 910, "Guide to Tax Services," provides a complete list of booklets and explains what each one covers.

or make that photo-related purchase. Ask yourself, "Can I satisfy IRS substantiation requirements?" "Does this proposed tax deduction meet current IRS guidelines?" When in doubt, give the IRS toll-free number a call: (800) 424-1040. For recorded tax information, call (800) 554-4477; for tax forms, call (800) 424-3676. If you use this simple procedure, you'll have few problems with the IRS (the percentages are actually heavily against your photo-marketing enterprise ever being audited) because you have followed the rules of the IRS game. You beat the system with your own system.

## Helpful IRS Publications

| Publication Number | Topics | IRS Code |
|---|---|---|
| 334 | Home Office | 162 |
| 463 | Travel, Telephone, Entertainment | 162 and 274 |
| 560 | SEP and Keogh Plans | 162 and 401 |
| 587 | Home Office | 280A |

Many thanks to Julian Block, a tax attorney and former IRS agent, for checking the accuracy of this chapter and for many of the sidebar notes. Block is author of *Julian Block's Tax Avoidance Secrets*, Boardroom Classics, 3 Washington Square, Larchmont, NY 10538-2032, (914) 834-3227. Check out his scheduled appearances on the tax forum on PRODIGY (EXPT16B).

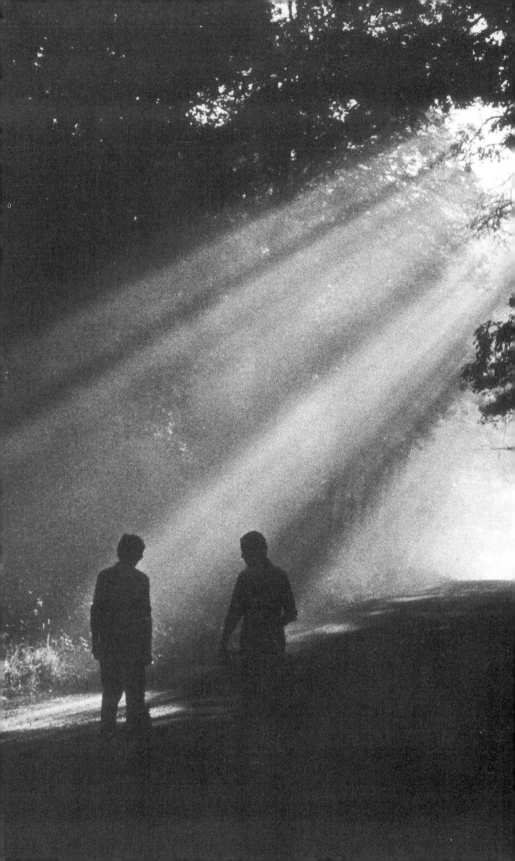

# Stock Photography in the Electronic Age

## Makes Life Easier?

"It'll save you a day a week!" proclaims the ad in the computer magazine. Hmmmm . . . Does that mean I can spend every Friday in the hammock?

Are computers good or bad for the stock photographer? Yes—they are good or bad. They can save you time and cost you time. They can save you money and cost you money. They can save you frustration and cause you frustration.

Time-savers they are. But like any new efficient tools designed to save labor, they can end up increasing labor. Remember when you switched from the push lawn mower to the riding mower? Instead of spending that extra hour in the hammock, you extended the size of your lawn. That hour you saved was spent mowing more lawn. You also put out more dollars. For the cost of the riding lawn mower, you could afford a grade school youngster trimming your lawn with nail clippers for six years. And the nail clippers don't even need gas and oil. If Parkinson would write a law for computers, he would probably say, "Thanks to its efficiency, a new tool that successfully saves labor will increase labor."

What's efficiency? Golf carts are efficient—you can finish your game a half hour sooner. But is that your attraction to the sport?

As you read this chapter, I hope it shines through that I'm all for computers. I may sound like I'm challenging them, but I'm actually offering *you* a challenge for restraint and moderation when it comes to investing in them, utilizing them and proselytizing about them. I first started with a Radio Shack computer (Model II) back in 1979, and I've expanded my business horizons to reach areas in the field of photography I probably wouldn't have ventured into if it weren't for the magic of the computer. I now have eight computers, all hooked up to a Novell network. I also have a Macintosh. If I had to do it over, yes, I would invest in a computer. But my business isn't *your* business. You might need one, or fifteen, or none. Keep this in mind when I, or any other person who talks about computers, start waxing gloriously about them.

In this chapter, I'll include comments from several stock photographers who have been kind enough to give me their input through correspondence, online chat sessions, seminars, phone calls and surveys. I believe their thoughts and advice will help to give you a better outlook on the computer as it affects you, the editorial stock photographer.

## Which Computer to Buy?

Buying a computer is like driving into a new community and asking the first person you see to recommend a good restaurant. If he likes Italian food, he'll probably say, "Luigi's!" The next person you ask will say, "The Fish House!" and a third person might say, "McDonald's!" You are at the mercy of their tastes, not yours. And of course, if the person's brother-in-law owns the Steak House, guess what he's going to recommend?

As photographers, most of us have learned that camera-store sales-people frequently know little about the product they're selling. You'll find the same is true in computer retailing. The last person on the list to talk to about a computer is the computer salesperson.

Here are the six most popular tidbits of advice you'll hear:

1. **Buy software first.** (Software is the stuff that tells your computer what to do.) If you're a neophyte, you're supposed to research the software and then buy the computer that fits the software.

2. **Buy a name-brand computer.** Leaders in the field at this writing are IBM, Compaq, Dell and Gateway. Macintosh and Mac clones are popular with designers and graphic artists. In any case, aim for a machine under $2,000 with a 100MHz Pentium microprocessor or equivalent, 16MB of RAM, a 1.6GB hard disk and a 14- or 15-inch monitor. Price wars in the computer business are always going on. You would do well to shop around at the computer superstores. One final note: Used computers are always a good deal. Like a watch or a camera, people don't give computers rough treatment (unless they were previously owned by a college student). Check out the yellow pages or call U.S. Computer Exchange, (800) 711-9000.

3. **Buy what your friends are using.** After all, if you're new at this, it would be nice to know that a friend could come to the rescue.

4. **Buy the power.** After you've done your homework, buy the most powerful machine your pocketbook can afford.

5. **Buy for service.** If your computer breaks down, and it usually will at crucial times, where will you turn for repair?

6. **Buy nothing.** Wait till the prices come down. What was selling for $3,000 five years ago is selling for half that price or less today.

Commenting on these six points:

1. It sounds good to say, "Buy software first." But throw this one out. Only computer-wise people buy software first, and if you were such a person, you wouldn't be buying your first computer, nor would you be reading this chapter. Which software to buy? Get the simple version. The manual

will be small and the program will be inexpensive. By the way, if you buy expensive software (over $250), you're probably taking on more than you can handle. The learning curve will be steep.

2. The reason for buying a name brand of anything is to ensure that service and parts will be available to you. But today, as far as computers are concerned, their interiors are so generic and interchangeable that most hardware problems can be solved quickly no matter what type of desktop computer you have. Should you buy a laptop? Yes, definitely, if you spend a lot of time away from HQ. But most editorial stock photographers spend a lot of time at base camp, where a desktop computer with a large monitor would be more convenient and practical.

3. Should you let friends influence your buying? Yes, if they know something about software problems and (minor) computer repair. They'll show you how things work and save you hours of trying to figure out the manual. As Lou Jacobs, Jr., says, "The manual writers are experts, and they assume far too much regarding the ability of the novice user."

Buy what your friends own, to be able to capitalize on their know-how. Put the law of probability on your side. For example, if ten people in your community have PCs and no one has a Mac, who will come to your rescue if your Mac breaks down? If you go ahead and join the ranks with a PC, you'll probably get answers, parts and condolences from your cohorts. A friend in need . . . But, at the same time, go cautiously . . . beware of *Technolust*, as Internet speaker and website development consultant David Arnold (www.daspeaks.com) calls it, a disease that afflicts many computer owners. These loyalists believe that their particular hardware is the *one and only*. It may be, for them. But if you're buying a computer, recognize that you won't get a balanced opinion from this breed.

4. Should you buy the biggest and the best? If you were a serious musician, you'd want to perform on the best musical instrument your pocketbook could afford. Look for the best that fits your budget. Keep in mind that if you buy in the fast lane, you are preparing for the future and you'll be able to capitalize on new software that requires faster processors and more memory (RAM). Your accountant will tell you that a state-of-the-art computer that you can amortize over five years is going to be cheaper (in the long run) than one that becomes obsolete in three years.

Keep in mind, also, that many computer systems can easily be expanded later on down the line, as you grow in size, need and wisdom. Buy smart. Don't buy a Boeing 747 if a Piper Cub will do, and the latter *will* do if you have less than five thousand pictures. The question comes down to how serious you are about your photo marketing. Definitely *buy big* if you are *thinking big* about your photo marketing. But don't become computer-rich and penny-poor. You'll know where to draw the line.

5. Service to your machine is essential, yes. But unless you buy something that you have to put together yourself, or a second-hand computer that went

out of production in 1995, service won't be a big problem. Most horror stories about computers being down translate to problems resulting from an act of God, or solvable human error like failing to make a backup of your data. Unlike the age we've grown up in, in which machinery equals moving parts, computers are a different animal. Except for the hard drives and cooling fans, there are few moving parts, hence less chance for break-downs. Help "Hot Lines" are available for most major-brand machines.

I am amazed that my home-built IBM look-alikes keep up with their newer compatriots. We clean them with darkroom airspray and replace the boards ourselves. For major repairs, such as a drive that's out of alignment or a zap to the boards from a lightning strike because someone left the modem attached to the phone line during an electrical storm, we truck an ailing computer over to Minneapolis (an hour and a half away), where it is hospitalized for three days. Knowledge of how a computer works is not necessary.

6. Finally, don't wait. Do your homework, yes. Read *Consumer Reports,* join computer clubs and read the computer magazines. But at some point, take the plunge. You will make some wrong decisions, yes. But as photographer/author Fredrik Bodin says, "The computerized photographers will leave you far behind if you don't make the leap." Waiting for the price to come down or the machinery to improve gets you "behinder and be-hinder." By getting your computer, what you gain in doubling your efficiency far outstrips what you might have gained in discount dollars by waiting. If you jump in now, you'll get a head start on learning the rudiments of im-aging, desktop publishing, cataloging and retrieving. You'll also be ready when online retrieval of photos becomes practical for the photobuyers you deal with. Lou Jacobs, Jr., sums it up, "My computer is not a luxury, it's a necessity, even before I owned it."

Your local library or bookstore will have many instructional computer books, some that will include a chapter on buying a computer. Many librar-ies provide free computer use to members, to search the Web or learn word processing.

## Cataloging and Retrieving Your Pictures

Your photo information—descriptions, file numbers, sales history and locations—can be stored in software (a *database*). You can buy "off the shelf" database programs and customize them for storing your photos. You can also buy custom software that is specifically designed for stock photographers.

Beware of software that files images sequentially, starting at 000001 and upward. You'll have to physically locate them in that order. Instead, choose software that will allow you to group your slides according to your PMS/A. Then when a photobuyer calls, you'll have them (except those that are cross-referenced) in one location.

## GET HELP

Editorial stock photography fits well onto the electronic highway. Parts of the highway are already in place, and if you aren't taking advantage of them, you may be missing some sales.

If you're a one-person operation, it's important to farm out as much of your operation as possible. Don't try to do it all yourself. In today's business vernacular, this is called *outsourcing*.

By relegating your shipping, marketing, scanning, printing and processing to others, you are able to put more attention to your "core" business. Without a clear knowledge of what your business is and where it's going, you're likely to hit a dead end.

If you buy a catalog/retrieval program and are satisfied, please let me hear about it. But I don't want to hear about it if you've cataloged fewer than 10,000 pictures. With fewer than 10,000, you don't need a computer system. The inexpensive device between your ears can handle that amount. But help is needed for 20,000 to 50,000 pictures.

If you are just starting out or starting over, $3'' \times 5''$ file cards or a notebook system continue to be the stock photographer's method of choice to locate and cross-reference a picture (see chapter thirteen). There's no machine to turn on, no skills or training involved or manual to refer to.

If you do have a compulsion to record data regarding your slides on your computer, do it like most stock agencies do: Record basic information about each slide into a computer database, usually when the slide is initially sent out on a sale (this justifies the cost of entering the information). If the agency wants to have a caption printed out, to track where the slide is or to search for *very general* (the issue here) categories, most simple database programs will do it. Many stock photographers like the software Filemaker Pro. It's a relational database and offers you both flexibility and room to grow.

Brian Wolske, director of Tony Stone Images, says, "There are too many nuances to pictures to entrust them to a computer program. Sales could be lost due to wrong information entered initially, or wrong requests made of the computer. *People* are still the best searchers in the files for images."

Computer consultant and lecturer David O. Arnold says, "To set up a system and then key in (or pay someone to key in) data on close to ten thousand slides to save an hour or two a month isn't worth it."

Stock-agency director and columnist Sharon Cohen says, "If you've got a lot of time on your hands, and you don't mind sitting in front of a computer for hours on end, then cataloging your pictures is OK. There's a great learning curve when it comes to this kind of software. It might be better to put your time to an accounting program. At least it'll be financially rewarding." She suggests cataloging pictures only by groups. "It's important to group your categories of pictures so that you'll be able to answer the questions

people are going to ask you. For example, a client might ask not just for 'elephants,' but, 'elephants feeding,' or 'elephants with young.' "

Stock-photographer Jim Pickerell says, "Installation and use of a computerized system would take too much time away from more important matters, such as photographing. Besides, there's always the decision about where to classify it and how to caption it. A photo one person might notate as *aviation,* another would file under *flying.* You can't give this decision to an assistant. Editorial stock-photo agencies might find that a computerized system would be fine because the pictures could be filed by job. As for me, the manual system is fast enough."

Royce Bair of the Stock Solution says, "Photographers should use caution when keying images on a computer retrieval system. The time and cost factors might be counterproductive in some cases. The national average for filing stock photos comes down to more than a dollar an image. Keying in the images, bar-coding them or placing magnetic strips on the slides only increases that filing cost."

Someone who is, however, a satisfied user of a computer cataloging and retrieval system is stock photographer Lewis Kemper, who uses the InView and StockView software. "Requests from photo editors are getting more and more specific nowadays," says Lewis. "Recently an editor wanted a white-tailed deer doing something specific. I set the program to search through my images of deer. In the past, finding those transparencies would have consisted of viewing several dozen slide pages on the light table. It saves on the eyesight." Lewis Kemper likes the "clairvoyance" feature of StockView. "If I start my search, I only have to type in the first few characters of my search. As with a voice mail search for a person's extension number, the program will activate once it makes a match, even with only three of four initial characters. The program then merges the information into my invoice, letter or other correspondence. It's great!"

Computers are great, but only for what they're good at. It's necessary to be selective. Refinements continually increase the capabilities of computers, and, in a great many areas, their performance is dizzying.

## CD-ROMs

"Send us your best pictures and we'll include them in our aviation disc," is how the ad reads. Will this be profitable for you? Yes, if your pictures are candidates for a typical stock-photo-agency catalog that requires the standard cliché images. In fact, if making postcard-type photos is your goal in stock photography, you can close the book now—you've found an avenue to sell those kinds of photos.

The royalty fees you receive from a CD-ROM (Compact Disc-Read Only Memory) range from fifteen to twenty-five cents. And the upfront payment ranges from $2 to $100, depending on the company you're dealing with. You are often free to continue to market the same pictures on your own.

Do editors use the clip art disc we see advertised in computer magazines? Some do. The digital quality is rarely adequate for use other than in newsletters, websites, low-budget publication or newspaper reproduction.

Here's the drawback of clip art photos. Photo editors primarily seek out editorial photos that will make their publications unique. CD-ROMs are, in effect, catalogs—and catalog pictures are not unique. That's one drawback of CD-ROMs. Another is that CD-ROM use requires that the editor do the searching. This is a reversal of the classic photographer/editor business relationship, where the photographer searches the file and comes up with an appropriate image. A third drawback is that CD-ROMs offer a limited selection. If a photobuyer is searching for, say, a Shetland sheepdog, the offerings on a CD-ROM are limited in number. The editor prefers to broadcast the need to an available-photographers list. And in the future, when online searching on the Web becomes more commonplace, CD-ROMs will become even less appealing to photo editors.

Should you produce your own CD-ROM custom disc? Probably not. Buyers are not convinced that CD-ROM is a medium that could make their lives easier. The problem is not just the unpredictable quality of the images, but also the inoperability of the technology. Without workable standards, buyers encounter frustration trying to make the discs operational in their computers and office network.

Many stock agencies, large and small, as well as individual stock photographers, have produced their own CD-ROM discs. But as one art director at a publishing house told me, "When we open the mail, we stand over a wastebasket. If a CD-ROM sampler comes in the mail, unless it's from a major stock-photo supplier, the disc gets trashed."

The inadequacies of a personal computer come to light when we attempt to ask it to perform tasks that it really can't do very well yet. CD-ROMs is one; categorizing and retrieving pictures is obviously another. By the same token, by the time you read this someone might have come up with that perfect hardware and search-capable universal software—user-friendly, low-priced, versatile, universally operable and speedy. Until then, it's rolling along with hunt 'n' peck. For a list of publishers who produce CD-ROMs, check the bibliography.

## Establish Your Own CD-ROM Service

The following idea might propel you to the head of the digital line and increase your picture sales.

At the present time, few photo editors are willing to take time to review CD-ROMs from unsolicited sources.

Here's the situation: Photo editors periodically send out "want lists" of specific photos. Traditionally they send them out by mail or fax, and sometimes by phone.

Enter the website: The Internet storefront address that—if you have one—

right now puts you a notch above the competition. With a website address, you'll be perceived as an important player in the industry. Photo editors are just now starting to send out their want lists to website photo suppliers' addresses and requesting that the supplier—at this point usually a photo agency—send them the requested pictures in digitized form on a CD-ROM.

This system helps the photobuyer in four ways:

1. It eliminates the need for buyers to do their own searches; the supplier handles the search in the traditional way.
2. It eliminates the liability and labor involved in receiving and returning original images.
3. Buyers can conveniently load the high-resolution image(s) into their own databases for later retrieval.
4. Buyers can load the picture(s) into a page layout for preview by a photo editor, client or designer.

Although few photo editors are presently using this system (few are even on the Internet!), this may become the first practical application of the electronic highway that could prove useful to individual editorial stock photographers.

Can you just put your images in a searchable file in your website and let the buyers do the initial search? No. Photo editors prefer that you narrow the search for them and send them a selection in a format that they can use immediately.

To set up your CD-ROM service, here's what you need to do:

☐ **Library**—Start with a minimum base of ten thousand images.[1]

☐ **Production**—Invest in a medium-price scanner (Nikon's CoolScan and Agfa's Arcus 2 come highly recomended) and a CD-ROM drive with the ability to write directly to disc. (Floppy disc delivery might prove successful, or possibly a SyQuest tape, but since the present-day medium of choice is CD-ROM, you might as well start with that.) Scanners and CD-ROM (write) drives have come down in price. Or you can always farm out this area to a local service bureau.

☐ **Website**—Since hypertext communication has led the buyer to you, there's no need to develop an elaborate CD-ROM delivery site. Convinc-

---

[1]Ten thousand images may seem a large amount if you are just starting out, but this figure is collectible if you form a co-op with ten fellow photo illustrators—each with about a one-thousand-image file. An advantage is to confine your co-op to one specialty area. Examples: medicine, agriculture, children or wildlife. In the future, you'll attract more photographers in that specialty area to join your co-op. You'll also attract more buyers who don't want to search generalized collections if they know of a specialized file (yours) that will lead them more quickly to their images of choice.

---

**SURF SAFELY**

Cyberfraud is always a possibility on the Internet, just as it's a possibility from unscrupulous telemarketers. Until consumer protection law and enforcement are developed to combat Internet fraud, keep a watchful eye as you surf the Net. The electronic equivalent of the Better Business Bureau is the National Fraud Information Center, (800) 876-7060. Their website provides daily updates, advice and helpful information. (http://www.fraud.org)

---

ing text and miniature graphics on your home page are sufficient. Do it yourself—but unless you are an accomplished designer, get help.

☐ **Package Design**—First impressions count, and very often we don't get a second chance. Make your delivery materials top-notch. Don't skimp. Invest in quality labels, delivery memos, promotion sheets and cards and mailing cartons. Full-color digital printing, such as INDIGO, can produce beautiful sell sheets and CD-ROM package designs comparable to conventional offset lithography, with one important advantage: Your production quantity can be as low as ten. (That's *ten*, not ten thousand.)

Eventually, many photo editors in the magazine and book publishing industry will be convinced that electronic searching is the optimum photo-acquisition method. Since their searches are so frequently for specific images, they will shun general-interest sites and target their searches to special-interest sites.

### Narrow Your Focus

Working backward, then, it's important that you establish a site (or join an already-established site) that is highly specialized. Remember, you are no longer working locally with markets, but worldwide. When you widen your customer base, you can narrow your product focus.

Electronic searching will not be an overnight phenomenon. Our stock-photography industry has little experience. Training is inadequate and, to complicate it all, the tools are not mature. If you jump in now, you can expect frustrations. But you can also expect an education in the right direction.

Of course this whole scenario can be accomplished by using conventional communication: phone, fax and FedEx—but by reaching photo editors through your website address, you're sure to collect an important number of computer-literate photo editors. When our stock-photo industry reaches electronic maturity, your preparation will have you all set to fly.

Several programs are now available that can be put to use by the photographer with a computer. Keep in mind that most of these programs (there are some exceptions) have limited track records. Write me for a free copy

of a list of programs. Include a self-addressed envelope with two first-class stamps affixed.

The following periodicals have featured compilations of computer software and assessed their potential worth to the photographer: *Photo District News* (various issues to date), 1515 Broadway, 11th Floor, New York, NY 10036-5701; *Outdoor Photographer* (various issues), 12121 Wilshire Blvd., Suite 1220, Los Angeles, CA 90025.

## The Three F's: Phone, Fax and FedEx

News of President Abraham Lincoln's election success took six weeks by horseback to reach the hinterlands. A century later, news can reach citizens anywhere in the world in six seconds—via computer, *online*. A modem attached to your telephone and computer can enable you to instantly receive information and pictures via the Internet. Your own printer then prints the information out for you, or it can be stored on disk for later viewing.

This speed is important to the editorial stock photographer. The postal *information float,* the lapsed time between when a photo editor sends a photo request list by mail and when it reaches the photographer's mailbox, amounts to three or four days. A generation ago, this meant that stock photographers who operated their business in the same city as a photo editor had an advantage. The photographer was on the scene for a phone request and same-day service. Today, a combination of telecommunications, faxes and express delivery services enables the outlying editorial stock photographer to be just as valuable a resource to photobuyers as the stock photographer down the street. If you have a computer and a modem, you're no longer at the mercy of postal information float. In addition, assignment and travel information, as well as time-sensitive business tips, are available to you on a variety of websites on an instant-summons basis, giving you a substantial business edge.

Software to operate your modem is inexpensive and available at discount stores and in catalogs. We found our QMODEM, P.O. Box 702, Cedar Falls,

---

### WATCH OUT FOR VIRUSES ON THE INTERNET

You can catch a cold in your computer system and spread it to other members of your software family, according to Hassan Schroeder, Webmaster at Sun Microsystems.

"Downloading 'binary executables,' programs ready to run from the Internet, is potentially hazardous," says Schroeder. "But then again, viruses have also been inadvertently spread on diskettes shipped directly from software manufacturers. Anytime you introduce new software into your system, you should use whatever security tools, such as virus checkers, you have. Be vigilant, and make regular backups of all your files." (hassan.schroeder@corp.sun.com)

IA 50613, (319) 266-4423, Modem: (319) 277-7072, on a "Shareware" Bulletin Board. We tried it, liked it and paid the $50 registration fee. We have since received an improvement update. "Shareware," by the way, is usually free. The owners don't charge you until your free trial has elapsed or you are ready to buy the new update. "Freeware" is actually free. It's usually produced by universities that gain prestige and continued grant income if they produce software that benefits the general public.

## Internet: The Electronic Post Office

Mini electronic post offices have sprung up since the mid-seventies—CompuServe, GEnie, Prodigy, America OnLine, Microsoft Network, WorldNet, NewsNet, MCI Mail and others. These are all available through the generic interchange, the Internet. They offer a variety of services to the computerized stock photographer. Each service is designed slightly differently, but basically they operate in the same style as a message center or a post office, except that you need travel no farther than your computer, PDA (personal communicator) or TV (set-top box) to get your mail.

You pay for this convenience, though, in that a meter begins ticking once you enter this electronic post office. Some of the services charge a flat fee, twenty-four hours a day; others charge a discounted rate after 6 P.M. or for special sections. Conversely, you may be charged a higher fee for using a faster baud rate or may have to pay a surcharge for using a special gateway, such as Dow-Jones, Dun & Bradstreet or the Official Airline Guide (OAG). While there, you can read the *bulletin boards* available in your interest areas. Some are free; others cost, generally by the hour. And, like at your hometown post office, you can trade business gossip with colleagues who are on the electronic system with you in the form of an electronic conference, generally called a *chat* area or roundtable. For example, subjects ranging from camera techniques to computer graphics are discussed on Joel Day's (he communicates from Australia) STOCKPHOTO FORUM (stockphoto@info .curtin.edu.au@inet#). For a complete list of photo-related discussion groups on the Internet (they range from Leica cameras, obsolete silver processes and photojournalism to underwater photography, image databases and Pentax cameras), write to me and include an SASE.

Our own *PhotoSource International* marketletters are examples of the kinds of information available through these electronic message centers. We offer our market newsletters on several services.

*NewsNet.* This network provides access to several hundred various business newsletters, and also features our monthly *PHOTOLETTER*. You can access all previous *PHOTOLETTER* issues back to August 1983, when we inaugurated our electronic editions. This means you can search for specific names of photobuyers or certain subjects, such as wildlife or gardening, by conducting an electronic *search*. In a matter of minutes, the NewsNet central computer will alert you to the specific back issues in which these subjects

can be found. If you wish, you can also search for the same subjects on all newsletters on NewsNet, (800) 952-0122.

On the Internet, our three newsletters are available either by subscription or on a "newsstand" basis. On the latter, you can take a look at a current issue for a fee. Or, as with a regular subscription to a magazine, you can sign up for a year's subscription at a discounted rate.

MCI Mail is another twist. It is strictly a mail service, handling both electronic and paper mail. There is no central database, as with NewsNet or our PhotoSource Bulletin Board. Subscribers to our marketletters via MCI receive their issues directly in their electronic mailboxes (or in paper form through the USPS). An issue remains in the electronic mailbox until it is accessed. (With MCI Mail, there is no hourly read-time fee.)

*CompuServe*, also known as CIS, is the granddaddy of electronic networks. It offers a department called the Photography Forum. Features similar to STOCKPHOTO FORUM are available to users. This active meeting place, led by Mike Wilmer, receives 150 to 250 messages per day. Our *PhotoSource International* representative is Bill Hopkins. He can be found in the chat section of both forums. Another online service similar to our *PhotoDaily* is the Visual Support Network, P.O. Box 25604, Anaheim, CA 92825.

For more information about any of these electronic services, call

America OnLine (800) 827-6364
CompuServe (800) 848-8199
GEnie (800) 638-9636
MCI Mail (800) 424-6677
NewsNet (800) 334-0329
PhotoSource International (800) 624-0266
Prodigy (800) 776-2066
Visual Support Network (800) 869-5687

The Internet started out in the 1960s as an information exchange for government and universities. Back in the early 1990s, a new medium called the World Wide Web (WWW) evolved, using the Internet format. The Web makes pictures and drawings available to users. The Web allows you to receive and deliver images, and to establish a "home page" and link up with other like-minded pages. More about this later.

## Online Delivery

Commercial agencies, starting with PNI (Picture Network International) and IPX (The Photo Exchange), and later with Corbis Media, Getty Communications and Infosafe's Design Palette, have pioneered the concept of online delivery of stock photos. It works like this. The online agency contains several hundred thousand images in its database. The images are supplied by

stock agencies and individual photographers. Photobuyers, looking for commercial stock photos, search the database using their modems and computers. When they find the pictures they need, negotiations are made and the selected images are delivered, usually on disk by FedEx next day or, in some cases, downloaded to the buyer's computer.

One problem. The concept is about ten years ahead of its time.

There are several shortcomings to online delivery, and until these are fixed, the concept will remain a "solution for a problem that doesn't exist." Here are the current inadequacies:

**Buyers.** The average editorial photobuyer is not convinced that online delivery of pictures is an improvement over the way photos are presently acquired.

**Hardware.** The equipment and training cost to get operational to retrieve pictures online has not convinced management that the ROI (Return On Investment) is there.

**Quality.** Unless you are dealing in top-of-the-line equipment, the quality necessary for reproduction does not meet standards. Film is still the medium of choice.

**Volume.** Photobuyers will use online services when millions of pictures are available for searching, not thousands, which is presently the case.

**Storage.** Until advances in compression technology for stock photography can be improved, there are severe limitations on how many images can be centrally stored on standard hard drives.

Since we talk with ten to twenty photobuyers a day here at PhotoSource International, we will be the first to know when online retrieval and delivery of pictures becomes a workable system for editorial stock photographers. In the meantime, the Internet and the various proprietary services remain an excellent highway for *communicating* (with words) within our industry.

One word of caution: Information overload is a hazard on the Internet, just as it is in the Sunday newspaper, on cable TV and in your mailbox. If you don't need the information, the delivery method is unimportant—whether it be over the Internet or via homing pigeons.

As more photographers begin to access telecommunication services, prices will go down and service will go up. No longer will it be necessary to live within shouting range of the large media centers. As long as a phone line is available, whether a stock photographer is in a high mountain cabin in Wyoming or a high-rise in Atlanta, she will be in touch.

## The Fax

The facsimile machine has become the office machine of choice for both photographers and photobuyers. This "photocopy" machine is the perfect tool for transmitting text and workprint copies of photos over the telephone lines with ease. No programming, no tie-ups and no need to become "fax literate"—you already are.

You can buy a quality plain-vanilla fax for under $400 at your local department store or discount warehouse. Once you get it operating, you'll wonder how you ever managed without one. There's no need to get a dedicated phone line. A "box" (under $150) can be plugged between your phone and your fax machine to direct the incoming call to one of four areas: your fax, your computer, your answering machine or you. (It recognizes the phone signal.) If you keep your computer on at all times, you could install a fax board in it at half the cost of a stand-alone fax. The only disadvantage is you'd need to buy a scanner to transmit any graphics.

We deliver one of our marketletters by fax. Most all photobuyers now have fax numbers. Request their numbers when you contact them. You can show the impact of your photo(s) by sending a fax of it. Black and whites are easy. To make a copy of a slide, you'll need a Vivitar Instant Slide Printer available from Polaroid, (800) 426-8686. At local discount houses, you can find them for under $150.

## Printers to the Rescue

Dot matrix, ink jet and laser printers are becoming commonplace in offices. What might become routine in the future is color printers in the stock photographer's office.

PC printers may soon be the answer to the request from a photo editor for a file copy of recent images. Canon manufactures a line of printers that can produce not only text, but color printouts that are close in quality to the real thing. The ink jet color machines cost between $175 and $500. Epson has come up with an equally high-quality printer for only $275. Hewlett-Packard also produces a comparable color printer. These printers have many consequences for editorial stock photographers. If photobuyers have color printers, they will be able to download photos from your website and either use them as layout examples (comps) or, if used tiny, for actual reproduction. Secondly, you'll be able to send off mini "sell sheets" for file use, once you return from your trip or self-assignment. If you don't own a scanner, you can have a company like Seattle FilmWorks or Wolff Camera develop your roll film and scan the images for you. SFW places them on a disk for you; Wolff places them on its website and you can download them to your computer, all scanned and ready to send to your ink jet printer.

You could also incorporate the use of a digital camera into this methodology, providing you deal only in low-resolution pictures for the WWW. For print reproduction in books and magazines, photo editors will require a much higher resolution than the average-price digital camera.

## Captions

Here's where the computer shines. What could be more tedious and boring than typing or writing the same caption, in neat, tiny, legible words and numerals, on the twenty boxes of slides . . . not including the times that

twenty captions need to be repeated because the slides are basically the same location or subject. It's enough to wither a blossoming stock-photo career. A computer can take over your captioning tasks.

Just as professional-looking stationery gets the attention of a photobuyer, so do neatly captioned slides. If you project the image of an efficiently run stock-photo operation, a photobuyer will want to consider you as part of the team.

It's to your advantage to dress up your slides with computer-assisted captions. Here are options for using your computer in captioning.

**Database generated** is the most popular approach. If you own a computer and database software, you assign a code number to each new slide. As long as that slide is part of your stock file, you can keep a record on it: Who has bought it, how many times, where it is today and so on. When you enter the slide into your system, you can also generate a caption on a small ($\frac{1}{2}'' \times 1\frac{3}{4}''$) slide-size label that you affix to the slide itself. If you don't want to spend the time testing and designing a system, you can purchase specialized software for captioning your slides, such as The CaptionWriter, Label Power, Proslide II, Photo Label, FotoAgent and Labeler.

**Bar-coding** is not only popular at the supermarket, but among stock photographers as well. By "swiping" the codes across a reader, the photographer can enter data about the slide into a file and then generate a report, including such information as the slide's whereabouts and productivity, at any time. If your stock file is twenty thousand images or more and you want to accurately trace the immediate whereabouts of your images, bar-coding is an answer.

Mark Antman of The Image Works says, "We think bar-coding is an excellent system. It's efficient. It simplifies the entry of delivery memos. It's accurate. Now we can track the whereabouts of any of our images at any given time." He uses Label Master.

Jim Pickerell, of Rockville, Maryland, disagrees. "I have concluded that bar-coding a large file is a waste of time unless you have a huge number of images going in and out on a daily basis. Many of the things I did ten years ago to manage a file turned out to be not cost-effective. Photographers need to be careful not to spend more money in managing a file than the file will generate in income."

Jeff Cook, of Stock Broker, is cautious about bar codes. "What if a photobuyer returns the right mount, but the wrong piece of film is in it? You need to look at the film itself."

Sharon Cohen of the Wildlife Collection says, "Bar-coding may be useful for large format photographs, and where your selection of images is limited, but for thousands of 35mms, it may be counterproductive."

A supplier of bar code labels is Watson Barcode Products, 3684 Forest Park Blvd., St. Louis, MO 63108, (314) 652-6715. The bar-coding hardware, which plugs into a computer keyboard, costs about $650. A supplier

of label programs is STRANDWARE, 1529 Continental Dr., Eau Claire, WI 54701, (800) 552-2331, Fax: (715) 833-1995. Their Bar Code Library sells for around $300, and their popular Label Master for around $480.

**Turnkey Software** such as the Cradoc CaptionWriter [Perfect Niche Software, 6962 E. First St., Scottsdale, AZ 85251, (602) 946-7875 or 945-2001] is designed solely for captioning slides. It is one of the first captioning softwares and continues to get good grades. The software will drive most computers and printers. Assignment and stock photographers often use the CaptionWriter with a laptop computer to accomplish their captioning right at the light table, in a motel room or in the office. Captions can be affixed immediately or printed out at a later time. The CaptionWriter has the ability to get twice the usual amount of words into a caption by featuring a *wrap-around label*. The cost ranges from $60 to $89.95, depending on your brand of computer. Another stand-alone caption software is SuperLabel. It is especially useful for beginners just starting to use a computer. It is also designed to sort your collection by market strength area (PMS/A). The ProSlide label features a peel-off four-sided label. You can print your caption material horizontally and vertically.

**Direct Printing** eliminates the need to affix labels to your slides. *DiaMind*, Elden Enterprises, P.O. Box 3201, Charleston, WV 25332, is a unit that will print up to sixty characters of caption information— twenty characters per line—onto the wide edge of a mount, or two lines on either narrow edge. It costs just under $1,300.

Another system that will print your captions directly onto your cardboard slide mounts is the A/10 Ink Jet Slidetyper from TRAC Industries, 26 Old Limekiln Rd., Doylestown, PA 18901, (215) 345-9311. Because there is no ink from ribbons (it uses ink jet printing), there is no chance of ink smearing across the slides.

Of course, if none of the above systems are in your future, you can always use the time-tested manual method of typing or handwriting the label or slide.

If someone were to invent a riding vacuum cleaner, we can agree that it wouldn't save time, because most housewives/househusbands would discover *more* places to clean. Automated slide captioning offers the same enticing trap. We'd caption everything in sight. A word of advice from software producer Mark Iocolano: "Put the photographs into the system as they are used, and convert gradually. When new photographs are taken or added to the file, put them into the computer that day. If you try to start from scratch, you'll never catch up."

## Word Processing

*Word processing,* the ability to produce professional business or form letters, is probably the computer's greatest advantage to the stock photographer. It's a real time-saver. The computer not only stores all your letters, graphics

or other documents, but also stores and merges address lists and integrates them into your documents and correspondence.

Word processing becomes a necessity for your promotional efforts. You will build a list of present buyers and potential buyers, along with individualized information about them, such as when was the last/first time they bought a picture, who they replaced at the magazine or publishing house and what the most convenient time to contact them is. When you're ready to announce an upcoming trip or a picture of yours that appears on the cover of *National Wildlife,* word processing is an efficient method to get a personalized notice in a letter or on a postcard out to people on your list.

Word processing also provides a bypass around one of the major roadblocks of writing: "I just don't like to do second and third drafts of my letters or manuscripts." No rewrites and convoluted insertions are necessary with word processing: Corrections, changes and additions are simple to incorporate. You'll find that writing becomes far less of a chore. I've seen no guarantee that a word processor is a surefire route to a Pulitzer Prize, but there's no doubt it gives you the edge over the competition who happen to be still tussling with the now-antiquated typewriter. Like buying the best musical instrument won't guarantee that you'll produce heavenly sounds every time, with a word processor, the end results are still up to you. But having the right equipment can give you confidence as you develop and refine your expertise.

## Spreadsheets

Before computers came along, accountants would use the stub of a pencil and large sheets of graph paper to combine available figures about a business in order to produce a forecast or present-day picture. Spreadsheet software does the same thing, but can do it bigger, better and faster. A stadium full of accountants with their pencils might not even be able to accomplish the same results as a modern-day spreadsheet program.

The charts on page 252 are good examples of what can be entered into a spreadsheet and then printed out in pie charts or bar graphs. Since information on your photobuyers and sales is already included in your computer's database, you'll be able to engage in "what if" projects. Spreadsheets supply you with facts to hang on to, as well as show you what's in store for you if you want to take up the challenge.

For example, if you wanted to increase your stock-photo sales next year from $10,000 to $12,000, a 20 percent increase, a spreadsheet program could let you know the percent of increase in sales you'd have to engineer with each of your photobuyer clients. It would also indicate how many new photobuyers you'd have to add to your roster. Of course, you could crank that figure up to a 30 percent or even a 50 percent increase. The results can tell you the work you have to perform to accomplish your goal.

Computerizing gives other benefits, too: San Diego photographer Bob

**Figure 17-1.** *The Cradoc Caption-Writer software can turn your computer and printer into a slide captioning tool. It features a ½" × 3½" label that wraps around both sides of a 35mm slide.*

**Figure 17-3.** *A bar code labeling system provides both a caption and a bar code. Depending on the software, they are printed separately or together.*

**Figure 17-2.** *Computer-generated slide captions add a professional touch to your stock-photo operation. In this illustration, the PhotoTrack software produces three-line labels using a 22 cpi printer. The software allows you to use your existing numbering system.*

**Figure 17-4.** *When a group of slides require the same repetitive information, the computer can generate duplicate caption labels.*

---

### MASSIVE STOCK AGENCIES—WILL THEY TAKE OVER?

In the Old West, the gunslinger ruled the town—until the rest of the populace got guns. We can draw the same parallel with electronic dissemination of photos. No longer do only the "big boys" have computer power. The massive stock agencies (Corbis Media, Getty Communications, et al.) will give competition to the classic commercial stock photographer, but not to the editorial stock photographer—you.

Why? Because you will always be one step ahead of the massive agencies.

Imagine yourself as a photobuyer in the coming era of New Media. You need a photo of a rodeo in Michigan. Necessary elements: teenage riders, fall colors, sunny skies and vertical. Photobuyers who need content-specific pictures for the success of their publications projects have learned that large agencies supply only generic pictures (images that have a long shelf life). The meager selection from a massive commercial stock agency won't come close to the twenty or thirty pictures the individual editorial stock photographer who specializes only in rodeos can provide. If you stick to a few specialties, you'll become an important resource to photobuyers worldwide in the coming new generation of photobuyers.

---

Culver lauds the ability of a computer "to give my business a professional look when I submit a computerized invoice." Software is available also for standard business needs such as accounts receivable, accounts payable, payroll and general ledger. As Minnesota photographer Lori Sampson says, "If nothing else, the computer gives me the feeling I'm getting organized."

## Graphics

The advent of digital photography has brought new vision, new meaning and increased opportunity to the field of editorial stock photography. In the past we were confined to the limitations of film-based pictures: Digital pictures provide a broad new dimension for us.

As photography has evolved over its 150 years of existence, it has brought along with it the notion that whatever you photographed should not be manipulated or changed. You were supposed to "take" a photo, not "make" a photo. When the school of photojournalism came along, it reinforced this principle. The public did not want misrepresentation of a newsworthy scene.

But what of non-news photos that relied more on the photographer's interpretation and insight? Do you add a dewdrop to a leaf to make it more effective, or photograph it as you found it?

The debate ended in the mid-1980s when it became evident that digital photography gave new license to image makers. Like the French Impressionists of the nineteenth century, digital-image makers began experimenting with this new medium. Young photo editors and photographers who were

## IS A WEBSITE USEFUL?

In the Dark Ages, B.W. (Before Websites), the Internet offered only text. Today, the World Wide Web (WWW) can feature your photo(s) on the "home page." The question, then: Is it worth it to construct a home page and expect any profits?

A home page on the Web, like any "home," costs money to build and to maintain.

Yes, it's true, you can construct a home page at very little cost. But will it be the quality you want to project to buyers?

Will you have the time for upkeep? Web pages that are static (no changes in picture content; no new information about your stock collection or travels) are known as "ghost ships."

Most home sites of individual commercial stock photographers on the Web are "vanity fairs" or ego trips. Photobuyers aren't really interested in browsing through dozens of home sites, especially if their modems won't allow speedy viewing of photos. One photobuyer told me, "If I'm going to look at pretty pictures, I'll go to a real gallery." Another said, "Yes, I look at Web portfolios, but I have this criteria: (1) It's a name photographer and (2) the stock agency or Web Gallery is well known. Otherwise, I don't have the time to explore."

### But a Website Is to Your Advantage

As an editorial stock photographer, you have a distinct advantage over commercial stock photographers, whose photos are varied, across-the-board in style and content, and not focused on a few well-chosen specialized subjects.

You are a specialist. Your clients, the photobuyers who purchase editorial stock photography, are not looking for name photographers or well-known stock agencies. They are searching for specific pictures. This is where the Web shines. If you list your "tags" with Web search engines and other photo-oriented information sites, buyers will find you—and they'll like being able to circumvent the cumbersome task of searching generalized portfolios to find the on-target photos they need.

For a list of interesting websites for stock photographers to visit, consult the bibliography. For more information on "tags," try the following: http://www.internic.net/cgt-bin/whois

Incidentally, for news about *Sell & Re-Sell Your Photos*, and updates to this book, type "Rohn Engh" at any search engine on the Web.

not bound by the accepted confinements of the past began producing a new entity called the *digital image.*

Although all of the technology is in place for editorial stock photographers to take advantage of this new medium, we have only to look at history to see that it takes about thirty years for a major innovation to be accepted

by the public. The old guard—the powers that be—resist change. And it takes thirty years, a generation, for the people in charge to be replaced.

It's important, then, not to take too seriously the hype from computer and software vendors that our traditional ways of doing things are going to change this afternoon, or at least by tomorrow. For editorial stock photographers it's pretty much "business as usual." Little by little, more and more, publishers and photo editors will climb aboard the electronic bandwagon. The transfer over has already started. But the wagon is moving at a slow pace. If you can keep informed, you'll know when to jump aboard. In the meantime, experiment with some of the current innovations I've mentioned in this chapter and don't worry—if you're taking it slow, you're not missing the boat (to mix a metaphor).

## Picture Enhancement

Do-it-yourself manipulation software is available for the editorial stock photographer who chooses to get involved in photo enhancement. A scanned photo can be broken down into millions of dots (pixels) and then rearranged for better effect. If this sounds like good old retouching, it is. You are now known as a *pixelographer*.

Very few editorial stock photographers are willing to invest big dollars in the equipment and training required for high-level computer graphics. When high-resolution results, intricate manipulation or enhancement are required by a photobuyer, you can always turn to a local service bureau.

Popular software packages (always being updated) are Photoshop, Live Picture, PhotoDeluxe, Painter, CorelDRAW, PhotoStudio and Picture Window.

Someday in the future, stock photographers are going to look back on the present-day system we use to market our stock photographs and shake their heads. As you read this, we are on the edge of a revolution in picture retrieval.

---

**IS IT REAL?**

Digital manipulation of images makes it possible to enhance, change and even distort them. Tony Stone Images, one of the largest international stock-photo agencies, has come up with a coding system that will enable photobuyers to know whether an image has been manipulated. The company will caption manipulated images in three categories: DC (Digital Composite); DE (Digital Enhancement); and CE (Color Enhancement). Only significant changes will be identified, and the photo notated with a specially designed icon. This rules out minor changes such as removing shadows. The identification will appear on the transparency caption.

Dan Tidwell
P.O. Box 834
Folsom, CA 95630-0384
(916)361-4283

Kearney Reitmann
Editor

555 De Haro Street
San Francisco, CA 94107

Article Suggestion:

Mr. Reitmann:

I am proposing an article for the REVIEW section that will cover these points.

I hope you are interested, may I hear from you soon, please.

Sincerely,

Dan Tidwell

*Figure 17-5.* Computer-generated line drawings aid the photobuyer in assessing the impact of a photo. Photographer Dan Tidwell uses his Macintosh to provide a catalog of selections for a potential buyer.

As you know, both you and the photo editor are limited to the pigeon-hole-retrieval method of locating pictures. You file them away in a slot and pull them out to view them. It's the same system our U.S. Postal Service uses to sort and find envelopes. The system was invented by our first postmaster, Benjamin Franklin. The U.S. Postal Service has been automating its system successfully over the past decade. Let's hope the stock-photo industry will enjoy the same success in the next decade.

Optical discs and cataloging software for the computer will eventually

come into price ranges affordable to photobuyers and stock photographers. Optical discs can store 10,000 to 50,000 full-color pictures and more, depending on the technology. In essence, the application is simple: You will be able to transfer your stock-photo file of original transparencies and black and whites to disc and send them by modem, or send a disc copy to a photo editor's main source disc, along with pertinent details about yourself and each picture.

When the system operator needs a specific picture, he enters a description into the computer, which locates a dozen or two dozen choices. The pictures can be viewed on screen, printed out in hardcopy or transmitted via phone lines or satellite elsewhere to another computer. Some stock agencies, such as Index Stock, The Stock Solution, PhotoDisc and others, are pioneering this area. Large corporations and the military are now using this method effectively. Eventually, the technology will be available to all of us.

## Where To From Here?

Computers offer stock photographers an excellent springboard to the automated business office. Is the noncomputerized stock-photography operation now a relic of the past?

*The good ol' days* for the stock photographer of the past generally translates to hand-printed captions on slides, carbon-paper copies of transmittal letters, typewritten correspondence, party-line telephone calls, Rolodex and $3'' \times 5''$ file cards, all handled by the U.S. Postal Service. If you made mistakes in the good ol' days, you couldn't blame it on a computer. But this doesn't mean that your office nowadays has to look like something out of *Star Wars* in order to compete.

At a time when leading agricultural economists have declared the small commercial dairy farm a has-been, many farm families from Pennsylvania to here in Wisconsin are proving that pronouncement decidedly wrong. These families, with a conservative approach to farm technology, with diversification and with tireless manual labor, children included, have, with wise management and planning, largely escaped the high debt that has accelerated the demise of the small, family farmer. The get-big-or-get-out theory that has dominated American farming for the past few decades may no longer be valid.

In like manner, an "addiction to computer technology," as photographer Mike Fuger calls it, can lead to high debt for the stock photographer.

"Whether you're using a postal meter or licking postage stamps, the package still has to contain good stock photography," says Alan Carey of The Image Works.

Photographer Dave Strickler of Newville, Pennsylvania, doesn't plan to invest in a computer—ever. "I can wait the extra days to receive market information," he says. "I leave the scrambling to other photographers. Not all stock photography needs to be delivered yesterday." Dave has been selling

his own stock photography successfully for thirty years.

For the new generation of stock photographers, it's going to be a different story. Changing technology will have a great impact on not only stock photography but also the other areas that affect it—publishing, printing, research, package delivery, communications and travel. In the area of marketing, for example, a stock photographer can get the full benefit of the "Total Net Worth" principle (see pages 60-61) by using a computer. Without one, you can still employ the "Total Net Worth" concept, but a computer lets you assess more information more efficiently, pointing you toward good business decisions faster.

Specialized closed-circuit networks for the electronic marketing of photography—via both computers and faxes—are no doubt around the corner. Another innovation: high-definition TV. In the future, stock photographers will keep their originals safely at home and market their wares electronically via satellite.

We've been treated so far to only a tiny portion of the computer's potential. We are all going to take a ride on a massive technological wave that will have some of us riding the crest, others swept into the roiling undercurrents. Computers and computer technology will increase the size and speed of that wave. But in the end, good management, good photo illustrations and wise business decisions, as usual, will be the key to moving forward in your stock-photography business. Contact us at *our* website: http://www.photosource .com.

## Interesting Reading

"Build Your Own Macintosh-Compatible Computer," by Charles Colby, *Radio Electronics,* January 1991.

"Establishing an Internet Presence," by Royce Bair, *Photo District News*, July 1996.

"Real Nerds Don't Buy Computers. They Make Them," by Alex Kozinski, *Forbes Magazine*, July 29, 1996.

### Free Catalogs for Stock Photographer Supplies

Image Innovations. 7685 Washington Ave., S., Minneapolis, MN 55439; Phone: (612) 942-7909, Fax: (612) 942-7852.

Light Impressions. Phone: (800) 828-6216, Fax: (800) 828-5539, Code #E1030.

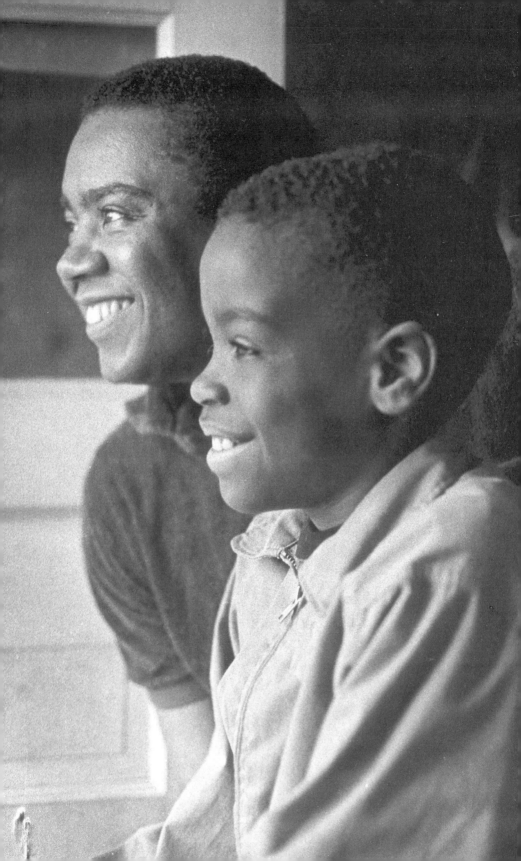

# Appendix A

## Third-Choice Markets

### Paper Product Companies

For want of a better name, I've grouped calendars, greeting cards, posters, postcards and the like under the heading *Paper Products*. This segment of the marketplace produces millions of products, but usually pays very little. And why not? There are millions of standard or excellent pictures available to these markets from thousands of photographers—all scrambling to sell their silhouettes of a seagull against the setting sun. As you learned in chapter two, you can't expect dependable sales from standard excellent shots because of the overwhelming competition. Moreover, the *large* calendar and greeting card houses do not welcome freelance submissions. Their photographic needs are filled by either staff people or their freelance regulars.

The middle-size and smaller calendar and card markets do rely on freelance submissions, but they also rely on your vanity to fill their photographic needs cheaply. Not only are their rates low, but they attempt to acquire three- to five-year exclusive rights and sometimes all rights (see chapter fifteen to define the difference) to your photograph. They may even ask you to transfer copyright of your picture over to them. Such terms, which take a photo out of circulation, are contrary to your working methods and diminish the resale and income potential of your stock photographs.

Remember this when you're thinking of dealing with a calendar or greeting card house: The stock-photo agencies seldom deal with them. When they do, they negotiate for a high fee and a two- or three-year limit for *one-time* picture use, and they allow North American rights only. (Otherwise, a greeting card or calendar company will resell your picture overseas or online for added profit—to them, not to you.)

Stock-photo agencies know they can get better mileage and better return elsewhere for their pictures, so why shouldn't you? Most newcomers to stock photography start out with the paper products field and then graduate to the more lucrative and dependable markets outlined in chapters one and

*(Left) Employ the 360 degrees available to you when you select a subject for photo illustration. A straight-on view would have had less impact.*

three. Why waste your time and talent in the paper products field when markets with healthy photography budgets are at this moment looking for *your* talent and know-how?

The one redeeming feature of greeting cards, posters and calendars is that they can offer a showcase for newcomers to the field. If you feel this exposure would be advantageous to you, deal with the well-established companies. Check an early edition of *Photographer's Market* against a current edition to see if a firm is still listed and the address is the same. I strongly advise you not to deal with paper products firms that have been in business less than three years, unless they come well recommended. If you are doubtful about a certain company, ask for a list of other stock photographers that have dealt with that company.

Here are the markets for paper products:

**Postcards.** You can sell and re-sell your travel pictures more often at higher fees elsewhere, so why bother with the low-paying picture postcard companies? If you want to pursue this field nevertheless, look on the back of current postcards in gift shops and stationery stores in the state or country you're visiting to find addresses of the companies that produce the cards. Also consult the yellow pages of the local telephone directory (under "Printers," "Publishers" or "Postcards") for companies and addresses. The same goes for souvenir color transparencies—the kind you buy in a gift shop at the airport. Send the companies color digital composites or photocopies of your work, with a request for their "photographer's guidelines." If you find the right company and can provide them with the right photographs, monthly royalties from a "best-seller" can provide you with a tidy stipend.

**Calendars.** Calendar markets usually prefer large-format, but more and more are looking at 35mm. They buy exclusive rights. They use staff or established service photographers who often shoot in 4″×5″ or 8″×10″. Sometimes they will use freelancers—especially the smaller companies.

Calendar companies usually accept the standard scenic clichés; however, some houses have become innovative in their photographic tastes. Every now and then a calendar company will produce a line of calendars featuring abstracts or art photography. However, the experienced (and financially successful) calendar houses have learned to stick with the standards that appeal to the common denominator of the general public.

**Greeting cards.** Trends change more quickly here; visit a stationery store to see what's selling now. Greeting card companies buy exclusive rights (see chapter fifteen); the pay is low and competition is high.

**Posters.** These are usually produced by calendar and greeting card houses; however, some are produced by independents. Nevertheless, the constraints mentioned for greeting card and calendar companies hold true for the poster markets. They rely on freelancers, but they also usually require exclusive rights. An excellent book in this field: *Publishing Your Art as Cards, Posters*

*and Calendars* by Harold Davis, The Consultant Press, Ltd., 163 Amsterdam Ave., New York, NY 10023, (212) 838-8640.

Do you plan to produce your own posters or art prints? You'll find the digital revolution has reached the poster printing process. Instead of investing big dollars in a large poster print run, it's now possible to produce "short-run" jobs, as low as twenty-five copies at a cost of only $125 for 11″ × 17″. Ask about digital color at NRS Publicity Printing, P.O. Box 70, Kimberly, WI 54136, or consult your yellow pages for "Indigo Printing."

**Puzzles, place mats and gift wraps.** Again, you can sell your pictures at higher rates to other markets. Unless you are doing a favor for an in-law, stay clear of these markets. Your time and talent are worth more than they can offer.

If you wish to try your luck at calendar, greeting card, poster and place mat sales, you'll find the market reference guides listed in table 3-1 and in the bibliography of some help.

Paper-product art directors historically buy more large-format pictures than 35mm. However, you can circumvent this problem by having enlarged reproduction-quality duplicates made of your choice 35mm slides. Consult the yellow pages or the companies mentioned in chapter five.

Contact markets for calendars, greeting cards and posters by using the mail techniques outlined in chapter nine. Table 8-2 tells you how much to charge for sales to these markets.

## Commercial Accounts

Commercial markets are concentrated in metropolitan areas. They attract service photographers. Many books and most how-to courses are devoted to some phase of commercial photography.

Commercial markets prefer to deal with photographers in person. They can afford to. The pay is high. So is the competition. It is *possible* to sell commercial and editorial stock pictures to commercial accounts; it's also possible to win the lottery. Commercial accounts do use stock photography, and they'll pay a good price if *you* want to pay the price—huge investments in time, prints, transparencies, shoe leather, travel fees, postage and UPS costs, phone bills and mental frustration—for *each* sale.

You might make sales of your stock photography to commercial outlets if you can answer yes to the following six questions:

1. Do you live conveniently close to the commercial account so that you can make periodic (at least monthly) visits to keep yourself and your work in the photobuyer's mind? (Commercial accounts "buy" the photographer as well as his photographs.)

2. Are you prepared to provide *rush* service to your clients?

3. Are you willing to shoot to a client's specifications, not your own? Commercial accounts have rigid photographic requirements: "I want a red background, a 1961 Dodge convertible and two blond males."

4. Can you provide model releases for all recognizable people in your pictures?

5. Are you willing to relinquish ownership of your pictures? Ordinarily, if you are dealing with commercial accounts, you will be doing so on a service-photography basis. (See the discussion of work for hire in chapter fifteen.)

6. Are you willing to invest in digital training and equipment? Commercial accounts rarely deal with photographers by mail. They figure the stakes are too high to risk dealing long-distance. Some ad agencies will use quality CD-ROM or download high-resolution pictures from the Internet. The markets in these areas, however, have been slow to develop.

Some commercial markets do use stock-photography regularly, but they usually obtain their stock pictures from stock-photo agencies they're familiar with, where they know they can get (1) speedy service, (2) immense volume to choose from, (3) a variety of styles to choose from, (4) the work of established service photographers, (5) the going rates, and (6) an established and easy line of communication.

The only advantage you have as an independent stock photographer breaking into the commercial markets is that you can charge a lower fee. But that isn't even an advantage at ad agencies or PR firms, where the fees *they* earn from their clients are a percentage of the fees the agencies pay for the components of the account, including the photography. They could actually lose money if they bought *your* picture at a low fee.

As I mentioned, commercial accounts prefer dealing in person with service photographers. Some even have policies against dealing long-distance, unless it's with a top-ranking pro (or his rep), who contacts the accounts through the electronic marketing services such as Visual Support Network and *PhotoDaily*, mentioned in the telecommunications section of chapter seventeen.

However, if breaking into the commercial side of stock photography is a challenge you just can't turn down, here are four books that will be helpful: *How to Shoot Stock Photos That Sell*, by Michal Heron, Allworth Press; *Professional Photographer's Survival Guide*, Charles E. Rotkin, Writer's Digest Books; *Publishing Your Art as Cards, Posters and Calendars*, by Harold Davis, The Consultant Press, Ltd.; and *Stock Photography, The Complete Guide*, Ann and Carl Purcell, Writers Digest Books.

Here are your commercial targets:

**Ad agencies.** Ad agencies rely heavily on photography for their visuals. The smaller the agency, the more apt they are to take time to look at you and your photography. The reality: Ad pictures are usually created and shot to order by an established service photographer. If ad agencies want stock photos, they historically go to a stock agency or to the established local pros first. Since ad agencies want to deal in person with their photographers,

contact agencies nearest you (check the yellow pages or the directories on pages 57-58).

**Graphic design studios.** The smaller studios do buy from freelancers. The pay is fair, and if you love knocking on doors, wearing out shoe leather and showing off a portfolio, these folks will entice you with a carrot on a string. They may like you, but you'll find that they still like dealing with a large stock agency or CD-ROM supplier.

**CD covers.** If you know the packaging industry backward and forward, you might score here with stock photography. But it's rare. Compact disc cover markets prefer dealing with local service photographers or massive stock agencies. If you deal with these companies, it is more likely to be as a service photographer supplying photography for promotional and advertising use, rather than the CD covers themselves.

**AV: Multimedia, motion pictures and CD-ROM.** Because a photo might be used for one second or less, these markets feel justified in budgeting a low payment fee for your stock photos. In any case, these multimedia markets rarely buy stock photography off the street. They turn to stock-photo agencies or have staff photographers shoot their needs. The prospective multimedia photographer must be prepared to adapt to rapid change. Time spent cultivating this market is usually fruitless, because the field lends itself best to the service photographer, who routinely visits clients.

**Business and industry.** Since businesses of any substantial size (and these are the only ones who have volume photo needs) have staff photographers and on-tap independent service photographers, your pictures won't carry much weight with them, even if your photos are outstanding. When these people need a stock picture, they consult a stock agency. Business and industry are not worth developing as markets for your editorial stock photos; selling stock photography to business and industry is usually a sometime thing. If you rely on reps or market services, they will usually find you business leads, such as annual reports or corporate in-house publications.

**Fashion.** Don't confuse fashion with *glamour,* which sells well to the publishing industry. The fashion industry sometimes has use for stock shots for backgrounds, but they consistently go to stock agencies for the selections. Unless you live in New York City or Los Angeles, your chances of scoring in this field are about zero. Fashion photography is service photography, and unless you can answer yes to the six questions posed earlier, fashion photography will be lost motion for you.

**Product photography.** Forget it. They don't buy stock pictures—it's all "to order."

An authoritative book used constantly by service photographers to price their work is *Gold Book of Photography Prices,* 21237 S. Moneta Ave., Suite 17, Carson, CA 90745, (310) 328-9272. Author Thomas I. Perrett publishes the "going rates" in service photography across the nation. Each

year, he surveys the industry and produces his new findings. (See table 8-2 for prices to charge for multimedia, CD cover and other commercial-market sales.)

## Other Third-Choice Markets

The following are included in third-choice markets because they rate an "A" in "Exposure Value," "C-minus" in pay and resale potential.

**Newspapers.** Sunday newspaper feature supplements sometimes buy editorial stock photography (see chapter one). Daily and weekly papers (a good starting place for the beginner) will occasionally buy a single photograph. The pay is low, but the exposure is helpful. It's like free advertising. Contact the photo editor of your nearest metropolitan newspaper for guidelines and payment information for picture stories, photo essays and single-picture sales. Your human-interest pictures and local scenics will sell to newspapers. Unlike book and magazine publishing, newspapers now accept color prints as a standard format rather than transparencies. If you've been shooting in color negatives rather than slides, newspapers may be a market for you.

**Government agencies.** Although the government is this country's largest publisher, it is also its smallest, since each unit deals on its own local, specialized level. Government photobuyers come with a variety of titles: art director, editor, promotion manager, etc. They buy pictures for their publications in a variety of fields: agriculture, transportation, commerce, health, education and so on.

They publish pamphlets, manuals, books and posters—the works. Finding the buyers is like entering a maze. It's said that it takes seven phone calls (don't give up) to locate the federal employee you're looking for. I know photographers who have persisted and found a market in the government for their photo illustrations, but they live in cities where there is a large Federal Center, such as Washington, DC, Kansas City or Atlanta. Caution: Government publications are often not copyrighted, which means your pictures could become public domain if a valid copyright notice is not included with your picture.

**Art photography.** A definition of art photography is elusive. Generally speaking, when photographers refer to it, they have in mind the photographs seen in magazines such as *American Photo, Popular Photography* and *Print*, and in salons and exhibitions. Art (or artful) photography is salable. Collectors will purchase it in much the same way as paintings, and for the same reason: The investment value is ultimately dependent on the renown of the painter or photographer.

Except for a few specialized, low-paying magazines, art photography is not marketable in the publishing world. Photobuyers rarely buy "art photos" for publication in their books or magazines.

Do single art pictures bring in money? Witness a Ben Shahn or a George Silk going for $1,000, a Eugene Smith for $700. Once you become famous,

your pictures will sell for prices like these and higher. So don't give up your Sunday photography. In the meantime, during the week keep shooting those marketable pictures I discuss in chapter two. Your family and your accountant will thank you.

If art photography is an area of interest to you, here is an excellent publication to check into: *The Photograph Collector,* Stephen Perloff, publisher, 301 Hill Ave., Langhorne, PA 19047-2819.

# Appendix B

## The New Way

*New Generation Media* is a phrase stock photographers will hear more and more in the coming decade. Where'd it come from? It's a response to the increasing ways you can transmit information—and create, transform and transmit images—in today's high-tech world.

The good news: These evolving forms of image creation and image delivery have created new markets for you. As a successful editorial stock photographer, you should be aware of what's ahead not only with the traditional print media—magazines, books, textbooks and catalogs—but also with the pioneering electronic media—the communication companies utilizing television, video processing, CD-ROMs, websites, electronic kiosks and new concepts like videophones, desktop image delivery, screen-touch educational tools and on-demand picture retrieval.

Many of the latter elements are poised to explode into wide use—just waiting in the wings for when photobuyers start routinely using the global electronic highway.

Classic commercial stock photography (the familiar scenics and generalized "situation" shots) as we've known it over the past decades will continue to be in demand, but the overwhelming supply of these generalized commercial stock shots, available now on CD-ROMs and from discount sources online, will diminish its value—and soon its price tag.

The New Generation Media market is so vast that it utilizes what has come to be known as "micromarketing," the ability to isolate specialized markets and respond to them effectively.

Micromarkets are specialized (niche) markets.

To survive in the New Generation Media, photo illustrators will become specialists themselves. The rules haven't changed, but the target has. The demand by photobuyers for content-specific images will spur New Generation Media photographers to focus on specific subject areas they enjoy, and then service markets whose needs match those areas. The generalist (the classic commercial stock photographer) will be phased out.

In my face-to-face meetings with stock-photography decision makers across the nation, I've gathered together the thoughts and opinions of these

leaders in the field. This revision of *Sell & Re-Sell Your Photos* recognizes many of the changes coming in our future as editorial stock photographers. As we enter the Digital Age, businesses small and large recognize more than ever that insight into tomorrow is the difference between success and failure.

### New Generation Media Photography

The technology is in place. It's only a matter of time before photo editors, publishers and stock photographers begin taking advantage of it.

How would you like to work with photobuyers who call you by your first name, allow you to call them collect and look forward with anticipation to your deliveries of pictures? And there's more. Your photobuyers are easy to please and rarely want to art-direct your images. Also rare: disputes, lost or damaged images and legal suits. Your photobuyers are accountable, and your relationship with them and their companies is long-term and worthwhile. Each new photobuyer you find in your particular market areas will be worth $20,000 to $50,000 in sales to you over the average ten to twelve years you maintain this buyer relationship.

I've described the new generation photobuyers, who are beginning today to change their buying patterns from broad-based to target-based. All arms of the media today are becoming more and more specific in their focus—each market targeting a different narrow segment of the customer base out there (with correspondingly specific content text, sound and picture needs).

No longer can a product appeal to a wide audience. Instead, advertisers or publishers select only a segment of that audience as their target. As a supplier of images, if one of your areas of strong coverage in your collection matches the buyer's photo needs, you have made a match.

The New Generation Media, thanks to computers and sophisticated database technology, will appeal to consumers of special interests: medicine, education, agriculture, transportation, and on and on. Separate markets will treat not the broad spectrum of each of these areas, but rather special interests within these categories. Medicine, for example, separates into a multitude of disciplines like nursing, surgery, dermatology, psychiatry and pediatrics. And pediatrics breaks down into areas of infancy, child care and childhood diseases.

The generic photo is out—and the *content-specific* photo is in. New Media conduits like CD-ROMs, websites and Interactive TV will require highly specific images to target their particular highly specific audiences.

Generic pictures (scenics, landscapes and general-situation scenes) will continue to adorn the walls of a photobuyer's office—but he will be signing checks for content-specific images.

In the new era of picture acquisition, look for more buyers to buy in volume—dozens of images at a time.

---

**HOW MUCH DO I CHARGE FOR A WEBSITE PHOTO?**

Stock photo usage on Web pages is increasing, and there aren't many places to go for help in your pricing. You might want to check out the following site: (http://www.netcreations.com:80/ipa/adindex) This site lists Webs that accept advertising, and the cost for advertising on the site. Many entries include the average number of daily hits. How can you utilize this info? Use it as a measuring rod (and supporting data) to help determine the rates you should charge when you're asked to supply images for a website. Check out the Seth Resnick Photography site for pricing your stock photos. (http://www .sethresnic.com). Also refer to FotoQuote.

---

### You Are Important

Because most publishers produce their products (magazines, books, video and educational programming pieces) in a "theme line," you fit into the production chain, and become an important resource not only to an individual market but to other markets within that theme line in the whole field. Any one particular buyer you deal with might change jobs or retire—but the theme of his company or publishing house remains, and you continue to be an important resource to that place of business. If your specialty area matches the needs of a buyer, you have made a lifelong relationship, one that can be worth $20,000 to $50,000 or more to you through the years.

Welcome to the next generation of editorial stock photography. As you begin to test the waters, you'll find yourself out in uncharted territory. Here at PhotoSource International we've already encountered many of the situations that you're going to face. In this appendix, I'll give you the answers to some questions you may have yet to ask.

## Payment: Will It Be By Royalty?

The music industry has set an example for stock photographers. When a musician cuts a CD, he, or his group, receives an up-front (usually small) payment. If the project is successful, "royalties," anywhere from 1 percent to 15 percent, begin to arrive in the form of monthly or quarterly checks.

The accounting is complicated, but today's computers handle the job. In the coming years, stock photography might move in this direction. Some photographers already receive royalties, especially those that supply photos for TV documentaries. "It works out fine," says Burton McNeely, a commercial stock photographer from Florida. "It's nice to receive that quarterly check. It's a pleasant surprise. It's like an annuity."

Royalty payments will work well for editorial photographers in the era of New Generation Media stock photography. It's only a matter of time until publishing houses and New Media companies put the bookkeeping machinery into place.

## Should I Sign Up With a Digital Stock Disc Catalog?

Paper (printed) stock catalogs have a limited life span. After about five years, dog-eared pages suggest to the graphic designer to go elsewhere for contemporary images. We can expect CD-ROMs will have a similar life span, about five years, but not because of dog-ears. High-powered online services, which will be in place in a few more years, will quietly bulldoze all those discs into the abyss marked "8mm, LP and 8-track." Time marches on.

But you still have time to get on a CD-ROM catalog. If nothing else, your investment will surely pay for itself over those five years, providing your CD-ROM publisher follows through with proper marketing procedures.

In interviews with CD-ROM catalog publishers Jim Pickerell (Digital Stock Connection) and Craig Aurness (Westlight), I learned that some CD-ROM catalog revenues are, for now, on an upward trend. DSC and Westlight in-house studies show that, relatively speaking, sales from their CD-ROM stock catalogs are keeping pace with, if not surpassing, sales from their paper versions.

When the bell tolls for CD-ROMs, will CD-ROM catalog companies go out of business? Probably not. Rather than fight and lose, they'll probably join the online movement. Your CD-ROM publisher just might elect to ride the flow onto online, and, for a nominal fee, you'll find your images transferred to that medium. You can't lose.

Play your cards right. Ask your CD-ROM publisher, "What happens if you elect not to go online?" "What happens if you do elect to go online?" Be sure something is spelled out in your contract.

## Should You Let a Client Use Your Photos on the Internet?

The art director phones you. "We liked your photo so much we are using it for our website experiment on the Internet. You should benefit by the publicity."

"Wait!" you say.

It's true that the exposure might benefit you. The clients know the value of exposure, that's why they're going to the expense ($10,000) of setting up first-class sites on the Web. No one is selling anything on the Internet yet; they're just getting their name out there—the same benefit a billboard offers. So they figure you should jump at the chance of getting your credit line exposed to thousands of viewers.

Just how much of a benefit will this be to you? It's difficult to say, since none of us have had commercial Internet experience long enough to give a reasonable answer. It could turn out to be an inexpensive way to get publicity, or it could be no more advantage to you than what the guy who painted the billboard received.

The art director has thrown the ball into your court. Do you charge him

anything? Is the exposure on the Internet worth the risk of someone scanning your picture for his own use?

"It's not that you're letting your client use your photos for free; it's that you're letting the world use them for free," you say. Thievery is certainly a consideration. But with today's sophisticated scanning tools, a thief could also steal your photo from an original magazine article or advertisement. No need to go online to do it.

What should you charge? A minimum? Depends on your overhead, track record, history of publication with the company and so on. Maybe you're doing this for a charity you'd like to help out. In the old days, classic stock photographers invented a "minimum" they would let a picture go out the door for. But this kind of reasoning isn't appropriate in online commerce.

Vince Streano of FotoQuote says, "It's difficult to quote prices for this kind of usage because there is still not much pricing history for such use. I know a photographer who received $1,500 for a picture for one year on a home page, and I know of others who received only $150.

"The photographer should also insist that a copyright notice appear with the picture and that the file size be limited to not more than 500K of information. This will make it difficult for someone to download the picture and take it for unauthorized uses."

Using Streano's low-fee example as a starting point, let's say you set a break-even "lowest" price of $150. That's your fee even if your client loses his shirt on the project or is giving the CD or online product away free as a premium.

Whatever the case, you establish with your client that your credit line should be prominent and your copyright notice clear.

Real help in this area will come when image-royalty companies are established and can (for a fee) negotiate costs and duration for you.

Be sure to put a time limit on the photo's use, say six months. If after that the company is still interested in using the photo, there must be a good reason, like it's become identifiable with the product as a sort of logo. This would be the time to negotiate a healthy fee.

In the end, to have your picture gathering dust in your files, going no place but out of date, probably isn't the best avenue. The client is on a fishing expedition: Why not cast out there yourself?

### Should You Switch to Digital?

Everybody's wondering when the digital revolution will arrive. Here are two things you can do that will tell you when it's time to buy a "digital back" for your camera, a scanner for your slides and a modem for transmitting your stock photos to your buyers.

One: Ask your photobuyers, "Have you gone to digital?" (meaning not gleaning public-domain images from CD-ROM, but downloading content-specific images from an online service).

Presently, digital editorial stock sales are negligible. Even if a supplier (you) has the necessary equipment, all too often the buyer doesn't have it, or has it but won't take the time to learn to use it, given the availability of standard methods of acquiring images.

Two: Observe the people who are the barometers in the stock-photo industry—the people who sell you basic products like archival plastic sleeves, standard cameras, lenses, film processors, slide-mount sealers, slide numbering devices, enlargers and custom photo enlargements. They know the way the market is moving.

They put out big money to sell their products. Observe the ads and promotions in the press. Are these people still advertising? More important, are they ceasing to come out with "new lines" and just trying to sell off their existing inventory?

If it's business as usual, and you detect no shift in their advertising thrust, you will know that it should be business as usual for you, too. Watch for the signs.

## Digital Imaging: Should I Do It Myself or Farm It Out?

Here are five points to consider if you're thinking about doing your own commercial-quality digital imaging:

**Time: Training.** You'll need time to get familiar with the software. How much time? That'll vary greatly between individuals and markets, but the typical operator break-in period is between three and six months for Macintosh-based digital imaging software. (This doesn't include training time for computer basics.)

You'll also need to anticipate making time to keep pace with change. Digital imaging is not a static technology. Hardware and software changes are frequent. Allow a couple hours per week to keep yourself on top of what you need to know.

And you'll need time to maintain your computer (problems come in all flavors). If all goes well, allow two hours per week. Be prepared to stay up all night if things go wrong.

**Money.** Equipment costs will depend on what sort of work you're doing. Lower resolution work (8- and 16-bit video stills or presentation slides) uses relatively small computer files and is less demanding in the way of color accuracy and image clarity. Photo-quality film and large color separation work require much larger files (50- to 100MB files are typical) and are painfully exacting in color accuracy/image quality requirements. Higher resolution work also requires more training time and training money.

**Depreciation.** Budget for change. Your photographic equipment will hold its value or even appreciate. But digital imaging hardware and software become obsolete quickly. Be sure your rate schedule allows for this and that your client base will bear the expense.

**Adaptability.** Most important, you'll need to be adaptable. Working with

a computer requires thought processes that are very different from those required for "traditional" methods. The initial transition can be vexing. It can even cause physical injury! (Repetitive Stress Syndrome and Carpal Tunnel Syndrome are examples.) The constantly changing hardware and software (and accompanying sales hype) can be overwhelming. And maintaining a computer system can be exhausting.

**Timing.** If you think digital imaging can be intimidating, you're right. At least for now. The good news is that entry-level software is becoming easier to use, hardware is becoming more affordable and markets are expanding. This may not be the time for you to make the investment in the technology. But the right time may get here sooner than we expect.

Thanks to desktop publisher Steve Carver for the above advice.

## Where Do You Fit In?

Photobuyers are never satisfied. A picture of a zebra won't do. It must be a mother zebra with two foals, and the background must look like the Serengeti.

In the coming decade, this request won't seem outlandish. New technology is making it possible to store, classify, search, find and deliver tightly specific images. Where do you fit in?

### The Pyramid

First, here's how an image agency picture collection will be structured. Imagine a pyramid. At the base of the pyramid are the generic pictures. At the top are the highly specialized content-specific pictures. Each category of images would be in its own pyramid.

If a photobuyer needed a picture of an animal, he would visit the pyramid representing animals and easily find general animal pictures at the base. More specifically, African animals would be farther up the pyramid. Content-specific zebra would be higher. Zebra foals would be higher, and zebra foals with foot-and-mouth disease would be highly content specific and found near the top.

### The Box

In contrast, today's picture searching is done in a box. The box has several pigeonholes. The picture researcher seeks out a photo supplier strong in animals and begins a tedious search, shuffling around the pigeonholes until he finds something "close." It's no wonder photobuyers are never satisfied.

As a photo illustrator, you can no longer afford to store your picture collection in a square-box format.

Unfortunately, stock-photo agencies continue to build on this flawed structure. Even the vaunted Corbis Media, PNI (Picture Network International), PhotoDisc and Digital Getty and some of the lesser online upstarts are following the same pigeonhole framework limitations of the past. It's

reminiscent of when early pioneer cinematographers began making motion pictures. They employed the only known dramatic format of the day: the proscenium stage.

But the New Media ship is about to set sail and you can be aboard. The need for images will multiply tenfold once consumers have Interactive TV (ITV) and Net Pcs in their homes and offices that will interact with central databases of information. For impact, the pictures will need to be highly content specific. (I calculated at one time that there are 2,300 possible categories that a photo illustrator can choose from to enter and become a specialist.) If your photo collection is highly specialized, you'll become a player.

You'll be able to compete even with such big outfits as Corbis Media and Digital Getty. You'll have the flexibility to be constantly adding fresh images to your collection. Photobuyers will go where it's easiest for them—where they have a choice among a large selection. They'll come to you if your collection is specific (maybe you specialize only in zebras) or more convenient (maybe the buyer is not equipped to receive digital transmissions—next day air will do) or your fees fit their budget.

Another aspect to consider: We can use the real estate industry as a model. Referrals may come to you because of your specialty image collection. You'll share the sale with the referring stock-photo agency or fellow photo illustrator, and share in sales that you refer to others.

And what about all those generic pictures that photobuyers have had to be satisfied with in the past, the catalog-type images at the base of the pyramid? They'll continue to sell, but because of the law of supply and demand, the pure volume will cause their monetary value to sink. This has already started to happen with the proliferation of these kinds of images on CD-ROM.

If you are considering setting up a stock agency, begin to specialize now. If you are an individual editorial stock photographer, begin to focus your picture taking on only those specialties that you enjoy and are an expert in. And begin now to build your own pyramids. You can monopolize your corner of the market.

# Appendix C

## Photo-Related Discussion Groups on the Internet

You can participate in the worldwide photo discussions happening on the Internet, even if you don't have an Internet account, by using the Internet mail gateways available on most online services (CompuServe, GEnie, AOL, Prodigy). These discussion groups work by simply sending and receiving regular mail messages.

Here's a selection of photo-related mailing-list servers on the Internet, gathered from various sources.

Due to the nature of the Internet, lists will come and go without warning. So, when you go looking, you may not be able to find all the lists mentioned here.

Mailing lists function like party lines. You post a message to the list, and the list rebroadcasts it to all subscribers. To start your subscription, send a message to the address listed below. There is no charge to subscribe to any of the following lists, but if you are accessing the Internet from another source, like CompuServe, your account may be charged a small fee to send/receive mail via the Internet. Check with your service provider.

The following documents may be downloaded from CompuServe's PhotoForum, Lib. 5, as file LISTSV.TXT; from GEnie's PhotoRT, Lib. 1, as file LISTSERV.TXT; or from the PhotoSource International BBS (Bulletin Board Service), (818) 363-8821, as file LISTSERV.TXT in the General file area. If you don't have access to these services, you can request this document electronically by sending a request for "Photo List Servers" to PhotoSource International via e-mail (psil@ix.netcom.com). You can also get your copy by sending an SASE to PhotoSource International, Attn: Photo List Servers, Pine Lake Farm, 1910 Thirty-fifth Rd., Station 5, Osceola, WI 54020-5602. Happy Surfing!—Bill Hopkins (PhotoStockNotes correspondent and online MarketLetter editor).

Following is a list of photo-related "chat" groups on the Internet, along with a description and information on how to subscribe.

Adobe PhotoShop and related problems or suggestions
PHOTOSHOP@HIPP.ETSU.EDU
Ask to be added to the list.

American Society of Journalists and Authors (ASJA) Contracts Watch
(frequent talks about electronic rights, etc.)
LISTPROC@ESKIMO.COM
SUBSCRIBE ASJACW-L <first name> <last name>

Anything that relates to the stock-photography industry
LISTPROC@INFO.CURTIN.EDU.AU
SUBSCRIBE STOCKPHOTO <your real name>

Canon EOS cameras and EOS cameras in practice
MAJORDOMO@AVOCADO.PC.HELSINKI.FI
SUBSCRIBE EOS <your real name>

Dedicated to the discussion of wire service photography and photographers
LISTSERV@PRESSROOM.COM
SUBSCRIBE WIREPHOTO-L

Discussion about stereo and 3-D photos, not computer-generated images
LISTSERV@BOBCAT.ETSU.EDU
SUBSCRIBE PHOTO-3d <your real name>

Discussion of all aspects of Panoramic Imaging, from traditional film-based
cameras to digital imaging
MAILSERV@PHYSICS1.PHYSICS.MONASH.EDU.AU
SUBSCRIBE PANORAMA

Emphasis on photo history, related items also welcomed, especially with a
historical twist
LISTSERV@ASUACAD.BITNET or LISTSERV@ASUVM.INRE.ASU.EDU
SUBSCRIBE PHOTOHST <your real name>

For beginners and pros dealing with equipment and shooting assignments/
stories
MAJORDOMO@IMSWORLD.COM
SUBSCRIBE PHOTO (nothing else)

For professional photographers and advanced amateurs to exchange
information and ideas
LISTSERV@INTERNET.COM
SUBSCRIBE PHOTOPRO

For professional photographers and advanced amateurs to exchange
information and ideas
MAJORDOMO@AVALONCORP.COM
SUBSCRIBE PHOTOPRO

For those interested in Olympus cameras
OLYMPUS-ADMIN@OIH.NO
SUBSCRIBE OLYMPUS (nothing else)

Geared particularly to ophthalmic photographers
MAISER@VISION.EEI.UPMC.EDU
SUBSCRIBE OPTIMAL <your real name>

General emphasis on photo-imaging education and professional practice
LISTSERV@RIT.EDU
SUBSCRIBE PHOTOFORUM <your real name> (not the same as
PhotoForum on CIS)

General photography from basic to advanced, equipment, travel and
aesthetics
LISTPROC@CSUOHIO.EDU
SUBSCRIBE PHOTO-L <your real name>

Leica cameras and Leica photographic practice
REID@MEJAC.PALO-ALTO.CA.US
Ask Brian, the list owner, about being added to the list.

Minolta cameras and Minolta photographic practice
LISTSERV@RIT.EDU
SUBSCRIBE MINOLTA-L <your real name>

National Press Photographers Association (NPPA-L)
LISTSERV@CMUVM.CSV.CMICH.EDUBIT.LISTSERV.NPPA-L
SUBSCRIBE NPPA-L <your real name>

News and information for members of the press
MALLY@PLINK.GEIS.COM
Ask the list owner, Michael Mally, about being added to the list

PHOTOFORUM, a discussion group for photographers
76703.4400@COMPUSERVE.COM
Ask the list owner, Mike Wilmer, about being added to the list.

PhotoPro
LISTSERV@INTERNET>COM
SUBSCRIBE PHOTOPRO <your real name>

A Photoshop users discussion group (different from the Photoshop listed
above)
LISTSERV@BGU.EDU
SUBSCRIBE PHOTSHOP <your real name> (note the missing *o* in
photshop)

Silver, nonsilver, obsolete processes and modifications to current processes
LISTPROC@VAST.UNSW.EDU.AU
SUBSCRIBE ALT-PHOTO-PROCESS <your real name>

Supported by Kodak—everything and more about PhotoCD
   LISTSERV@INFO.KODAK.COM
   SUBSCRIBE PHOTO-CD <your real name>

Town Hall for visual communicators, news photographers, photo editors, systems and graphics editors, freelancers, page designers, journalism educators and students
   LISTSERV@CMUVM.CSV.CMICH.EDU or LISTSERV@CMUVM.BITNET
   SUBSCRIBE NPPA-L <your real name>

Underwater photography—all aspects of this photo specialty
   LISTPROC@PHT.COM
   SUBSCRIBE UW-PHOTO <your real name>

Unmoderated bulletin board for discussion of image databases
   LISTSERV@LISTSERV.ARIZONA.EDU
   SUB IMAGELIB <your real name>

When completed, this list will deal with Pentax cameras and Pentax photographic practice
   RICH@ARRAYCOMM.COM
   Ask Rich Turner to add you to the list.

# Bibliography

## Web Addresses of Interest to Stock Photographers

| Name of Company | Website |
|---|---|
| Against All Odds Products | http://www.cyber24.com/htm3/aboutaao.htm |
| AG Editions, Inc. | http://www.ag-editions.com |
| Apple Computer, Inc. | http://qtvr.quicktime.apple.com |
| ASJA | http://www.asja.org/ |
| ASMP | http://www.asmp.org/ |
| Authors Registry | http://www.web.com/registry |
| The Basic Darkroom Book | http://www.wmbg.com/mindstore |
| Black Star | http://www.blackstar.com |
| Contact | http://www.mica.edu |
| Copyright Clearance Center | http://www.copyright.com |
| Corbis Media | http://www.corbis.com/ |
| Creation Captured | http://www.webcom.woody |
| DacEasy, Inc. | http://www.daceasy.com |
| Dastphoto | http://www.dastcom.com/dastphoto/dastphoto.html |
| Digimarc | http://www.digimarc.com |
| Earth Water Stock | http://www.earthwater.com |
| Eastman Kodak Company | http://www.kodak.com |
| E-Mail Addresses | http://people.yahoo.com |
| Folionet | http://www.folionet.com |
| Getty Images | http://www.getty-images.com/ |
| Global Photographers Search | http://www.photographers.com/ |
| Graphic Artist Guild | http://www.gag.org |
| Horticultural Photography | http://www.gardenscape.com/hortphoto.html |
| Impact Visuals | http://www.interport.net/~sr |
| Index Stock Imagery | http://www.indexstock.com |
| Infonautics | http://www.infonautics.com |
| Infosight | http://www.daspeaks.com |
| Library of Congress Photos | http://www.lcweb2.loc.gov/ammem |
| Netscape Navigator | http://www.netscape.com |
| Outdoor Photographer | http://www.outdoorphotographer.com |
| Outsight | http://www.outsight.com |
| Para Publishing | http://www.parapublishing.com |
| Photo Book Store | http://www.all-photo.com |
| Photo District News | http://www.pdn-pix.com |
| Photo Electronic Imaging | http://www.peimag.com |

| | |
|---|---|
| Photographers Index | http://photographersindex.com/ |
| Photographers News Network | http://www.photonews.net |
| Photography | http://www.corbis.com/ |
| Photography Discussion Groups | http://www.rit.edu/~andpph/photolists.html |
| Photogreen | http://www.photogreen.org |
| Pictra Net | http://www.pictranet.com |
| Picture Network International | http://www.publishersdepot.com |
| Picture Search | http://www.ulink.com/ssphoto/search.htm |
| Portfolio Central | http://www.portfolicentral.com |
| Portfolios Online | http://www.portfolios.com |
| PPA Publications | http://www.ppa-world.org |
| Presslink | http://www.presslink.com |
| Carl & Ann Purcell | http://www.purcellteam.com |
| Ron Engh | http://www.photosource.com |
| Royal Publishing | http://www.royalpublishing.com |
| Sell Photos | http://www.sellphotos.com |
| Seth Resnick Photography | http://www.sethresnick.com |
| Stock Connection | http://www.pickphoto.com |
| Stockphoto | http://www.odyssey.apana.org.au/~joel-day/ |
| The Photo Source Bank | http://www.photosource.com/psb |
| The Stock Market | http://www.stockmarket.com |
| The Stock Solution | http://www.tssphoto.com |
| Submit It | http://www.submit-it.com |
| USA Today | http://www.usatoday.com |
| Visual Support Network | http://www.vsii.com |
| West Stock | http://www.weststock.com |
| Zzyzx A & I Color | http://www.e-folio.com/zzyzx/ |

## CD-ROM Publishers

Adobe Image Library, San Jose, CA (403) 294-3195, Fax: (888) 502-8393, Website: http://www.adobestudios.com

A La Carte Digital Stock, Mesa, AR, (602) 807-6577

Arc Media Inc., Toronto, Ontario, Canada, (716) 633-2269

Artbeats Software Inc., Myrtle Creek, OR, (800) 444-9392, Website: http://www.artbeatswebtools.com

Aztech New Media Corp., Canada, (800) 494-4787

CD Plus Technologies, 333 Seventh Ave., New York, NY 10001, (212) 563-3006, Fax: (212) 563-3784, Email: webmaster@ovid.com

CD-Rom Galleries Inc., 36 Seascape Village, Aptos, CA 95003, (408) 685-2315, Fax: (408) 685-0340

CDRP Inc., 101 Rogers St., #204, Cambridge, MA 02142-1049, (617) 494-5330, Fax: (617) 494-6094

Classic PIO Partners, Pasadena, CA, (800) 370-2746

Clip Shots, Toronto, Ontario, Canada, (800) 551-3826

Computer Imageworks, Ltd., 277 Alexander St., Suite 212, Rochester, NY 14607

Copernicus Software, Lake Oswego, OR, (800) 368-6231

Corel Corporation, 1600 Carling Ave., Ottawa, Ontario K1Z 8R7, Canada, (613) 728-8200, Fax: (613) 728-9790

Dataware Technologies, 222 Third St., Suite 3300, Cambridge, MA 02142, (617) 621-0820, Fax: (617) 621-0307

Digital Impact Inc., 6506 S. Loewis, Ste 275, Tulsa, OK 74136, (800) 775-4232, Fax: (918) 742-8176, Email: sales@digitalimpact.com

Digital Stock Corporation, 750 2nd St., Encinitas, CA 92024, (800) 545-4514, Email: steve@digitalstock.com

Digital Textures, Rockford, IL (815) 967-0886, Fax: (800) 254-0886

Digital Wisdom Inc., Water Lane, P.O. Box 2070, Tappahannock, VA 22560-2070, (800) 800-8560, Fax: (804) 758-4512

Digital Zone Inc., P.O. Box 5562, Bellevue, WA 98006, (800) 538-3113

D'Pix, Columbus, OH (614) 299-7192, Website: http://www.monotype.com

Dynamic Graphics Inc., 6000 N. Forest Park Dr., Peoria, IL 61656-1901

Earthstar Stock Inc., Chicago, IL, (800) 424-0023

Eldar Co., Stamford, CT, (800) 573-7753, Website: http://www.eldarco.com

FotoSets, San Francisco, CA, (800) 577-1215

4More Inc., New York, NY, (800) 675-5372

Gazelle Technologies, 7434 Trade St., San Diego, CA 92121, (800) 843-9497, Fax: (619) 536-2345

HammerHead Publishing Inc., Deerfield Beach, FL, (954) 426-8114

Harpy Digital Inc., Los Angeles, CA, (310) 397-7636

Image Club Graphics Inc., 729 Twenty-fourth Ave., Calgary, Alberta T2G 1P5, Canada, (403) 262-8008, Fax: (403) 261-7013

Imagefarm, Toronto, Ontario, Canada, (416) 504-4161, Fax: (800) 438-3276, Website: http://www.imagefarm.com

Letraset USA, Paramus, NJ, (800) 526-9073, Website: http://www.letraset.com

Mary and Michael Photography, Palo Alto, CA, (415) 326-9567, Website: http://www.commerce.digital.com

MetaTools Inc., Carpenteria, CA, (800) 472-9025, Website: http://www.metatools.com

Multi-Ad Services Inc.,1720 W. Detweiller Dr., Peoria, IL 61615-1695, (309) 692-1530, Fax: (309) 692-6566

Neo Custom Painted Environments Inc., Chicago, IL, (312) 226-2426

Pacific CD Corporation, P.O. Box 31328, Honolulu, HI 96820, (808) 949-4594, Fax: (808) 949-4594

Philips CD-ROM Publishing, 2500 Central Ave., #B, Boulder, CO 80301, (303) 440-0669, Fax: (303) 443-8242

PhotoDisc, 2013 Fourth Ave., #4, Seattle, WA 98121, (800) 528-3472, Fax: (206) 441-9379

Photoriffic, Los Angeles, CA, (310) 289-8753

PhotoSphere Images Limited, Vancouver, British Columbia, Canada, (800) 665-1496, Website: http://www.photosphere.com/photos

Pixar, 1001 W. Cutting Blvd., Richmond, CA 94804, (510) 236-4000

PixelChrome Professional, Dallas, TX, (214) 447-0806, Website: http://ramp ages.onramp.net/~pixlchrm

Quanta Press Inc., 13 Fifth St., #223A, Minneapolis, MN 55414, (612) 379-3956, Fax: (612) 623-4570

Royalty Free Digital Images, (619) 792-2942, Email: michele@ardellgroup.com

Rubber Ball Productions, Orem, UT, (801) 224-6886

Seattle Support Group, Kent, WA, (206) 395-1484, Website: http://www.ssgr p.com

Softkey International, P.O. Box 629000, El Dorado Hills, CA 95762-9983, (800) 242-5588, Fax: (800) 582-8000

TechScan, P.O. Box 895, Port Hueneme, CA 93044-0895, (805) 985-4370, Fax: (805) 985-7221

Texture Farm, San Francisco, CA, (415) 284-6180

TextWare Corporation, P.O. Box 3267, Park City, UT 84060, (801) 645-9600, Fax: (801) 645-9610

Totem Graphics Inc., Tumwater, WA, (360) 352-1851, Website: http://www.g ototem.com

Transmission Digital Publishing, New York, NY, (800) 585-2248

Vivid Details, Ojai, CA, (800) 948-4843, Website: http://www.vivid.com

Walnut Creek CD-ROM, 4041 Pike Lane, Concord, CA 94520, (800) 786-9907, Fax: (510) 674-0821

Wayzata Technology Inc., 2515 E. Highway 2, Grand Rapids, MN 55744, (218) 326-0597, Fax: (218) 326-0598

Weka Publishing Inc., 1077 Bridgeport Ave., Shelton, CT 06484, (800) 222-9352, Fax: (203) 944-3663

## Books

*ASMP Professional Business Practices in Photography*, Allworth Press, 10 E. 23rd St., New York, NY 10010.

*Basic Book of Photography*. Tom and Michelle Grimm. Viking Penguin Inc., 375 Hudson St., New York, NY 10014-3657.

*Big Bucks Selling Your Photography*. Cliff Hollenbeck. Hot Shot Productions, P.O. Box 4247, Seattle, WA 98104.

*Complete Photography Career Handbook*. George Gilbert. Consultant Press, Ltd. and The Photographic Arts Center, 163 Amsterdam Ave., Suite 201, New York, NY 10023.

*Creating Effective Advertising: Using Semiotic*. Nadin & Zakiaa. Consultant Press, Ltd. and The Photographic Art Center, 163 Amsterdam Ave., Suite 201, New York, NY 10023.

*Cut Your Photo Costs*. Bill McQuilkin. 728 Hill Ave., Glen Ellyn, IL 60137.

*Freelance Photographer's Handbook*. Fredrik D. Bodin. Curtin and London, Inc., Van Nostrand Reinhold Co., 135 W. Fiftieth St., New York, NY 10020.

*Great Travel Photography.* Cliff and Nancy Hollenbeck. Amherst Media, Inc., 155 Rano St., Suite 300, Buffalo, NY 14207.

*A Guide to Travel Writing and Photography.* Ann and Carl Purcell. Writer's Digest Books, F&W Publications, Inc., 1507 Dana Ave., Cincinnati, OH 45207.

*How to Get the Best Travel Photographs.* Fredrik D. Bodin. Curtin & London, Inc., Van Nostrand Reinhold Co., 135 W. Fiftieth St., New York, NY 10020.

*How to Shoot Stock Photos That Sell.* Michal Heron. Allworth Press, 10 E. Twenty-third St., New York, NY 10010.

*How You Can Make $25,000 a Year With Your Camera (No Matter Where You Live).* Larry Cribb. Writer's Digest Books, F&W Publications, Inc., 1507 Dana Ave., Cincinnati, OH 45207.

*Nature and Wildlife Photography.* Susan McCartney. Amphoto Books, 1515 Broadway, New York, NY 10036.

*Nature Photography: A Current Perspective.* Ted Anderson and Katheryne Gall. Roger Tory Peterson Institute of Natural History, 311 Curtis St., Jamestown, New York 14701.

*Photographer's Digital Studio.* Joe Farace. Peachpit Press, 2414 Sixth St., Berkeley, CA 94710.

*Photomarketing Handbook.* Jeff Carson. Image Media, 89 Fifth Ave., #903, New York, NY 10003-3020, (212) 675-3707.

*PhotoWorks,* Joe Ferace, Seattle Film Works, 1260 16th Ave. W., Seattle, WA 98119. Gives entry-level photographers an easy and inexpensive way to enter the world of film-to-digital processing.

*The Photographer's and Writer's Guide to Global Markets,* Michael Sedge, Allworth Press, 10 E. 23rd St., New York, NY 10010. If you plan to enter global commerce, this book will pave the way.

*The Professional Photographer's Guide to Shooting and Selling Nature and Wildlife Photos.* Jim Zuckerman. Writer's Digest Books, F&W Publications, Inc., 1507 Dana Ave., Cincinnati, OH 45207.

*Selling Stock Photography.* Lou Jacobs, Jr. Amphoto Books, 1515 Broadway, New York, NY 10036.

*Stock Photo Deskbook.* Consulant Press, Ltd. and The Photographic Art Center, 163 Amsterdam Ave., Suite 201, New York, NY 10023.

*Stock Photography: The Complete Guide.* Ann and Carl Purcell. Writer's Digest Books, F&W Publications, Inc., 1507 Dana Ave., Cincinnati, OH 45207.

*Successful Fine Art Marketing.* Marcia Layton. Consultant Press, Ltd. and The Photographic Art Center, 163 Amsterdam Ave., Suite 201, New York, NY 10023.

*Techniques of Natural Light Photography.* Jim Zuckerman. Writer's Digest Books, F&W Publications, Inc., 1507 Dana Ave., Cincinnati, OH 45207.

*Travel Photography.* Susan McCartney. Amphoto Books, 1515 Broadway, New York, NY 10036.

*Traveling Photographer.* Ann and Carl Purcell. Amphoto Books, 1515 Broadway, New York, NY 10036.

*Where to Sell Your Photographs in Canada.* Melanie E. Rockett. Proof

Positive Productions Ltd., 1128 Quebec St., #304, Vancouver, BC, Canada. Email: ppp@proofpositive.com
Canada.
*Winning Photo Contests.* Jeanne Stallman. Image, 89 Fifth Ave., #903, New York, NY 10003-3020.

## Business Side

*ASMP—Professional Business Practices in Photography.* American Society of Media Photographers. 14 Washington Square, Suite 502, Princeton Junction, NJ 08550-1033. A how-to book for the assignment photographer and the commercial stock photographer.

*The Basic Darkroom Book: A Complete Guide to Processing and Printing Color and Black-and-White Photographs.* Michelle and Tom Grimm. P.O. Box 1840, Islamorada, FL 33036. Been around a long time and in its fourth revision.

*Big Bucks.* Cliff Hollenbeck. Hot Shot Productions Inc., P.O. Box 4247, Seattle, WA 98107. Excellent and recommended. Business tips by this working pro are especially adaptable for the travel photographer.

*Chase's Annual Events.* Contemporary Books, 180 N. Michigan Ave., Chicago, IL 60601. Key in your trips with festival dates.

*Classification of Pictures and Slides.* Stanford J. Green. PhotoTrack, (303) 690-6664, 6392 S. Yellowstone Way, Aurora, CO 80016.

*Communication Briefings.* 700 Black Horse Pike, Suite 110C, Blackwood, NJ 08012. Fine-tune the business side of your operation. A monthly newsletter.

*The Dr. Jeffrey Lant Catalog.* Jeffrey Lant Associates, Inc., 50 Follen St., Suite 507B, Cambridge, MA 02138. Includes self-promotion manuals for the entrepreneur. Name the business topic and one of Lant's books treats the subject.

*The Encyclopedia of Small Business Resources.* David E. Gumpert and Jeffrey A. Timmons. Harper & Row, 10 E. Fifty-third St., 6th Floor, New York, NY 10022. A compendium of business tips for the entrepreneur.

*The Expert Witness Handbook: Tips and Techniques for the Litigation Consultant.* Dan Poynter. Para Publishing, P.O. Box 8206, Santa Barbara, CA 93118-8206, (805) 968-7277, Fax: (805) 968-1379, E-mail: 75031.35 34@CompuServe.Com Website: http://www.1h.com/para

*Finding Images On-Line,* Paula Berinstein, Pemberton Press, 462 Danbury Rd., Wilton, CT 06897.

*F8 & Being There.* P.O. Box 3195, Holiday, FL 34690. A folksy newsletter jammed with information for the nature photographer.

*Getting Your Public Relations Story on TV and Radio.* Tracey St. John. Pilot Books, P.O. Box 2102, Bldg. 3, Greenport, NY 11944. Learn the right way to approach the TV and radio media.

*Gold Book of Photography Prices.* Thomas I. Perrett. Photography Research Institute, Carson Endowment, Carson, CA 90745. Learn what others are charging in major cities of the U.S.A. For the service photographer.

*Homemade Money.* Barbara Brabec. Betterway Books, F&W Publications,

Inc., 1507 Dana Ave., Cincinnati, OH 45207. Guide to success in a home business.

*Homeowner's Property Tax Relief Kit.* Lawrence J. Czaplyski and Vincent P. Czaplyski. McGraw-Hill, Inc., 1221 Avenue of the Americas, New York, NY 10020.

*How to Avoid 101 Small Business Mistakes, Myths & Misconceptions.* Gary L. Schine, Consultant Press, Ltd. and The Photographic Art Center, 163 Amsterdam Ave., Suite 201, New York, NY 10023.

*How to Market You & Your Book,* Richard F.X. O'Connor, Cour de Lion Books, Santa Barbara, CA.

*The Legal Multimedia Law and Business Handbook.* J. Dianne Brinson and Mark F. Radcliffe. Ladera Press, 3130 Alpine Rd., Suite 200-9002, Menlo Park, CA 94025. Brings you into the Twenty-first century if you are considering publishing in print or on the Web.

*Making a Living Without a Job.* Barbara J. Winter. Bantam Books, 1540 Broadway, New York, NY 10036.

*Marketing Without Money,* Nicholas Bade, NTC Business Books, 4255 W. Touhy Ave., Chicago, IL 60646-1975. A guide for small businesses to increase productivity.

*Making More Money on the Internet,* Alfred and Emily Glossbrenner, McGraw-Hill, 55 Francisco St., San Francisco, CA 94133.

*Money Sources for Small Businesses.* William Alarid. Puma Publishing Co., 1670 Coral Dr., Suite RA, Santa Maria, CA 93454. How to get seed money for a fledgling business.

*Multimedia Law and Business Guide,* Ladera Press, 3130 Alpine Rd., Suite 200-9002, Menlo Park, CA 94025.

*Negotiating Stock Photo Prices.* Jim Pickerell. ASMP, 110 E. Frederick Ave., Suite A-3, Rockville, MD 20850. Offers practical pricing guidelines from a top pro for selling commercial stock photography either through stock-photo agencies or individually.

*Opportunities In Travel Careers.* Robert Scott Milne. National Textbook Company, 4255 W. Touhy Ave., Lincolnwood (Chicago), IL 60646-1974. Outlines educational preparation and suggests specific steps for getting started. (Milne is publisher of *Travelwriter Marketletter.*)

*Permanence and Care of Color Photographs.* Henry Wilhelm and Carol Brower. Preservation Publishing Company, 719 State St., P.O. Box 567, Grinnell, IA 50112-5575.

*Photographer's Internet Handbook,* Joe Farace, Allworth Press, 10 E. 23rd St., New York, NY 10010.

*Photographer's Digital Studio,* Joe Farace, Peach Pit Press, 2414 6th St., Berkeley, CA 94710. Insights on how to transform your photos into pixels.

*Photographer's Guide to Exhibition and Sales Spaces.* The Photographic Arts Center, 163 Amsterdam Ave., Suite 201, New York, NY 10023.

*Photographer's Guide to Getting and Having a Successful Exhibition.* The Photographic Arts Center, 163 Amsterdam Ave., New York, NY 10023.

*Photographer's Law in Plain English,* Leonard D. DuBoff, Allworth Press, 10 E. 23rd St., New York, NY 10010.

*Power Calling II, How to Build New Business In a Crowded Marketplace.*

Joan Guiducci. Power Calling, P.O. Box 497, Calistoga, CA 94515.
*Procedures Manual for Cataloging Photographs.* 6392 S. Yellowstone Way,
Aurora, CO 80016. A thesaurus for categories for your stock photos.
*Publishing Your Art as Cards, Posters and Calendars.* Harold Davis. The
Consultant Press, Ltd., 163 Amsterdam Ave., New York, NY 10023. An
excellent and well-written book, especially useful for the art
photographer—but with good promotional tips for all.
*Science of Business Negotiations.* Pilot Books, P.O. Box 2102, Bldg. 3,
Greenport, NY 11944.
*Secrets of Self-Employment,* Sarah and Paul Edwards, G.P. Putnam's Sons,
200 Madison Ave., New York, NY 10016. All you need to know.
*Self-Publishing Manual.* Dan Poynter. Para Publishing, P.O. Box 8206, Santa
Barbara, CA 93118-8206.
*Small Time Operator.* Bell Springs Publishing, P.O. Box 640, Bell Springs Rd.,
Laytonville, CA 95454, (707) 984-6746. Simplified business techniques.
*Starting a Business After 50.* Pilot Books, P.O. Box 2102, Bldg. 3, Greenport,
NY 11944.
*Travel Guides for Photographers.* Photo Traveler Publications, P.O. Box
39912, Los Angeles, CA 90039, Website: http://home.earthlink.net/~phot
otravel/ Tips on where to go and what to photograph.
*Travel Photo Source Book.* Society of American Travel Writers (SATW), 4101
Lake Boone Trail, Suite 201, Raleigh, NC 27607.
*Travel Writer's Handbook.* Louise Purwin Zobel. Surrey Books, Inc., 230 E.
Ohio St., Suite 120B, Chicago, IL 60611.
*WebSite Stats,* Rick Stout, McGraw-Hill, 55 Francisco St., San Francisco, CA
94133
*Woman's Guide to Starting a Small Business.* Bell Springs Publishing, P.O.
Box 1246, Willits, CA 95490, (800) 515-8050.
*The ZIP/Area Code Directory.* R. Marks. Pilot Books, P.O. Box 2102,
Bldg. 3, Greenport, NY 11944. All-in-one directory to find those ever-
changing numbers.

## Newsletters
*ASJA.* American Society of Journalists and Authors, Inc., 1501 Broadway,
Suite 302, New York, NY 10036.
*ASPP Newsletter.* 2025 Pennsylvania Ave. NW, Suite 226, Washington, DC
20006, (202) 223-8442. For the editorial stock photographer.
*BoardRoom Reports.* Boardroom Business Reports Inc., 330 W. Forty-
second St., New York, NY 10036.
*BottomLine.* Boardroom Business Reports Inc., 330 W. Forty-second St.,
New York, NY 10036.
*Chicago Artists' Coalition.* 11 E. Hubbard, 7th Floor, Chicago, IL 60611,
(312) 670-2060, Fax: (312) 670-2521.
*Commercial Image.* PTN Publishing Co., 650 S. Clark St., Chicago, IL
60605-1799.
*Communication Briefings.* 1101 King St., Suite 110, Alexandria, VA 22314,
(703) 548-3800.

*CopyRights.* 1247 Milwaukee Ave., Suite 303, Glenview, IL 60025-2425.

*Editorial Experts, Inc.* 66 Canal Center Plaza, #200, Alexandria, VA 22314-1538.

*Editors Only.* 275 Batterson Dr., New Britain, CT 06053.

*Entry.* (Contests) P.O. Box 7648, Ann Arbor, MI 48107.

*Freelance Photographer's Handbook*, Cliff and Nancy Hollenbeck, Amherst Media, P.O. Box 586, Amherst, NY 14226.

*Guilfoyle Report.* AG Editions Inc., 41 Union Square W., #523, New York, NY 10003.

*Home-Based Business Directory News.* Mountain View Systems, 930 S. Washington Ave., Suite 111, Scranton, PA 18505.

*Home-Run Business.* 7627 Iron Gate Lane, Frederick, MD 21702.

*Ilford Photo Newsletter.* W. 70 Century Rd., Paramus, NJ 07653.

*Imagist.* Photographic Administrators, Inc. (PAI), 1150 Avenue of the Americas, New York, NY 10036.

*Linked Ring Letter.* 163 Amsterdam Ave., New York, NY 10023.

*Mind Your Business.* P.O. Box 14850, Chicago, IL 60614.

*Natural Image.* Lepp & Associates, P.O. Box 6240, Los Osos, CA 93412, (805) 528-7385.

*Nature Photographer.* P.O. Box 2019, Quincy, MA 02269-2019, (617) 847-0091.

*PartyLine.* 35B Sutton Place, New York, NY 10022. (212) 755-3487. Fax: (212) 755-3488, E-mail: byarmon@ix.netcom.com, Website: http://www.wbs.com/partyline/

*Photak.* 180 Main St., Menasha, WI 54952-3174, (800) 723-9876, Fax: (414) 722-9163.

*The Photograph Collector.* 301 Hill Ave., Langhorne, PA 19047-2819.

*Photographer Guidelines.* Picture This, 88 Howard St., Suite 1002A, San Francisco, CA 94105.

*Photographic Resource Center Newsletter.* 602 Commonwealth Ave., Boston, MA 02215.

*Photography for Industry.* 38 Rick Lane W., Peekskill, NY 10566.

*PHOTOLETTER* and *Photobulletin.* PhotoSource International, Pine Lake Farm, 1910 Thirty-fifth Rd., Osceola, WI 54020, (800)624-0266.

*PhotoStockNotes.* PhotoSource International, Pine Lake Farm, 1910 Thirty-fifth Rd., Osceola, WI 54020, (800) 624-0266.

*Photo Traveler.* P.O. Box 39912, Los Angeles, CA 90039, (213) 660-0473.

*Photowork.* Orvil Stokes's monthly, 317 E. Winter Ave., Danville, IL 61832-1857.

*Publishing Poynters.* Para Publishing, P.O. Box 4432-881, Santa Barbara, CA 93140-4232, (805) 968-7277.

*Quick Trips Travel Letter.* P.O. Box 3308, Crofton, MD 21114, (301) 262-0177. Newsletter featuring three- to five-day getaways.

*Range of Light Works.* P.O. Box 100, Yosemite, CA 95389, (209) 372-4024.

*SPAR Newsletter.* (Reps) 208 5th Ave., 7W, New York, NY 10010. (212) 684-0245.

*Stock Photo Report.* 7432 N. Laymon Ave., Skokie, IL 60077, (708) 677-7887, Fax: (847) 677-7891, E-mail: bseed@wwa.com

*Taking Stock.* Jim Pickerell, 110 Frederick Ave., Suite A, Rockville, MD 20850, (301) 251-0720, Fax: (301) 309-0941.
*WCPP Newsletter.* 10915 Bonita Beach Rd., #1091, Bonita Springs, FL 33923, (813) 992-4421, Fax: (813) 992-6328.
*Western Photographer.* 2031 E. Via Burton, #C, Anaheim, CA 92806-1202.

## Workshops

Jay Abraham Marketing Seminars. 7811 Montrose Rd., Potomac, MD 20854, (800) 844-1946, Fax: (301) 424-6228.
Anderson Ranch Arts Center. P.O. Box 5598, Snowmass Village, CO 81615.
Arles Journees De L'Image Pro (JIP). Sylvie Havez, Press Relations, 1 Rue Copernic, 13200 Arles, France. 011 33 90 96 44 44, Fax: 011 33 90 96 47 77.
Gene Boaz Workshops. Route 5, Benton, KY 42025.
Paul Bowling Workshops. P.O. Box 6486, Annapolis, MD 21401-0486.
Barbara Brundege Workshops. P.O. Box 24571, San Jose, CA 95154.
Laura Buckbee Workshops. NESPA, P.O. Box 1509, New Milford, CT 06776.
Michele Burgess Seminars. 20741 Catamaran Lane, Huntington Beach, CA 92646, (714) 536-6104, Fax: (714) 536-6578.
China Photo Workshop Tour. 2506 Country Village, Ann Arbor, MI 48103-6500, (800) 315-4462.
Colorado Mountain College Workshops. P.O. Box 2208, Breckenridge, CO 80424.
Communication Unlimited Workshops. P.O. Box 6405, Santa Maria, CA 93456.
Creative Vision Workshops. Orvil Stokes, 317 E. Winter Ave., Danville, IL 61832.
Jay Daniel Workshops. 816 W. Francisco Blvd., San Rafael, CA 94901.
Richard Day Workshops . 6382 Charleston Rd., Alma, IL 62807.
Dillman's Sand Lake Lodge Workshops. P.O. Box 98, Lac du Flambeau, WI 54538.
Rohn Engh's Workshops. Sell & ReSell Your Photos. Pine Lake Farm, 1910 Thirty-fifth Rd., Osceola, WI 54020, (800) 624-0266.
Charlene Faris Workshops. 610 W. Popular, #7, Zionsville, IN 46077.
Friends of Photography Workshops. 250 Fourth St., San Francisco, CA 94103.
Gerlach Nature Photography Workshops. John Gerlach, P.O. Box 259, Chatham, MI 49816.
Great American Nature Photography Weekend Workshop. 5942 Westmere Dr., Knoxville, TN 37909-1056, (615) 539-1667, Fax: (615) 539-1348.
Guide to Photo Tours. Bill Hammer, 39 Westchester Dr., Rocky Point, NY 11778.
Art Kane Photo Workshops. 1511 New York Ave., Cape May, NJ 08204.
Ron Levy Workshops. P.O. Box 3416, Soldotna, AK 99669.
Los Angeles Photography Center Workshops. 412 S. Park View St., Los Angeles, CA 90057.

Macro/Nature Photography Workshops. Robert Sisson, P.O. Box 1649, Englewood, Fl 34229-1649.

Maine Photographic Workshops. 2 Central St., Rockport, ME 04856, (207) 236-8581.

Missouri Photo Workshop. 27 Neff Annex, Columbia, MO 65201.

Motivating the Reader and Selling the Graphic Arts Buyer Workshops. Dynamic Graphics, Inc., 6000 N. Forest Park Dr., Peoria, IL 61614.

National Press Photographers Association Seminars, Inc. 3200 Croasdail Dr., Suite 306A, Durham, NC 27705.

New School Workshops. 66 W. Twelfth St., New York, NY 10011.

New York Institute of Photography Workshops. 211 E. Forty-third St., Dept. WWW, New York, NY 10017, E-mail: nyi@soho.ios.com

Ogunquit Photography School Workshops. P.O. Box 2234, Ogunquit, ME 03907.

Olden Workshops. 1265 Broadway, New York, NY 10001.

Owens Valley Photography Workshops. P.O. Box 114, Somis, CA 93066.

Palm Beach Photographic Workshops. 2310 E. Silver Palm Rd., Boca Raton, FL 33432, (407) 391-7557.

Parsons School of Design Workshops. 66 Fifth Ave., New York, NY 10011.

Photo Adventures Workshops. JoAnn Ordano, P.O. Box 591291, San Francisco, CA 94118.

Photographic Society of America Regional Seminars. 3000 United Founders Blvd., Suite 103, Oklahoma City, OK 73112.

Photography and the Art of Seeing Workshops. Karen Schulman, P.O. Box 771640, Steamboat Springs, CO 80477-1640, (970) 879-2244

Photography and Travel Workshop "Directory." Serbin Communications, Inc., 511 Olive St., Santa Barbara, CA 93101.

Photography in Nature Workshops. Bob Grytten, P.O. Box 3195, Holiday, FL 34690, (813) 934-1222.

Photo Marketing Outdoor Workshop. Ron Sanford, P.O. Box 248, Gridley, CA 95948.

Maria Piscopo Workshops. Creative Services Consultant, 2038 Calvert, Costa Mesa, CA 92626.

Professional Workshop for the Visual Artist. The Graphic Artists Guild, 11 W. Twentieth St., 8th Floor, New York, NY 10011.

Professional Workshops of America. 1090 Executive Way, Des Plaines, IL 60018.

Rochester Institute of Technology Workshops. P.O. Box 9887, Rochester, NY 14623-0887.

David Sanger Workshops. David Sanger, 920 Evelyn Ave., Albany, CA 94706, (510) 526-0800, Fax: (510) 526-2800.

Santa Fe Photographic Workshops. Lisl Dennis, P.O. Box 9916, Santa Fe, NM 87504.

Self-Publishing for Artists Workshop. Harold David and Marcia Keegan, Wilderness Studio, 299 Pavonia Ave., Jersey City, NJ 07302, (201) 659-4554.

Shaw Guides Workshops "Directory." Dorlene Kaplan, 10 W. Sixty-sixth St., Suite 30H, New York, NY 10023, (212) 787-6021, Fax: (212) 724-9287.

Shenandoah Photo Workshops. P.O. Box 54, Sperryville, VA 22740, (703) 937-5555.

Shutterbug/PhotoPro Workshops. 5211 S. Washington Ave., Titusville, FL 32780, (407) 268-5010.

Sierra Photographic Workshops. Lewis Kemper, 3251 Lassen Way, Sacramento, CA 95821.

Carol Siskind Workshops. 501 Course Rd., Neptune, NJ 07759.

63 Ranch Workshops. Sandra Cahill, P.O. Box 979-S, Livingston, MT 59047.

Elaine Sorel Professional Photographer Workshops. 640 West End Ave., New York, NY 10024.

David M. Stone Photo Workshops. 7 Granston Way, Buzzards Bay, MA 02532.

Carren Strock Workshops. 1380 E. Seventeenth St., Brooklyn, NY 11230, (718) 375-8519.

Summer Photography Workshops. Rochester Institute of Technology, Technical & Education Center, One Lomb Memorial Dr., Rochester, NY 14623.

Tallac Photography Commission Workshops. Steven Short, P.O. Box 488, Glenbrook, NV 89413.

Texas Parks, Big Bend Ranch Spring, Photo Workshops. Jim Carr, 1019 Valley Acres Rd., Houston, TX 77062, (713) 486-8070, Fax: (713) 486-8112.

Touch of Success Photo Seminars. Bill Thomas, P.O. Box 194, Lowell, FL 32663.

Travel Writer's Workshops. Louise Purwin Zobel, 23350 Sereno, Villa 30, Cupertino, CA 95014, (415) 691-0300.

Travel Writing Workshops. Effin and Jules Older, P.O. Box 163, New St., Albany, VT 05820. Phone/fax: (802) 755-6774.

Ultimate Image Workshops. Bob Deasy, P.O. Box 22, Lawton, PA 18828.

Vail Valley Arts Council Workshops. P.O. Box 1153, Vail, CO 81658, (970) 476-4255, Fax: (970) 476-4366.

Visual Studies Workshop. 31 Prince St., Rochester, NY 14607.

Voyagers International Workshops. P.O. Box 915, Ithaca, NY 14851, (607) 257-3091, Fax: (607) 257-3699.

Web Sites Workshops—Rohn Engh. 1910 Thirty-fifth Rd., Pine Lake Farm, Osceola, WI 54020, (800) 624-0266.

West Coast School of Professional Photography Workshops. Allen Roedel, P.O. Box 395, Imperial Beach, CA 92032.

Wildlife Research Photography Workshops. P.O. Box 3628, Mammoth Lakes, CA 93546-3628, (619) 924-8632, E-mail: moose395@qnet.com

Winona International School of Professional Photography Workshops. 1090 Executive Way, Des Plaines, IL 60018.

Robert Winslow Photo Tours, Inc. P.O. Box 334, Durango, CO 81302-0334.

Woodstock Photo Workshops. 59 Tinker St., Woodstock, NY 12498.

Norbert Wu Workshops. 1065 Sinex Ave., Pacific Grove, CA 93950, Website: http://siolibrary.ucsd.edu/nwu/index.html

Truman Yeager Workshops. 921 Pine Terrace N., Lake Worth, FL 33460-2411.

*Local camera stores often sponsor half-day workshops. Consult the yellow pages.*

*Photography magazines often list current seminars and workshops (for the pro and amateur).*

*Universities, colleges and technical schools conduct seminars and workshops. Consult your telephone directory.*

## Directories

*Advertising Photographers of America Directory.* 27 W. Twentieth, Room 601, New York, NY 10010. Or: 7201 Melrose Ave., Los Angeles, CA 90046.

*Advertising Red Book.* West Telemarketing Corp., 9910 Maple St., Omaha, NE 68134.

*American Book Trade Directory.* 121 Chanlon Rd., New Providence, NJ 07974.

*American Hospital Association Directory.* 840 N. Lake Shore Dr., Chicago, IL 60611.

*American Society of Journalists and Authors Directory.* 1501 Broadway, Suite 302, New York, NY 10036.

*American Society of Media Photographers.* 14 Washington Square, Suite 503, Princeton Junction, NJ 08550-1033.

*American Society of Picture Professionals Directory* (ASPP). 2025 Pennsylvania Ave. NW, Suite 226, Washington, DC 20006.

*ArtNetwork Yellow Pages.* P.O. Box 1278, Penn Valley, CA 95946.

*ASMP Stock Photo Handbook (ASMP National).* 14 Washington Square, Suite 503, Princeton Junction, NJ 08550-1033.

*Association for Education & Communications.* 1025 Vermont Ave. NW, Suite 820, Washington, DC 20005.

*Audio Visual Market Place.* R.R. Bowker Company, 121 Chanlon Rd., New Providence, NJ 07974. Extensive directory of audiovisual and film companies.

*Bacon's Publicity Checker.* Bacon's Publishing Company, 332 S. Michigan Ave., Chicago, IL 60604.

*The Bowker Annual of Library and Book Trade/Information.* 121 Chanlon Rd., New Providence, NJ 07974.

*Broadcast Interview Source.* 2233 Wisconsin Ave. NW, Washington, DC 20007.

*California Media.* P.O. Box 1197, New Milford, CT 06776.

*Canadian Almanac.* 200 Hadlaide St. W., 3rd Floor, Toronto, Ontario MH5 IW7, Canada.

*Cassell's Directory of Publishing.* Villiers House 41/47, Strand, London WC2N 5JE England.

*Chicago Talent Sourcebook.* 212 W. Superior, Room 203, Chicago, IL 60611.

*Congressional Yellow Book.* H&M Publishers, 44 W. Market St., P.O. Box 311, Rhinebeck, NY 12572, (914) 876-2081.

*Contact Book for the Entertainment Industry.* Celebrity Service

International, 1780 Broadway, Suite 300, New York, NY 10019.
*Creative Black Book.* 115 Fifth Ave., 3rd Floor, New York, NY 10003.
*Decor Services Annual.* Commerce Publishing Co., 330 N. Fourth St., St. Louis, MO 63102.
*Design Firm Directory.* Wefler & Associates Inc. P.O. Box 1167, Evanston, IL 60204. Annual directory of design firms.
*Directory of Art Publishers, Book Publishers & Record Companies.* The Consultant Press, 163 Amsterdam Ave., #201B, New York, NY 10023. An excellent guide for selling your "Track A" photos.
*Directory of Free Stock Photography.* InfoSource Publications, 10 E. Thirty-ninth St., 6th Floor, New York, NY 10016.
*Directory of Post Secondary Institutions, 1990.* Superintendent of Documents, U.S. Government Printing Office, Washington, DC 20402.
*Directory of Professional Photographers* (PP of A). 57 Forsyth St. NW, #1600, Atlanta, GA 30303-2206.
*Directory of Washington Representatives.* H&M Publishers, 44 W. Market St., P.O. Box 311, Rhinebeck, NY 12572, (914) 876-2081.
*Direct Stock for Independent Stock Photographers.* 10 E. Twenty-first St., 14th Floor, New York, NY 10010, (212) 979-6560.
*Editor & Publisher International Yearbook.* 11 W. Nineteenth St., New York, NY 10011-4234.
*Educational Marketer Yellow Pages.* Knowledge Industry Publications, 701 Westchester Ave., White Plains, NY 10604.
*Encyclopedia of Associations.* Gale Research Inc., 835 Penobscot Bldg., 645 Griswold St., Detroit MI 48226-4094. Annual directory of active organizations. Since associations specialize, the directory will help you focus on and match up your photo strength area with an association of the same interest.
*Feature News Publicity Outlets.* H&M Publishers, 44 W. Market St., P.O. Box 311, Rhinebeck, NY 12572, (914) 876-2081.
*Federal Yellow Book.* H&M Publishers, 44 W. Market St., P.O. Box 311, Rhinebeck, NY 12572, (914) 876-2081.
*Focus on Photography Information.* P.O. Box 2182, Madison, WI 53701-2182. A brochure with nationwide listings: societies, organizations, fellowships, grants and mail-order services.
*Gebbie Press All-In-One Directory.* P.O. Box 1000, New Paltz, NY 12561.
*Gift and Decorative Accessory Buyer's Directory.* Geyer McAllister Publications, 51 Madison Ave., New York, NY 10010.
*Gold Book of Photography.* Photography Research Institute, Carson Endowment, 21237 S. Moneta Ave., Carson, CA 90745, (213) 328-9272. Shows you the going prices for service photography. Updated annually. Recommended.
*Great American Photographic Directory.* L.A. Photogram, P.O. Box 2015, San Gabriel, CA 91778. Another compendium. If you need a product, you'll find where to buy it in here.
*Guide to American Directories.* B. Klein Publications, P.O. Box 8503, Coral Springs, FL 33065.

*Hudson's Washington News Media Contacts.* H&M Publishers, 44 W. Market St., P.O. Box 311, Rhinebeck, NY 12572, (914) 876-2081.

*IMS Directory of Publications.* Gale Research Inc., 835 Penobscot Bldg., Detroit, MI 48226.

*Information USA Directory.* Viking Penguin Books, 375 Hudson St., New York, NY 10014.

*Interior Design Buyer's Guide.* Interior Design Publications, 475 Park Ave. S., New York, NY 10016.

*Internal Publications Directory.* Reed Elsevier Publishing, P.O. Box 31, New Providence, NJ 07974.

*The International Buyer's Guide of the Music-Tape Industry.* Billboard Publications, 1515 Broadway, New York, NY 10036.

*The Journal of the Society for Photographic Education.* Directory Exposure Magazine. % University of Colorado, Campus Box 318, Boulder, CO 80309.

*Lesl's Handbook of Public Relations and Communications.* H&M Publishers, 44 W. Market St., P.O. Box 311, Rhinebeck, NY 12572, (914) 876-2081.

*Literary Market Place.* R.R. Bowker Company, 121 Chanlon Rd., New Providence, NJ 07974. Annual directory listing book publishers. Here's where you'll match your photo collection with book publishers who need them.

*Looking Good in Print.* H&M Publishers, 44 W. Market St., P.O. Box 311, Rhinebeck, NY 12572, (914) 876-2081.

*Madison Avenue Handbook—The Image Makers Source.* Peter Glenn Publications, Ltd., 42 W. Thirty-eighth St., Suite 802, New York, NY 10018, (800) 223-1254, Fax: (212) 869-3287.

*The Mail-Order Business Directory.* Catalog Division, B. Klein Publications, P.O. Box 8503, Coral Springs, FL 33065.

*Manufacturers Directories.* 1633 Central St., Evanston, IL 60201-1569.

*Metro California Media.* H&M Publishers, 44 W. Market St., P.O. Box 311, Rhinebeck, NY 12572, (914) 876-2081.

*Newsletter National Directory.* Gale Research Inc., 835 Penobscot Bldg., Detroit, MI 48226.

*Newspaper Travel Editors,* 5337 College Ave., #258, Oakland, CA 94618, (510) 654-3035.

*New York Publicity Outlets.* Public Relations Plus, Inc., P.O. Drawer 1197, New Milford, CT 06776.

*O'Dwyer's Directory of Corporate Communications.* H&M Publishers, 44 W. Market St., P.O. Box 311, Rhinebeck, NY 12572, (914) 876-2081.

*O'Dwyer's Directory of Public Relations Firms.* J.R. O'Dwyer Co., 271 Madison Ave., New York, NY 10016.

*Online Business Information Sources.* Cuadra Associates, 655 Avenue of the Americas, New York, NY 10010.

*Patterson's American Education.* Educational Directories Inc., P.O. Box 199, Mount Prospect, IL 60056-0199.

*Photographer's Market.* Writer's Digest Books, 1507 Dana Ave., Cincinnati, OH 45207.

*Photo Source, The Working Photographer's Guide.* Professional Photo Source, 568 Broadway, 605A, New York, NY 10012, (212) 219-0993. A compendium of valuable addresses of suppliers to the industry.

*Photoworkshop & Travel Directory.* PhotoPro, 5211 S. Washington Ave., Titusville, FL 32780, (407) 268-5010.

*Professional's Guide to Publicity.* H&M Publishers, 44 W. Market St., P.O. Box 311, Rhinebeck, NY 12572, (914) 876-2081.

*Reader's Digest Almanac and Yearbook.* Pleasantville, NY 10570.

*Reed's Worldwide Directory of Public Relations Organizations.* H&M Publishers, 44 W. Market St., P.O. Box 311, Rhinebeck, NY 12572, (914) 876-2081.

*Register of the Public Relations Society of America.* 33 Irving Place, New York, NY 10003.

*Society of American Travel Writers Directory.* 4101 Lake Boone Trail, Suite 201, Raleigh, NC 27607, (919) 787-5181.

*Standard Directory of Magazines.* Oxbridge Communications, Inc., 150 Fifth Ave., Suite 301, New York NY 10011.

*Standard Periodical Directory.* Oxbridge Communications, Inc., 150 Fifth Ave., Suite 301, New York, NY 10011. Biannual directory listing most magazines. Ask your librarian to obtain this one!

*Stock Direct.* American Photography Showcase, 724 Fifth Ave., New York, NY 10019.

*Stock Photo Deskbook.* The Photographic Arts Center, 163 Amsterdam Ave., #201, New York, NY 10023.

*Stock Workbook.* 940 N. Highland Ave., Los Angeles, CA 90038, (800) 547-2688.

*Syndicated Columnists.* H&M Publishers, 44 W. Market St., P.O. Box 311, Rhinebeck, NY 12572, (914) 876-2081.

*Talk Show Guest Directory.* Broadcast Interview Source, 2233 Wisconsin Ave. N., #540, Washington DC 20007.

*Television Contacts.* H&M Publishers, 44 W. Market St., P.O. Box 311, Rhinebeck, NY 12572, (914) 876-2081.

*Traveler's Guide to Info.* U.S. Dept. of Commerce, U.S. Travel Service, Visitor Services Division, Washington, DC 20230.

*Travel Writer's Markets Directory.* Winterbourne Press, 7301 Burnet Rd., #102-279, Austin, TX 78757.

*Ulrich's International Periodicals Directory.* R.R. Bowker Co., 121 Chanlon Rd., New Providence, NJ 07974.

*Washington Information Directory.* H&M Publishers, 44 W. Market St., P.O. Box 311, Rhinebeck, NY 12572, (914) 876-2081.

*Webster's New World Dictionary of Media and Communications.* H&M Publishers, 44 W. Market St., P.O. Box 311, Rhinebeck, NY 12572, (914) 876-2081.

*Workbook.* The National Directory of Creative Talent, 940 N. Highland Ave., Los Angeles, CA 90038.

*Working Press of the Nation.* Reed Elsevier Publishing, 5201 Old Orchard Rd., Skokie, IL 60077-1021.

*The World Almanac.* United Media, 200 Madison Ave., 4th Floor, New York, NY 10016-3903.

*World Aviation Directory.* News American Publishing Inc., 210 South St., New York, NY 10002.

*World Travel Directory.* Ziff-Davis Publishing Co., 1 Park Ave., Room 1011, New York, NY 10016.

*Writer's Guide to San Francisco/Bay Area Publisher & Editors.* Zikawuna Books, P.O. Box 703, Palo Alto, CA 94302.

*Writer's Market.* Writer's Digest Books, 1507 Dana Ave., Cincinnati, OH 45207.

*The Yearbook of American and Canadian Churches.* 475 Riverside Dr., Room 866, New York, NY 10115.

## Associations and Organizations

Advertising Photographers of America (APA). 7201 Melrose Avenue, Los Angeles, CA 90046, (213) 935-7283, Fax: (213) 935-3855, Website: http://www.apamational.com

Advertising Photographers of New York (APNY). 27 W. Twentieth St., New York, NY 10011, (212) 807-0399, Fax: (212) 727-8120.

American Film Institute (AFI). John F. Kennedy Center for the Performing Arts, Washington, DC 20566, (202) 828-4000.

American Society of Journalists and Authors (ASJA). 1501 Broadway, Suite 302, New York, NY 10036, (212) 997-0947, Fax: (212) 768-7414.

American Society of Media Photographers (ASMP). 14 Washington Rd., Suite 502, Princeton Junction, NJ 08550, (609) 799-8300.

American Society of Photographers (ASP). P.O. Box 52836, Tulsa, OK 74158.

American Society of Picture Professionals (ASPP). 2025 Pennsylvania Ave. NW, Washington, DC 20006, (202) 233-8442, Fax: (202) 223-0034, E-mail: dcwnb07@plink.geis.com

Arts Information Center. 280 Broadway, New York, NY 10007, (212) 227-0282.

Association for Multi-Image International (AMI). 8019 N. Himes Ave., Suite 401, Tampa, FL 33614, (813) 932-1692.

Author's Guild. 330 W. Forty-second St., New York, NY 10036, (212) 563-5904, Fax: (212) 564-8363, E-mail: staff@authorsguild.org

British Association of Picture Libraries and Agencies (BAPLA). 13 Woodberry Crescent, London, N10 1PJ, United Kingdom, +44-81-444-7913, Fax: +44-81-883-9215.

Graphic Artists Guild. 11 W. Twentieth St., 8th Floor, New York, NY 10011.

Greeting Card Creative Network. 1200 G St. NW, #760, Washington, DC 20005, (202) 393-1780.

HALT! (American For Legal Action), 1612 K St., Ste 510, Washington, D.C. 20006-2802

International Fire Photographers Association (IFPA). P.O. Box 8337, Rolling Meadows, IL 60008, (708) 394-5835.

International Food, Wine & Travel Writers Association (IFW & TWA). P.O. Box 13100, Long Beach, CA 90803, (310) 433-5969, Fax: (310) 438-6384.

International Glamour Photographers Association (IGPA). P.O. Box 620, Dept. B, Washington, MO 63090.

National Association for the Cottage Industry. P.O. Box 14850, Chicago, IL 60614, (312) 472-8116.

National Press Photographers Association (NPPA). 3200 Croasdaile Dr., Suite 306, Durham, NC 27705, (919) 383-7246 or (800) 289-6772, Fax: (919) 383-7261, E-mail: sweitzer@wish-tv.com; loundy@lightside.com Website: http://sunsite.unc.edu/nppa

National Writers Union. 837 Broadway, Suite 203, New York, NY 10003, (212) 254-0279, Fax: (212) 254-0673, E-mail: nwu@netcom.com. (nyt)

North American Nature Photographers Association (NANPA). 10200 W. Forty-fourth Ave., Suite 304, Wheat Ridge, CO 80033-2840, (303) 422-8527, Fax: (303) 422-8894, E-mail: nanpa@resourcenter.com Website: http://www.mcs.net/~rjacobs/nanpa.htm

Photographic Society of America (PSA). 3000 United Founder Blvd., Suite 103, Oklahoma City, OK 73112.

PhotoGreen. 30 Musconetcong River Rd., Hampton, NJ 08827-9540, (908) 537-4313, E-mail: bobs@photogreen.org Website: http://www.photogreen.org

Picture Agency Council of America (PACA). P.O. Box 308, Northfield, MN 55057-0308, (800) 457-PACA or (507) 645-6988. Fax: (507) 645-7066. E-mail: paca@earthlink.net (Directory cost: $15.)

Professional Photographers of America (PPA). 57 Forsyth St. NW, Ste. 1600, Atlanta, GA 30303, (404) 522-8600. Fax: (404) 614-6400. E-mail: jhoppe r594@aol.com

Small Office Home Office Association (SOHOA). 1765 Business Center Dr., Reston, VA 20190, (703) 438-3060 or (888) SOHOA11, E-mail: msgmod @aol.com

Society of Photo Education (SPE). P.O. Box 222116, Dallas, TX 75222-2116, (817) 272-2845. Fax: (817) 272-2846, E-mail: socphotoed@aol.com Website: www.arts.ucsb.edu/spe/

Society of Photographers and Artists Representatives (SPAR). 1123 Broadway, Room 914, New York, NY 10010, (212) 924-6023.

Society of Professional Videographers (SPV). P.O. Box 1933, Huntsville, AL 35807, (205) 534-9722.

University Film and Video Association (UFVA). School of Cinema Television, University of Southern California, University Park, MC2212, Los Angeles, CA 90089.

Wedding & Portrait Photographers International (WPPI). 1312 Lincoln Blvd., Santa Monica, CA 90401, (310) 451-0090, Fax: (310) 395-9058, Website: http://www.wppi.online.com

PhotoSource International ™
Pine Lake Farm
1910 Thirty-fifth Rd.
Osceola, Wisconsin 54020-5602
Website: photosource.com

Note: A signed copy (8″ × 10″) of any of the photographs in this book is available for $25 by writing the author: Pine Lake Farm, 1910 Thirty-fifth Rd., Station 5, Osceola, WI 54020.

We publish the current photo needs of national photobuyers in our three services:
PhotoDaily (daily)
PHOTOLETTER (weekly)
PhotoStockNotes (monthly)

Phone us for more information: (800) 624-0266

Or

For extensive Information Kit containing samples and full details, send $5.00 to
PhotoSource International
Phone orders: (800) 624-0266
Fax: (715) 248-7394

# Index